AMERICAN ART NOUVEAU

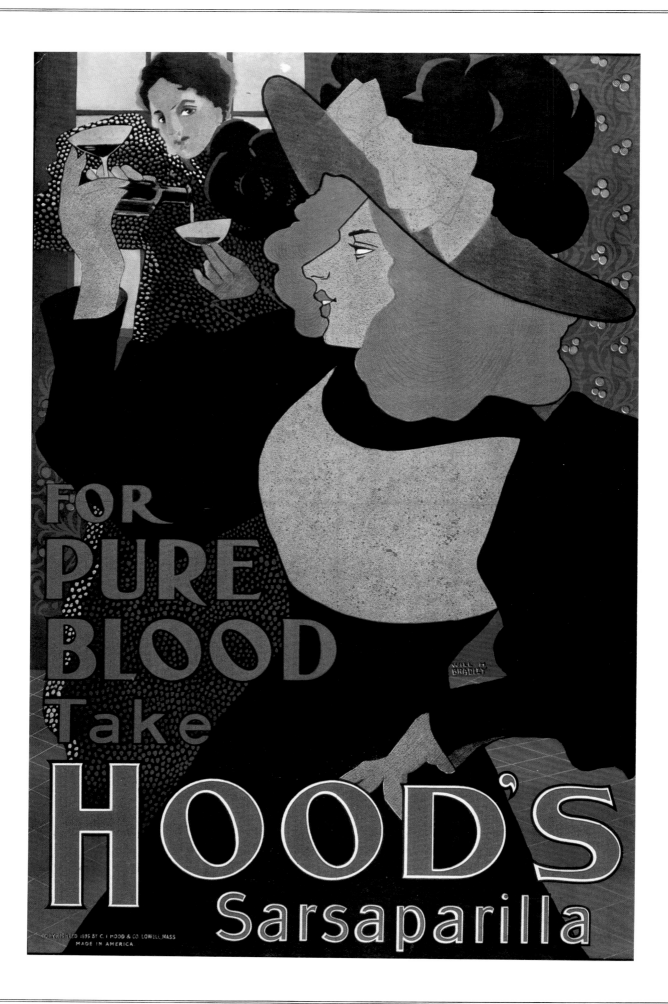

AMERICAN ART NOUVEAU

DIANE CHALMERS JOHNSON

HARRY N. ABRAMS, INC., PUBLISHERS, NEW YORK

LIBRARY OF CONGRESS CATALOGING IN PUBLICATION DATA
Johnson, Diane Chalmers, 1943–
American art nouveau.
Bibliography: p.
Includes index.
1. Art Nouveau—United States. 2. Art, Modern—
19th century—United States. I. Title.
N6510.5.A77J63 709′.73 78-31815
ISBN 0-8109-0678-3

Library of Congress Catalogue Card Number: 78-31815

*Published in 1979 by Harry N. Abrams, Incorporated, New York
All rights reserved. No part of the contents of this book may be
reproduced without the written permission of the publishers*

Printed and bound in Japan

Editor: Patricia Egan
Designer: Judith Michael
Photographic Research: James A. Murch

Frontispiece: WILL H. BRADLEY. Advertising Poster for Hood's
Sarsaparilla. 1895. Color lithograph.
Kunstbibliothek, Staatliche Museen Preussischer
Kulturbesitz, Berlin

Note on the captions:
In dimensions, height precedes width.
Unless otherwise specified, paintings are in oil
on canvas, and prints and drawings are on paper

To

JOHN KENRICK CHALMERS
DOROTHY AURIT CHALMERS
my parents

PROFESSOR KLAUS BERGER
my academic mentor

ROBERT CAREY JOHNSON
my husband

We unite all things by perceiving the law which pervades them; by perceiving the superficial differences, and the profound resemblances.

— RALPH WALDO EMERSON

CONTENTS

ACKNOWLEDGMENTS

My intent has been to bring together in this book a broad survey of American art that was related to concepts of Art Nouveau. I have had to rely a great deal on the research of others; their books, articles, and dissertations will be found in the chapter notes and bibliographies, but I wish to acknowledge each of them once more. It is my hope that the juxtapositions I have presented here will stimulate the further research in American art that is still needed for many facets.

My book has come into existence with the help of many people, all of whom I thank, though I can name only a few of them here. For the early stages of the work I make grateful acknowledgment to Professor Klaus Berger for his guidance of my graduate study in Art Nouveau and my dissertation on Will Bradley; to Brenda Gilchrist for her initial support of my idea to make a survey of American Art Nouveau; to Candace and Lester Bickford in particular, together with numerous and extremely helpful librarians, members of museum staffs, and private owners, for their aid in the task of gathering visual and written materials; to Dr. John M. Bevan and the College of Charleston for the Faculty Research Grants awarded me in the summers of 1976 and '77 and sabbatical leave in the fall of 1977, which provided the money for necessary travel and photography as well as the time for my final writing; to the typists who, over the years, have fought their way through my handwritten drafts, especially Gail Sanford and Lin Levgard; and to William Buggel for his help in photography copy-work.

For the intermediate stages I am much indebted to Anthony Janson, my former colleague, for his patient, close reading of the entire manuscript; his comments, corrections, and suggestions were of inestimable value. Likewise my thanks to colleague Kenneth Severens, whose reading of the Louis Sullivan chapter helped to clarify many crucial points and who was always on call with information on Sullivan material.

For their acceptance and production of the book I owe unlimited thanks to the staff of Harry N. Abrams, Incorporated, and especially to Robert Morton, who greeted the manuscript so enthusiastically; to Patricia Egan, who brought the words of my text into final form and tirelessly pursued the clarification of its many details; to Barbara Lyons and James Murch, who tracked down the illustrations in such varied sources, and to Libby W. Seaberg, who listed them; and to Judith Michael for its appearance in print.

Finally, for their constant support in so many ways, my thanks to my husband, Robert, to my sons, Chalmers and Marshall, and to Mary Grant, who took care of us all for these last five years.

D.C.J.

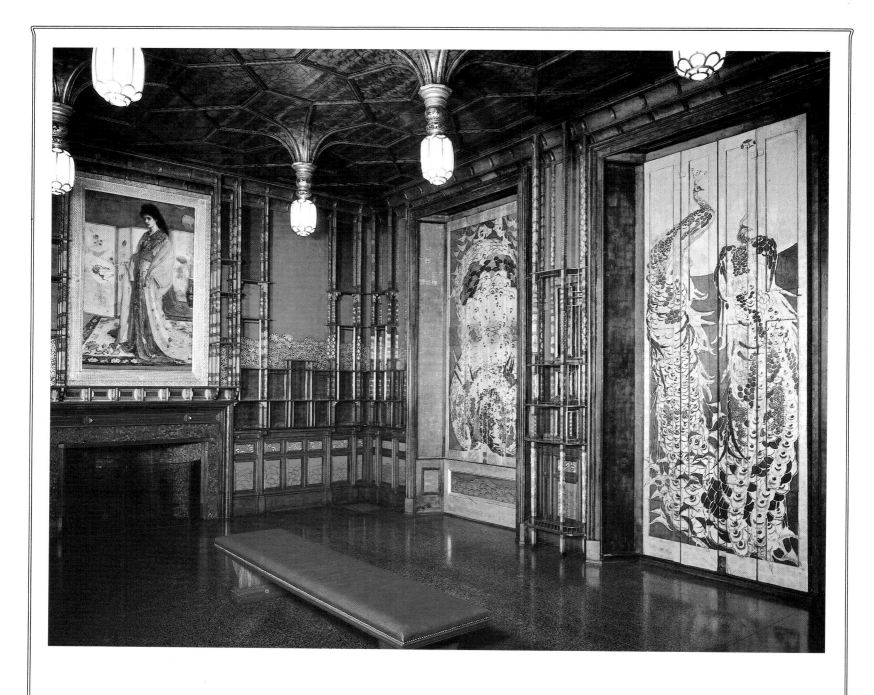

1. JAMES MCNEILL WHISTLER. Peacock
Room. 1876–77. Oil and gold on wood,
canvas, and leather. Frederick Leyland
residence, London; now installed in Freer
Gallery of Art, Smithsonian Institution,
Washington, D.C.

INTRODUCTION
ART NOUVEAU:
A GENERAL DISCUSSION

ORIGINAL DEFINITION

The term "Art Nouveau" entered the vocabulary of art when Samuel Bing opened his first *Salon de l'Art Nouveau* in Paris on December 26, 1895, presenting to the public the first representative collection of works in what he considered a "new style." He later wrote that "really the title of the salon should have been 'Le Renouveau dans l'Art' ":

> In certain branches of art, painting for example, which has steadily continued its development in a normal and regular way, no revival was called for. It was only in relation to art as applied to decoration, to furniture, to ornamentation in all its forms, that the need of a new departure was felt. . . .[1]

As used by Bing, Art Nouveau referred mainly to the applied arts, and he also called it "a movement, not a style." The basic principles of this movement were "to subject each object to a strict system of logic relative to the use for which it is destined and to the material from which it is formed"; to emphasize "purely organic structure"; to show clearly the part played by every detail in the architecture of an object; to avoid, "as one would flee leprosy," the fictitious luxury of falsifying every material and of carrying ornament to extremes.

Bing wished to raise the stylistic level of design in the applied arts to that evident in paintings by young French artists, such as those in the group recently formed called the Nabis; he thought their art best expressed "the general spirit of the age," and their paintings, prints, and designs for stained-glass windows by Tiffany dominated Bing's first *Salon de l'Art Nouveau* (see plate 87). Followers of Paul Gauguin, these artists held an ideal not so different from the medievalism of the Arts and Crafts artists in England, stressing the need to make painting part of a unified scheme of decoration.

> No more easel paintings! Down with useless objects! Painting must not usurp the freedom which isolates it from the other arts. . . . Walls, walls to decorate. . . . There are no paintings, there are only decorations.[2]

James McNeill Whistler had already made this attitude a reality in the 1870s in England with his carefully designed interiors, the Primrose Room and the Peacock Room (plate 1). Maurice Denis' exhortation in 1891 to artists in his "Definition of Neo-Traditionalism," to "Remember that a picture before it is a war horse, a naked woman, or some anecdote, is essentially a flat surface covered with colors arranged in a certain order,"[3] is likewise similar to the English Aesthetic attitude of the 1870s and 1880s, expressed in Oscar Wilde's own Whistlerian statement of 1882, that "a painting is a beautifully coloured surface, nothing more."[4] Samuel Bing's concern to raise the aesthetic level of the ornamental arts to that of contemporary painting is itself similar to the preceding English "renaissance" in these arts initiated by the Pre-Raphaelites about 1850, then by William Morris, Whistler, and the Arts and Crafts Society founded a decade later by Walter Crane and Lewis Day. Indeed, both Whistler and Crane were included in Bing's first *Salon de l'Art Nouveau*.

The blending of these two factions, English Arts and Crafts ideals with the aesthetics of French Post-Impressionist painting, was hastened by the important exhibitions of these arts held by the avant-garde Belgian group, *Les XX*. In 1891 their Fine Arts exhibit, which usually centered on Post-Impressionist and Symbolist painting, admitted English applied art—children's books illustrated by Crane, ceramics by A.W. Finch—as well as the new French applied art, the poster.[5] In 1893, the English Arts and Crafts periodical *The Studio* began to use photographs to illustrate works by artists and craftsmen, making these available internationally.[6] The results of this peculiar mingling of French and English aspects of late nineteenth-century art were evident in Bing's 1895 salon, and Bing, by his promotional talent and wide business acquaintance, distributed the "new art" throughout Europe and America.

Bing's title "L'Art Nouveau" served mainly as a label, consolidating and identifying the design concepts that gained popularity through subsequent exhibitions in the 1890s and dominated the 1900 Paris and 1902 Turin international expositions. Bing cannot be said to have "begun" Art Nouveau, but his definitions give a firm starting point for further analysis of what the "new art" involved.

ART HISTORICAL DEFINITIONS

Recent books on Art Nouveau offer a number of alternatives for defining its style, its place within the historical development of modern art, and the level of aesthetic quality of its various works. Nikolaus Pevsner defined the stylistic element of Art Nouveau as "the sinuosity of vegetation-inspired floral forms," its "leitmotif" the "long sensitive curve, reminiscent of the lily's stem, an insect's feeler, the filament of a blossom or occasionally a slender flame, the curve undulating, flowing, and interplaying with others, sprouting from corners and covering assymmetrically all available surfaces."[7] Stephan Tschudi Madsen preferred to see a broad set of variations within works from four countries: "the abstract and plastic concepts of Belgium; linear and symbolic in Scotland; floral and plant-inspired in France; and constructive and geometric in Germany and Austria."[8] With this degree of stylistic variety in the Art Nouveau movement, the variety itself should be discussed, rather than be denied in favor of "finding" one central visual "style."

Even more disparate than the stylistic descriptions are the estimates of Art Nouveau's place in the overall history of modern art. Pevsner, in *Pioneers of the Modern Movement*, 1936, considered Art Nouveau to be "a style of decoration around 1890, which appeared occasionally in architecture, but which mainly referred to a style of handicraft and of art

for art's sake items." For him, its historical significance lay in the initiating of a period of original forms, a transition that became "a blind alley," a "short but significant fashion in decoration." Tschudi Madsen also considered Art Nouveau an "anti-movement," seeking the new for its own sake, and essentially an "interlude" in the history of art. Robert Schmutzler defined it as a style of ornament which soon spent itself in becoming internationally fashionable, each nation developing its own short-lived variant.[9] Likewise Renato Poggioli described Art Nouveau as a fashion based on "eclectic aestheticism or vulgarized decadence."[10] On the other hand, James Grady saw Art Nouveau as neither a beginning nor an interlude, but as a culmination of the nineteenth-century idea of Nature as an aesthetic experience.[11] The constant reevaluation of Art Nouveau is evident in Pevsner's revised discussion of the movement in 1973, in *The Anti-Rationalists*.[12] Noting a trend in architecture toward individualism, plastic and sculptural values, and picturesqueness and fantasy, Pevsner reconsiders Art Nouveau works as early expressions of the anti-rationalism which seems to alternate with the rationalism of classical and International Modern.

These few definitions (the list could be much longer) pose many questions. Was Art Nouveau so complex that it encompassed certain essentials of all these ideas? Did the movement include ornament as well as architecture, objects of handicraft as well as art-for-art's-sake paintings? Were its styles both plastic and linear, floral and geometric, abstract and symbolic? Was it a style as well as a fashion, and at once an end, a transition, and a beginning? Did it revere tradition, while stressing originality at the same time? If the answer to all these questions is possibly yes, then Art Nouveau loses importance as a concept and gains importance as a reflection of the times that produced it.

Emerson's statement that begins this book expresses the desire of most nineteenth-century thinkers to find laws in literature, philosophy, religion, science, or art that would unite the multitude of "things" in reality. The search was on for "correspondences" or underlying relationships that would overcome the increasing sense of meaninglessness created by the cultural fragmentation pervading the "century of progress." Although it is now a cliché to speak of the nineteenth century in terms of industrial and democratic revolutions, the breakdown in many areas of personal, social, cultural, political, and religious life, as well as in art, undeniably came from these two revolutions and the drastic changes they brought to man's life. Industrialization fragmented and mechanized every profession, creating more specialization, faster changes, and a market based on quantity and cheaper materials. Its devastating effects on art, especially the so-called minor arts of design, became evident in the exhibits at the world's fairs in London and Paris in 1850 and 1855. As Samuel Bing later stated so clearly, "The present century, to its unprecedented shame, has not been able to forge a style of its own. The thread of tradition is broken, and the fragments scattered."[13]

From 1850 on, groups of artists, designers, and critics organized in many places with one idea in common—to synthesize a new aesthetic for the modern world. Many Europeans looked to America as having a distinct advantage in the attempt to develop a "new art," because, as Bing expressed it:

> . . . her brain is not haunted by the phantoms of memory; her young imagination can allow itself a free career, and, in fashioning objects, it does not restrict the hand to a limited number of similar and conventional movements. America, taken all in all, is indeed only a ramification of our ancient sources, and consequently the heir of our traditions. But again, she has a special destiny, occasioned by the fact that she does not possess, like us, the *cult,* the *religion* of these same traditions. Her rare privilege is to profit by our old maturity and, mingling therein the impulse of her vigorous youth, to gain advantage from all technical secrets, all devices and processes taught by the experience of centuries, and to place all this practical and proven knowledge at the service of a fresh mind which knows no other guide than the intuitions of taste and the natural laws of logic.[14]

ART NOUVEAU IN AMERICA

What is America's place in the international "new art" movements of the 1880s and 1890s? Most surveys of Art Nouveau, if they include America at all, mention out of proper context Louis H. Sullivan's architectural ornament, Louis C. Tiffany's glassware, and Will H. Bradley's posters and graphic designs. How are these artists and their works related to the various movements of European Art Nouveau? Do other American artists deserve inclusion? How, when, where, and why does Art Nouveau occur in America?

The following chapters will proceed chronologically, beginning with the events and ideas from approximately 1876 to 1893 which laid the groundwork for Sullivan, Tiffany, and Bradley. The years 1891 to 1898 seem to mark the most creative "Art Nouveau" phases of all three men, plus certain of their earlier and later works, and we will emphasize those produced during this span. But the American public was not familiar with Art Nouveau, European or American, until the late 1890s, particularly after the 1900 Paris Exposition; and the second, more derivative and commercial phase of American Art Nouveau that developed in the first decade of the twentieth century followed direct contact with European styles.

After 1893 American architecture turned strongly toward European historicism. Meanwhile, the arts of painting and sculpture, with European traditions of naturalism to overcome, proceeded along a slow and irregular path, from the first Japanese-inspired compositions and suggestive symbolism in works of the 1870s and 1880s by such artists as Whistler, Inness, Vedder, La Farge, Blakelock, and Rimmer, to the development of abstract art early in this century, coming from contact with European Post-Impressionist and Cubist art, and leading to "modern" works by Demuth, O'Keeffe, and Dove.

The art of the European Post-Impressionists that underlies all of Art Nouveau is crucial to the development of modern American art as well. Among the few Americans of the 1880s and 1890s who achieved a "new style," Louis Sullivan's very "original" ornamented architecture stands out as the most creative and most deeply expressive. Louis Tiffany's productions are somewhat haphazard; among his many excellent works are mixed a few poor ones, and an eclecticism is sometimes apparent. Will Bradley's graphic art often achieves a high excellence and individuality of design and expression, but essentially it is derivative from that of Aubrey Beardsley and other major European graphic designers. Certain works by a few painters—Vedder, La Farge, Ryder, Inness, and others—correspond in form and expression to European Post-Impressionist concepts; in general, American painters had no thorough understanding of these until the second decade of the twentieth century.

American art at the turn of the century and its interrelationships with European developments offer many intriguing aspects which we will consider here, but a great deal remains to be done of specific research and documentation for many American artists. This book seeks to present to the curious reader some of the excellent works of art and the concepts underlying them which suggest fascinating interactions within American art and between American and European art, in hopes of stimulating investigation into the modern artist's continual attempt to unite the fragments, to synthesize a visual expression meaningful for the modern world.

CHAPTER ONE

THE AMERICAN CULTURAL RENAISSANCE

OSCAR WILDE'S AESTHETIC MESSAGE, 1882

On January 2, 1882, the British liner *Arizona* docked at New York City, and out stepped the already notorious Oscar Wilde. His forthcoming year-long lecture tour of the United States would take him to some fifty cities and into the homes of many notable Americans (plate 2).[1] The blaze of publicity that greeted Wilde made clear the chief reason for his tour in the New Land: the backers of Gilbert and Sullivan's new operetta *Patience*, an 1881 satire on the English Aesthetic Movement, were about to launch the work in America, and Oscar Wilde at twenty-eight, a colorful figure in that movement, was just the man to publicize the Aesthete in *Patience*. Wilde accepted the lecture tour hoping to gain the experience, publicity, and money that would help his determined climb to fame in England; perhaps he had even partially convinced himself that in traditionless America his aesthetic message would fall on fertile soil.

In his first lecture Wilde matter-of-factly informed Americans, "as in your cities, so in your literature, it is a permanent canon and standard of taste, an increased sensibility to beauty (if I may say so) that is lacking." Yet he also remarked that the "very absence of tradition may be rather the source of your freedom and your strength."[2] Wilde continued his fairly long lecture on "The English Renaissance" with an intricate explanation of the new artistic ideas then prevalent in England, a curious mixture of the Arts and Crafts ideas of John Ruskin and William Morris, the artistic philosophy of the Pre-Raphaelites, aesthetic attitudes based on Walter Pater, and decorative concepts of Japanese art (plate 3). His philosophical discussion covered many topics: the meaning of the French Revolution for art and society; quotations from William Blake on the importance of the clear outline in art (see plate 309); the history of the Pre-Raphaelite Brotherhood and its concern for the spiritual in art; a condemnation of the intellect dominating the sensual in Western art, as compared to Eastern art; a definition of a painting as "a beautifully coloured surface, nothing more";[3] a plea for modes of criticism which would ignore questions of morality and

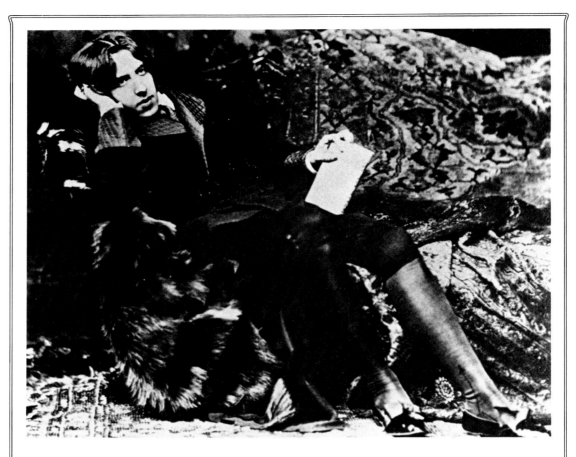

2. Oscar Wilde, photographed at about the time of his American lecture tour

3. KIYOSHIGE. *Warrior*. 1758. Woodcut, hand colored, for the cover of a Japanese children's book. Private collection

consider only whether or not a poem was written well; quotations from Plato on the importance of the decorative arts and the need for beauty in even the meanest vessels of the house, to help man toward a "gracious existence leading to divine harmony of spiritual life"; and a broad classification of world outlook into two types—one based on Pater's search for experience itself, the other on Morris' doctrine of injecting the joy of art into labor. Closing the ninety-minute lecture, Wilde resoundingly declared that "the secret of life is in art."

After several months of delivering this interesting, but rather confused, "English Renaissance" lecture, Wilde prepared another one entitled "House Decoration," with a lower aesthetic approach, first given in May:

> Having seen some fifty or so cities, I find that what your people need is not so much high imaginative art, but that which hallows the vessels of everyday use.[4]

In this lecture the Aesthete described with evident horror the state of the applied arts in America. He condemned the use of "meaningless" machine-made ornament, the unconcern with decorative color schemes in interior design, and the general misunderstanding by American designers of the difference between "decorative" and "imaginative" art. The basic problem, as Wilde saw it, was:

> Your people do not sufficiently honor the handicraftsman. . . . I find that one great trouble all over is that your workmen are not given to noble designs. . . . What you must do is bring artists and handicraftsmen together.

This last idea he made more specific in a third lecture, "Art and the Handicraftsmen":

> People often talk as if there was an opposition between what is beautiful and what is useful. There is no opposition to beauty except ugliness: all things are either beautiful or ugly, and utility will always be on the side of beautiful things, because beautiful decoration is always an expression of the use you put a thing to and the value placed on it. . . . Every material and texture has certain qualities of its own . . . and the use one puts the object to should guide one in the choice of design. . . . We should remember that all the arts are fine arts and all the arts are decorative arts.[5]

Wilde's clear explanation of the ideal blend of art and craft indicates that he understood the prevailing ideas expressed by so many artists, in both America and Europe. Indeed, he speaks of the relation of decoration to object much as Samuel Bing was to do two decades later (see p. 13). Wilde's plea that artists should unite with craftsmen, though it grew out of William Morris' ideal, went beyond any revival of medieval crafts; he exhorted Americans not to regress to historicism, but to stress "modernity" and "individualism of expression," two elements that became essential to all phases of the "new art" of the late nineteenth century.

Although Wilde met with ridicule from the vast majority of Americans, his suggestions were praised and followed by a fairly influential minority. The explosive expansion of cities and urban life in the last quarter of the nineteenth century had produced a new type of woman; many of these, having no previous social position, now wished to capture "culture" and social status in the new urban environment as quickly as possible.[6] With the wealth and leisure won for them by their enterprising husbands, these women pored over etiquette books, bought anything imported from Europe and especially from England, and, guided by new magazines such as the *Ladies Home Journal* (founded 1883) and *Good Housekeeping* (1885), sincerely tried to put into practice some of Oscar Wilde's artistic ideas.

Women of the upper middle class, particularly, liberated from household routine by their means to hire help and buy "labor-saving" machines such as clothes washers, began

to use their free time for numerous club activities. As one writer put it in 1880: "We have art clubs, book clubs, dramatic clubs, pottery clubs. . . . We have sewing circles, philanthropic associations, scientific, literary, religious, athletic, musical, and decorative arts societies."[7] By 1889 these clubs were so numerous and influential that they joined into one national system, the General Federation of Women's Clubs, which continued to sponsor the "arts," especially the arts of England.

"Anglomania" in the decorative arts had followed the Philadelphia Centennial Exhibition of 1876, where the new British applied arts had been introduced by William Morris, Walter Crane (plates 4, 5), and the Royal School of Art Needlework (see plate 21).[8] Many Americans strongly desired to emulate in this country the social structure of England's entrenched nobility and serene gentry, hoping to set themselves off from the thousands of immigrants pouring into American cities. In keeping with this imitation of England's aristocratic society was the growing admiration for British (and for traditional French) decorative arts.[9] By 1880 the Aesthetic Movement had already made its mark on many American homes. American men were generally too busy making money to pay attention to matters of art, but Wilde's growing audience of "idle, fashion-hungry women," who, he noted, were "the only people in America who have any leisure," were now ready to follow his advice down to the placement of the last china vase. Candace Wheeler's New York Society of Decorative Arts, established in 1878 for "the employment of idle gentlewomen," set to work on Wilde's suggestions for decorating everyday household goods;[10] meanwhile in Chicago the Decorative Arts Society, also founded in 1878, listened carefully to Wilde and then designed interiors based on his explanations of Whistler's calculated interior color schemes. To these cultured few Oscar truly appeared, as the *New York Sun* described him, "a man of cultivation, taste, imagination, education, and refinement."

To this minority opinion the vast majority of Wilde's audiences, consisting mainly of middle-class, often urban people, was in strong contrast. These were eager to possess the glorious products of the new industrial society. They were not much interested in artistic spiritualism as preached by Oscar Wilde, being still too close to the sterile poverty of frontier life to admire works of handicraft. The "homemade" they rejected as tedious, old-fashioned, and "countrified." What they wanted were the very things Wilde condemned —the products of the "Age of Invention," new marvels of "Science and Mechanization," everything from electric corsets and hairbrushes to elaborately carved, machine-made furniture.[11] Their taste too had been set in 1876 at the great Centennial, where the keynote was "Art and Industry," the union of the "two great elements of civilization." Since that Fair the growing businesses of mass-merchandizing and advertising had perpetuated and exploited this taste. These people wanted not simple, honest, handcrafted goods but "gaudy, gilt furniture . . . with a nymph smirking at every angle and a dragon mouthing on every claw," which to Wilde was fit only for "periwigged pomposities."

The intense publicity that preceded and accompanied Wilde's visit, and his own showmanship in dress, statement, and behavior, made his tour a triumphant success as entertainment. However, much rather hostile satire was written about him; if Wilde found the general public irreverent and blind to the beautiful, they found in him an example of the immoral decadent, as well as a poor lecturer, and these factors prevented the working-class "people" from accepting his message. Although his lectures were fairly coherently written, Wilde's "cultured" manner of speaking helped to negate the impact of his ideas. As the *Fort Wayne News* expressed it:

> Wilde's speech was a languid, monotonous stream of mechanically arranged words, scholarly but pointless, and as instructive as a taxlist to a pauper, and scarcely as interesting.[12]

To a nation that thrived on forceful rhetoric from its ministers and politicians, Wilde's "languid" delivery apparently left much to be desired. And associated with his message of

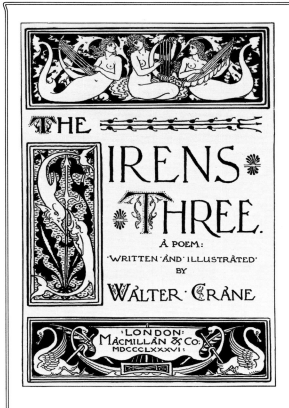

4. WALTER CRANE. Title page of *The Sirens Three,* Macmillan, London, 1886. Photogravure. Harvard College Library, Department of Printing and Graphic Arts, Cambridge, Mass.

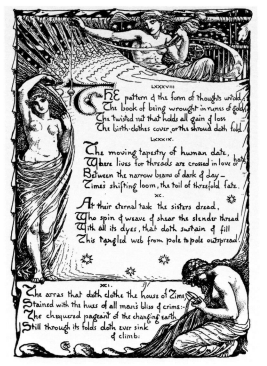

5. WALTER CRANE. Illustrated page with verses 88–91, *The Sirens Three,* Macmillan, London, 1886. Photogravure. Harvard College Library, Department of Printing and Graphic Arts, Cambridge, Mass.

Aestheticism, his rumored perversions gave fuel to one strong group in its attack on art in general. A sensuous devotion to art challenged directly the puritanic Protestantism of American religion. Since the Civil War Americans had been increasingly exposed to European art through the assembling of collections, the opening of museums in the 1870s, and the foreign travel of unprecedented numbers of citizens; members of the ministry were becoming disturbed by the spreading interest in art. Soon after Wilde's visit Washington Gladden, writing on "Christianity and Aestheticism" in the *Andover Review,* began by admitting that "the old Puritan doctrine, that art is sinful, has been roundly repudiated, as it ought to have been." Nevertheless he noted the danger in too strong a reaction in the opposite direction: he expressed thanks for Wilde's recent and highly publicized trip, claiming it helped to clarify "just what Aestheticism was," and he warned his readers that historical periods when art had been of supreme interest in human life had always been periods of national decadence:

> No subtler or more dangerous foe of civilization is now abroad than the moral indifference which infests so much of our art, and which accustoms us to look coolly and curiously on the plastic forms of human character, caring little whether they are good or evil.[13]

The American Cultural Renaissance, 1876–1893

This line of attack was continued in 1888 from academic circles by Charles Eliot Norton of Harvard, this time condemning artists for similar attitudes:

> It is a bad sign that artists feel that art and morality are absolutely independent, that the relation between the Beautiful and the Good is purely external, and that it is an impertinence to ask for anything in a work of art more than that it should be well executed.[14]

Against such strong and eloquent attacks, Wilde's role as an apostle of the Aesthetic Movement dwindled in retrospect. If he had come with an impelling vision of founding a cult of the beautiful among American workers, he must have known within a few months that this was attempting the impossible. Except for a handful of men and especially women who were already quite interested in the English art movements, the large, irreverent crowds he had drawn had come to see a curiosity, a long-haired man in short pants.

Wilde himself had no doubts about "culture" in America. He confessed to the *New York Tribune* on the eve of his departure that his mission to America's "barbaric shores" had been substantially a failure. Wilde's final conclusion:

> For the American, Art has no marvel, Beauty no meaning, and the Past no message.[15]

THE ARTIST-CRAFTSMAN IDEAL

In spite of Oscar Wilde's indictment, the decade after his visit saw Americans optimistically pursuing the "marvels of Art," spending hours reading, sitting through lectures, and expounding on the "meaning of Beauty," as well as plundering the European "Past" in the hope of establishing traditional underpinnings for their arts. Nor did the warnings of men like Gladden and Norton dim the eagerness of the American middle and upper classes to surround themselves with "artistic" houses, interiors, furniture, ceramics, stained-glass windows, paintings, books, and magazines. In its own way, America had embarked on a renaissance.[16]

The American Renaissance of the 1880s found its principal model, of course, in England —the Pre-Raphaelites, the Arts and Crafts Society, and Aestheticism. Artistic connections between England and the United States were steadily strengthened by the pioneer work of moral and social-minded men such as William Morris and, especially, Walter Crane. Crane had been lauded at the 1876 Centennial, and awarded prizes for his designs for wallpaper and other applied arts. His illustrated children's books became very popular and influential in America during the 1870s and 1880s;[17] in 1885 the Grolier Club of New York arranged a large exhibit of English illustrated books including many by Crane (see plate 285), a few by Kate Greenaway, and a number of William Blake's works.[18] The well-known Swiss-French designer, Eugène Grasset, whose designs for the French book *Histoire des Quatre Fils Aymon* of 1879–83 combined Japanese, Celtic, and medieval manuscript sources (plates 6–8), also began to gain a following in America after 1882, when he was commissioned to draw the November cover for *Frank Leslie's Illustrated Newspaper*.[19]

Together with the decorative arts of Crane and Grasset, the concepts and designs of Japanese art were also becoming interesting to Americans since the 1876 Centennial.[20] In his book on that exposition Walter Smith wrote:

> Certainly at the present there is an uncertainty not as to what is good, [but] as to what is best in decorative art that suggests a change of some sort. The influence of Japanese art is making itself felt in Europe and England, as anyone walking through the Main Building must have noticed.[21]

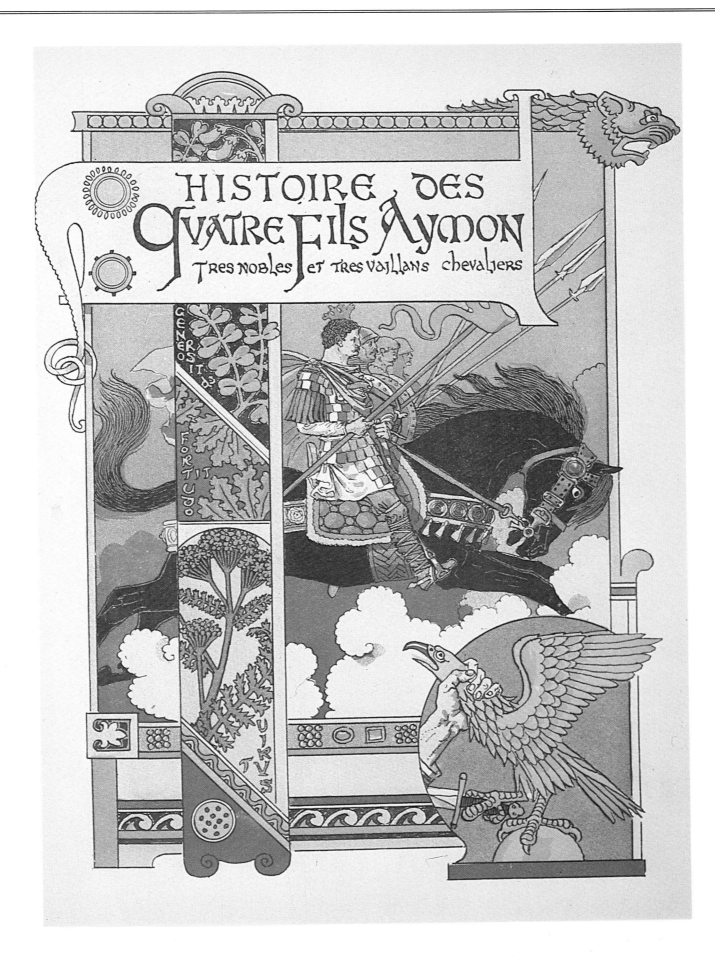

6. EUGÈNE GRASSET. Cover of *Histoire des Quatre Fils Aymon,* Launette, Paris, 1883

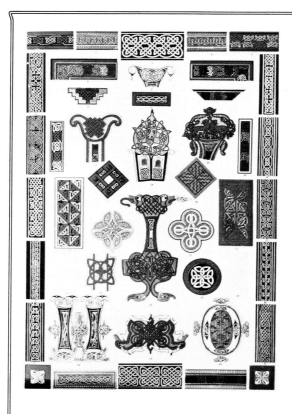

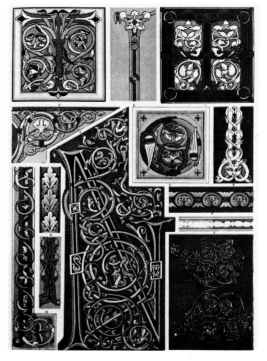

7. OWEN JONES. "Celtic No. 2," Plate LXIV in *The Grammar of Ornament,* London, 1856

8. OWEN JONES. "Illuminated Mss. No. 1," Plate LXXI in *The Grammar of Ornament,* London, 1856

During the 1880s the awareness of Japanese art became a dominant factor in American design as the availability of this art increased. Among the important European *Japonistes* to become involved with America was Samuel Bing, who already had a New York branch of his business of purchasing and selling Japanese goods in 1880, furthering American collections of everything Japanese, from woodcuts and decorative screens to sword guards and pottery (plates 9, 10).[22] Wilde constantly praised the fine quality of Oriental decorative arts, and Bing exerted a strong influence through his store and through his richly illustrated international periodical of 1888–91, *Le Japon Artistique* (published in English in 1889–91 as *Artistic Japan*). Among the many Americans responding to Japanese decorative arts after the Philadelphia Centennial, two were particularly important: Maria Longworth Nichols, who founded the Rookwood Pottery in Cincinnati, Ohio, in 1880, largely inspired by Japanese concepts (and staffed by at least one Japanese designer, Shiradayamani) and soon to be internationally famous; and Tiffany and Company's Edward C. Moore (manager after 1868 of the company's art manufacturers), who imported many Japanese craftsmen during the 1870s and 1880s to help in creating special works in silver.[23]

American enthusiasm for the beauty and simple elegance of Japanese art was allied with interest in the synthesis of art and craft in Japan, where crafts were "arts" and an expression of "the people." Americans developed similar fondness for other artistic cultures of the Near and Far East. Examples of Egyptian and also of Islamic architecture, crafts, and design were especially popular at the Philadelphia Centennial (see plate 20), and objects

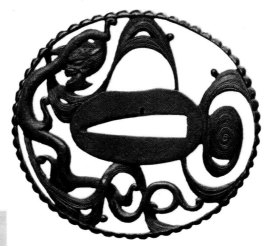

9. ISSAN. Sword Guard with dragon and waves. Edo Period, early 19th century. Iron, diameter 2⅞". Cleveland Museum of Art (Gift of D. Z. Norton)

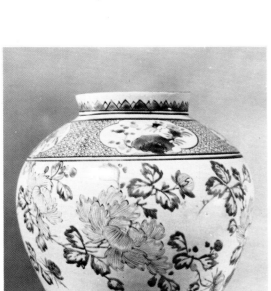

10. Porcelain Jar with floral design. Kakiemon ware, early 17th century. Art Institute of Chicago (Gift of Robert Allerton)

were collected avidly by Tiffany and Company's Edward C. Moore and other close friends of Louis C. Tiffany.[24] A third and related interest developed in the decorative arts of medieval Ireland, such as the Tara Brooch exhibited in London in 1851. All of these styles attracted the collectors of exotica, and all reflected the highest levels of craftsmanship, objects which were truly works of art.

Stimulus from the 1889 Paris Exposition strengthened, broadened, and consolidated these forces in American design. The Grolier Club in New York exhibited Japanese colored woodcut prints in spring 1889, and a show of French lithographic posters in autumn 1890, centering on works by Chéret and Grasset (see plates 6, 227).[25] Crane himself came to the United States in 1890 to lecture on the "Decorative Illustration of Books," and he painted murals in John Root's new Women's Christian Temperance Union building in Chicago (including Burne-Jones-type female figures representing Temperance, Purity, Mercy, and Justice).[26] In 1889 Grasset designed two posters for Harper and Brothers.

Fundamental to these movements reviving high quality in American applied arts was the notion that "artists" must become designers, and in the 1870s many artists had extended their talents beyond the traditional limits of art. Henry H. Richardson exemplified the concept of unified design in his plans for Boston's Trinity Church in 1872 by selecting the

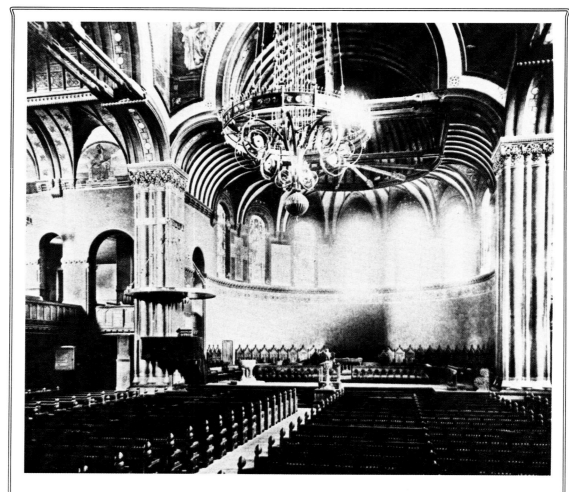

11. HENRY HOBSON RICHARDSON and JOHN LA FARGE. Interior of Trinity Church, Boston. Decoration 1876 (contemporary photograph)

painter John La Farge to help him create an interrelated system of the arts of architecture, painting, sculpture, and ornamentation (plate 11). The decorative plan was to be based on an overall color scheme suggested by Richardson's desire for a "red effect."[27] The completed interior brought La Farge's work great admiration (see plate 23), both for the harmonious effect of the unified decoration and for the idea of a distinguished artist undertaking the decoration of an entire building.

Trinity Church is the earliest example of Richardson's belief that his role as an architect should extend to the harmonious coordination of all the elements in the total environment of his buildings. On occasion he also provided furniture, fixtures, and decorative details (see plates 41, 47, 69),[28] working in collaboration with American artist-designers as well as with the Frenchman Auguste Bartholdi and with international groups, such as those around William Morris. The thorough integration of the design of these objects with the architecture has, like several of the designs themselves, what we would now call an Art Nouveau quality.

There are many instances of artists concerning themselves with "decoration" in the 1870s and '80s. Already in the 1860s La Farge, dedicated to the concept of artist-as-craftsman, had painted a ceiling, designed a set of oil panels for a dining room, and illustrated books and magazine stories (see plates 301–3). By 1876 he had a shop of assistants to help with mural and glass production, and eventually he became involved in everything from embroidery design to mosaics (see plates 88, 90).[29]

Louis C. Tiffany, a painter member of the Society of American Artists in the 1870s together with Inness, Colman, and La Farge, became a leading American Art Nouveau designer. His Associated Artists, founded in 1879, designed total decorative schemes for interiors, blending exotic elements such as Islamic carvings, embroidered hangings, painted friezes, and stained glass (see plates 29, 34).

James McNeill Whistler, the American expatriate painter living first in Paris and then in London, was probably, along with architect-designer Edward Godwin, the source of many of Wilde's statements on the unified interior. Based on Japanese design principles, Whistler's Primrose Room, exhibited at the Paris International Fair of 1878 but no longer extant, proclaimed his belief that "the painter must also make of the wall on which his work is hung, the room containing it, the whole house, a Harmony, a Symphony, an Arrangement, as perfect as the picture or print which becomes a part of it."[30]

Another American painter, Elihu Vedder, designed Christmas cards for Prang's competition in 1882 (see plate 226), and magazine covers for *Harper's* and *The Century Magazine*. In 1882 he met Louis C. Tiffany and went to work with him, producing curiously proto-Art Nouveau designs for windows (see plate 124) as well as for cast-iron firebacks of a sun god and a Japanese dragon. Indeed Vedder's best-known works were not his paintings but his book design and illustrations for the *Rubáiyat of Omar Khayyám*, published in Boston by Houghton, Mifflin in 1884 (see plates 305–8).[31] Perhaps even more curious are Albert Pinkham Ryder's three painted panels for a decorative screen in the late 1870s, decidedly Japanese in their vertical format and two-dimensional conception (see plate 360).[32]

These few intriguing cases are selected to exemplify the American artists' desire to extend their abilities to all the arts and crafts, and to create good design as well as good art—an idea central to Art Nouveau. Their motives were neither altruistic nor in any way socialistic; money-making was a foremost concern for several artists—such as La Farge, who convinced the young Stanford White to give up painting in favor of a more lucrative career in architectural design.[33] The age of invention and patent competition extended into art, and the 1880s saw both La Farge and Vedder suing Louis Tiffany for "stealing" their ideas.

THE KNIGHT ERRANT, 1892

The periodical which appeared in Boston in April 1892, *The Knight Errant: A Magazine of Appreciation* (plate 12), gives precise evidence of the impact upon the United States of England's Aesthetic Movement. In the preface the editors wrote:

> The Quest: Being an apology for the existence of the review called *Knight Errant*: Man against an epoch; is it not that after all? One by one in this last night, the beautiful things have disappeared, until at last, in a world grown old and ugly, men, forced to find some peculiarity of their environment, have discredited even beauty itself, finding it childish, unworthy, and—*unscientific*. This is a condition that demands a new chivalry . . . a new quest for beauty.

Thus the ideas of the new English Renaissance as presented by Oscar Wilde ten years before had definitely affected a small but influential American avant-garde intellectual and artistic group. The tone of *The Knight Errant* was somewhat nostalgic and Pre-Raphaelite, as conveyed in its title and in its stated purpose:

> The Knight is called to action, to war against the Paynims of *realism in art*, to assail the dragon of *materialism*, and the fierce dragon of *mammonism*, to ride for the succour of forlorn hopes and the restoration of forgotten ideals.

Elements of English and Japanese art were dominant in its design and content. The cover drawing was by Bertram Goodhue in a Kelmscott Press, medievalizing woodcut style, and most of the articles dealt with William Morris and the Pre-Raphaelites (especially Burne-Jones), and with principles of Japanese art.

The first issue of *The Knight Errant* opened with a photogravure reproduction of *La Columbine* by Bernardino Luini and a reprinted address of 1888 by Charles Eliot Norton on "Art in America," strongly stating the antimaterialistic attitude of the magazine:

> The conditions of life in America have hitherto been such as to afford little opportunity for the culture of the poetic imagination, and for its expression in the arts. Life has been too busy with hard physical toil, with mastering the earth, with material conquests on a great scale, with social and political organization, to leave the intelligence unimpeded for higher tasks. . . . For its happy and productive exercise, the creative imagination requires a certain spiritual and intellectual atmosphere, and this America does not yet supply. . . .
>
> Even the most enthusiastic asserters of American progress in the arts can hardly refuse to acknowledge that there has not been as yet in America a single painter, sculptor, or architect who has created a great work of art, who has succeeded in giving beautiful expression to the aspects and interests of contemporary life in forms which might define and complete the dim and imperfect ideals of this great, groping, unimaginative community.
>
> Yet, at the same time, the spirit of self-satisfaction, begotten of our material prosperity and our general ignorance of the great achievements of the fine arts, is so strong in us that we accept and applaud and admire the work, trivial most of it, bad much of it, that is offered to us by men who have nothing to say that is worth listening to.[34]

Goodhue continued his deprecatory discussion of art in America, adding:

> The correlation of Art and Morals, one with another, may effect the modern decline in artistic insight; for no one can but admit that the state of these two at the present moment is at one of the lowest ebbs in the history of all time.[35]

A slightly more positive approach was taken in Ralph Adams Cram's article "Concerning the Restoration of Idealism and the Raising to Honor once more of the Imagination." The issue concluded with a discussion by Fred H. Day, "Regarding Recent Books and Bookbinding," in which he praised Oscar Wilde's new book, *A House of Pomegranates*, with illustrations and design by Charles Ricketts.

Walter Crane's art and ideals dominated the second issue, with a photogravure of his illustration of *La Belle Dame sans Merci* as the frontispiece, and his article, "Of Aesthetic Pessimism and the New Hope." Another lengthy article presented "Some Thoughts on the Beauty of Typography suggested by the work of William Morris at the Kelmscott Press." Also in this issue were two poems by Cram on the painting of Botticelli and Fra Angelico, and a study by Hugh McCullock, Jr., of the poetry of Paul Verlaine.

The third issue, dated October 1892, was largely concerned with Oriental art, with a reproduction of Hishiyama Hoyen's painting *The Bodhisattva Kwannon* as the frontispiece. In it was a long and important article by Ernest F. Fenollosa, influential as an early collector of Japanese paintings and the first Curator of Oriental Art at the Boston Museum of Fine Arts;[36] Fenollosa compared Japanese painting to the works of Fra Angelico and Fra Filippo Lippi, and went on to argue against applying the deprecatory term "decorative" to all Oriental art:

> It would be pitiful to use the imbecile phrase of the day, and say Japanese art is "decorative." That art alone, whether Japanese or European, is properly decorative,

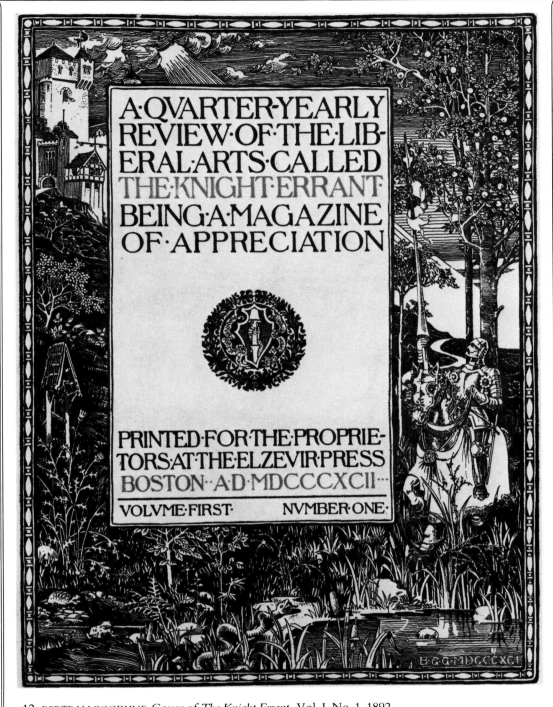

12. BERTRAM GOODHUE. Cover of *The Knight Errant,* Vol. I, No. 1, 1892

which has been designed to ornament something useful, as a wall or utensil. But this Kwannon decorates nothing. It is self-complete expression. What deceives us is this perverse habit of using the word *decorative* as if it were synonymous with *beautiful.* Is, then, the function of decorating the principle, the root-idea, of all beauty? Is music decorative? . . . This inadequate term is only a despairing device of the realists to cover their retreat by raising a false issue. It attempts to draw a line where there is no line. Driven from Poetry, driven from Music, driven from Architecture, driven from the designing of art-industries, driven from the old masters, driven from the realm of colour, driven from everything that makes beauty beautiful and nobility

noble, these realists would coax the world to believe that there is one realm from which they cannot be driven, namely, the *non-decorative*. But there is no such place—in Art, at least. If decoration be synonymous with beauty, synonymous with synthesis, then it is synonymous with Art.[37]

Discussion of the term "decorative" was taken up again in the last issue, 1893, with an enlightened analysis of Japanese pictorial art written by Arthur W. Dow, Fenollosa's artist-friend who would succeed him at the museum in 1897 as keeper of Japanese paintings and prints. In "A Note on Japanese Art and What the American Artist May Learn Therefrom," Dow described those qualities of Japanese art that had particularly appealed to a new school of French artists;[38] he was thoroughly familiar with the new Synthetist-Symbolist art of Gauguin and the Nabis, having spent four years in Paris at the Académie Julian and summers in Pont-Aven.[39] In explaining Japanese art to Americans, Dow played the part of teacher, and began with intellectual and social implications:

> Japanese art is the expression of a people's devotion to the beautiful. It is an art which exists for beauty alone, in isolation from science and mechanics, from realism and commercialism, from all that has defogged and debased other art.

Concerning the difference between "decorative" Eastern art and "realistic" Western art, Dow explained:

> All Japanese artists are designers; the same was true of European artists until the Renaissance. To compose a picture requires a knowledge of design; for the inability to manage line and its sister principles, in their simplest forms, involves the impossibility of using them successfully in a picture, which is only an elaborate and complicated design. In Japanese art, composition is omnipresent. The American artist is in danger of sacrificing composition to realism.

Dow continued with a more specific analysis of Japanese methods (the subject he was to teach for many years at Pratt Institute and Columbia University's Teachers College in New York, using his famous text, *Composition*):

> The Japanese are masters of those interrelationships of line whereby they mutually affect each other and proportionately divide spaces. The next point is the development of the Light and Dark principle—*Notan*—the division of the surface by line is followed by its division into contrasting masses of dark and light.

In his short, simple article was a very clear explanation of Japanese art and how it differed visually from the art of the Western world, so concerned with the realistic depiction of the single, solid object.

This final number of *The Knight Errant* also contained two articles on the contemporary English movement in the art of fine printing and book illustration. Bertram Goodhue wrote of the art of Burne-Jones, the Pre-Raphaelite who "would seem to contain enough of the element of greatness to even outlive being fashionable"; William Morris, "one of Mr. Burne-Jones' warmest friends"; Walter Crane; and "amongst the more recent names," C. S. Ricketts, C. Shannon, Reginald Savage, and "the last star of any brilliancy," Aubrey Beardsley, "whose beautiful drawings illustrating the *Morte d'Arthur* of Sir Thomas Malory are being brought out by J. M. Dent and Company." Then there are "the *Hobby Horse* men, Mr. Herbert Horne, Mr. Selwyn Image, Mr. Arthur Mackmurdo, and others, who have for years been writing and drawing for the few who could and would see and hear." He referred to this entire group of men as a "latter Pre-Raphaelite brotherhood"[40] (plate 13; see plate 218).

13. SELWYN IMAGE. Cover of *Hobby Horse,* No. 1, 1886 (design 1884)

Goodhue ended the publication of *The Knight Errant* on a forward-looking note by discussing Oscar Wilde's forthcoming book *Salome*, illustrated by Aubrey Beardsley (see plates 221, 255):

> One's impatience for the arrival of Mr. Oscar Wilde's latest book, be that what it may, is easily pardoned, but when that author has undertaken a play founded upon biblical history, and when this is to be illustrated by Mr. Aubrey Beardsley, even the traditional philistine must be at least curious as to the result. *Salome* is quite different from any of Mr. Wilde's former work. . . . It is almost unnecessary to say that he

has departed as far as possible from the Salome of the Bible. He has discarded all of the motives which we have hitherto been led to believe the causes of the dancer's strange demand of Herod, and has skilfully portrayed in her a self-willed creature, governed by a mysterious and unhealthy passion and a slave to that strange personal attraction which Mr. Wilde is so fond of introducing, and which, were it done by a less clever writer, would appear to be merely the instinct of an animal.

Mr. Beardsley has, in the pictures, surpassed all of his previous work. The frontispiece, title page, and "The Climax" are truly wonderful examples of his marvelous power in the use of black and white and his weird, original designs establish his position as unique in the artistic world.

In the final paragraph Goodhue referred to the growth of a number of periodicals like *The Knight Errant*, mentioning the new British *Yellow Book* and the forthcoming American *Chap-Book*.[41] He ended with what would soon be a major understatement:

> If all reports are to be believed, however, these are but the heralds of a host of such pleasant things. There are periodicals and rumours of periodicals everywhere. Even now we hear wind-whisperings of a great new Review to be devoted to everything; while a more modest affair, the "Chap-Book," is already an accomplished fact.

The Knight Errant had been published in an idealistic effort to combat the growing commercialism and materialism of a highly industrialized society at the turn of the century. Although its impact was probably quite limited, the periodical offered a strong and clear reiteration for interested Americans of many of the ideals of the English Renaissance, especially in the realm of fine printing and book illustration, and it clarified as well the concepts of Japanese art which had steadily and crucially influenced European arts for the previous two decades.

Interest grew in the topics presented by *The Knight Errant*, but the periodical quietly ceased in 1893 with its fourth issue, the reason given as "lack of support." One year later the situation would have been different, for the World's Columbian Exposition in Chicago fanned the "artistic" embers in America and the quest of *The Knight Errant* was taken up with variations throughout the country. All areas of modern American life were to become "artistic"; the year 1893 would show to the entire world the glories of the "American Renaissance." According to Henry Van Brunt:

> Whatever may have been the causes which finally culminated in the brilliant solidarity of the arts in the Italian Renaissance, it can hardly be doubted that if a new and equally brilliant era shall presently be begun in the New World of Columbus, upon a far larger field, with nobler opportunities and without embarrassment of traditions and prejudices, it will date its initial movement and inspiration in the last decade of the nineteenth century, where the Exposition at Chicago taught its great lessons of civilization.[42]

ART AT THE WORLD'S COLUMBIAN EXPOSITION, CHICAGO, 1893

For the great majority of those planning the Fair and the great majority of visitors, the Columbian Exposition was a tremendous success (plate 14). William Walton, who wrote one of the large illustrated catalogues, described the Fair as "an architect's dream, sketched in iron and washed in plaster";[43] in *Architectural Record* Frank D. Millet regretted only that the buildings could not remain permanently;[44] Montgomery Schuyler wrote also of the "brilliant success" of the Fair's architecture, a success "admitted and admired by all the world."[45] In discussing the expected influence of the Fair on the country's future architec-

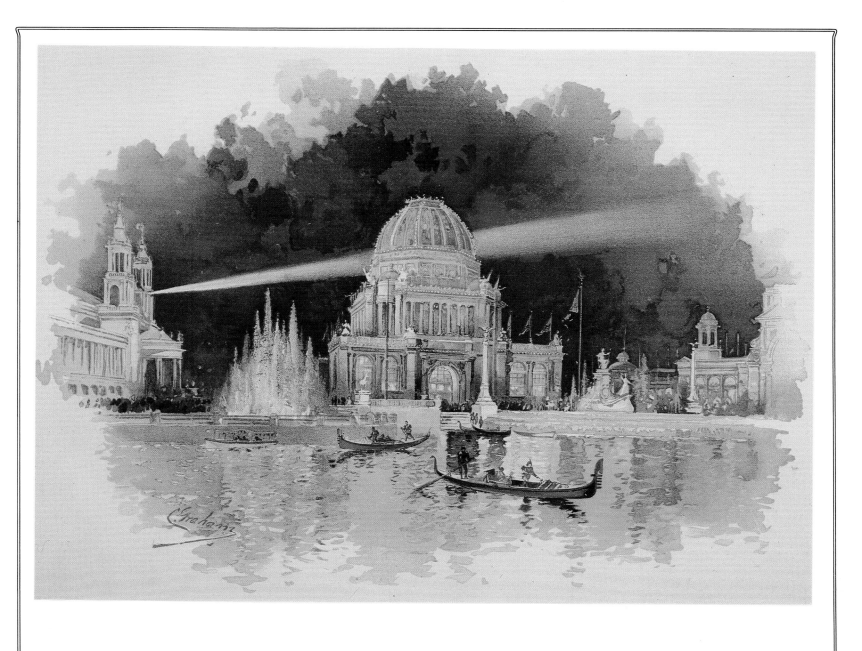

14. *"At Night in the Grand Court,"*
World's Columbian Exposition, Chicago,
1893. Photogravure of watercolor by
C. Graham, *Watercolors of the Fair,*
Chicago, 1893

tural developments, Schuyler quoted the perceptive Daniel Burnham, Director of Works at the Exposition:

> The influence of the Exposition on architecture will be to inspire a reversion toward the pure ideal of the ancients. We have been in an inventive period, and have had rather contempt for the classics. Men evolved new ideas and imagined they could start a new school without much reference to the past. But action and reaction are equal, and the exterior and obvious result will be that men will strive to do classic architecture.[46]

What Burnham described as the great "vision" of the people was seen within only twenty years to have been a deadly apparition. Louis Sullivan, one of those "inventive" architects who tried to "start a new school," later wrote:

> These crowds were astonished. They beheld what for them was an amazing revelation of the architectural art, of which previously they in comparison had known nothing. To them it was a veritable Apocalypse, a message inspired from on high. Upon it their imagination shaped new ideals. They went away, spreading again over the land, returning to their homes, each one of them carrying in the soul the shadow of the white cloud, each of them permeated by the most subtle and slow-acting of poisons. . . . For what they saw was not at all what they believed they saw, but an imposition of the spurious upon their eyesight, a naked exhibitionism of charlatanry in the higher feudal and domineering culture, conjoined with expert salesmanship of the materials of decay. . . .[47]

The bitterness that Sullivan expresses at the outcome of the nation's reversion to antique architecture was not evident at the time of the Fair. His own colorful Transportation Building, although considered by Walton as "a radical departure from the stately architecture" of the Fair and "curiously resented by some of the architects of the other buildings,"[48] was also highly praised for its decorative beauty by many foreign visitors and Americans.

In keeping with the Roman classical style of the architecture at the Fair, the arts of painting and sculpture, especially when applied to buildings and their setting, also imitated a Beaux-Arts classical style. Ideal, academic personifications were everywhere, from MacMonnies' fountain (plate 15) and Daniel Chester French's enormous statue of the *Republic* to Kenyon Cox's huge mural of *Art and Poetry*.

Thus went the official "major" arts. Among the "minor" arts, however, somewhat different styles were admired. For European visitors as well as Americans three of the most popular exhibits were the displays of work by the Tiffanys—the famous Tiffany and Company of New York and Louis C. Tiffany's Glass and Decorating Company—by the English Arts and Crafts designers, and by the Japanese.[49] While the Fair's architecture, painting, and sculpture conformed to the solid, stately tradition of the "American Renaissance," these minor arts signified brand-new, excitingly "modern" artistic products.

Louis Tiffany's chapel and two "salons" delighted the seekers after exotic fashion with their rich Romanesque-Byzantine style, deeply colored stained-glass windows, and decorative furniture, lamps, draperies, tiles, and vases (see plates 16, 17). According to Tiffany's biographer Robert Koch, this rather flamboyant exhibit "received more attention from visitors than any other product of American industrial art."[50] Tiffany's fame in America and Europe was meteoric after the Chicago Exposition.[51] Likewise, Americans continued to be fascinated by the English designers' lovely tapestries, wallpapers, and illustrated books, and by the sophisticated and elegant "arrangements" of the Japanese interiors. In the Fair could be clearly seen the split in United States taste between the "official" Fine Arts and the applied arts.

American Art Nouveau

On the long-term ramifications of the effects of the Chicago Exposition on the develop-

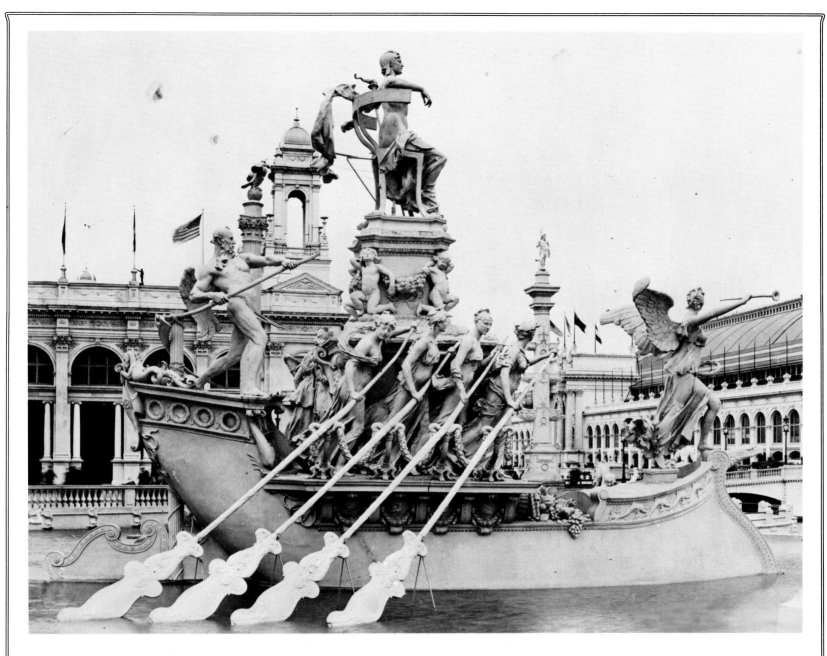

15. FREDERICK MACMONNIES. *Barge of State* or *Triumph of Columbia,* central group of Grand Fountain, World's Columbian Exposition, Chicago, 1893 (destroyed; contemporary photograph, Ryerson Library Collection, Art Institute of Chicago)

ment of the American arts, there are differing points of view. When considering concepts of Art Nouveau the reactions of American and European artists and critics at the time of the Fair are more important to note than those of later decades. The articles written by André Bouilhet are particularly interesting; he represented the Union Centrale's Musée des Arts Décoratifs, a leading organization in the support of French Art Nouveau, and his writings give an excellent view of the contemporary European movements in the decorative arts (see Bibliography 3, "Koch"). Likewise, the writings of the art dealer and promoter Samuel Bing, who traveled through America in 1893, offer a similar viewpoint. The stated intentions of the artists themselves, as well as the evaluations by contemporary American and European critics, will give us a more accurate idea of what concepts the creators and immediate viewers considered important in the arts.

The American Cultural Renaissance, 1876–1893

CHAPTER TWO

LOUIS COMFORT TIFFANY AND ART NOUVEAU APPLIED ARTS IN AMERICA

It is evident to me that it is the Americans, who have nothing behind them, who have no models to copy, who have certainly put their hands on something new; and it is very curious that the doctrines held and put forward by the *Union Centrale* for renewing in France our decorative arts by inspiration more directly from the plant, have already produced in their own houses such results; it will be America from whom will come the style which will characterize the beginning of the Twentieth Century.

—ANDRÉ BOUILHET,
Revue des Arts Décoratifs, 1893, p. 79

ART AND INDUSTRY

In his *History of the World's Fair*, Benjamin Truman described the Tiffany Pavilion at Chicago, its "triple-arched entrance, with a saffron-colored doric column 100 feet high, surmounted with a globe and a golden eagle," as presenting to the public "almost every example of the gold and silversmith's skill, from a six-shooter with richly drawn silver handles to a toilet table worth $9000."[1] This description refers to the work done by Louis Comfort Tiffany's father's firm, Tiffany and Company. Charles Tiffany had established this firm in the 1840s, and by 1893 it was internationally famous, especially for silverwork and diamond jewelry. The $9,000 toilet table, described by Truman as "pretty well encrusted with sterling silver," had been "sold to a European patron of the Tiffanys." Truman continued in the same paragraph to discuss the younger Tiffany's exhibit:

The Tiffany Glass and Decorating Company has not so costly an exhibit. but is quite artistic and beautiful.[2]

36

Louis Comfort Tiffany was and perhaps still is the most widely recognized American Art Nouveau artist; his interior designs for a chapel and two drawing rooms at the Chicago Exposition drew great attention for their unique "newness." Louis Tiffany's rise to international fame was aided to some extent by the ready capital and the wide contacts and reputation of his father's firm. As two examples of this coat-tail effect, Louis Tiffany had no specific provisions at the Chicago Fair for exhibiting his essentially ecclesiastical chapel, but arrangements were soon made to give him a portion of the space allocated to Tiffany and Company; and in 1900 at the Paris Exposition, both Tiffany companies exhibited side by side in the same pavilion. Shortly before Charles Tiffany's death in 1902, Louis began to merge sections of the two companies. Any consideration of Tiffany's part in the development of American decorative arts must involve both father and son, for men working for Tiffany and Company influenced Louis Tiffany's style of interior decorating and later his glass works. One of the strongest influences was by Edward C. Moore, artistic director for Tiffany and Company since 1868; Moore was, according to the Oriental art dealer Samuel Bing,

> . . . one of the first to comprehend the real value of the art treasures just emerging from the Orient. With great perseverance, Moore accumulated what he felt to be the most representative examples of the decorative arts of Arabia, Persia, India, China, and Japan.[3]

Through Moore, Louis Tiffany also began to collect such objects, and his interior designs rely heavily on the Oriental eclecticism already evident in Moore's collection. Likewise Moore invited other designers to Tiffany and Company in the 1870s and 1880s to create silver and jewelry designs in a style strongly suggestive of Art Nouveau.

Louis Tiffany's famous glass windows, which appeared in Samuel Bing's first *Salon de l'Art Nouveau* in 1895, as well as his glass vases of the mid-1890s that became internationally famous, represent only two among several areas of American Art Nouveau decorative arts. By 1893 Tiffany's reputation was already secure as a designer of "new" interiors and a master of varied uses for glass. But to European visitors at the Chicago Exposition the process Tiffany used in "manufacturing" his work was more important than the style of the works themselves. André Bouilhet concluded his account of the Fair by saying that he "had not seen in the American exposition any other industry [than Tiffany's] to which one could truly give the name industry of art."[4] Samuel Bing, reporting in 1896 on American art, praised highly this American ability to organize the industrial process toward products of high artistic quality. A union of art and industry had been the expressed goal of the 1876 Philadelphia Centennial, and one immediate effect was the explosive productivity of American firms in meeting the increased demand in the 1880s for "art" objects—furniture, glass, pottery, and wallpaper.

An important distinction between the Aesthetic movements in America and England was America's union of industrial processes and labor; William Morris and Company and Arthur Mackmurdo's Century Guild had both adopted regressive, medieval guild-inspired handicraft processes. Americans, unwilling to restrict the joys of decorative art to the realm of the few, seemed determined to reach a large clientele and to succeed commercially as well as artistically. Samuel Bing greatly admired this alliance of art and industrial methods, and saw in it the salvation of modern decorative art:

> Tiffany saw only one means of effecting this perfect union between the various branches of industry: the establishment of a large factory, a central workshop that would consolidate under one roof an army of craftsmen representing every relevant technique: glassmakers and stone setters, silversmiths, embroiderers and weavers, casemakers and carvers, gilders, jewelers, cabinet makers—all working to give shape to the carefully planned concepts of a group of directing artists, themselves united by

a common current of ideas. Through the boldness of such corporate enterprises America may well insure a glorious future to her industrial art.[5]

Bing made the point that artistic goals must first be established by the "artists" before the manufacturing processes took over:

> With unremitting regularity, the machine did all the work piece by piece, cutting, grinding and polishing the thousands of models of exactly identical things—But well before this entry into the fray of the mechanical unconscious, art had already completed its own work, giving shape to the task.[6]

He was well aware, however, of the constant problem that any art industry faces in keeping financially afloat through a large buying public, while at the same time maintaining the "nobility" of the artistic goal. He cited other companies engaged in the modern art industry: Charles Tiffany's great silver and jewelry company; Gorham and Company, silversmiths, of Providence, Rhode Island, "who have the largest factories in America, if not the entire world"; Whiting Silver Company of New York; Spaulding of Chicago; the stained-glass factories of John La Farge and Louis C. Tiffany in New York, of William Heith of Philadelphia, of Cully and Miles and of Healy and Millet, both of Chicago; wallpaper factories—twenty in Pennsylvania and New York alone; wrought iron made by Yale and Towne Manufacturing Company, and Winslow Brothers of Chicago; and ceramics from Rookwood in Cincinnati. From his writings it is clear that Bing's understanding of the possibilities of using mechanization for producing applied art was well thought out in terms of goals:

1. The complete and total rehabilitation of that category of art which, renouncing the glories long restricted to painting and lofty sculpture, is concerned with enhancing the prestige of everyday objects, those whose perfection is a thousand times more important than any other.
2. The establishment of huge factories to concentrate the most diverse branches of decorative art in a search for a determined goal, prescribed by the powerful will of a single directing spirit.
3. A moral bond and tacit collaboration uniting scattered efforts . . . unthwarted by unreliable recollections of a past centuries old. . . .
4. The strict subordination of questions of ornament to those of organic structure; the inner conviction that every useful object should draw its beauty from the rhythmic ordering of lines, which, before all other considerations, is subject to the practical function to be fulfilled.
5. The enthusiastic adoption, even at enormous financial sacrifice, of the most advanced methods, the organization of model factories and workshops . . . to be ever and always equal to the perpetual metamorphosis of the times, the day and the present hour—in every branch of human activity ripe for development.[7]

America was advanced enough, artistically and industrially, to create this new art. Yet Bing constantly warned: "in all American products, every level of quality is found, from the strangest aberrations to the most exquisite creations."[8]

In surveying American Art Nouveau decorative arts, it must be kept in mind that no strong tradition existed nor any real guiding unity of direction, theory, or style, but rather the striving of many for success, for wealth, and for fame as well as for artistic quality. Unfortunately, the wealthiest Americans seemed to Bing, as to Oscar Wilde ten years earlier, to have the worst taste.[9] But an ever-hopeful Bing concluded his report on an optimistic note:

> In the past, like a parvenu frantic to enjoy his recently acquired wealth, the American people, elated by the results of their efforts, felt they had achieved the supreme goal.

But the passage of time has sobered this kind of intoxication; new generations have brought new aspirations. At this very moment, a new era dawns at the very heart of a pompous empire of money; an intellectual aristocracy has evolved which will move far and fast. The time is not far off when, in her midst, poverty of aesthetic feeling will be greater cause for shame than any form of material want.[10]

NEW CONCEPTS OF AMERICAN INTERIOR DESIGN, 1876–1904

The Louis Tiffany chapel exhibited at Chicago in 1893 included vestments, candlesticks, a baptismal font, and a jeweled altar cross (plates 16, 17). In style the work displayed the popular neo-Byzantine design, described more precisely at the time as "a style which recalls a bit the byzantine, making one think of the grand mosaics which formed the basis of the decoration of Justinian's palace in *Theodora*,"[11] the latter a reference to a European theatrical hit of 1890 starring Sarah Bernhardt. The chapel's interior was lavishly decorated with brilliant glass mosaic. Described and praised by André Bouilhet in his 1893 report on the Exposition for the *Revue des Arts Décoratifs*, the chapel, as well as the two additional rooms or salons, truly represented the culmination of a decade of Louis Tiffany's interior design. Bouilhet was impressed by the decorative peacock design of the reredos made of marble and glass and lit by electric light, producing a "magic" effect, "perhaps a bit theatrical, but very successful." The geometry of the domed space, the round recessed arches, and the simple rectangular altar set a quiet, static mood against which a feeling of mystery was established by the opulent play of light flowing through the stained-glass windows and reflecting from glass mosaic surfaces all around. Tiffany was well aware of the symbolic meanings of his forms, from the peacock found in "late Roman and therefore Christian churches, . . . held in high esteem because it seemed to symbolize the sun with its wheel of brilliant, eyed feathers," to the mosaic inscriptions on the steps, those on the lower five signifying the five wounds of Christ and on the upper three the Trinity.[12]

Besides the chapel, Tiffany's two rooms were decorated in different color schemes—one a "dark room" ranging the entire color scale of green, and a "light room" done in silver and opal. Bouilhet described the style of the rooms as generally Byzantine also, and was particularly impressed by the fine chains of tiny glass balls which formed a kind of drapery. A collection of these "verres-draperies" was all Bouilhet could afford to purchase for Union Centrale, the French organization for modern design. He described the furniture as made of straight and regular forms of natural wood ornamented by extremely fine marquetry work. The rectangular table held a lamp in the "mauresque" style (plate 18). He found the decor of the rooms "strange," but he concluded that the "general tone is agreeable and it all forms an absolutely complete ensemble."[13]

A European criticism by now familiar appeared in the Frenchman's statement that although each object or piece of furniture was itself perhaps not of the best form, the entire set was desirable, and had he had "an American fortune" he would have loved to see the ensemble travel across the Atlantic and "give us the impression" of the "sentiment de l'art très nouveau et très personnel des Américains."

This "art très nouveau" was already a well-developed style of American design. The concepts and sources seen in Tiffany's interiors had been forming since shortly after 1876, the previous American world exposition. Artists in this field, stimulated by the foreign displays of goods in Philadelphia and tied to the tastes and desires of the patrons who made up their clientele, had expanded the decorative arts tremendously as wealth suddenly increased in America in the late 1870s and early 1880s. The craving for luxury, as Bing nicely stated it later,

> . . . complicated the earlier traditions of domestic life. . . . This change was not due to instinct, and still less to a sudden vision of Beauty. With the privilege of wealth

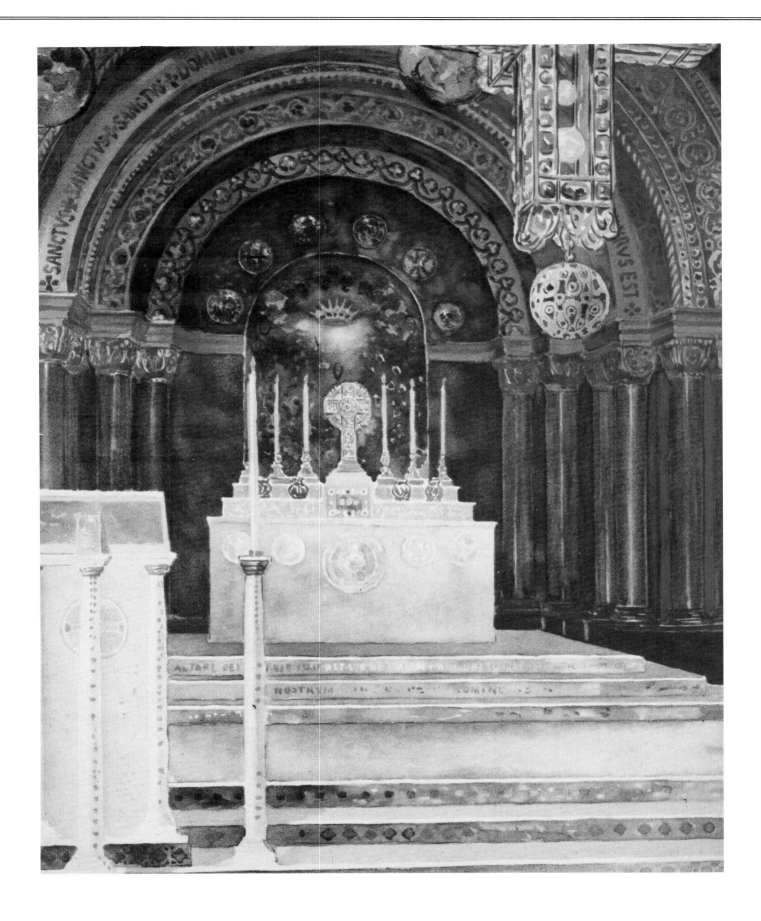

16. LOUIS COMFORT TIFFANY. Tiffany
Chapel, World's Columbian Exposition,
Chicago, 1893. Photogravure of watercolor
by C. Graham, *Watercolors of the Fair,*
Chicago, 1893

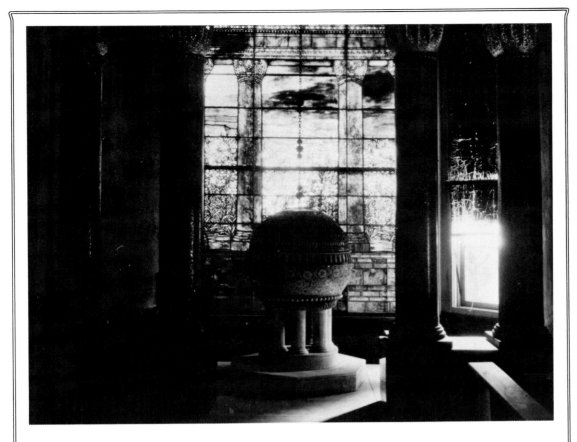

17. LOUIS COMFORT TIFFANY. Baptistery of Tiffany Chapel, World's Columbian Exposition, Chicago, 1893 (contemporary photograph, courtesy of Robert Koch)

18. LOUIS COMFORT TIFFANY. "Mauresque" Ceiling Fixture from the H. O. Havemeyer residence, New York City. 1890–92. Stained glass. Collection Dr. Egon Neustadt, New York

Louis Comfort Tiffany and Art Nouveau Applied Arts in America

had come the strong desire for things which would best reflect it. The outcome, then, was the absolute triumph of bad taste, and since America herself was as yet incapable of manufacturing the desired luxuries, Europe saw opening before her that hallowed era when she could export across shoddy wares by the cargo load, imitations of things that, in themselves, represented the worst period of our decadent century.[14]

Many "shoddy wares" appeared at the 1876 Exhibition and some won top honors: the black marble chimneypiece by M. Marchand of Paris won the Legion of Honor award for its designer (plate 19).[15] Complete with allegorical figures of Music and Poetry flanking Minerva above, the work was a typical *pastiche* of classic, Baroque, Gothic, Etruscan, and Italian Renaissance bits, arranged with no regard for meaning or scale in a style often called "Neo-Grec." The theme of the Philadelphia Exhibition was Art and Industry, but the fact that industry had been used to create "objects of art" was still carefully hidden. As yet there was no real

> . . . union of the two great elements of civilization—Industry, the mere mechanical, manual labor, and Art, the expression of something not taught by nature, the presentation of that ideal, the mere conception of which raises [the] hand above the level of savagery.[16]

Not only was there no real sense of, nor belief in, the union of art and industry, but the Ruskinian "reform" movement from England, soon to be dominated by the Arts and Crafts groups, stressed the evils of industrialization and advocated a return to the medieval craftsmanship of handmade items. This message had reached America in the early 1870s largely through Charles Lock Eastlake's *Hints on Household Taste* (published 1868), stressing "simple and honest" construction, rectangular lines, and Gothic ornamentation. As Great Britain was the major foreign exhibitor at the Centennial fair, its "art" furniture and design ideas became a strong rallying point for those Americans with taste enough to condemn "vulgar renditions of the French Renaissance," who consequently began to turn from French and Western European styles toward the more exotic foreign displays in search of other "new" design concepts (plate 20). Americans, traveling widely to "enchanted" faraway places, started collecting all types of exotica, especially Japanese but also Egyptian, Indian, and Moorish "objets d'art," which they proudly exhibited in their fine homes. To many travelers these handcrafted art objects from nonindustrial parts of the world seemed models of what Western craftsmen should try to achieve.

The overall effects of the Centennial Exhibition were, first, to reinforce the taste of the very wealthiest Americans, who continued to prize and purchase French traditional imports. The second was to stimulate a crafts movement, largely woman-oriented, along the lines of England's Royal School of Art Needlework (plate 21); this school's work had appealed to the artist-designer Candace Wheeler, leading her to found in New York the Society of Decorative Arts in 1878, with the purpose of "encouraging profitable industries among women. . . ." Oscar Wilde realized after his 1882 tour that a large part of the American "art decoration" movement was based upon the social idea of providing employment opportunities for "ladies." The exhibition brochure of the English firm Howell and James at the Paris 1878 Exposition stated with saccharine optimism:

> It was a happy idea, that which directed the attention of ladies to an employment at once pleasant and remunerative, giving, or rather extending, occupation for women —a social requirement universally admitted.[17]

The women's movement was to become so strong in America that by 1893 the Chicago Exposition boasted a large Woman's Building, with Mrs. Potter Palmer of Chicago presiding over the Board of Lady Managers. Mrs. Palmer's opening address was well

19. Chimneypiece of black marble by M. MARCHAND, Paris. Exhibited 1876 at Centennial International Exhibition, Philadelphia. Illustration in *Masterpieces of the Centennial*, Vol. II

20. Cabinet by G. PARVIS, Cairo. Exhibited 1876 at Centennial International Exhibition, Philadelphia. Illustration in *Masterpieces of the Centennial*, Vol. II

21. Embroidered Fire Screen by Royal School of Art Needlework. Exhibited 1876 at Centennial International Exhibition, Philadelphia. Illustration in *Masterpieces of the Centennial*, Vol. II

attended by loudly applauding and handkerchief-waving "ladies" as she condemned the failure of industry to afford relief to the masses, and praised the women who "cling to respectable occupations while starving in following them."[18] She further asked "men of the finest and most chivalric type, who have poetic theories about the sanctity of the home and the refining, elevating influence of woman in it," to open their eyes and see "not the fortunate few of a favored class . . . but the general status of the labor market," and "women everywhere in large numbers . . . actively engaged in the lowest and most degrading industrial occupations, laboring mainly as underpaid drudges, to the great profit of manufacturers and producers." The importance of the women's movement to the art industry of the turn of the century cannot be underestimated, either in actual production, especially in pottery, or in the violent response of many men in dealing with and portraying the "new woman."

By 1876, though not yet in the public limelight, the true reformers of American decorative art, such as the architect Henry H. Richardson and the artist John La Farge, were becoming well known. Richardson planned his buildings down to details of furniture, fixtures, and overall color schemes, attempting to create the much-sought-for "unity of effect." He collaborated with other designers, including the Englishmen of Morris, Marshall, Faulkner and Co. in London, the Frenchman Auguste Bartholdi, and the Americans John La Farge, Augustus Saint-Gaudens, and John Evans, as well as with the American designer Francis Bacon in the 1880s and the furniture-maker A. H. Davenport (plate 22).[19]

To coordinate painters, sculptors, and architects—La Farge, Saint-Gaudens, and Stanford White, for example—in the field of interior design was a self-conscious attempt on the part of overly self-confident Americans to rival the great era of the Renaissance.[20] Inherent in this dream was the revived interest in mural painting and other decorative arts. This was stimulated by the Beaux Arts-trained Richardson, who in 1876 commissioned his fellow-artist John La Farge, also French-trained, to decorate Trinity Church in Boston, and in 1878 was largely responsible for securing William Morris Hunt to paint two murals in the New York State Capitol at Albany. Both of these early projects were completed under very poor conditions, but each artist reacted positively, nevertheless, and showed a "true artistic enthusiasm for a work so novel and affording such an opportunity for the highest exercise of a painter's talents."[21] Part of Richardson's original concept had been to make of Boston's Trinity a "color church," and La Farge responded to the architect's preference for red. Beyond the brief suggestion of color in Richardson's early sketch, however, he left the complexities of decoration and iconography to La Farge, whose remarkable solutions were highly praised (plate 23; see plate 11):

> The interior decoration is a noteworthy undertaking . . . and it is the first instance, I believe, where the whole decoration has been put under the direction of an artist of distinction, to be carried out by himself, and his fellow artists, with the object of bringing the whole work—general color, decorative detail, and figures—into a consistent and harmonious whole.[22]

Several tenets of the design by Richardson and La Farge were to be expanded during the next quarter century into Art Nouveau: emphasis on the importance of decoration itself; artists working also as designers; concepts of "harmonious wholes"; and a continuing use of rich, refined color, often referred to as "Venetian splendor" or "color borrowed from Oriental carpets." Although these concepts would become basic to the Art Nouveau movement, the decoration in Trinity Church is a rather eclectic blend of Venetian, Byzantine, and medieval styles. La Farge's personal achievement was considerable, however, in integrating structural decoration with mural paintings and stained-glass windows, and his success led many Americans along the path of integrated, original design.

Trinity Church itself as well as Richardson's insistence that a painter should control its decoration introduced new thoughts to America about the decorative arts and their rela-

22. HENRY HOBSON RICHARDSON.
Chair, from photograph in
Richardson's Office Album. c.
1880. Harvard College Library,
Department of Printing and
Graphic Arts, Cambridge, Mass.

23. JOHN LA FARGE. Interior east wall of tower, Trinity Church, Boston. 1876

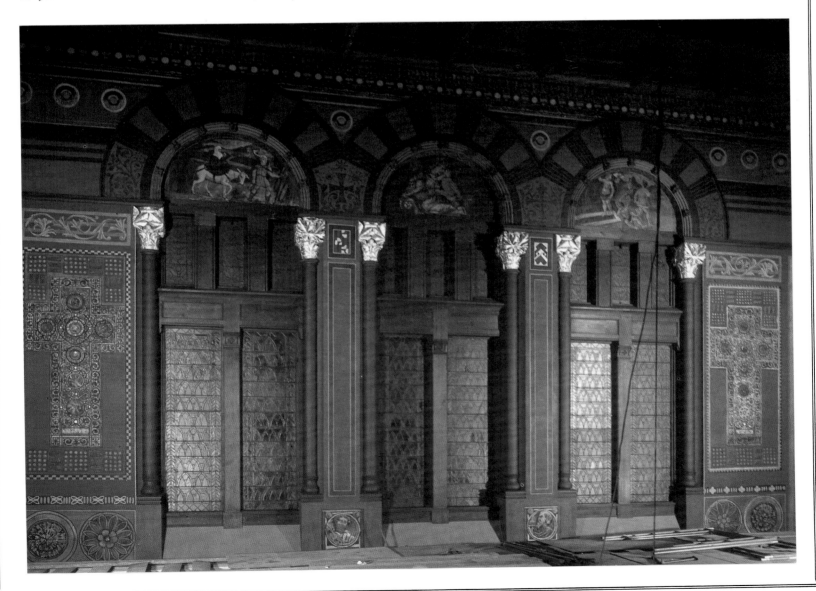

24. FRANK FURNESS. Stairhall of Pennsylvania Academy of the Fine Arts, Philadelphia, 1875
(photograph Will Brown)

tionship to architecture. Richardson was not alone in wishing to create an "original" style expressive of late nineteenth-century culture in America. Similar inventiveness, if not coherence, was the hallmark of Frank Furness, whom his young pupil Louis Sullivan described as "an original." Furness borrowed heavily from non-Western sources in inventing his decorative details, some having today a remarkably "modern" look (plate 24).[23]

During the 1880s the desire spread for unified interior design, perhaps as a much-needed reaction against the haphazardly filled interiors of the eclectic 1870s. Close study of the photographs in George Sheldon's two volumes of *Artistic Houses* (1883) will make clear the attitudes, concepts, and practices of design that underlay domestic architecture for the wealthy. Sheldon states with characteristic American certainty in his preface that "the domestic architecture of no nation in the world can show trophies more original, affluent, or admirable."

As Samuel Bing would emphasize later, the wealthiest Americans continued after the Centennial to prefer their art in traditional European styles. Sheldon, for instance, described the A. T. Stewart mansion as "palatial":

> . . . money flowed abundantly during the seven years when this white-marble palace was building for a merchant-prince, and in exchange for it came magnificence, splendor, luxury.[24]

Importing Carrara marble, Gobelin tapestries, and even an Italian artist, Brigaldi, who decorated the house with many thousands of dollars' worth of frescoes, the Stewarts did include American art among their vast collection of mostly European works. In the entrance hall (plate 25):

> The *Water-Nymph* by Tandardini stands on its pedestal opposite the *Fisher-Girl* by Tadolini, each nearly nude; Crawford's *Demosthenes* faces Harriet Hosmer's *Zenobia;* Crawford's *Flora,* holding in her hand a great wreath of flowers, is *vis-à-vis* to Randolph Rogers' *Blind Girl of Pompeii.* Between the Crawford statue and the *Zenobia* rises an immense French clock, from the factory of Eugène Cornu, Paris, surmounted by a silvered bronze figure, holding in her right hand a swaying pendulum, the whole 14 feet high, and indicating not only the hour, minute, and second of the day, but also the day of the week, the change of the moon, the record of the barometer and thermometer and various other matters.[25]

The Stewart "picture-gallery" boasted Meissonier's celebrated *1807,* "for which Mr. Stewart paid sixty thousand dollars," Bouguereau's *Return from the Harvest,* Gérôme's *Charioteers,* several by Munkacsy, and many by lesser artists mingling with works by American artists such as Daniel Huntington, Eastman Johnson, Frederic Church, Albert Bierstadt, and a copy of Hiram Powers' *Greek Slave.*

Compared with this pseudo-Renaissance luxury, the interiors that Louis Tiffany designed appear modern and unified (plates 26, 27). Stressing Tiffany's abhorrence of any "servile imitation" of past styles, Sheldon explained that the designer's "principle of fitness" led to an expressive visual effect suited to the "function" of each room.[26] Thus the dark, mysterious passageway of the hall in Tiffany's own apartment had bright red woodwork, rough pine beams, and stained glass in "very rough pieces"; by contrast, the "Moorish feeling" of the drawing-room decoration was thought to be "best suited to such a place":

> In this drawing-room, for instance, the Moorish feeling has received a dash of East Indian, and the wall-papers and ceiling papers are Japanese, but there is a unity that binds everything into an *ensemble,* and the spirit of that unity is *delicacy.*[27]

Reflecting Tiffany's beliefs in truth to materials and in decorations as essentially two-

25. Entrance hall of A. T. Stewart residence, New York City (photographed before 1883)

dimensional, Sheldon describes the Japanese wallpapers as being "much finer than the heaviest French specimens, having the faculty of so working in the flat that the material always looks like paper and always expresses the quality of paper, and not of anything else." Continuing to emphasize decorative unity, Sheldon discussed the young designer's concept of fitting paintings into the decorative scheme:

> The artist has tried to keep the whole work, frame and picture, flat, as a part of the wall, and by so doing, to prevent the picture from disturbing the line of color scheme of that part of the room. . . . He proposed that [the painting] should enter into the general scheme of its surroundings. . . .[28]

This attitude is much in keeping with, and probably borrowed from, Whistler's ideas (see page 14), derived in their turn from Japanese concepts; these may have reached Tiffany through Oscar Wilde's lectures or Edward Godwin's exhibits and publications of the late 1870s. A second "principle" noted by Sheldon was Tiffany's insistence, again essentially Japanese-inspired, on "irregular balance" in order to "avoid monotony."

Tiffany's taste in Japanese and Islamic or "Moorish" styles was greatly stimulated by his friendship with such men as the painter Samuel Colman; according to Bing:

> Colman was one of the first to promulgate change in modern furnishings, claiming they must be rescued from worn-out forms. . . . He insisted that the useful need not be synonymous with the ugly . . . with impassioned ardor, he preached his point of view to all those who, by virtue of their wealth, were equipped to experiment. His talents as a draftsman helped him to convey in eloquent lines the burgeoning forms of his fertile imagination, as his abilities as colorist enabled him to sublimate the palette of his distilled tones into charming symphonies.[29]

26. LOUIS COMFORT TIFFANY. Hallway of Tiffany's apartment in Bella Apartments, E. 26th St., New York City (photographed 1882)

27. LOUIS COMFORT TIFFANY. Drawing room of Tiffany's apartment in Bella Apartments, E. 26th St., New York City (photographed 1882)

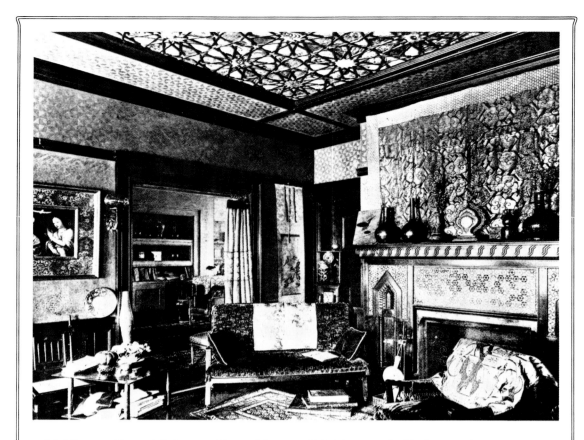

28. Library of Samuel Colman residence, Newport, R.I. (photographed before 1883)

In Colman's house the various Oriental elements were blended into color harmonies that include his own colored wood stain, his unique use of firebacks for flooring in the hall, and his own stained-glass windows (plate 28).[30]

As a collector and designer, Tiffany was also greatly influenced by the leanings of Tiffany and Company's chief designer, Edward Moore, whose excellent collection of Persian and Oriental objects he knew, and who had won European recognition as early as 1867 for silver designs blending Japanese, Persian, and classical motifs. The collection of Chinese art belonging to Colman, and of East Indian art owned by Lockwood de Forest, likewise provided fertile sources for ideas and objects used in the interior decorating schemes of Louis C. Tiffany and Associated Artists, formed in 1879, which included Candace Wheeler, herself the founder of the New York Society of Decorative Arts.

During 1879–81 the new company filled one of its first major commissions, the George Kemp mansion. "The general motif of the decoration," wrote Sheldon, "is Arabic, with an inclination to the Persian in the forms, the purpose of the artist having been to produce utmost delicacy of linear and chromatic effect."[31] Truly luxurious in the number of fine patterns, the Kemp salon achieves a certain dynamic unity through its flat Oriental patterns in "irregular balance," enhanced by the planar, pierced furniture and stained-glass windows (plate 29). In Tiffany's work there is always a rather original blend, more or less successful, of various non-Western decorative patterns taken from Japanese, Arabic, and Celtic sources; although he made considerable use of Moorish "effects" he did not aim at creating "replicas," such as Mr. Ottendorfer's Pavilion (plate 30), discussed by Sheldon with reference to the famous "principles" of Owen Jones, "the leading authority on Moresque ornamentation," together with a lengthy passage from Washington Irving's popular *The Alhambra*.[32] Likewise, Tiffany's work that is based on Japanese design concepts

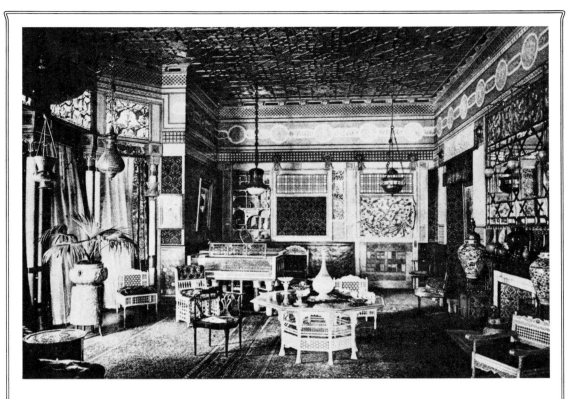

29. LOUIS COMFORT TIFFANY, designer. Salon of George Kemp residence, New York City. 1879 (photographed before 1883)

30. Interior, Mr. Ottendorfer's Pavilion, New York City (photographed before 1883)

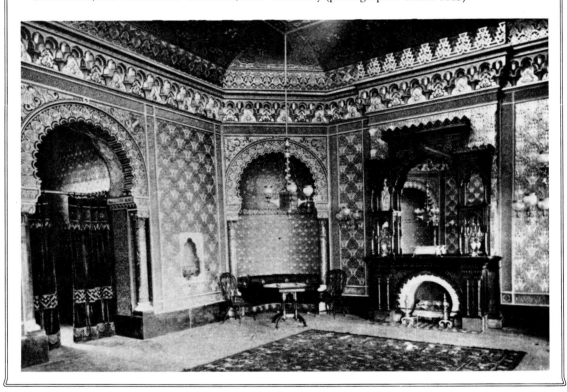

is not related to the usual Japanese interiors in American homes, most of them Victorian rooms filled with Japanese art objects (plate 31).

What might be called an American "reform" style of interior design of the early 1880s can be seen in other interiors that Sheldon describes: Mr. E. E. Chase's dining room, and

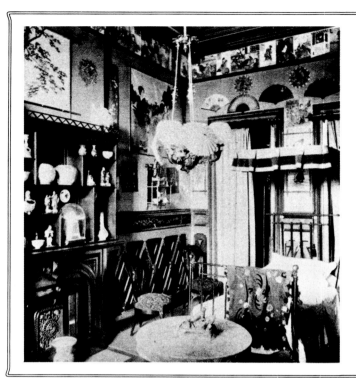

31. "Japanese" Bedroom of
William A. Hammond residence,
54th St. near 5th Ave., New York
City (photographed before 1883)

Mr. H. G. Marquand's house (on which Colman and La Farge collaborated). Although derived ultimately from the Anglo-Japanese interiors of Godwin (plate 32) and Whistler, the elegant simplicity of Japanese design was not what inspired the wealthy Americans: on the contrary, more ornamented, exotic decorations were favored, based on the art of Byzantium, the early Middle Ages, and the Islamic world—or, as Bing described it, "in any art where amplitude of line, at once picturesque and simple, was enhanced by coloring that was sumptuous without being violent."[33]

Nor was Tiffany's new style altogether successful. Sometimes it was merely one more "style" added to many others in a wealthy man's home, to prove him "up to date." An excellent example of such overwhelming eclecticism is Mr. David Einstein's "very interesting house," produced, according to Sheldon, by "a lavish expenditure of money under the direction of a cultivated taste" (plate 33).[34] In addition to traditional European styles— "from a Louis Seize parlor through an Early English Renaissance hall to a Louis Treize library"—this interior included many "contemporary" elements, such as stained-glass windows lighted from behind by gas jets, and a dining-room chandelier of jeweled globes ("an interesting exponent of what is doing in this country in the direction we are considering"). Scattered throughout the rooms were elements of English Aesthetic design: Morris-like sunflower wallpaper, and, in the library, a set of the sunflower firedogs made famous at the Philadelphia Centennial by the Englishman Thomas Jekyll.

Tiffany and Associated Artists became a leading design firm in America in the 1880s, yet their work was often considered too "splendid" for good taste. For instance, the unidentified author of "Some of the Union League Decorations" in *The Century Magazine*, then the Olympian voice of the intellectuals, was obviously puzzled and irritated by certain elements: he found in the entire Union League building a "negation of repose," noting instead "a certain animation and sprightliness which in themselves are by no means displeasing."[35] He emphasized its factors of "eccentricity" and attention-arresting diversity, and admitted some disappointment at the overall impression of John La Farge's work, though admiring his Victory relief and his rose window. Then he described his ambivalent reactions to Tiffany's work (plate 34):

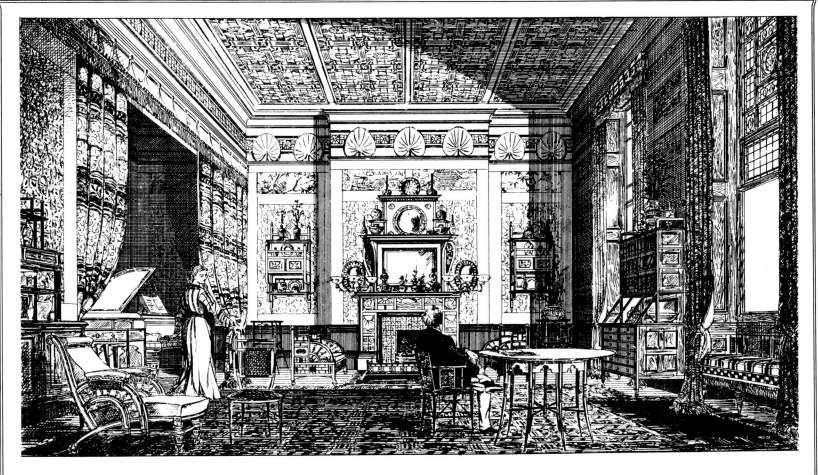

32. EDWARD WILLIAM GODWIN. *Design for a Drawing Room.* Illustration in William Watt's catalogue, *Art Furniture,* London, 1877 (after designs by E. W. Godwin). New York Public Library

33. Hall and Staircase of David L. Einstein residence, 39 W. 57th St., New York City (photographed before 1883)

34. LOUIS COMFORT TIFFANY, designer; PEABODY AND STEARNS, architects. Staircase of Union League Club, 39th St. and 5th Ave., New York City. 1881–82 (contemporary photograph); demolished 1930

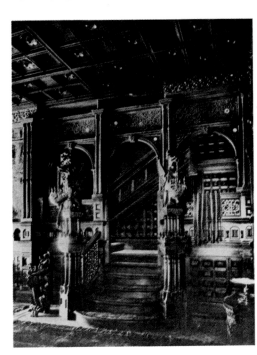

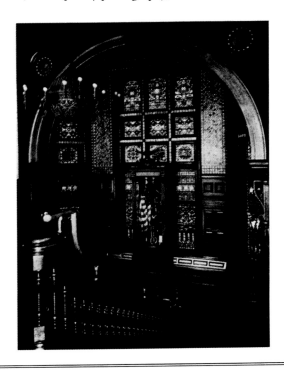

The halls . . . were consigned to Mr. Louis C. Tiffany, and, of course, they leave the strongest impression . . . on account of their size and—shall we say?—their quasi-splendor. Splendor is a quality, however, which in general has an unfortunate drawback. If it fails to please, it offends. . . .

Green and silver may not be agreeable to many tastes, but it is necessary to admit that they at least avoid commonplace. In fact, they do more; they avoid the look of professional decoration.[36]

The cautious hesitations of the *Century* writer contain hints of possibly more violent reactions to Tiffany's interiors. One of these is described by Samuel Bing:

A name synonymous throughout the world with enormous wealth had commissioned Tiffany to design the decor and furnishings of a formal sitting room to be based on the artist's ideas. The expenses came to over one hundred thousand dollars. But after the house-warming, when it had been apparent that the break with consecrated rules had horrified the visitors, the whole installation was promptly demolished and replaced by a decor pure Louis XVI.[37]

Louis Tiffany and his Associated Artists were consistently praised for originality, harmonious designs, and unity of rich color effects. Yet the modern eye tends to see the underlying Victorian love of "clutter" in the amalgam of furniture, glass, leather, friezes, chandeliers, rugs, ironwork, paint, woodwork, and "objets d'art" in their rooms of the 1880s.

Perhaps the "splendor" of Tiffany's work was more suited to the theater. In 1885 he designed the interior for Steele MacKaye's new Lyceum Theatre in New York (plate 35). MacKaye hoped to carry out the ideas of Oscar Wilde, whom he had met in 1882, for building an ideal theater "according to the highest standards of aesthetics and art."[38] When the Lyceum opened in April, the New York *Morning Journal* headlined an article with "Wilde Outdone by MacKaye," and described the work as belonging "to no school unless the ultra-aesthetic. . . . Everything was a departure from the hackneyed forms of theatrical decoration."[39] Especially noted was the electric lighting, installed by Thomas Edison himself. The decoration was complex and rich, covering all surfaces, an academic figural mural in the arch mixing with decorative patterns of all kinds, from Greek to East Indian. Again Tiffany was praised, if not for a totally integrated design, at least for having "blent them into a general effect, avoiding all aggressive detail." Similar in many respects is Louis Sullivan's interior for the Chicago Auditorium Theater, two years later (plate 36).

Wealthy Americans in the 1880s had, of course, alternatives to Louis Tiffany's "new" interior designs. The Boston architectural firm Peabody and Stearns, builders of the New York Union League Club, used the Richardsonian round arch and Byzantine ornamentation in domestic interiors also, such as Mr. R. H. White's parlor illustrated in Sheldon's second volume of *Artistic Houses* (plate 37).[40] Praising the unusual degree of simplicity and unity in this room, Sheldon stressed the architects' control here over the finishing as well as the construction, in contrast to the Union League Club. In consequence, "architecturally considered, the lines are beautiful; and, as a piece of color-decoration, this parlor is superb." The accent is on the rich color patterning provided by the materials themselves, referred to by Sheldon as "simplicity of materials":

The walls are of plaster, painted many times in a low, deep tint, suggestive of old gold; the arch inclosing the clock is of glass mosaic; and the immense fireplace has a facing of Victorian marble, a lining and hearth of glazed tile, and a back of iron . . . creating an effect of richness in reserve.

Louis Sullivan's highly decorated, enframed arches in the Chicago Auditorium Theater balcony are strikingly similar to these (plate 38), and both undoubtedly stem from Richard-

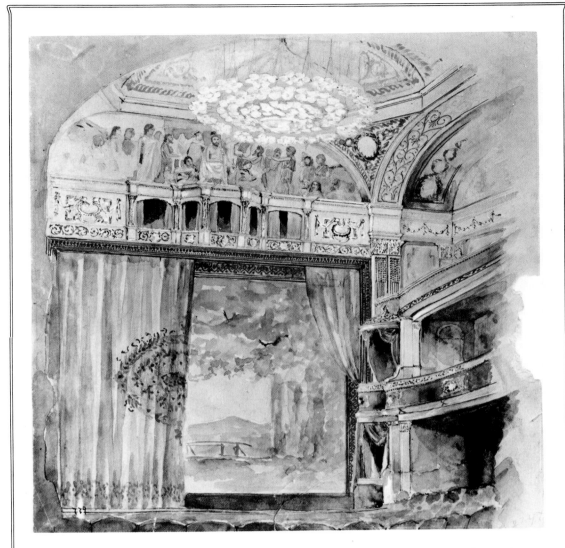

35. LOUIS COMFORT TIFFANY. Interior of Lyceum Theater, New York City. c.1885. Watercolor, 11⅜ x 11″. The Metropolitan Museum of Art, New York City (The Elisha Whittelsey Collection, The Elisha Whittelsey Fund, 1953)

son's architecture. It was Richardson's "simplicity" of elegant design that served as an alternative to the more eclectic Tiffany style. The underlying geometry of enclosing rectangles and circular forms of Richardson's Court of Appeals Room in Albany, of 1881, creates order within the extremely rich patterns of the Byzantine ornament (plates 39 –41); the proto-Art Nouveau elements in the carved panels over the fireplace blend with the natural patterns of veined marble; and the lavishly ornamented fireplace is enhanced by the surrounding quiet of the wood-paneled walls. The furniture designed for the room conveys the same sense of rich materials simply designed, the elegant ornament accentuating the structural lines of each piece while repeating the circles, spirals, and curvilinear plant forms of the fireplace. The visual coherence of Richardson's designs—the unity of clear structure, reliance on natural patterns of material, and carefully placed ornamentation related to the structure of forms in an expressive way—can be seen as either a forerunner or an early instance of Art Nouveau interior design. Except that its formal idiom is Byzantine rather than Japanese-based, Richardson's work, such as in the John Hay residence (plate 42), compares favorably with that of his contemporary, the Englishman Arthur H. Mackmurdo (plate 43). Both architects combined simplicity and purity of craftsmanship

Louis Comfort Tiffany and Art Nouveau Applied Arts in America

55

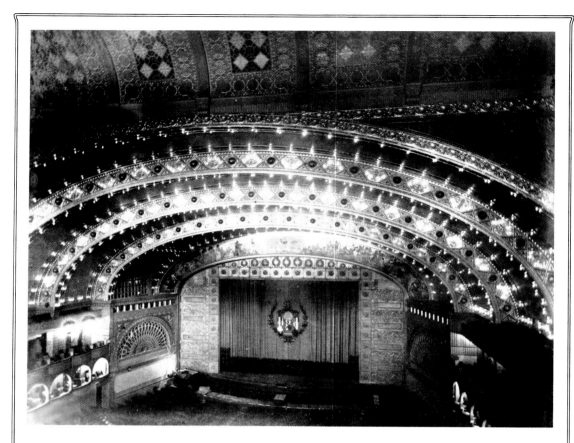

36. LOUIS H. SULLIVAN. View from Balcony, Auditorium Theater, Chicago, 1886–88 (photograph c.1895, courtesy Chicago Historical Society)

37. PEABODY AND STEARNS, architects. Parlor of R. H. White residence, Boston (photographed before 1883)

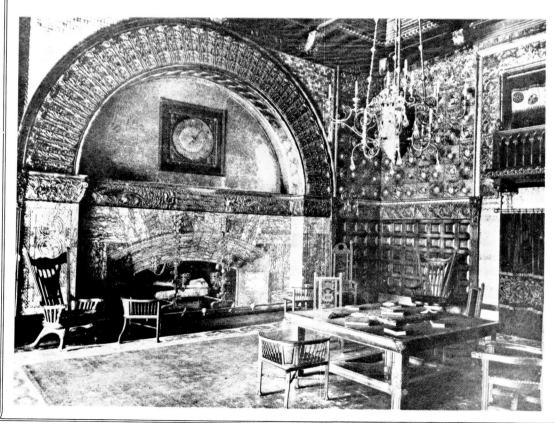

38. LOUIS H. SULLIVAN. Arch in Balcony (with mural by Fleury), Auditorium Theater, Chicago. 1886–88 (photograph c.1895, courtesy Chicago Historical Society)

39. HENRY HOBSON RICHARDSON. Court of Appeals Room, New York State Capitol, Albany. 1881 (contemporary photograph)

40. OWEN JONES. "Byzantine No. I," Plate XXVIII in *The Grammar of Ornament*, London, 1856

41. HENRY HOBSON RICHARDSON. Portion of Fireplace, Court of Appeals Room, New York State Capitol, Albany. 1881 (contemporary photograph)

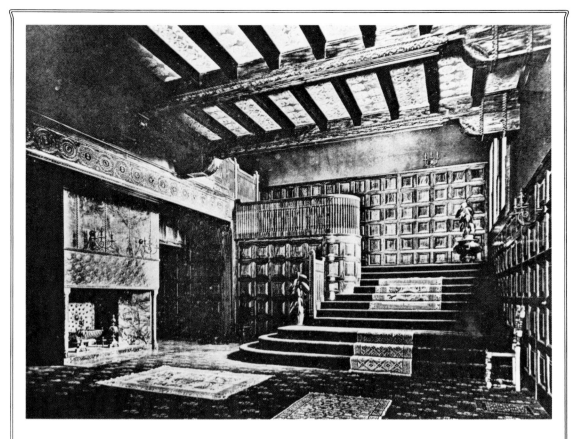

42. HENRY HOBSON RICHARDSON. Hall and Staircase of John Hay residence, Washington, D.C. c.1885 (contemporary photograph); destroyed 1927

43. ARTHUR H. MACKMURDO. Music Room, in Century Guild Inventions Exhibition. Illustration in *Hobby Horse,* 1887. New York Public Library

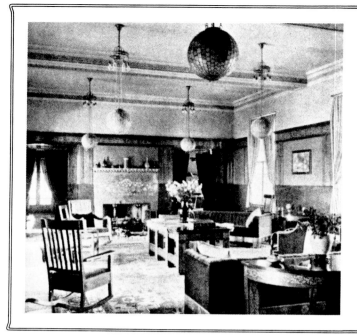

44. LOUIS COMFORT TIFFANY, designer. Parlor of The Briars, Tiffany's country house on Long Island, N.Y. Photographed 1900; illustration in *Dekorative Kunst*, Vol. 9, 1901

with aesthetic ideas of exquisite ornamentation based on forms freely abstracted from nature, Mackmurdo creating what is generally agreed to be the first truly Art Nouveau style in England.

More closely aligned to the geometrically controlled Art Nouveau styles of the Scottish and Austrian designers than to the Belgian, French, or Spanish styles, American interiors of the last quarter of the nineteenth century retain the unity, color harmonies, and elegance of ornamentation for which Art Nouveau is famous.

By 1901 the interiors designed by the leading American Art Nouveau artists, Louis Tiffany and Will Bradley, though less unified, should be compared with rooms by Mackintosh in 1901 or by the Austrian Josef Hoffman in 1900 (plates 44–46). During the late 1890s both Americans had evidently picked up from *The Studio* strong influences of Charles F. A. Voysey and M. H. Baillie Scott.[41] Conversely, it has rightly been suggested that English artists between 1886 and 1893 had considerable interest in the American work of Richardson, Stanford White, and John La Farge, which probably served in the early formation of this English-Scottish Style.[42] Thus the most original "new design" in America continued, through the works of 1900–1901 by Tiffany and Bradley, to be allied with the English rather than the Belgian or French movements. From Richardson's 1884 Hay residence to the 1901 interiors of Louis Tiffany, structures of rectilinear simplicity are mixed with rich patterns purveying an Oriental mood.

All of these original designers either created their own accessories—andirons, iron railings, and furniture—or controlled the design of these, such as Richardson for the clock and chairs in the Albany Court of Appeals room. By the mid-1880s Richardson's ornamental designs often have decidedly Art Nouveau characteristics. His Malden Library chair of 1885 (plate 47), its subtle leaflike ornamentation accenting its smoothly flowing curves, foreshadows chairs made much later by Edward Colonna and Eugène Gaillard (plates 48, 49),[43] two designers who worked for Samuel Bing's Maison de l'Art Nouveau at the turn of the century.[44] Louis Tiffany's furniture for the Havemeyer residence of 1890–92 (plate 50) must have resembled that exhibited in his Chicago Exposition rooms in 1893. Its strongly rectilinear structure is contrasted with richly carved panels, reflecting the similar play of the ornamental panels with naturalistic details set within the rectilinear framework of the entire room. These chairs recall Eastlake-inspired chairs of the 1880s, such as Syd-

American Art Nouveau

50. LOUIS COMFORT TIFFANY. Drawing-room Chairs in H. O.
Havemeyer residence, New York City. 1890–92. Illustration in
The Architectural Record, Vol. 2, 1893

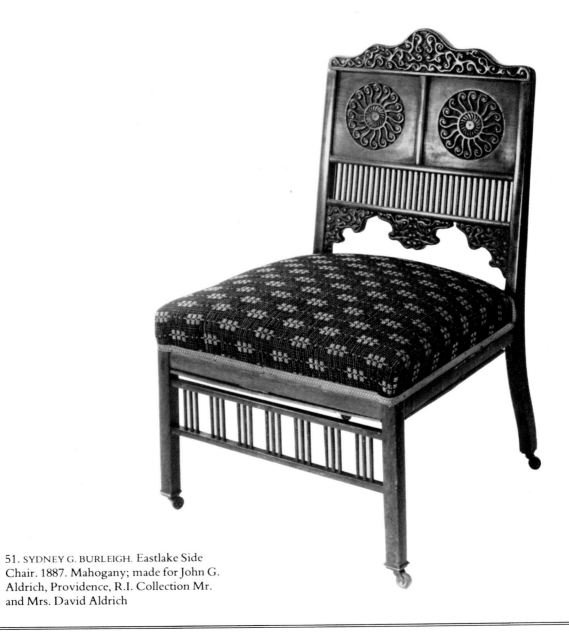

51. SYDNEY G. BURLEIGH. Eastlake Side
Chair. 1887. Mahogany; made for John G.
Aldrich, Providence, R.I. Collection Mr.
and Mrs. David Aldrich

ney Burleigh's 1887 side chair for John Aldrich (plate 51), who was a prime figure in the Arts and Crafts movement in Providence, Rhode Island. But Tiffany seems finally to have picked up the furniture style developed in his friend Samuel Bing's establishment, in contrast with this Eastlake style with its East Indian-type woodcarving. A strong similarity unites a Tiffany chair (plate 52), its shallowly curved, uncarved wood accented by richly patterned upholstery, with Colonna's well-known furniture style made for Bing about five years before. Since Colonna had worked for Louis Tiffany and Associated Artists in 1882, a tie between their work seems tenable.

By the late 1890s American originality in design had largely yielded to strong influences from Europe: Will Bradley's borrowing of interior designs from Voysey and Baillie Scott is especially evident (plates 53, 54). And after the 1900 Paris Exposition, the extravagant curvilinear style of French and Belgian origin appeared in several centers in the United States.

Only one American furniture maker of renown used this curvilinear idiom: Charles Rohlfs, of Buffalo (plates 55–59). Working first in a geometric and rustic format related to the developing American Mission style, Rohlfs made furniture that was described as "queer, dark, crude, medieval,"[45] but he became widely known in America and Germany through articles in the January 1900 *House Beautiful* and in *Dekorative Kunst* in 1901. The Craftsman revival is now evident in many of his designs—contrasts of interlocking planes, rough wood stained black, brown, or green, and peg nails and leather strips; these are combined with refined curvilinear elements in parts of the forms (as in the calendar holder) and especially in the carved decorative panels, typical of Art Nouveau in their organic abstraction. Although aligned with the principles of handcrafted furniture—he built all of it himself, with only his wife to help—Rohlfs' work touched on two American Art Nouveau concepts: the accentuation of the inventive practicality of furniture, such as efficient storage drawers in a desk and a footstool that rocked, and a creativity based on precepts of evolution or embryology. For Rohlfs the "character" of a person or an object was "largely the result of environment and self-cultivation." A brief article by him, "The Grain of Wood," describes his great pleasure in "speculating as to the probable causes for this curl or flower or wave in the grain of wood," and he believed strongly in combining nature with art:

> I owe to the natural lines in wood the inspiration for many an effective design. . . . Perhaps the reader will choose to let his fancy roam with mine and try to see in the markings of the natural wood the story of storm and calm, of zephyr and breeze, and conclude that there in the wood is the record of their music.[46]

These nature-based, curvilinear abstractions bring Rohlfs' furniture close to the European styles of artists such as Emile Gallé and Eugène Gaillard (plate 60; see plate 49); the angularity and originality of their structure recall works by Richard Riemerschmid (plate 61), as well as by Will Bradley and Frank Lloyd Wright.

Mass-produced "Art Nouveau lines" were offered after 1900 by many American commercial furniture firms. In design these were largely influenced by the French works seen at the Paris Exposition, such as the buffet (plate 62) made by Gaillard for his dining room in Bing's Pavillon d'Art Nouveau (and illustrated in the 1900 *Studio*); this direction was reinforced by examples in the French Pavilion at the St. Louis Exposition of 1904 (plate 63). The Flint Company cabinet of 1910 (plate 64) copied quite closely a cabinet designed by Louis Majorelle, but most of these mass-produced works were ungainly *pastiches* of Victorian and "French style" ornamentation. The firm of S. Karpen and Brothers of Chicago and New York won a *Grand Prix* at the 1904 St. Louis Exposition with an orchidaceous "Catillya l'Art Nouveau Suite" (plate 65), and produced cheaper varieties of furniture as well (plate 66). The original elegance and the high quality of crafting in rich materials quickly degenerated.

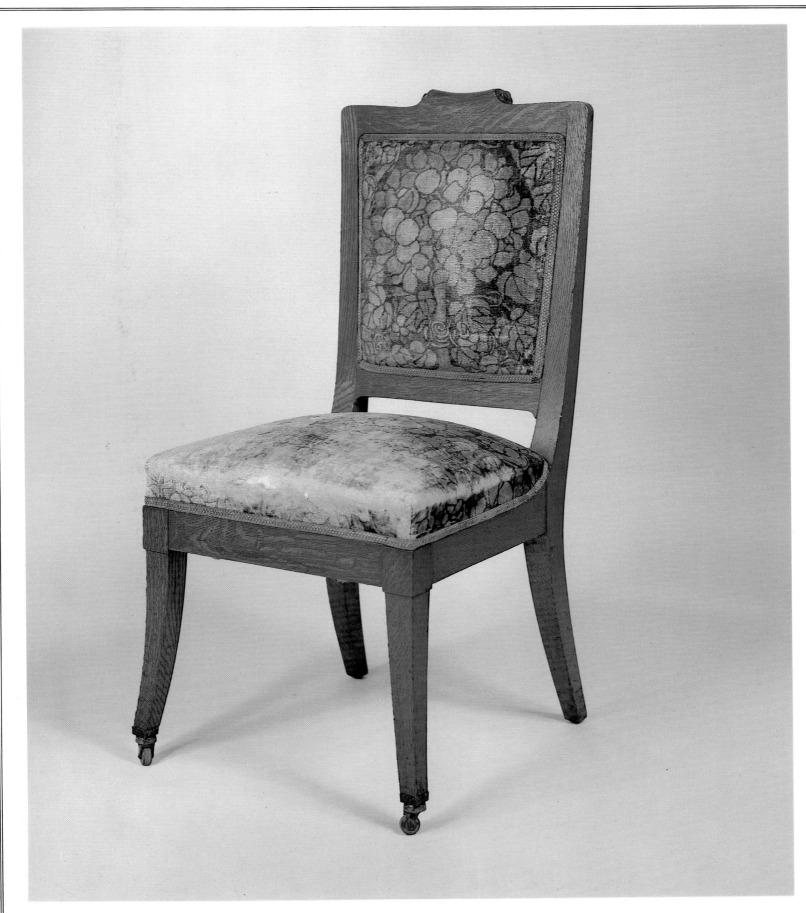

52. TIFFANY STUDIOS. Side Chair. c.1905.
Oak, with upholstery of stenciled velvet;
height 43″. One of a pair from the William
Wrigley residence, Chicago. Art Institute of
Chicago (Gift of Mrs. Philip K. Wrigley)

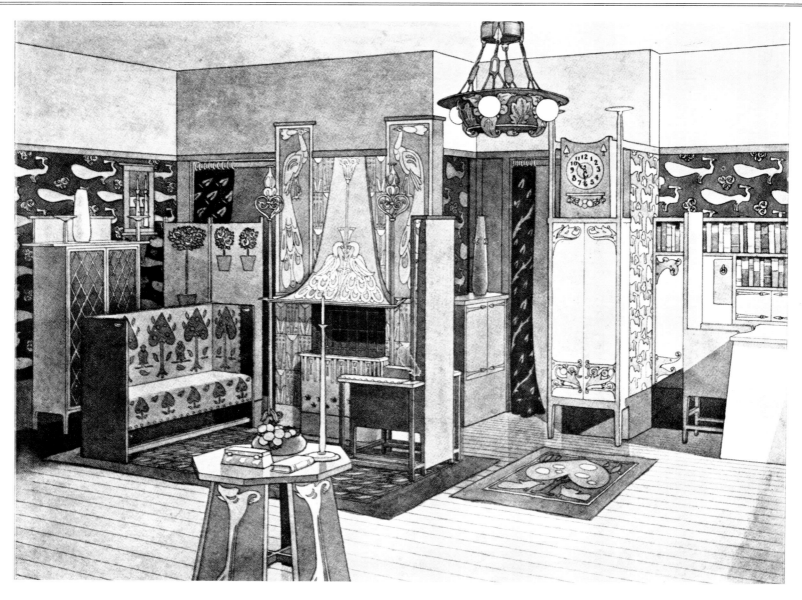

53. WILL H. BRADLEY. *Design for a Boudoir.*
Watercolor; illustration for the "Bradley
House," *Ladies Home Journal*, 1901. The
Metropolitan Museum of Art, New York
City (Gift of Fern Bradley Dufner, 1952)

54. C. F. A. VOYSEY. Bookcase and
Stationery Cabinet. Illustration in *The
Studio*, Vol. VII, 1896

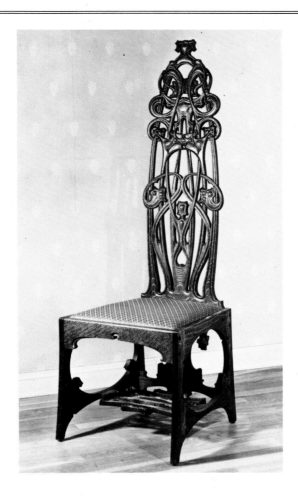

55. CHARLES ROHLFS. Chair. c.1898.
Oak, height 54″. Art Museum, Princeton
University, Princeton, N.J. (Gift of Roland
Rohlfs)

56. CHARLES ROHLFS. Chest of Drawers,
upper side view. c.1900.
Fumed oak, entire height 65½″.
Art Museum, Princeton University,
Princeton, N.J. (Gift of Roland Rohlfs)

57. CHARLES ROHLFS. Lamp. c.1900. Oak and shell, height 23″. Art
Museum, Princeton University, Princeton, N.J. (Gift of Roland Rohlfs)

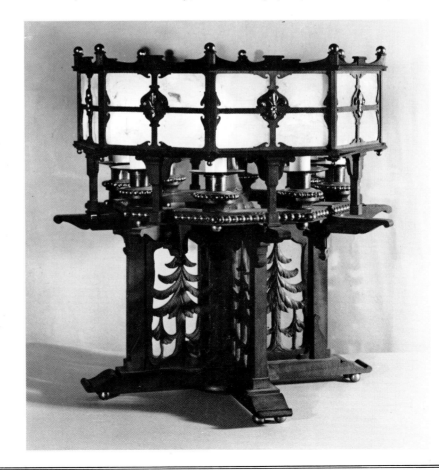

58. CHARLES ROHLFS. Table. Illustration in
House Beautiful, January 1900

59. CHARLES ROHLFS. Lectern. Wood.
Illustration in *Dekorative Kunst,* Vol. 9,
1901

61. RICHARD RIEMERSCHMID. Armchair.
1900–1901. Wood, painted red; height
33½". Museum Bellerive, Sammlung des
Kunstgewerbemuseums, Zurich

60. ÉMILE GALLÉ. Side Chair with Umbels.
c.1902. Beechwood, with upholstery of
cut velvet; height 37½". Musée des Arts
Décoratifs, Paris

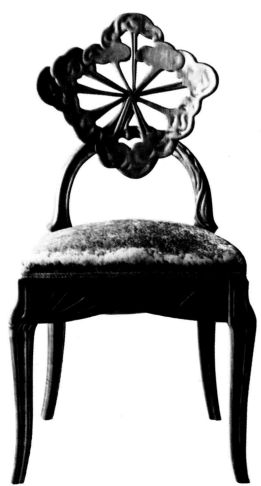

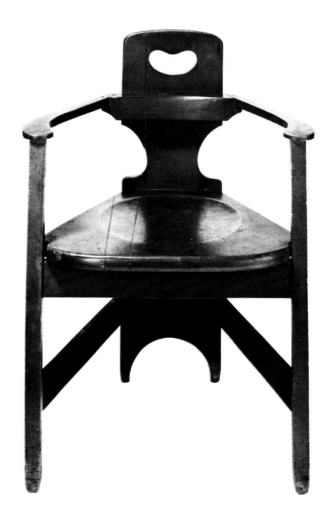

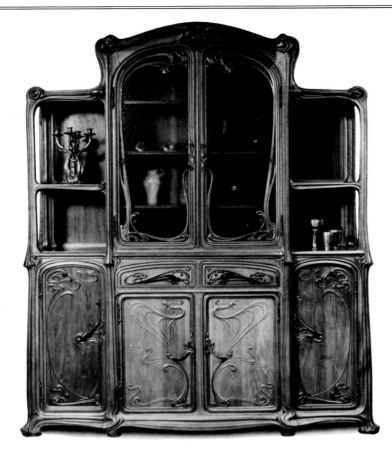

62. EUGÈNE GAILLARD, for Samuel
Bing. Buffet. c.1900. Wood.
Kunstindustrimuseet, Copenhagen

63. Interior of French Pavilion,
Louisiana Purchase Exposition,
St. Louis, 1904 (contemporary
photograph, courtesy Cooper-
Hewitt Museum, Smithsonian
Institution's National Museum of
Design, New York City)

64. GEORGE C. FLINT AND COMPANY
(New York). Cabinet. c.1910. Mahogany
with glass and velvet; height 53¾". The
Metropolitan Museum of Art, New York
City (Purchase, 1968. Edgar J. Kaufmann
Charitable Foundation)

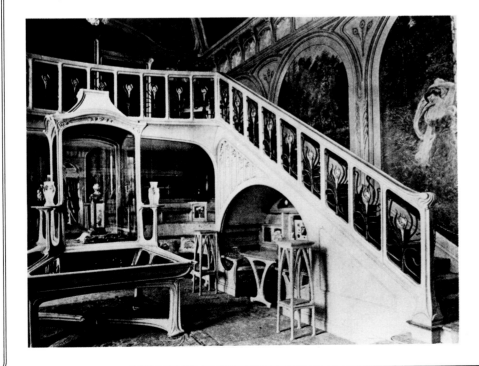

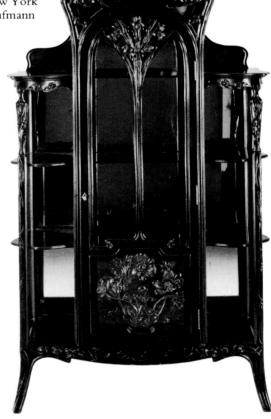

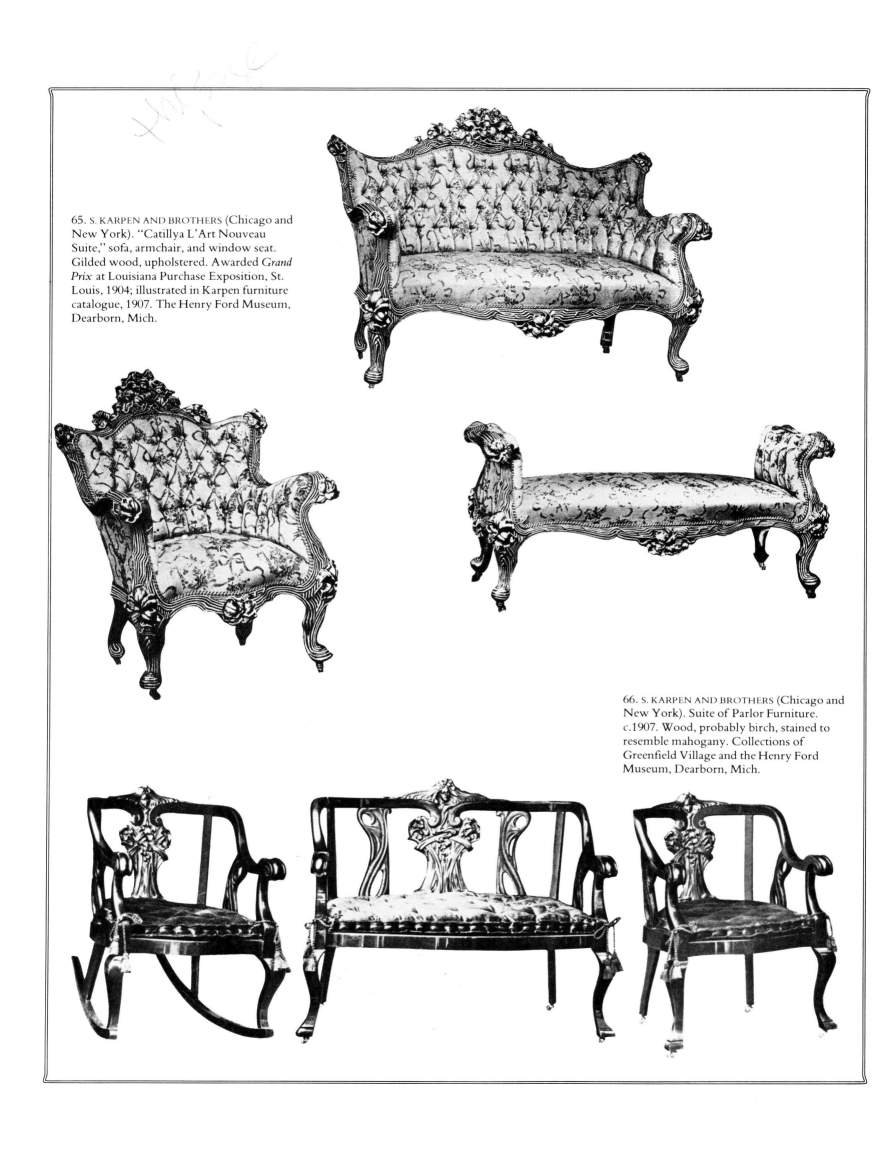

65. S. KARPEN AND BROTHERS (Chicago and New York). "Catillya L'Art Nouveau Suite," sofa, armchair, and window seat. Gilded wood, upholstered. Awarded *Grand Prix* at Louisiana Purchase Exposition, St. Louis, 1904; illustrated in Karpen furniture catalogue, 1907. The Henry Ford Museum, Dearborn, Mich.

66. S. KARPEN AND BROTHERS (Chicago and New York). Suite of Parlor Furniture. c.1907. Wood, probably birch, stained to resemble mahogany. Collections of Greenfield Village and the Henry Ford Museum, Dearborn, Mich.

67. FRANK FURNESS. Entrance
Hall Fireplace with Fireback,
Williamson Free School, Elwyn,
Penna. 1887 (photograph Cervin
Robinson)

68. ARTHUR H. MACKMURDO.
Screen. c.1884. Satinwood with
satin embroidered panels. William
Morris Gallery, Walthamstow
(Crown Copyright reserved)

69. HENRY HOBSON RICHARDSON. Drawing of Andirons for Austin Hall, Harvard University. c.1881. India ink with ink wash on tracing paper, 9 x 7″. Harvard College Library, Department of Printing and Graphic Arts, Cambridge, Mass.

70. M. H. BAILLIE SCOTT. Design for Fireplace Dog Grate. Illustration in *The Studio,* Vol. VII, 1896

Relationships and developments occurred among other objects of interior design, here suggested by only a few interesting instances. The iron fireback in an 1887 building designed by Frank Furness and an 1884 embroidered screen designed by Arthur Mackmurdo (plates 67, 68) share an abstraction of attenuated natural forms—the flame and the flower respectively—into Art Nouveau rhythmic, curvilinear patterns. Richardson's andiron designed for Harvard University's Austin Hall is related to the dog grate by M. H. Baillie Scott one decade later through controlled and symmetrical spirals and circles (plates 69, 70). Geometrical rather than organic curves can also be seen in American decorative ironwork, from Furness to John Root and Louis Sullivan (plates 71–73).

In wallpaper design the development goes from a naturalistic form, flatly treated, to an abstracted natural form, and then to a totally abstract pattern. Thus Louis Tiffany's early spiderweb and clover pattern contrasts with the Art Nouveau forms of Will Bradley's "Silver Brook" pattern of 1896 (plates 74, 75), yet both designs rely on nature; in 1904 the commercial manufacturer M. H. Birge and Sons of Buffalo created a wholly abstract ornamental design derived from European sources (plate 76). The transformation in all the applied arts of original American patterns into derivative ones occurred in the late 1890s, and especially after the 1900 Paris Exposition.

AMERICAN GLASS AND ART NOUVEAU WINDOWS

Although Louis Tiffany's work undoubtedly interacted with that designed or available in his father's company, his goal was to establish himself in the areas of interior design and glasswork. In these he made his greatest contribution to the new art of the turn of the century. Stained-glass windows had become popular in America after the work of Morris and Burne-Jones in the 1860s and especially the 1870s, going hand in hand with other medieval revivals.

It was the technical invention of opalescent glass and metallic luster or iridescent glass (used first for windows, later for vases and other objects) that brought fame to the Americans John La Farge and Louis Tiffany. In the 1870s architects desired glass of rich, permanent color in floral patterns; Frank Furness experimented with painting on the back of glass tile in rich, transparent colors, and placing behind the designs a layer of gold foil which "imparted the colors in a particularly beautiful lustre" (plate 77).[47] About 1877–79 John La Farge invented a process for producing opalescent glass in windows, after his attempt to use contemporary English glass in his Harvard Memorial Hall window proved a failure.[48] Tiffany, when La Farge introduced him to the new glass process that created windows of rich color shadings, proceeded to compete with La Farge during the 1880s and eventually to undermine some of his fame and business. Embarrassed by La Farge's success in obtaining the Cross of the Legion of Honor at the Paris Exposition in 1889 for his work in glass, Tiffany was spurred to create a large show window, *The Four Seasons* (plate 78; see plate 93), and to make "Tiffany" the name associated with "American glass" and Art Nouveau throughout Europe.

La Farge and Tiffany used processes that were slightly different technically, enough to allow the U.S. Patent Office to grant separate patents to each man. These distinctions were described by Caryl Coleman in 1893:

> The above named artists began their studies, investigations and experiments almost simultaneously. For a time they worked on identical lines, to at last diverge in their methods, although they both held to the mosaic system, believing it would yield the best results.
> Mr. Tiffany aimed particularly to develop the "inherent properties" of the glass to their "fullest extent" in color and texture, in order to obtain in the glass itself light and shade, through depth and irregularity of color in union with inequality of sur-

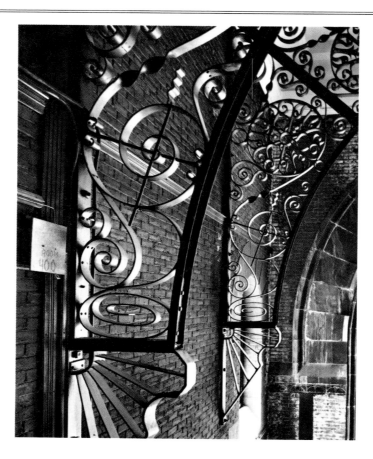

71. FRANK FURNESS. Iron Brackets of Stair Tower, University of Pennsylvania Library, Philadelphia. 1888–91 (photograph Cervin Robinson)

72. JOHN WELLBORN ROOT. Iron Stairs, Mills Building, San Francisco. 1890–92 (photograph Donald Hoffmann)

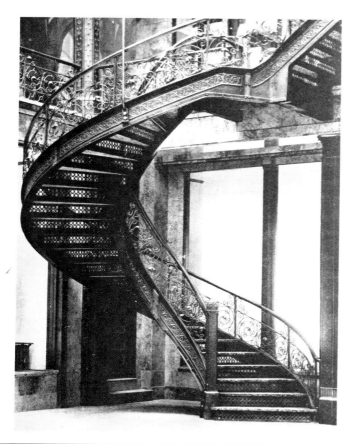

73. LOUIS H. SULLIVAN. Staircase in Auditorium Hotel, Chicago. 1887–98 (photograph Chicago Architectural Photographing Company)

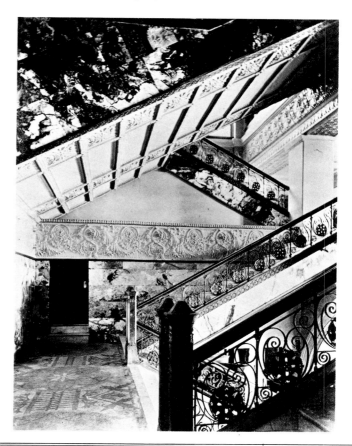

face, in that way hoping to avoid the "dullness and opacity" which invariably accompany the use of paint.

Mr. La Farge endeavored to obtain the same effects by separating his lights and darks from one another by ideal lead-lines, in some cases plating glass over these lines, seeking to lose the lines or more truly making them apparently a part of the glass, or, in other words, working out his drawing with small pieces of glass, assisted with carefully studied lead-lines, and bringing the whole together with a glaze by plating one, two and three thicknesses of larger pieces over them, much as the human skin covers the flesh and blood of the hand.

It may be said with truth of both these methods that they are the artistic methods par excellence, "a new style of glass-painting, founded on the most perfect practice of the mosaic system," viz.: the putting together in juxtaposition of various pieces of glass of divers colors and shades, so as to form a translucent picture, where depth of color, light and shade, correctness of drawing, roundness and distinctness are carefully preserved.[49]

From the beginning, the American inventions were primarily concerned with color. Samuel Bing noted:

> . . . in contrast with the virile splendor of an early Gothic window, . . . present-day material was revealed in all its aesthetic poverty, devoid of brilliance or consistency. Unless its appalling harshness and cold transparency of tone—either washed-out or strident—could be remedied, it was inconceivable to think of restoring the noble art of the early glassmakers.[50]

Along with the striving for rich, warm, strong colors, Tiffany and La Farge were fascinated by opalescence and iridescence, desiring to find a modern equivalent for the "magical" effects created in glass by the natural chemical reactions which take place slowly through time:

> The unconscious actions of nature must be supplemented carefully by scientifically developed effects; and conversely, the artifices of a highly sophisticated science must act as substitute for the naïve intuitions of an earlier people. Besides the invention of pearly tones with opaline shimmer, craftsmen worked with mixing natural materials with the tiny bits of glass—transparent pebbles, filtering a mysterious daylight, or precious stones, sparklingly faceted. All these materials, crushed, carved, polished, mounted, or fitted together, were thus formed into strange new harmonies undreamed of in the past.[51]

Although the new glass was much used for church windows, it was in domestic and public interior design that the new techniques of glass mosaic as well as window glass were most admired:

> Louis C. Tiffany discovered how to adopt the lofty character of Byzantine splendor to contemporary taste. He shifted the emphasis from oriental majesty to the soft harmonies appropriate to family living. From the walls of spacious entrance halls gleamed a rich variety of subtle shadings, sober chalky whites surmounted by polychromed friezes, diapered with the thousand details of woven cashmere. Elsewhere mosaics covered the walls with a soft warmth, like silken hangings, while on the countermarches of staircases, on ceilings and cornices, mosaic recaptured the richness of its first vibrant glow, as its design and tonalities revealed an unmistakably modern character. . . . In the form of cabochons, or other varied motifs, glass appeared in electric lighting fixtures, hanging chains, balustrades, in any place that could provide a rationale for its sparkle; glass, its facets often irregular and unpolished, gleamed in the warmly colored light.[52]

74. LOUIS COMFORT TIFFANY. Wallpaper.
Illustration in Clarence Cook, *What Shall
We Do with Our Walls?*, New York, 1880

75. WILL H. BRADLEY. "The Silver Brook,"
wallpaper design. 1896

76. M. H. BIRGE AND SONS
(Buffalo, N.Y.). Wallpaper.
1904. 26¾ x 21¾". Collection
Martin Eidelberg, New York

77. FRANK FURNESS. Glass Tile, hand painted, from Broad St.
façade, Pennsylvania Academy of the Fine Arts, Philadelphia.
1872–76. Collection Pennsylvania Academy of the Fine Arts,
Philadelphia (photograph Will Brown)

Tiffany's sophisticated understanding of the Oriental concept of exploiting certain materials for the appropriate expression of essential moods was greatly admired. The small window in his own hallway was described as consisting of "very rough pieces," in keeping with the effect of "mystery" and roughness desired for the hall (plate 79). The pattern of the window is a strong Art Nouveau curved abstraction, suggestive of an Oriental "yin-yang" spiral of light against dark. Relying heavily upon the natural forms and colors in the pieces of glass, Tiffany created a totally abstract symbol of natural life, not unlike the large series of windows done about 1900, where underwater images merge in spiral-like compositions (plate 80). The "subject" of many of Tiffany's windows, which occurs in contexts that range from abstract designs to allegorical figures, can be related to the theme of the Seasons, emphasizing change in the cycle of life–death–rebirth. For the symbolical-minded public at the turn of the century, subject matter was very important, whether figural or abstractly expressing a mood through various colors and their harmonies:

> The window, being the opening to admit light, is always the first attraction to catch the eye. The deep warmth of the ruby, the tender contentment of the sapphire, the glow and coruscation of the amethyst, the brilliancy and cheerfulness of the emerald, the glitter and distinctiveness of the diamond, may all be summoned to the satisfaction of the least cultivated eye by the infinite wealth of the glass-stainer's art.[53]

Of course there was often a practical reason for using colored glass in domestic and public settings in pre-electric times, that of bringing much-needed daylight into the buildings and yet blocking out the growing ugliness of urban street views. This escapism—hiding the sights and conditions of urban life and substituting a romantic mosaic of color—may be not dissimilar to many of the Impressionists' omission of smoke pollution, coal barges, and factories from their color-mosaic paintings of Paris in the 1870s.

The demand for colored glass windows exploded in the decade of the 1880s. The firms of Louis Tiffany (founded in 1885 as the Louis Tiffany Glass and Decorating Company), John La Farge, and others such as Healy and Millet in Chicago produced thousands of windows, usually working with architects rather than individual clients. It was Healy and Millet that created the many splendid windows in Sullivan and Adler's 1887 Auditorium Building (plate 81), and displayed a "remarkable collection of small panels" at the Paris 1889 Exposition, several of which were purchased by the Musée des Arts Décoratifs (plates 82, 83). The French glass designer Edouard Didron described these:

> These pieces are skillfully designed to seduce the eye: interlaces in the Byzantine style, intricate and most delicately formed and yellow in color, separated by straight leads from a white background that has an onyx appearance; scrollwork branching into green palm leaves with red fruits; Persian stained-glass windows in vivid and varied hues resembling translucent carpets; garlands in gray tones on a white background, studded with large gold cabochons. All of these ornamentations certainly provide unforeseen effects and have marked originality, although inspired by Oriental art. There is a pearly glass with reflections of olive yellow, greens, and reds, colored with a power unknown until now and most arresting to see; it suggests nearly transparent marble, or at times thick sheets of horn, that encloses precious stones and glittering spangles. Cut into narrow strips with rough surfaces catching the light, or in minuscule fragments that seem to sparkle with a rare intensity, American glass is a superb material and brings to our windows a precious element.[54]

The success of "American" glass in Europe and the influence of its materials on the decorative design of the European artists then developing Art Nouveau are documented in Herwin Schaeffer's article, "Tiffany's Fame in Europe."[55] Especially interesting are the author's comparisons of Healy and Millet's windows in the Musée des Arts Décoratifs with later glass designs by Henri van de Velde and Victor Horta (plate 84). The point of dif-

78. LOUIS COMFORT TIFFANY. *Winter,* from
The Four Seasons window. 1890. Stained
glass, 39 x 32". Morse Gallery of Art,
Winter Park, Fla. (The McKean Collection)

79. LOUIS COMFORT TIFFANY. Stained-glass window in Tiffany's apartment in Bella Apartments, E. 26th St., New York City (photographed 1882)

80. LOUIS COMFORT TIFFANY (or Tiffany Studios?). Four stained-glass panels. c.1900. Formerly the Museum of Modern Art, New York City

81. HEALY AND MILLET. Window in Sullivan's Auditorium Building, Chicago. 1887 (photograph Wayne Andrews)

82, 83. HEALY AND MILLET. Stained-glass
panels, exhibited 1889 at Paris Exposition.
Illustrations in *Revue des Arts Décoratifs,*
Vol. X, 1889–90

84. VICTOR HORTA. Panel of stained-glass
window from Frison residence, Brussels.
c.1894. 40¼ x 20½". Collection
L. Wittamer-de Camps, Brussels

ference between European, particularly French, and American designs for windows is also defined in Didron's article in a criticism continuously leveled at the American artists' attempts at figural windows:

> But this method cannot be readily applied to every kind of composition, and particularly not to figures. Messieurs Healy and Millet wanted, nevertheless, to design a small figure after M. Bartholdi's [*Statue of*] *Liberty*, an effort on which they cannot be congratulated. Mr. John La Farge, an artist little known in France though celebrated in the United States, who seems to be the inventor of American glass, did not hesitate to use it for a religious scene composed of several figures; now, in order to obtain the very numerous gradations of hues and the finished modeling that he needed, the painter settled for inserting many folds of drapery into the leading. This [resulting] mosaic is a labor of great patience but minimal interest. Mr. La Farge was more inspired in his little stained-glass window of yellowish background; the scrolls, formed by one line of lead, turn into little leaves and fantastic creatures of tiny dimensions which possess an extraordinary charm in their strong iridescent coloring.[56]

We must assume that La Farge won his Legion of Honor award for developing the glass materials rather than for the design of his Watson Memorial window in Buffalo (plate 85).

The uniting of precise form and line with rich color was a problem basic to much nineteenth-century art—from painting to designing glass windows. Caryl Coleman quoted John Ruskin on this issue in his article on the rebirth of the glazier's art:

> Color, to be perfect, "must have a soft outline or a simple one; it cannot have a refined one; and you will never produce a good painted window with good figure drawing in it. You will lose perfection of color as you give perfection of line."[57]

In Tiffany's figural windows an academic-naturalistic style is juxtaposed with the technique of abstraction, which produces an uneasy effect (plate 86). He claimed that his interests were only in color, and he constantly used designs by other well-known artists, such as Elihu Vedder, in the 1880s (see plate 124). Bing, when planning the first *Salon de l'Art Nouveau* in 1895, commissioned Tiffany for windows after designs by French artists of the Nabi group, semiabstract in style and derived from the study of medieval glass and cloisonné enamels (plate 87). These are a perfect blend of form and materials.

John La Farge faced the same criticism of his figural windows, but he was a gifted pictorial artist and broadly trained, and his grasp of form usually worked with rather than against the new decorative principles. His early painting was strongly influenced by Japanese art, and later his windows, when not showing a figural Christian theme, typically rely upon Oriental vertical axes, flat asymmetrical compositions, and stylized natural images such as flowers and peacocks that had already been adapted to decorative concerns. His purely abstract windows depend, much like Tiffany's, on geometric Islamic or Celtic principles.

Unlike many glass designers, La Farge seems to have consciously tried to design his windows with an eye to their architectural settings; undoubtedly his collaboration with Richardson, White, and Saint-Gaudens reinforced this logic. Consequently his windows in Trinity Church emphasize the ornamental over the figural; in White's redecorated Watts Sherman residence La Farge carried the surrounding rectilinear forms into his two-dimensional format by devising a Japanese-inspired lattice with interweaving flower forms (plates 88, 89). For the sumptuous Oriental interior of the Vanderbilt Moorish Room (plate 90), and for the Marquand and Ames houses, he created delicately intricate Japanese compositions of peacocks and peonies set asymmetrically in richly ornamented frames (plate 91). La Farge also took care to match his figural windows with the surrounding architectural style, using Romanesque hieratic frontality and strict symmetry for his *Christ in Majesty* in Richardson's Trinity Church (plate 92).

85. JOHN LA FARGE. *Noli Me Tangere,* Watson Memorial Window. c.1888–89. Stained glass. Memorial Chapel, Trinity Episcopal Church, Buffalo

86. LOUIS COMFORT TIFFANY. *The
Bathers*. Stained-glass window
in Laurelton Hall, Oyster Bay,
Long Island, N.Y. Installed before
1913; destroyed by fire 1957

In general La Farge was more successful than many of his American contemporaries in reconciling the nineteenth-century demand for naturalistic form with the inherent flatness of the glass material itself and in creating a decorative mosaic of heavy outlines and brilliant colors. His turn to Japanese art reflects the similar response of many European artists at the time, who were reconsidering their work in terms of flat canvas surfaces covered with patches of color. A comparison of windows by La Farge and Tiffany (plate 93) clearly shows their differences in compositional control and unity—Tiffany relying on the rich material, La Farge subordinating this to his well-thought-out decorative design.

By the turn of the century most Oriental interiors had given way to a simpler geometric

87. PIERRE BONNARD and LOUIS COMFORT TIFFANY. *Mother and Child*. 1895. Stained-glass window commissioned and acquired by Samuel Bing. Illustration in *The Magazine of Art,* 1898

style, the ornamentation usually restricted to specific areas or panels. The windows by Tiffany Studios correspond in their simplicity to those by architectural designers like George Elmslie, Frank Lloyd Wright, and Louis Sullivan (plates 94–96).

Finally the developing European stress on "truth to materials" turned men's thought back to clear glass; ironically, the issue had been raised in America as early as 1882 by the skeptical author who discussed Tiffany's Union League windows in *The Century Magazine* (see plate 34):

> The larger ones on the first landing it is hardly possible to admire so much, unless one's taste exactly fits in with them, in which case, of course, they are triumphant successes. And it is undoubtedly fortunate that mere taste plays so large a part in the judgment of such art-products as stained-glass; otherwise one might urge as an objection to a window, that it was opaque or muddy or anything else, and according to the logic of transparent material—the objection would be fatal.[58]

Louis Comfort Tiffany and Art Nouveau Applied Arts in America

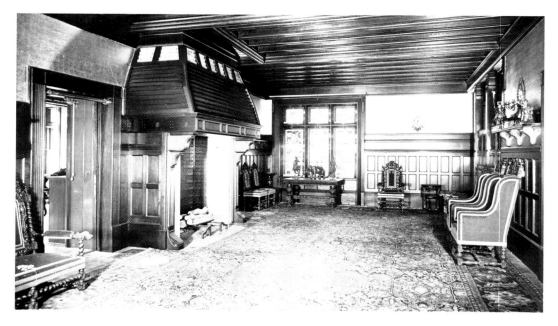

88. Hall of Watts Sherman residence, Newport, R.I. Built by H. H. RICHARDSON. 1874–76; enlarged and decorated by STANFORD WHITE. 1881 (photograph Newport Historical Society)

89. JOHN LA FARGE. *Flower and Trellis Window*. 1877. Stained-glass window in three panels from hall of Watts Sherman residence, Newport, R.I. Museum of Fine Arts, Boston (Gift of James F. O'Gorman)

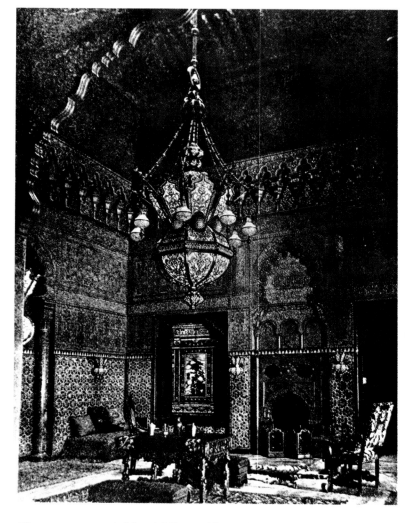

90. GEORGE B. POST. Moorish Room (formerly Drawing Room), Cornelius Vanderbilt residence, New York City. 1879–81. Stained-glass window, *Peonies Blown in the Wind,* by JOHN LA FARGE. 1881–82 (photograph in *Architectural Record,* June 1898)

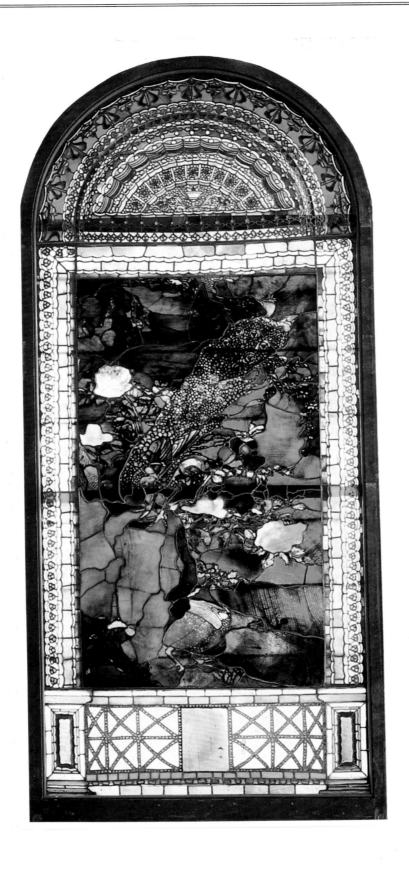

91. JOHN LA FARGE. *Peacock and
Peonies,* stained-glass window
from Frederick L. Ames residence,
Boston. 1882.
National Collection of Fine
Arts, Smithsonian Institution,
Washington, D.C.

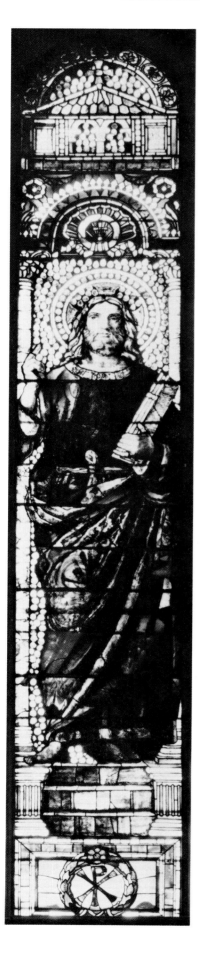

92. JOHN LA FARGE. *Christ in Majesty*. Stained-glass window in west wall, Trinity Church, Boston. 1883 (photograph Richard Cheek)

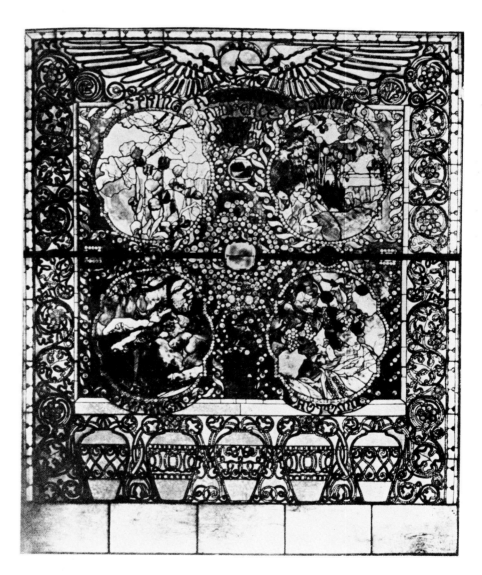

93. LOUIS COMFORT TIFFANY. *The Four Seasons,* stained-glass window. 1890. 9'3" x 7'3" (later dismantled into 4 panels; see plate 78). Morse Gallery of Art, Winter Park, Fla. (The McKean Collection)

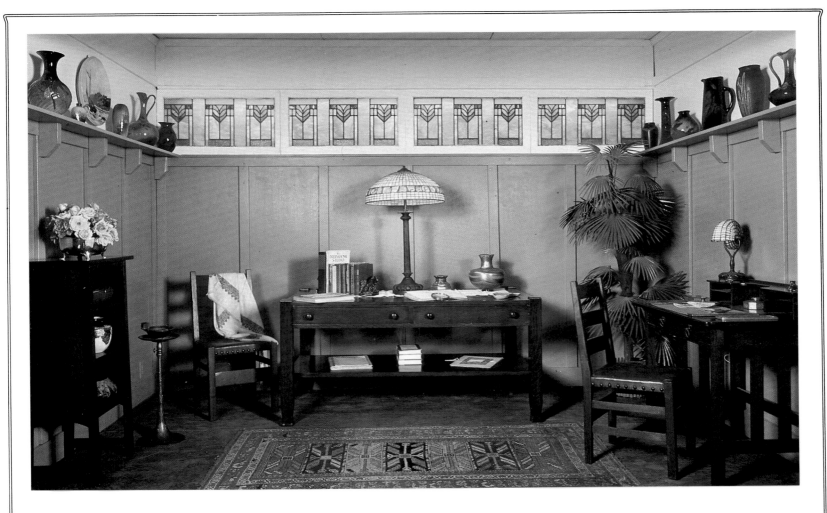

94. Interior with windows and lamps by
Tiffany Studios; Mission oak furniture;
Rookwood pottery. Design by Jeannette G.
McKean. Morse Gallery of Art, Winter
Park, Fla. (The McKean Collection)

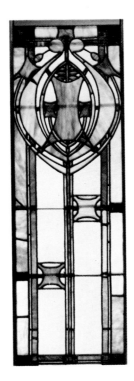

95. GEORGE ELMSLIE. Leaded
stained-glass window from
Dr. J. C. Cross residence,
Minneapolis. 1911. 63 x 15″.
The Metropolitan Museum
of Art, New York City (Gift
of Roger G. Kennedy, 1892)

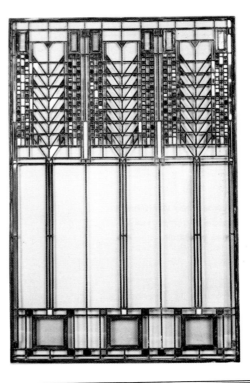

96. FRANK LLOYD WRIGHT.
"Tree of Life,"
leaded-glass window from
Darwin D. Martin residence,
Buffalo. 1904. 26¼ x 41½″.
Art Institute of Chicago (Gift
of the Antiquarian Society)

In his review of the Chicago Exposition André Bouilhet, himself a silversmith, gave close attention to the state of this art in America.[59] He cited three exhibits which displayed "les tendances originales": Tiffany, Gorham, and Whiting. Whiting was discussed for its use of naturalistic-symbolic detail, the author noting that the company had recently sacrificed naturalism to "un style nouveau," "inspired by India, and baptized *style saracénique* by its creator, M[onsieur] Moore, one of the artistic directors of the Maison Tiffany" (plate 97). Although he rated Whiting below the other two companies artistically, Bouilhet was obviously impressed with the large number of workers (350) in the "industry."

The exhibit of Tiffany and Company, in contrast, was described at length, including its stylistic elements, especially the Japanese influence in small vases of "great originality" that succeeded the "tentative happinesses of 1878." Bouilhet remarked, however, that rather than continuing to rely so heavily on Japanese style (plate 98),

> They have found a new expression in demanding from the forms of romping animals and flowing waves, the same form for the vases and their decoration.[60]

Referring to "tour de force" trophies and other showpieces (plates 99–101), he quoted a writer who had complained in 1889 that Tiffany's works were most pleasing to purchasers "whose fortunes had been formed more rapidly than their taste" (plate 102). Large showpieces like the Magnolia Vase were criticized as being too confused in composition (plate 103). Declaring the execution to be extraordinary, Bouilhet continued, "but why conquer such difficulties for so feeble a result! As for the *table de toilette*, I prefer to forget it. It has the pretension to be Louis XVI. What error in taste!"[61]

Bouilhet then explained that the Gorham Manufacturing Company differed from Tiffany and Company since it was properly a silver company, not a jeweler or "grand deluxe bazaar" for imports. Gorham, an established manufacturing company in Providence with 1,200 workers, had, apart from its silver works, a bronze foundry for statues, and it fabricated church articles as well as artistic pieces. The author associated Gorham's designs stylistically with Tiffany's, both imitating the Japanese interpretation of nature without simplifying it. Again criticizing compositions in which "ornament is pushed to excess" as in the Exposition's famous "Service à Roses," Bouilhet admitted that Tiffany's Magnolia Vase was a "tour de force" of technique, but commented, "But one is fatigued looking at it! The form disappears under the ornament."[62]

Bouilhet was especially impressed to find that the "ideas which the Union Centrale had initiated" and the principles it had posed in France had produced in America such vigorous fruits. "When the silversmiths speak in public, they hold to the motto: The Beautiful in the Useful." He quoted from Gorham's superbly illustrated publication (with "remarkable photo-type reproductions for which Americans were well known"):

> The house of Gorham has always maintained that every object within the limits of its manufacture, however humble and ordinary, can be made beautiful as well as useful.[63]

Gorham's publication also gave credit to the varied national origins of its workers— England, France, Germany, Russia, Sweden, Norway, and Italy. The interaction of these immigrant craftsmen upon their American counterparts must have been important for developing the many "new" ideas of the 1880s.

Other decorative arts were discussed: door handles in forged iron by Yale and Towne Manufacturing Company, their "personal American character" inspired largely by Louis Sullivan's ornamental designs. Bouilhet hoped to purchase examples for the Union

American
Art Nouveau

90

97. EDWARD C. MOORE, for Tiffany and
Company. Teapot. 1888. Silver with
enamel, in Islamic style; 4⅞ x 11″. The
Metropolitan Museum of Art, New York
City (Gift of a Friend of the Museum, 1897)

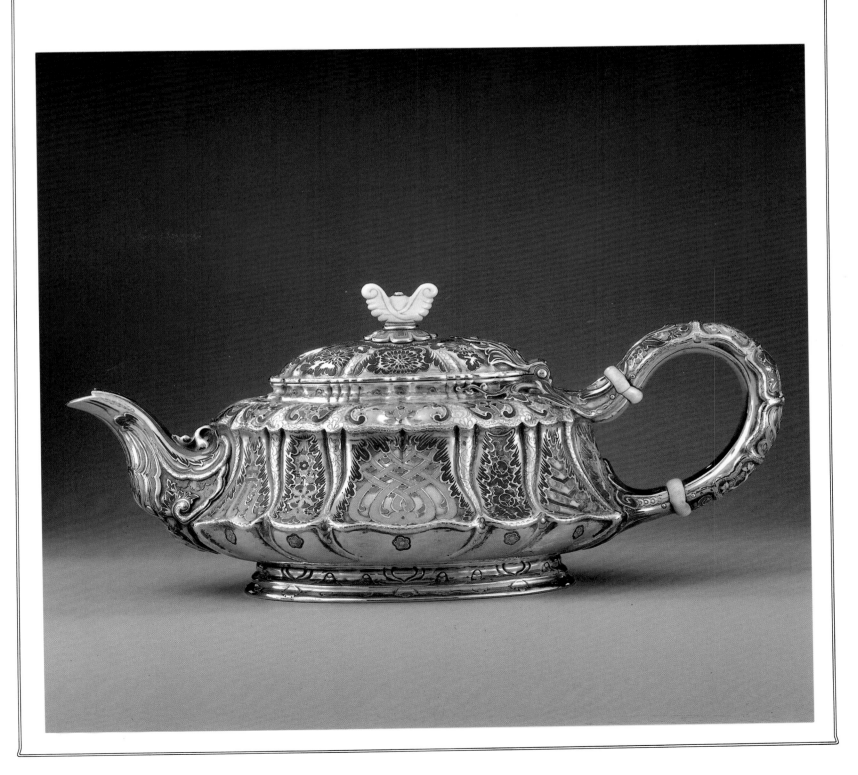

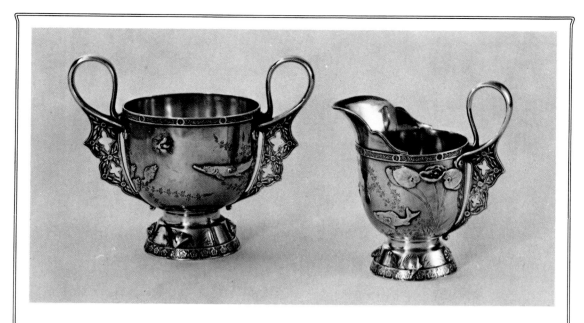

98. TIFFANY AND COMPANY. Sugar Bowl and Creamer. 1874. Silver, in Japanese style. The Metropolitan Museum of Art, New York City (Edgar J. Kaufmann Charitable Foundation, 1969)

Centrale's collection. In conclusion, he praised American silversmiths for remaining of their country and for being of their times:

> They think that in a new country it is necessary to be new, and they have created a composite style, a bit barbaric, a bit savage perhaps, which I volunteer to call *the American style*, and which is neither Hindu, nor Arabic, nor Japanese, but a bit of all these at once, revitalized by a study curiously based on the plant, rejuvenated by a fresh conception of nature, which they admire.[64]

A fine example of this new American style is the Tiffany and Company silver-and-enamel tea service of about 1888 (see plate 97), probably designed by Edward C. Moore, a director of the company and manager of its manufacturing side when the company incorporated in 1868. Moore evolved the highly eclectic "Saracenic" style that combined, as Bouilhet put it, Hindu, Arabic, and Japanese;[65] his superb collection of Indian and Near Eastern objects undoubtedly provided inspiration for himself, Louis Tiffany, and others. Tiffany and Company's silverware won a *Grand Prix* at the Paris Exposition of 1889, and Moore was made a chevalier of the Legion of Honor. Like the coffee service of 1874, his tea set of 1888 uses Islamic and Indian designs (plates 102, 104), but its form and decoration are now smoothed out into a more abstractly organic design derived from the Japanese, elements of which were already present in 1874 (see plate 98). The exquisite colors in the 1888 service are an outgrowth, as Bing described it, of Moore's

> . . . bringing teams of Japanese craftsmen to America, under whose guidance tonalities of every kind were mixed with silver. The effect of these inlays, to which niello had already been added, was burnished still further by other coloring methods. Experiments with enamels followed, in which, by alternating muted, sombre tones with brilliant, translucent ones, a maximum degree of technical skill and ingenuity was attained.[66]

American Art Nouveau

In contrast with the undigested eclecticism of Gorham's East Indian designs and Tiffany

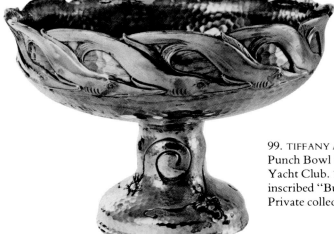

99. TIFFANY AND COMPANY. Trophy
Punch Bowl for the New York
Yacht Club. 1880. Parcel gilt,
inscribed "Buck Cup...188–."
Private collection

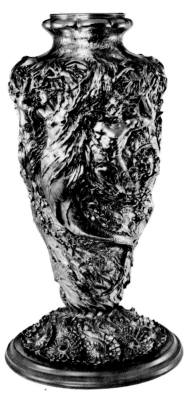

100. TIFFANY AND COMPANY. Trophy
Vase for the New York Yacht Club. Silver,
inscribed "Goelet Cup 1886." Private
collection

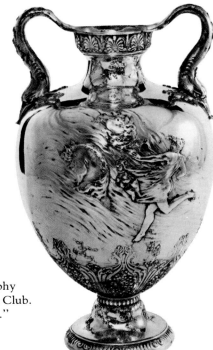

101. TIFFANY AND COMPANY. Trophy
Amphora for the New York Yacht Club.
Silver, inscribed "Goelet Cup 1888."
Private collection

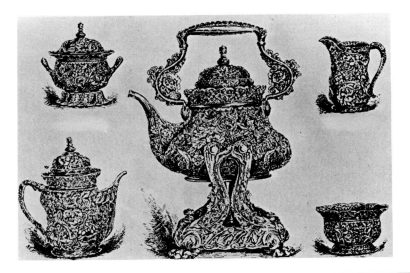

102. TIFFANY AND COMPANY.
Tea Set. 1888; exhibited 1889
at Paris Exposition.
Silver with repoussé surface.
Illustration in *Jewelers'
Weekly*, 1889

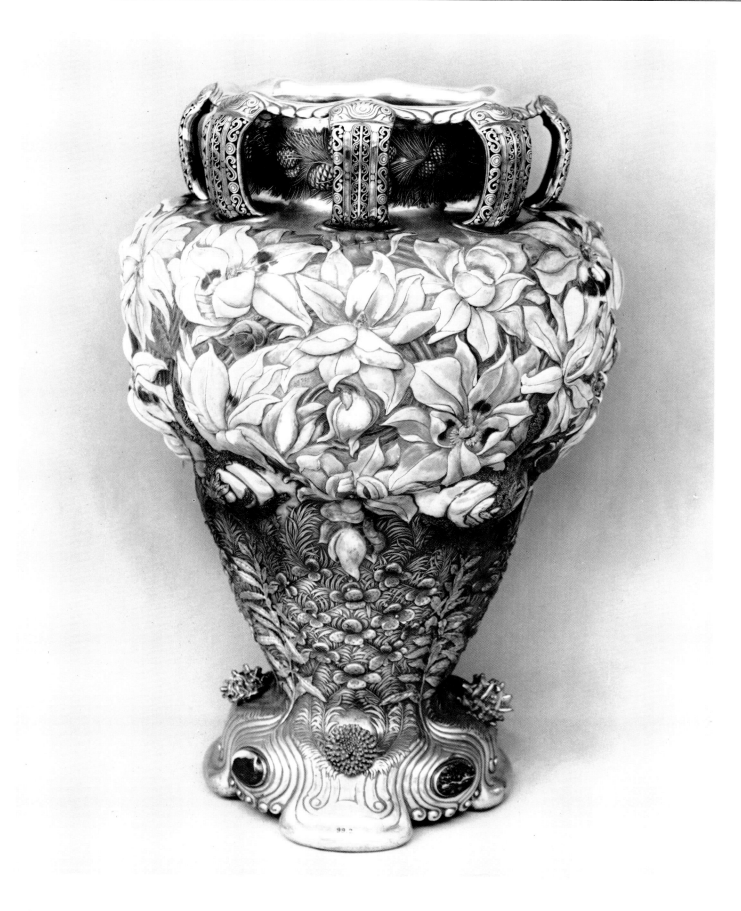

103. JOHN C. CURRAN, for Tiffany and Company. Magnolia Vase. Exhibited 1893 at World's
Columbian Exposition, Chicago. Silver, gold, and enamel; height 31″. The Metropolitan Museum
of Art, New York City (Gift of Mrs. Winthrop Atwell, 1899)

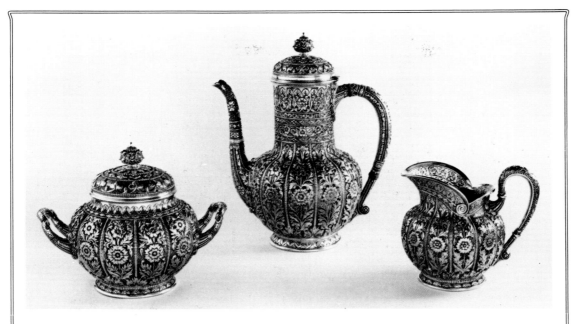

104. TIFFANY AND COMPANY. Coffee Set. 1874. Silver with niello, in Islamic style; presented to Henry Kiddle by the Teachers of the Public Schools of the City of New York, Christmas 1879. Museum of the City of New York (Lent by Alfred M. F. Kiddle)

and Company's repoussé tea service encrusted with American ferns and flowers (see plate 102), small wonder that European critics found worthy of praise and attention these more fluidly integrated Art Nouveau forms.

Also exemplifying America's "new" style is the scarab mirror shown at the Columbian Exposition by Tiffany and Company (plate 105); it was illustrated in Wilhelm Bode's article "Moderne Kunst in den Vereinigten Staaten von Amerika," in *Kunstgewerbeblatt*, 1894. Typical of exotic eclecticism, based this time on Egyptian and Indian imagery, the mirror is made of scarab, cobra, and lotus forms with continuous spirals and a spreading leaf, the background a diaper of interlocking circles. The two winding snakes that form the handle serve functionally as well as formally. Richly detailed and absolutely symmetrical, the mirror exudes a Cleopatran wealth and vanity. This scarab mirror evolved from a style related to Tiffany and Company's designer James Whitehouse; he won fame in 1874 with his competition piece, the Bryant Vase (plate 106), and designed an eclectic silver flagon in 1876, both having all-over surface designs and numerous decorative details tightly controlled by symmetry.

Three American hand mirrors—the scarab mirror, made just before 1893; Louis Tiffany's silver-and-enamel peacock mirror, of about 1900 (plate 107); and a dressing-table mirror by the Sterling Company of Providence, of about 1901 (plate 108)—provide a survey of stylistic development in American applied art during this decade. By the late 1890s Louis Tiffany knew well the European, especially French, style of Art Nouveau, its asymmetrical organic and curvilinear designs largely simplified from Japanese art, and his peacock mirror symbolizes the vanity and the timelessness of eternal beauty. In contrast to the strong symmetry holding many elements together in the scarab mirror, the simpler images and forms now cohere into greater unity. The fluid silver seems stretched to enframe the enamelwork, where gold outlines the iridescent blues and greens. Slight asymmetry sets up a sensuous movement that was absent in the earlier work; the subtle use of open spaces in handle and frame brings positive and negative curves into organic interplay. The symbolism of eyes, of eternal life, and of ultimate vanity are pulled together with ex-

Louis Comfort Tiffany and Art Nouveau Applied Arts in America

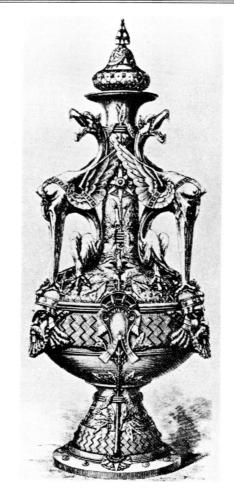

106. JAMES WHITEHOUSE, for Tiffany and Company. Bryant Vase. 1874. Silver. Illustration in *Jeweler's Weekly*, 1889.

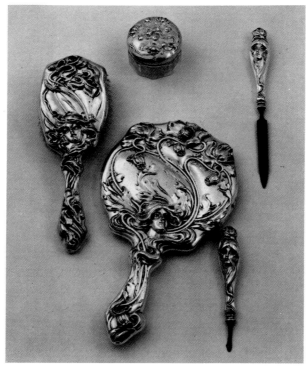

105. LOUIS COMFORT TIFFANY. Scarab Mirror. Exhibited 1893 at World's Columbian Exposition, Chicago. Silver. Illustration in *Kunstgewerbeblatt*, 1894

107. LOUIS COMFORT TIFFANY. Peacock Mirror. c. 1900. Silver, enamel, and sapphires; 10¼ x 4¾". The Museum of Modern Art, New York City (Gift of Joseph H. Heil)

108. THE STERLING COMPANY (Providence, R.I.). Dresser Set. c.1901. Silver. Virginia Museum, Richmond (Lent by Mr. and Mrs. William T. Reed, III)

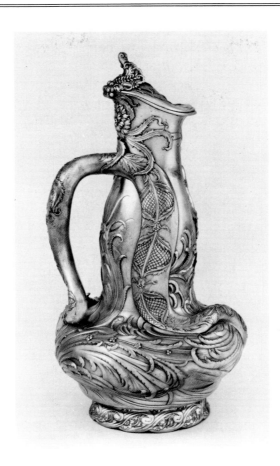

109. WHITING MANUFACTURING
COMPANY (New York City).
Trophy Pitcher with Lid, for the
New York Yacht Club. Silver,
inscribed "Goelet Cup...1886."
Private collection

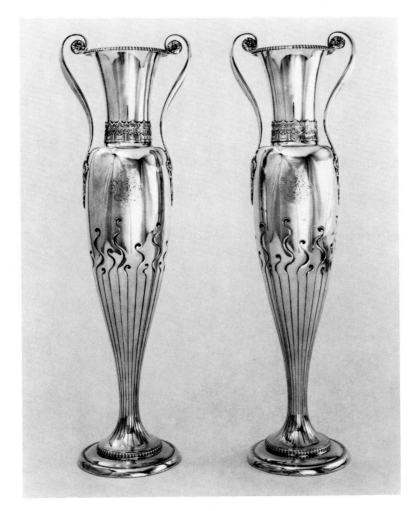

110. TIFFANY AND COMPANY. Pair
of Vases. 1894. Silver. Museum of
the City of New York (Gift of
Harry Harkness Flagler)

quisite workmanship (the mirror was undoubtedly produced by Tiffany and Company craftsmen) in a rich play of color and sophisticated organic composition.

No such design and craftsmanship are shown by the Sterling Company's commercialized maiden-flower mirror. The suggestion of asymmetry within an essentially symmetrical design confuses the clarity and negates the power of either form of balance. All the readily recognizable elements of "Art Nouveau" are here, whiplash stems and swirling plants mingling with the flowing hair of the dreamy-eyed woman. But heavy lines and thick details exemplify the enormous output of "Art Nouveau" by commercial silver companies in America after the 1900 Paris Fair.

The exact place of American silver design in the overall development of international Art Nouveau is not yet clear. Several works of the 1880s by Tiffany and Company and by the Whiting Manufacturing Company must be seen in the light of the international movement.[67] The strong simplicity of an 1880 parcel-gilt punch bowl (see plate 99) made by Tiffany and Company for a yachting trophy is Japanese in origin, yet its sensuous curves, rich color, and stylized naturalism seem to foreshadow the Art Nouveau peacock hand mirror that Louis Tiffany designed twenty years later. Likewise, the uneasy symmetry that confines the aquatic females and abundant swirling forms of the Sterling Company's post-1900 mirror have earlier precedents in the 1886 and 1888 trophy cups by Tiffany and Company as well as in Whiting's 1886 trophy (plate 109).

Curving linear elements that rise, swell, taper, and curl at the ends, first appearing in the lower part of Tiffany and Company's 1888 amphora trophy (see plate 101), are seen in the base of the Magnolia Vase (see plate 103), the company's 1893 showpiece designed by John C. Curran, chief designer for the silver works after Edward Moore died in 1891. These become attenuated rising curves in the two silver vases of 1894 (plate 110). The upper part of the pair of vases is a typical Tiffany and Company combination of neo-Renaissance, Beaux-Arts classical forms, like the supernaturalistic plant forms with East Indian handle shapes in the Magnolia Vase. Although the abstractly curving elements are certainly Art Nouveau, the designer has used them only in certain areas. The particular form of the curves strongly recalls the work of Edward Colonna, who is thought to have sent a copy of his 1887 *Essay on Broom-Corn* to his former employer, Louis C. Tiffany.[68] In this small, relatively unknown but precocious booklet Colonna included a design for a silver frame having noodle-like lines that curve upward around simplified flower forms and end in tight spiral knots (plates 111, 112); the format is perfectly symmetrical, like all of Colonna's broom-corn designs. Colonna soon left the United States to become a main designer for Samuel Bing's Maison de l'Art Nouveau, and his role remains enigmatic as a link between Art Nouveau in the United States and Europe.

It might seem possible to argue from the few instances described that the applied arts style eventually called Art Nouveau in Europe was anticipated, if not influenced, by American silver designers of the early and mid-1880s. Silver pieces were among the first decorative arts from America to be recognized in Europe: in 1867 Tiffany and Company became the first foreign exhibitor to receive an award at the Paris Exposition. The London *Spectator* commented:

> We confess we were surprised and ashamed to find at the Paris Exposition that a New York firm, Tiffany and Company, had beaten the Old Country and the Old World in domestic silver-plate.[69]

The next year the New York firm opened a branch in London, followed by a large watch-manufacturing plant in Geneva, there to "unite the best European skill with the latest mechanical improvements and labor-saving methods that American ingenuity could devise"; the Swiss experiment failed, after a thorough trial, because "the conditions surrounding European labor were found to be wholly inapplicable to American methods."[70] Broader European fame came to Tiffany and Company in Philadelphia in 1876, when "in

111. EDWARD COLONNA. Design for a Frieze. Illustration in *Essay on Broom-Corn,* Dayton, Ohio, 1887
(courtesy Newark Public Library)

112. EDWARD COLONNA. Broom-corn Mirror Frame. Silver.
Illustration in *Essay on Broom-Corn,* Dayton, Ohio, 1887
(courtesy Newark Public Library)

addition to a gold medal, special recognition and certificates of award were bestowed for the display of jewelry, jeweled watches, silverware, silver inlaid with niello and copper, and wedding stationery." In 1878 the company received the *Grand Prix* in Paris for silverware, a gold medal for jewelry, and six medals to individual co-laborers; Charles Tiffany, who attended that exposition, was made a chevalier of the Legion of Honor, and appointments followed as Imperial and Royal Jeweler, Goldsmith, and Silversmith to most of the monarchs and dignitaries of Europe. Tiffany's was awarded the *Grand Prix* for silverware again in 1889; Edward Moore was made a chevalier; and Tiffany and Company received sixteen medals—for jewelry, precious stones of North America, leatherwork, ivory carved and mounted, copperplate engraving and printing, glassware, and clocks—and ten medals to co-laborers. In 1893 a similar story in Chicago: thousands of admiring visitors daily, over fifty-five awards, and many favorable press reviews, as in the London *Art Journal* of October 1893:

> Passing to the exhibit of Messrs. Tiffany and Co., of New York, one finds a display more varied in expression and original in design, more distinctive and individual, than the work of any other firm in the Art metal group.[71]

In addition to creating designs in metal and jewelry and displaying these internationally, Tiffany and Company also brought back the most avant-garde European designs. Bouilhet noted that Charles Tiffany's "grand bazaar artistique" in New York contained porcelain from Sèvres, Copenhagen, and Limoges; works by Auguste Delaherche, Emile Gallé, and Ernest Chapelet; and bronzes by F. Barbédienne and H.-L. Thiébaut.[72] By 1893 the interaction of American and European decorative arts was well under way.

The Gorham Manufacturing Company of Providence (largely thanks to the English silversmiths William Christmas Codman and his son, who joined the firm about 1891) was producing by the end of the 1890s a line of Art Nouveau silver called Martelé (plates 113, 114).[73] Silver forms hammered by hand, these works were praised in an article in the 1899 *House Beautiful* by an Arts and Crafts-oriented author, Charlotte Moffitt, as "reminding us of other days, when machines did not exist and the intellect of the artisan himself went into the work." The fluidity of the work and design of their punch bowl—organic details in whiplash curves and dreamy-eyed, smiling water maidens—are familiar Art Nouveau elements. The Gorham tea set, however, carried a design more abstract and curvilinear in style (plate 115).

In contrast to Gorham's handmade silver Martelé (plate 116), other American manufacturers began to turn out quantities of small, machine-made Art Nouveau silver objects. Unger Brothers of Newark, New Jersey, specialized in these about 1900 (plate 117) as did William B. Kerr and Company of Newark (plate 118), and Marcus and Company. These companies also produced jewelry, and we can see in it similar stylistic and developmental relationships to those in larger silver objects. Charles Tiffany's company was well known for its jewels, diamonds in particular. At Philadelphia in 1876 it exhibited the 30-carat Brunswick Yellow Diamond set into a large peacock-feather brooch (plate 119), a design used through 1910 and adopted with slight variations by many Art Nouveau designers, including Alphonse Mucha (plate 120). Illustrated in the *Centennial Masterpieces*[74] with the peacock-feather brooch are a pair of earrings that have a vertical format, rising tendrils, filigree, and small droplets (plate 121); these elements seem to be forerunners of designs by Edward Colonna (plate 122), whose first job after arriving in the United States in 1882 was with Louis Tiffany. And, curiously, some of Colonna's later designs for Bing's Maison de l'Art Nouveau resemble motifs from Elihu Vedder's 1887 stained-glass door design for Louis Tiffany (plates 123, 124).

Other early designs by Tiffany and Company included insects, often the dragonfly. These motifs were probably Japanese-inspired, created by the many Japanese artisans whom Edward Moore had brought to Tiffany and Company about 1878 to work in

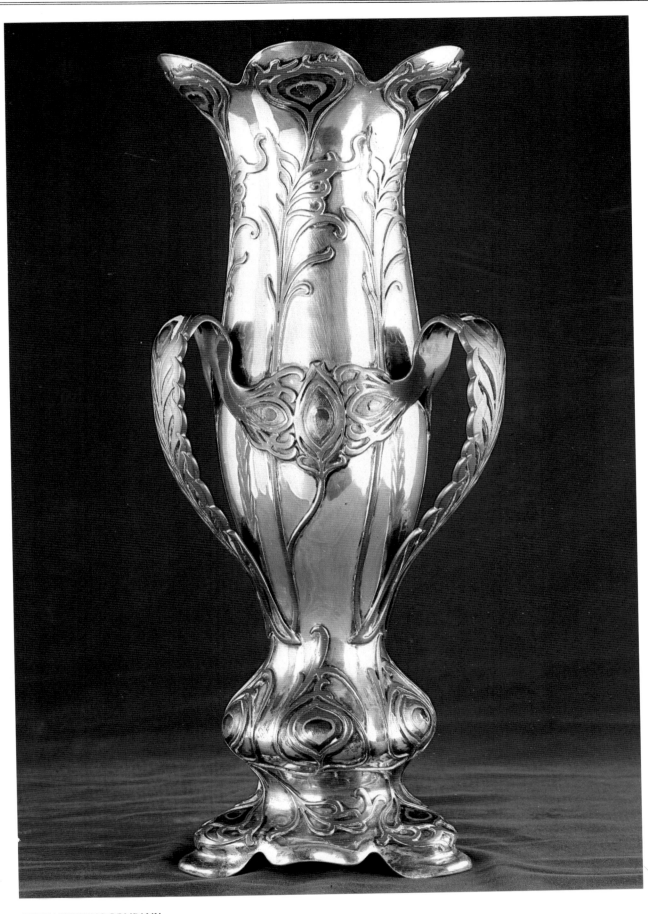

113. GORHAM MANUFACTURING COMPANY
(Providence, R.I.). Athenic Vase. c.1890.
Silver, with copper and enamels; height 13″.
Chrysler Museum at Norfolk, Va. (Gift of
Walter P. Chrysler, Jr.)

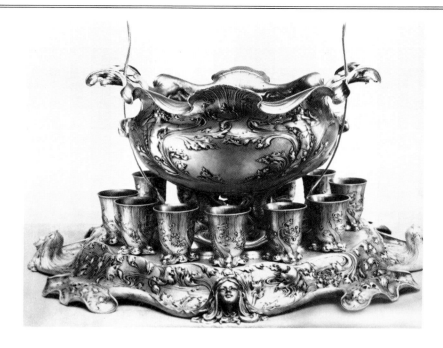

114. GORHAM MANUFACTURING COMPANY (Providence, R.I.). Punch Set Martelé. After 1900. Silver, diameter of plateau 26½″. Illustration in Gorham catalogue

115. GORHAM MANUFACTURING COMPANY (Providence, R.I.). Tea Set Martelé. After 1900. Silver. Illustration in Gorham catalogue

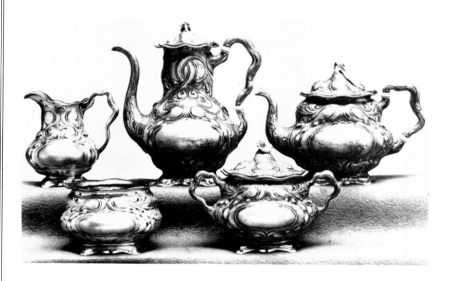

116. GORHAM MANUFACTURING COMPANY (Providence, R.I.). Belt Buckle Martelé. c.1900. Silver and copper, with mother-of-pearl. Formerly Macklowe Gallery, Limited, New York City

117. UNGER BROTHERS (Newark, N.J.). Brooch, Letter Opener, and Belt Buckle. c.1900. Silver. The Metropolitan Museum of Art, New York City (Gift of Ronald S. Kane, 1967)

118. WILLIAM B. KERR AND COMPANY
(Newark, N.J.). Brooch. c.1900. Silver.
Macklowe Gallery, Limited, New York City

119. TIFFANY AND COMPANY.
Peacock-feather Brooch, set with
the Brunswick yellow diamond.
Exhibited 1876 at Centennial
International Exhibition,
Philadelphia. Illustration in
Masterpieces of the Centennial,
Vol. II

120. ALPHONSE MUCHA. Brooch.
Illustration in A. Mucha,
Documents décoratifs, Paris, 1902

121. TIFFANY AND COMPANY. Earrings. Exhibited 1876
at Centennial International Exhibition, Philadelphia.
Illustration in *Masterpieces of the Centennial,* Vol. II

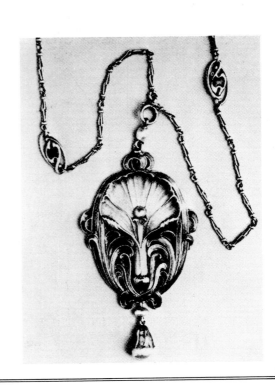

122. EDWARD COLONNA, for
Samuel Bing. Floral Pendant and
Chain. c.1900. Illustration in *Art et
Décoration,* September 1900

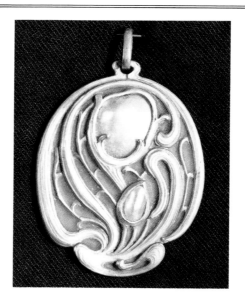

123. EDWARD COLONNA, for
Samuel Bing. Pendant. 1898–1900.
Green translucent enamel on gold,
with baroque pearls; 2 x 1⅜″.
Musée des Arts Décoratifs, Paris
(Gift of Marcel Bing, 1908)

124. ELIHU VEDDER. Drawing for *The Mermaid Window,* stained-glass window to be executed by
Tiffany. 1882 (signed and copyrighted 1887). Crayon and gold on paper; left and right panels 7¼
x 2⅛″, center panel 8⅞ x 3¾″. Cooper-Hewitt Museum, Smithsonian Institution's National Museum
of Design, New York City

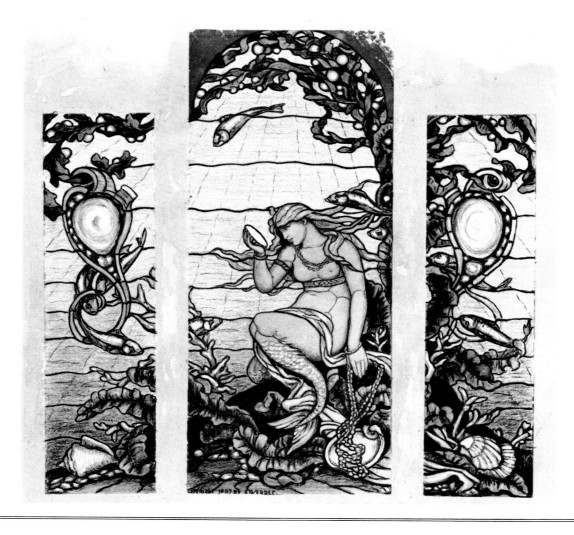

125. LOUIS COMFORT TIFFANY. Medusa Pendant.
Exhibited 1906 at the Paris *Salon.* Gold, with opals
and green and red stones.

126. LOUIS COMFORT TIFFANY. Necklace.
Exhibited 1906 at the Paris *Salon.* Gold, with
opals and enamel. The Metropolitan
Museum of Art, New York City
(Gift of Sarah E. Hanley, 1946)

127. LOUIS COMFORT TIFFANY. Peacock Necklace. Exhibited at the Paris *Salon,* 1906. Gold,
with precious stones. Morse Gallery of Art, Winter Park, Fla. (The McKean Collection)

128. Hispano–Mauresque Textile, with confronting peacocks.
12th century. Silk. Victoria and Albert Museum, London

varicolored metals and enamels. By the late 1890s Louis Tiffany was closely involved with his father's firm; he had been one of its six trustees since at least 1893. Whether he himself designed objects for Tiffany and Company before the turn of the century is a matter under investigation, but by 1900 he was designing such works in metal and jewelry as the peacock mirror, and the brooch in Medusa form which attracted notice at the 1906 Paris *Salon* (plate 125; see plate 107);[75] two necklaces in floral and peacock form were also exhibited there (plates 126, 127). The range of style in these three works is evidence of Tiffany's three major sources of design: organically stylized natural forms in asymmetric composition, derived from Japanese art; severe symmetry, rich color, and mosaic-and-bead designs with peacocks, derived from Islamic art (plate 128); and naturalistic plant forms in irregular stones and enamels, designed with his own love for American floral and botanical species.

GLASS VASES AND POTTERY

In contrast to the problem of form versus color in glass windows (see page 80), Louis Tiffany's favrile glass vases, made after 1894, so completely reflected the technical inventions and processes that produced them that design was inevitably united with decoration (the term "favrile" was registered in 1894 as "a composition of various colored glasses, worked together while hot"[76]). In keeping with the techniques of Venetian blown glass (rather than Germanic cut glass), the organic development of the form of Tiffany's works also produced its ornament (plate 129). By 1900 Louis Tiffany was most famous for his favrile vases, especially in Europe (the 1900 Paris Exposition showed many imitations), and in these his individualism and his reliance on fine materials are especially evident. Constantly on exhibit between 1895 and 1902, in Munich, Bohemia, Austria,[77] and most importantly in 1896 and 1898 at the *La Libre Esthétique* in Brussels, with Henri van de Velde's interiors, the vases were collected throughout Europe. The last European exposition where his glass was shown was at Turin in 1902.

Interest in iridescent glass had first been stimulated by the excavation of antique glass, and this led by 1873 to experiments at producing similar results in contemporary glass in Vienna and, in 1878, by Thomas Webb in England. Arthur Nash, an employee of Webb's, came to New York in 1893 to run Louis Tiffany's glassworks factory in Corona, Long Island. Nash and his sons brought invaluable skills and knowledge with them, although Tiffany apparently sketched designs and supervised every stage of the production.[78] The process used by Louis Tiffany for his favrile vases involved the incorporation of tiny bits of glass of different textures and colors into a ball of hot iridescent glass. As Bing described it, ". . . in the operation is hidden the germ of the intended ornamentation," and the rest of the process allowed Tiffany to "control chance to the interpretation of his own fancy." After repeatedly adding color and bits of glass—sometimes twenty times—the glass was blown to its final state:

> The motifs introduced into the ball when it was small have grown with the vase itself, but in differing proportions; they have lengthened or broadened out, while each tiny ornament fills the place assigned to it in advance in the mind of the artist.[79]

Thus form and design were based on a "germ" which evolved by the natural growth and differentiation of the organism itself. The results of this method, especially in the complex peacock-feather vases (plate 130), were described by Bing:

> For some years already Tiffany had been able to produce in this way the veining of leaves, the outlines of petals of flowers. On the material there flowed meandering waters and fantastic cloud forms . . . he saw in this motif (the peacock's feather) a theme admirably adapted to enable him to display his skill.
>
> Just as in the natural feather itself, we find here a suggestion of the impalpable, the tenuity of the ponds and their pliability—all this intimately incorporated with the texture of the substance which serves as background for the ornament. Never, perhaps, has man carried to greater perfection the art of faithfully rendering Nature in her most seductive aspects, while subjecting her with so much sagacity to the wholesome canons of decoration.[80]

The matt surface of the glass, silky to the touch, and the incredible complexity of the "natural" decoration and forms were all praised by Bing, who then defined the supreme character marking Tiffany's originality and his extension of the art of glassmaking:

> . . . the means employed for the purpose of ornamentation, even the richest and most complicated, are sought and found in the vitreous substance itself, without the use of either brush, wheel, or acid.[81]

Tiffany's achievement was seen as especially impressive in view of the prestige of Venetian glassware:

> . . . so elegant as to outline, but somewhat too frail and artificial; after the delicate jewellery of the Chinese glass workers, who treated their curious material as they would the rarest cameos; after the wonderful progress realised in vitreous art in Bohemia; after the astonishing work produced by Emile Gallé; in the presence of all these marvels, could inventive genius be expected to go farther?[82]

Tiffany knew well the work of his contemporary Emile Gallé, the Frenchman from Nancy (plates 131, 132). By 1893 the Tiffany store in New York was selling examples of Gallé's work, and he had already seen it at the 1889 Paris Exposition, where Gallé received a *Grand Prix* and, like America's Edward Moore, was made a chevalier of the Legion of Honor. Gallé participated in the Chicago Exposition in 1893, triumphed in Munich in 1897, and in Paris in 1900 won two *Grands Prix* plus a gold medal, and was named a commander of the Legion of Honor. An eclectic artist, Gallé, like Tiffany, ran through naturalism (especially botanical forms), then incorporated Egyptian and Near Eastern arabesques, and drew on Islamic, medieval, Renaissance, and Japanese sources. Many works by these two geniuses of glass have a similarity, although Tiffany preferred more brilliant, saturated colors and somewhat simpler ornamentation, more abstract and less naturalistic (plates 133, 134).

By the late 1890s the range of Tiffany's glasswork had expanded to Roman-shaped bottles, iridescent bowls, peacock and flower vases, heavy "lava" vases, and elegant paperweights (plates 135, 136). Other American glass firms produced a variety of Tiffany-inspired designs: Durand Art Glass Company, Quezal Art Glass Company, and Steuben Glass, whose designer Frederick Carder continued the style into the second decade of the twentieth century (plates 137–40). Other American glassmakers picked up European designs after 1900, as seen in a Honesdale Company vase (plates 141, 142).

About 1900, Tiffany's expanded and merged business, now called Tiffany Studios, produced items in great variety, from desk sets and twine holders to electric lamps and furniture (plate 143; see plate 52).[83] Compared with such works by Gallé as his mushroom lamp, Tiffany's late glass designs continued to be less organic, more geometrically controlled (plates 144, 145). Likewise the "mushroom" lamp by America's Fulper Pottery Company greatly simplified the lamp designed by the Frères Muller of the Nancy School (plates 146, 147).

At the St. Louis Exposition in 1904, Tiffany exhibited the fruit of several years' experiments with favrile pottery.[84] Like his works in glass, much of his pottery was based on simple Oriental forms; his floral ornament, often derived from American flowers, shows similarities to that on Alexandre Bigot's 1894 stoneware vase (plates 148, 149). The native flower determines the form of Tiffany's jack-in-the-pulpit vase, and the flow of the glaze during firing creates subtle color tones (plate 150).

Louis Tiffany's "art pottery" contributed to one of the longest-established American ventures into a "new art" industry. The work of Rookwood Pottery, founded in Cincinnati, Ohio, in 1880, was largely based on Japanese prototypes. Simple, elegant lines, decorative motifs of stylized natural forms, and refined glazing techniques won Rookwood international fame throughout the 1890s and early 1900s (plate 151). Influenced by European Art Nouveau, a few of Rookwood's artists created works related to the avant-garde style (plates 152, 153). Closest to Art Nouveau was Artus Van Briggle, whom Rookwood sent to Paris in 1893 for three years to study painting at the Académie Julian and clay modeling at the Beaux-Arts Académie.[85] After his return Van Briggle worked to incorporate into his pottery the curvilinear female forms of Parisian Art Nouveau posters and paintings. Forced by ill health to move to Colorado in 1898, he trained a twelve-man force

129. LOUIS COMFORT TIFFANY. Group of Vases; five of favrile glass, one of ceramic.
After 1894. The Metropolitan Museum of Art, New York City

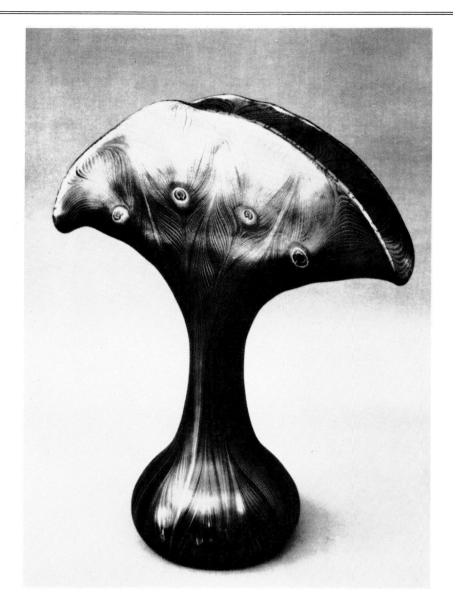

130. LOUIS COMFORT TIFFANY. Peacock Vase. c. 1892. Favrile glass. The Metropolitan Museum of Art, New York City (Gift of H. O. Havemeyer, 1896)

of workers, and by 1900 he had achieved beautifully integrated pottery, the decoration—figural or floral—completely unified with the form of the vase itself (plates 154, 155). His sensuous female figures struggling to be free or melting into the elemental body of the vase recall Rodin's sculpture as well as French pottery works by such men as A. P. Dalpayrat. Twenty-four pieces of Van Briggle's work were accepted at the Paris *Salon* of 1903 and over half were awarded prizes—two gold, one silver, and twelve bronze medals. The exhibit was sent to the 1904 Louisiana Purchase Exposition in St. Louis and received similar accolades. The artist died before the Exposition closed, and many of his themes—the Lorelei, Despondency, and the poppy forms—suggest his awareness of his coming death (plate 156).

A most unusual American pottery designer was George Ohr of Biloxi, Mississippi. Ohr, impressed by pottery exhibited at the Centennial and inspired by patriotism on the nation's hundredth birthday, conceived ceramic works of extraordinary design and technique. His

*American
Art Nouveau*

110

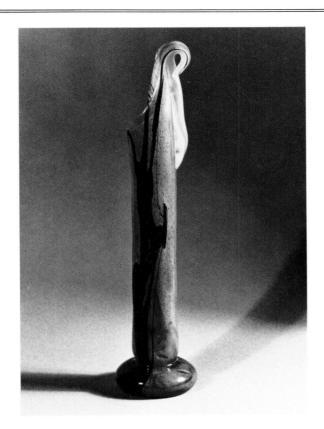

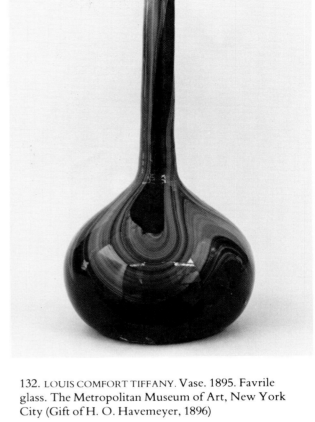

131. ÉMILE GALLÉ. Agate Vase. 1889–90. Glass, agatized. Collection J.-Cl. Brugnot, Paris

132. LOUIS COMFORT TIFFANY. Vase. 1895. Favrile glass. The Metropolitan Museum of Art, New York City (Gift of H. O. Havemeyer, 1896)

133. ÉMILE GALLÉ. Crocus Chalice. Probably 1903. Glass. Private collection

134. LOUIS COMFORT TIFFANY. Vase in Flower Form. c.1895. Favrile glass, height 14½″. Chrysler Museum at Norfolk, Va. (Gift of Walter P. Chrysler, Jr.)

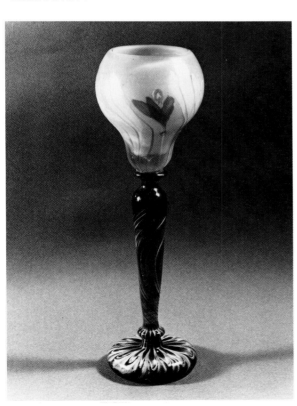

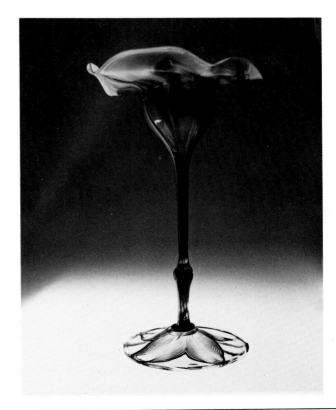

forms were twisted, dented, and folded into strange shapes in an almost Expressionist fashion (plate 157). A sign in his shop during the late 1890s read: "American born, free and patriotic, blowing my own bugle, and will tackle the greatest of all potters in the world."[86]

Ohr's work was exhibited as early as 1885, in the New Orleans Cotton Exposition, but it never became known abroad, apparently, although some of the stronger free forms with their sense of "primitive originality" can be compared to Gallé's work in glass (plate 158). Maria Longworth Storer's metal vase with underwater imagery is another freely experimental work within a Japanese-derived Art Nouveau style (plate 159).

Among the numerous American "art pottery" companies in business by 1900, one of the best known was the Grueby Faience Company in Boston. Simple leaflike forms and dark green matt glaze were drawn from French works by Auguste Delaherche, shown in Paris in 1889 and in Chicago in 1893 (plates 160, 161).[87] Like Tiffany's, the Grueby pots maintained an organic unity between the American leaf and floral forms and the appropriate color and surface texture. Hand-thrown, the pottery was then decorated in factories by young women who followed designs given them, the procedure used by numerous pottery firms at the turn of the century: Newcomb College Pottery in New Orleans and Marblehead Pottery in Massachusetts, among others (plates 162, 163). Later works often reflect a decline of the native impulse and a turn toward European sources. The interplay of American works with French pottery styles, by Colonna (plate 164) and by other designers for Bing, increased after 1900; Bing was Rookwood's general European agent between 1900 and 1903, handling their award-winning exhibit at Turin in 1902.[88] He also sold Grueby pottery in Europe to individuals and to museums such as the Victoria and Albert Museum in London and the Museum of Decorative Art in Copenhagen.[89]

Commercialization in the field of pottery ran parallel with similar developments in the other applied arts.[90] Mass-produced "lines" of Art Nouveau pottery appeared after 1901, such as S. A. Weller's "sicardo-ware" produced in Zanesville, Ohio, and marketed in 1903. These works were executed by Jacques Sicard, a French designer brought over by the firm (plate 165); he had learned the techniques for iridescent glazing from the inventive French potter Clément Massier, whose works, like those of Delaherche, had made a sensation at the 1889 Paris Exposition. In 1904 Weller produced a line of pottery of free-form plants and curvilinear decorations called simply, like Karpen's line of furniture, "L'Art Nouveau." Louis Tiffany's factories and most of these pottery firms and other "art industries" employed several designers and a large number of women laborers, and between 1900 and World War I they turned out thousands of decorative "Art Nouveau" items.

Louis Comfort Tiffany's views of himself and his mission might recall William Morris' ideal: Tiffany's objects, with their handcrafted fineness emphasizing the fitness of form, materials, and expression, often decorated the new Craftsman-style, Mission interiors. But he was a millionaire, nevertheless—raised among millionaires and working largely for them. In the depressed economic conditions of the 1890s his "new" works appealed to the "new" rich, who thirsted for an art and culture equal to that of wealthy Europeans but essentially "American" in style. Tiffany saw himself as one of the "Knights Errant" in continual search for Beauty, Beauty rich, luxurious, and ornamental. In February 1913 Louis Tiffany staged a huge banquet, a costume fête re-creating the splendors of ancient Egypt, and appearing himself, as Robert Koch put it, "in turbaned magnificence as an Egyptian potentate"; the next day, by coincidence, saw the opening of the sensational, taste-turning Armory Show in New York, which Tiffany found full of shockingly "ugly" works. Three years later, on his birthday, he put on a masque called "The Quest of Beauty," and in it, ironically, he accused the new artists of precisely what he himself had been criticized for decades before:

The "Modernists"—as they are called for want of a better term—I mean Cubists, Futurists, etc.—wander after curiosities of technique, vaguely hoping they may light on some invention which will make them famous.[91]

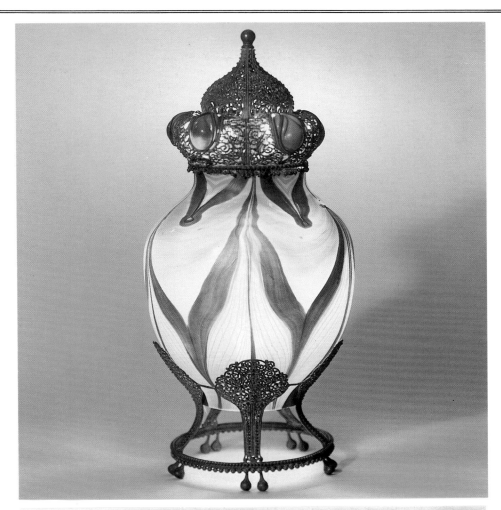

135. LOUIS COMFORT
TIFFANY. Hurricane
Lamp. c.1895. Favrile
glass, height 21½″.
Collection Dr. Egon
Neustadt, New York

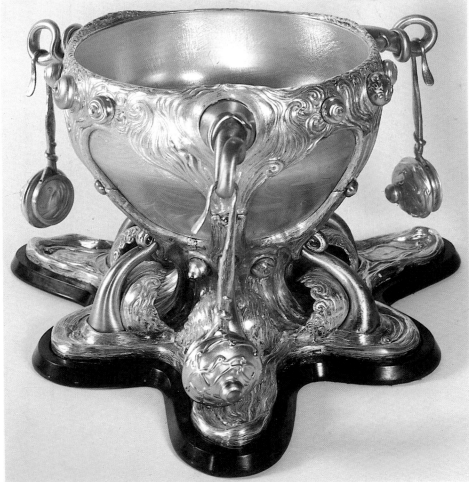

136. LOUIS COMFORT
TIFFANY. Punch Bowl.
Exhibited 1900 at Paris
Exposition. Favrile glass
mounted in gilded silver;
height 14¼″. Virginia
Museum, Richmond

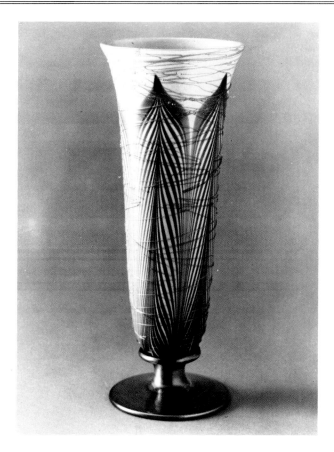

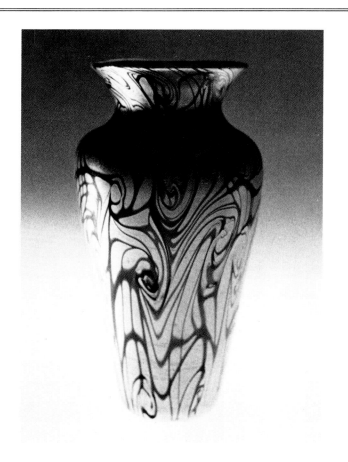

137. DURAND ART GLASS COMPANY (Vineland, N.J.).
Vase in Feather Design. Late 1890s. Glass with iridescent
threading, height 12¼″. Morse Gallery of Art, Winter
Park, Fla. (The McKean Collection)

138. QUEZAL ART GLASS AND DECORATING
COMPANY (Brooklyn, N.Y.). Vase. After
1900. Glass, height 8¼″. Chrysler Museum
at Norfolk, Va. (Gift of Walter P. Chrysler, Jr.)

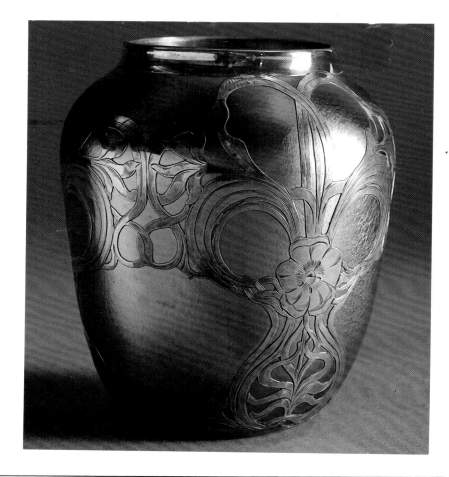

139. QUEZAL ART GLASS
AND DECORATING
COMPANY (Brooklyn,
N.Y.). Vase. After 1900.
Glass with silver overlay.
Morse Gallery of Art,
Winter Park, Fla. (The
McKean Collection)

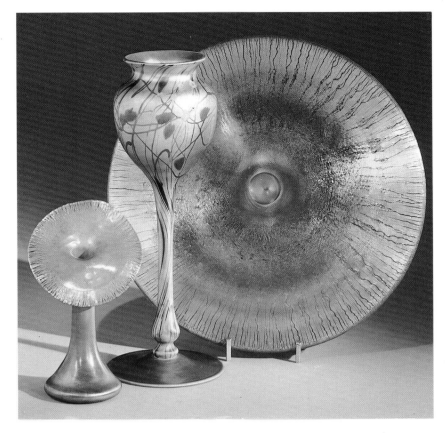

140. FREDERICK CARDER, for Steuben Glass Company (Corning, N.Y.). Group of three works. 1917. Gold Aurene glass, with trailed decorations. Tall vase, National Museum of History and Technology, Smithsonian Institution, Washington, D.C.; disk and jack-in-the-pulpit vase, private collection

141. LÉON LEDRU. Vase. c.1902. Cased crystal with wheel-cut decoration, height 11⅜″. Galerie L'Ecuyer, Brussels

142. HONESDALE COMPANY (Honesdale, Pa.). Vase. Before 1910. Cameo glass, height 14⅜″. The Metropolitan Museum of Art, New York City (Anonymous Gift Fund, 1969)

143. TIFFANY STUDIOS.
Lily-cluster Lamp. c.1900.
Favrile glass and bronze,
height 21″. Collection Lillian
Nassau, New York City

144. ÉMILE GALLÉ. "Les Coprins" (Lamp in form of
mushrooms). c.1900. Glass with metal base.
Collection J.-Cl. Brugnot, Paris

145. TIFFANY STUDIOS. Table Lamp with Nine Dragonflies.
1900–1905. Favrile glass, height 27″. Chrysler Museum at
Norfolk, Va. (Gift of Walter P. Chrysler, Jr.)

146. FULPER POTTERY COMPANY (Flemington, N.J.). Lamp, "Clean Stem Mushroom." 1911–1915. Pottery with leaded glass (destroyed)

147. LES FRÈRES MULLER (Nancy, France). Lamp with Owl and Bats. 1900–1910. Glass with enamel and engraving. Musée de l'Ecole de Nancy

148. TIFFANY STUDIOS. Vase with molded decoration of Tulips. 1905–19. Pottery, height 11″. Collection Martin Eidelberg, New York

149. ALEXANDRE BIGOT. Vase. c.1894–95. Stoneware with relief decoration, height 9⅞″. Collection Gertrud and Dr. Karl Funke-Kaiser, Cologne

150. LOUIS COMFORT TIFFANY. Jack-in-the-Pulpit Vase. 1906. Pottery with molded decoration. Morse Gallery of Art, Winter Park, Fla. (The McKean Collection)

151. CHARLES SCHMIDT, for Rookwood Pottery. Ovoid Vase with Peacock Feathers. 1904. Pottery with underglaze decoration; height 10¾″. Cooper–Hewitt Museum, Smithsonian Institution's National Museum of Design, New York City

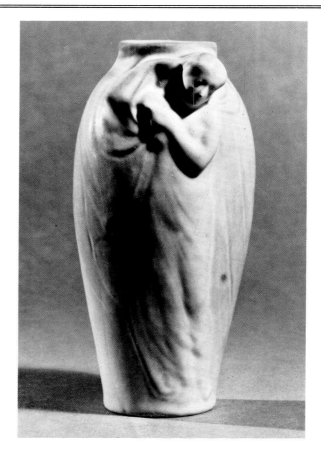

152. JOHN D. WAREHAM, for Rookwood
Pottery. Vase with Poppy Seed-pods. 1901.
Pottery, with green, red, and purple glazes;
height 7½″. The Museum of Modern Art,
New York City

153. WILLIAM P. MCDONALD, for Rookwood
Pottery. Vase with molded design of a
Woman. 1900. Pottery, height 5½″.
Collection Martin Eidelberg, New York

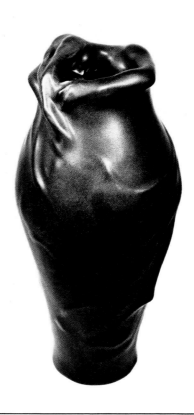

154. ARTUS VAN BRIGGLE.
Vase with molded decoration
of Leaves. 1904. Pottery,
height 15″. National Museum
of History and Technology,
Smithsonian Institution,
Washington, D.C. (Gift of
the Van Briggle Pottery
Company, Colorado Springs)

155. ARTUS VAN BRIGGLE.
Lorelei Vase. 1902. Pottery,
with molded form of a
woman; height 9½″. Private
collection

156. ARTUS VAN BRIGGLE. Plate with molded design of Poppy Leaves and Flowers. 1902. Pottery, diameter 8⅝". Collection Martin Eidelberg, New York

157. GEORGE E. OHR. Vase. c.1900. Pottery, height 8½". National Museum of History and Technology, Smithsonian Institution, Washington, D.C. (Gift of George E. Ohr)

158. ÉMILE GALLÉ. Seahorse Vase ("L'Hippocampe"). 1901. Molded cased glass, with surface applications; height 7½". Musée des Arts Décoratifs, Paris (Bequest of Joseph Reinach, 1925)

159. MARIA LONGWORTH NICHOLS STORER. Vase. After 1900. Copper-glazed molded pottery on bronze standard set with pearls and moonstones; on base, waves and octopus with tiger-eyes; height 15½". Morse Gallery of Art, Winter Park, Fla. (The McKean Collection)

160. AUGUSTE DELAHERCHE. Vase. 1890. Stoneware with incised decoration, height 6⅛". Musée des Arts Décoratifs, Paris

161. GRUEBY FAIENCE COMPANY (Boston).
Group of four pottery works. 1900–1905.
Private collection, New York

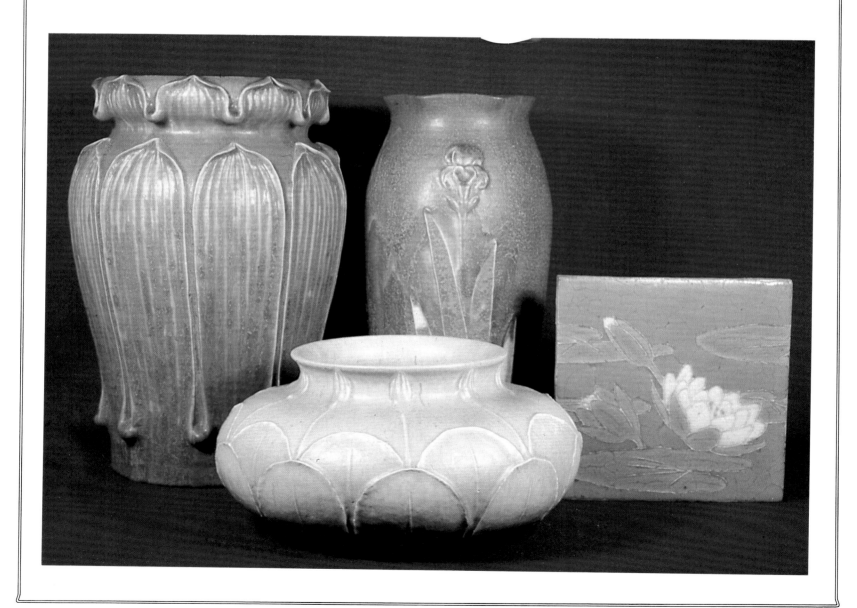

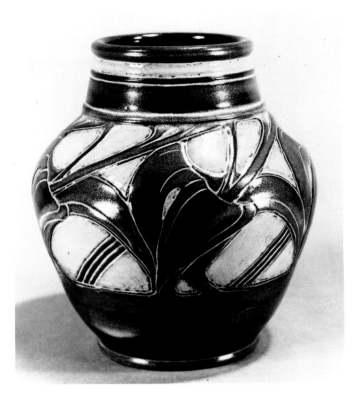

162. SADIE IRVING, for Newcomb College Pottery (New Orleans). Vase with incised decoration of Leaves. After 1910. Pottery, height 6⅞″. Cincinnati Art Museum (Gift of Mary G. Sheerer, 1939)

163. HANNA TUTT, for Marblehead Pottery (Marblehead, Mass.). Vase with molded decoration. 1908–10. Pottery, height 7″. Newark Museum, Newark, N.J. (purchase, 1911)

165. JACQUES SICARD, for S. A. Weller (Zanesville, Ohio). Vase with molded decoration of leaves and painted design of honeysuckle. 1901–7. "Sicardoware," pottery with iridescent glazes of gold, purple, and green; height 5½″. Private collection

164. EDWARD COLONNA, for Samuel Bing. Vase with stylized Flowers. c.1900. Pottery, height 8½″. Musée des Arts Décoratifs, Paris

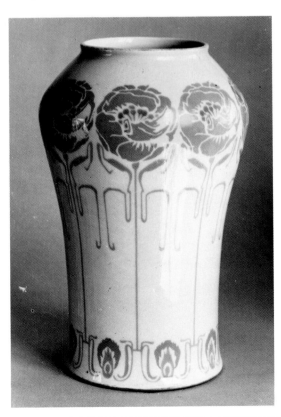

CHAPTER THREE

LOUIS H. SULLIVAN AND AMERICAN ART NOUVEAU ARCHITECTURE

In his report of 1895 on *Artistic America* Samuel Bing declared: "In no branch of art have the American people displayed more overwhelming vigor than in the development of architecture."[1] He stressed the importance of a European training for American architects, especially at the Ecole des Beaux-Arts, but he recognized that architectural style must not be transplanted, but be "appropriate to the environment from which it sprang."[2]

Bing combined in his reaction to Richardson's and Sullivan's commercial buildings his admiration of the architects' remarkably practical and inventive solutions to new problems, as well as the expression they conveyed which could be called Art (plate 166):

> No one could remain unmoved by these cyclopean structures that rank among the most eloquent and grandiose expressions of human energy, solving all of the great problems at just the time when unforeseen needs have created them. Once we acknowledge that abstract concepts are not the sole refuge of Beauty, that if certain practical products may borrow a share of poetry from the very magnitude of the efforts required to create them, and of which they become the significant symbols and if, furthermore, art can consist in establishing a harmonious accord between the external appearance of things and their inner significance, between their rationale and goal, then it is undeniable that perfection has been achieved.[3]

The idea that Bing expressed, that Beauty might reside in a form created to solve a complex practical need, was truly modern, and not well understood by most of his contemporaries. Although the belief was widely held, as one architect put it, that "A thing of beauty may have no immediate practical use, a thing of use no appreciable beauty; but in their union the creative genius of man finds its highest and divinest expression,"[4] beauty was usually seen to reside in more or less practical forms enhanced by the ornamentation attached to them. Thus the intense desire for "beauty in all aspects of life" during the last quarter of the nineteenth century found expression in the application of ornament to all

166. HENRY HOBSON RICHARDSON. Marshall Field Wholesale Store, Chicago. 1885–87; demolished 1930

kinds of useful objects, such as cast-iron stoves, and to all kinds of areas, such as the walls of public buildings. A major goal of Art Nouveau artists and other reformers was to create ornamentation that was more fitting to and expressive of the object adorned, and of the era and nation producing it. It is within the context of this goal that Louis Sullivan achieved so much, resolving most successfully the poles of form and ornamentation, of function and aesthetic beauty. Only in a later generation would the goal shift, and form itself, unadorned, become the sole carrier of beauty as well as of functional necessity.

THE TRANSPORTATION BUILDING, CHICAGO, 1893

In 1893 Louis Sullivan's Transportation Building in Chicago was indeed greatly admired for its "beauty" (plate 167). In publications on the Fair many American writers commented particularly on Sullivan's use of color as "a courageous artistic experiment in the midst of snow-white palaces," and emphasized the "perfect harmony" of the colors, the "handsomely original cupola," and the "beautiful arcaded framework, the ornamentation of which is both chaste and effective."[5] The "Golden Gate" was spoken of as "its chiefest beauty," a "most daring expression" with its "bands of geometric designs in rich oriental fantasy" (plate 168). Describing this door as a "magnificent bit of decoration," one editor discussed its beauty in these terms:

Louis H. Sullivan and American Art Nouveau Architecture

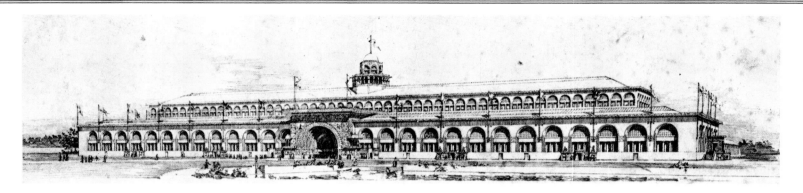

167. LOUIS H. SULLIVAN. Transportation Building, World's Columbian Exposition, Chicago. 1893.
(Photogravure. Art Institute of Chicago)

168. LOUIS H. SULLIVAN. "Golden Gate," main entrance of Transportation Building, World's Columbian
Exposition, Chicago. Photogravure of watercolor by C. Graham, *Watercolors of the Fair,* Chicago, 1893

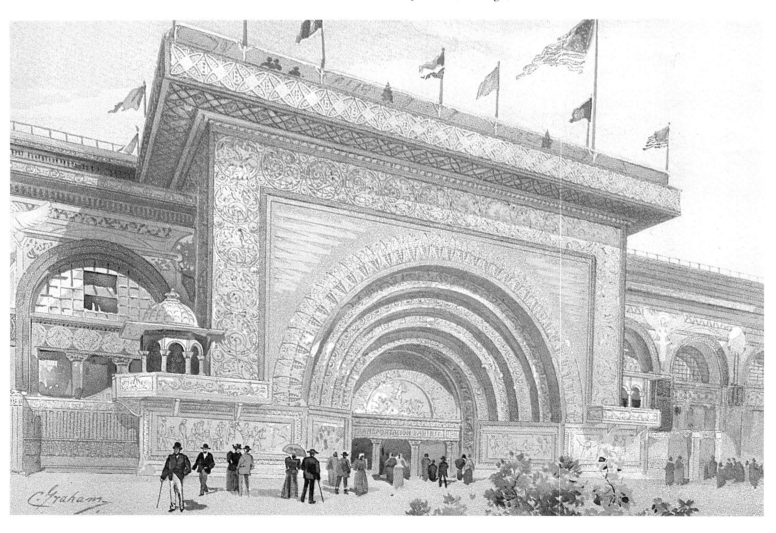

The main entrance . . . consists of an immense single arch enriched with carvings, bas-reliefs, and mural paintings; the entire feature forms a rich and beautiful, yet quiet color climax, for it is treated entirely in gold leaf. . . . The remainder of the architectural composition falls into a just relation of contrast with the highly wrought entrance.

In the architects' own statement of February 1893, Dankmar Adler and Louis Sullivan stressed the site of the Transportation Building, located on the "picturesque" quadrangle, axial to the Manufacturers' Building.[6] The "simple architectural treatment" in a "style somewhat Romanesque" was meant to serve as a contrast with the "highly wrought entrance." Stressed also was the "beautiful scheme of polychrome decoration, for to treat the building externally in many colors was the original thought of the architects in the first conception of their design." Their article continued:

The ornamental designs for this work in color are of great and intricate delicacy; the patterns, interweaving with each other, produce an effect almost as fine as that of embroidery. As regards the colors themselves, they comprise nearly the whole galaxy, there being not less than thirty different shades of color employed. These, however, are so delicately and softly blended and so nicely balanced against each other, that the final effect suggests not so much many colors as a single beautiful painting. . . . The color scheme of the building as a whole, of course, culminates in the great golden doorway. . . .

The color effect seems to have been very successful, to judge from William Purcell's memory of the building a half century later:

. . . like zinnias in a golden bowl. . . . It was all lush, robust, saturation, sunshine. . . . Crimson is the right term for the principal color area and the key for the Transportation Building's color. . . . Those female figures with wings showed several kinds of white and I believe silver against ultramarine panels.[7]

Louis Sullivan, talking to the World's Congress of Architects in 1893, emphasized his specific interest in the coloration of the exterior; indeed his topic was "Polychromatic Treatment of Architecture." Thus his article and lecture both strongly support the idea that his concern was, as Montgomery Schuyler described it, "an attempt at nothing less than the creation of an exterior, plaster architecture."[8] Rather than simulate masonry, Sullivan had concentrated upon the plaster façade, creating a colorful effect in impermanent materials that was appropriate to the temporary function of the building as an exhibition hall.

The praise in America for the beautiful ornamentation of Sullivan's building was echoed in the European report by André Bouilhet, who lauded it for being "the only building among the palaces which is truly original."[9] In comparison with the novelty of the elaborate and symbolic ornamentation of the Fisheries Building, Sullivan's was "better conceived and of more beautiful proportions."[10] Bouilhet added that the doorway was "of an overwhelming richness." In 1894, on the basis of his report and recommendation, the Union Centrale des Arts Décoratifs awarded Sullivan three medals—bronze, silver, and gold—for his ornamental designs, and Bouilhet persuaded the architect to donate casts of these, as well as models of the Getty Tomb, to the Union's Musée des Arts Décoratifs. According to Sullivan's biographer Hugh Morrison, "This material was assembled in a special Sullivan section of the museum, and after its exhibition created so much interest that the directors of an art gallery in Moscow asked to have duplicates made of the things on display. Subsequently so many other requests of a similar nature came in that the museum granted special permission to a firm in Paris to make replicas for various institutions throughout Europe."[11] The effect of the Transportation Building extended to Fin-

land, where Eliel Saarinen tacked a picture of it above his drafting board, and to Amsterdam, where Hendrik Berlage admitted to having been much impressed by it.[12]

In contrast to these positive reactions from American and European contemporaries, later critics have commented on what they consider to be a lack of unity and originality in the design—the "isolated fragment" of the golden door, stuck onto an exceptionally eclectic Gothic basilica plan.[13] Sullivan's original plan, however, had called for two main entrances; Burnham thought this design would be detrimental to the building's axial symmetry vis-à-vis George Post's Manufacturers' Building across the lagoon, however, and Post asked Sullivan to "have one great entrance toward the East, and make this much richer than either of the others you had proposed."[14] In its day the building was considered extremely effective in its coloration and astoundingly "modern" in its ornamentation.

Like Louis Tiffany's chapel (see plate 16), Sullivan's Transportation Building relied on an elaborate combination of Richardsonian forms, ornate "Moorish" details, and "appropriate" symbolic elements; in style the building as well as its decoration was broadly eclectic. The serious search by recent historians for the sources of Sullivan's art will surely reveal him to be a man of his times, for he borrowed extensively from innumerable sources. This borrowing was apparent to his contemporaries, but they also saw his ability to synthesize these elements into a "personal" and "truly original" style of great complexity and rich expression.

SULLIVAN'S STYLISTIC "SOURCES" AND "AFFINITIES"

Louis Sullivan's sources can be summarized into two types: the styles of his immediate and senior contemporaries, and the historic styles that they used. The Romanesque element in the Transportation Building's great semicircular arches is related to Richardson's work as well as to certain Romanesque buildings, such as the decorated façade of Notre-Dame at Poitiers. Neither architect intended to create historically accurate replicas; Richardson freely used the heavy stone and geometric simplicity of the Romanesque as a fitting expression of American industrial life, whereas Sullivan's more Gothic approach, applying ornamentation to lighten wall surfaces supported by a skeletal structure, was his attempt to transcend mundane materialism. Sullivan greatly admired the strength and individuality of Frank Furness' work in Philadelphia in the 1870s, yet it was Richardson's ability to fuse borrowed and invented forms and ornaments into a truly "homogeneous, dynamic whole whose many parts are rationally subordinate one to another in accordance with their function" (as Bing described it[15]) that appealed most strongly to that instinctively rational Romantic, Louis Sullivan.

The third architect who contributed to Sullivan's interrelationship of form, function, and ornament was Chicago's John Wellborn Root, prematurely deceased in 1891. The Transportation Building's Golden Gate immediately recalls the radiating voussoirs and interlaced ornament of the entrance of The Rookery in Chicago, designed by Burnham and Root in 1885 (plate 169). A Richardsonian strength was expressed by the heavy masonry of the outside of the building, Root adding the counterpoint of large glass window areas and rich ornamentation throughout to make symbolic play on the identity of the building —City Hall—and the nickname of the administration's temporary home—The Rookery:[16] inside, the vast open vault of iron and its lush foliate ornamentation suggests "a most fantastic aviary" (plate 170).[17] Root's design for The Rookery, a functional and expressive unity worked out in a romantic interplay of dualities, served Sullivan well in his own attempts to "establish a harmonious accord between the external appearance of things and their inner significance."

Finally, the Transportation Building included many Islamic elements; Sullivan's contemporaries recognized these, referring to the "oriental fantasy of the ornament" and the "kiosks" on either side of the door (the very word "gateway," used to describe the door,

169. BURNHAM AND ROOT. West entrance, The Rookery, Chicago. 1885–88 (contemporary photograph, courtesy Donald Hoffman)

170. BURNHAM AND ROOT. Lobby, The Rookery, Chicago. 1885–88 (contemporary photograph, courtesy Chicago Historical Society)

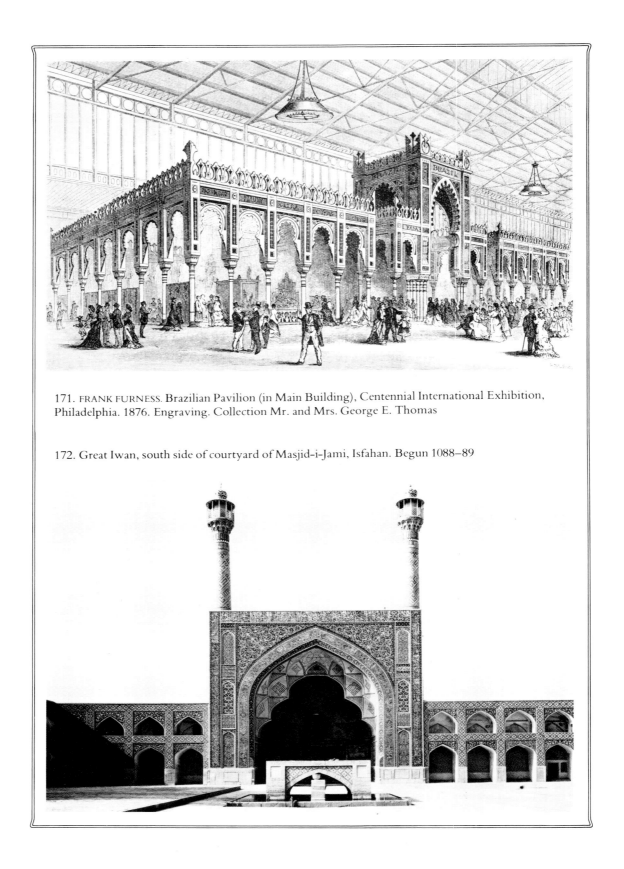

171. FRANK FURNESS. Brazilian Pavilion (in Main Building), Centennial International Exhibition, Philadelphia. 1876. Engraving. Collection Mr. and Mrs. George E. Thomas

172. Great Iwan, south side of courtyard of Masjid-i-Jami, Isfahan. Begun 1088–89

suggests Islamic art). Sullivan's Islamic sources can be found in works by his contemporaries: Root, whose Rookery was said by Tallmadge to have "Hindoo" overtones, or more likely Furness, with whom Sullivan worked in 1873 and whose Brazilian Pavilion at the 1876 Centennial borrowed rather explicitly from Islamic design (plate 171).[18] Islamic elements of design used in the Transportation Building may have come directly from Islamic architecture—the central pavilion and long colonnades of bazaar architecture, the

173. OWEN JONES. "Arabian No. 4,"
Plate XXXIV in *The Grammar of Ornament*,
London, 1856

large arched gate set within a strong rectangular frame, the octagonal "kiosks," the elaborate arabesque ornament in stucco panels, and the brilliant polychromy—though this need not be the case (plate 172). Finally, the design of the ornament is closely related to Owen Jones' detailed drawings in his *Grammar of Ornament* of what he called "Arabian" ornament (plate 173): in the nineteenth century the term "Islamic" included a remarkable variety of styles, from Mogul tombs in India to Moorish palaces in Spain, and it could refer to "Arabic, Mohammedan, Turkish, Moorish, Persian, Saracenic, or Hindoo."

Original Islamic architecture, itself eclectic, has been described as a "coloristic skin over a late antique structural mode."[19] To Americans, the arched arcades and arabesque decorations of Persian structures such as the famous Friday Mosque at Isfahan seemed especially suitable for exhibition architecture at world's fairs—Furness' Brazilian Pavilion and the "Mauresque" Horticultural Hall at the Philadelphia Centennial, the United States exhibit in the Manufacturers' Building at the 1867 Paris Exposition, and many other examples. In 1892, A. D. F. Hamlin referred to the "Islamic mode" as "trivial, playful and gay."[20]

But the style was not limited to Exposition architecture. One "proper" use of Islamic motifs in America came to be for the religious buildings of Judaism, as Furness exemplified in 1869 in his designs for the Rodeph Shalom Synagogue in Philadelphia (plates 174, 175).[21] Richard Morris Hunt found the linear, colored, surface patterns of Islamic ornament particularly suited to the painted cast-iron façades of his commercial buildings, such as the Tweedy and Company Store, New York (1871–72), much acclaimed in America and France (plate 176).[22] The style appeared in a few individual houses built for wealthy "artistic" men of exotic tastes, from Frederic Church's Olana of 1874 to Louis Tiffany's Laurelton Hall of 1902–5 (plates 177, 178). But the theater provided the most "appropriate" area for the escapist richness of Oriental and Islamic designs: in the Casino Theater of 1880–82 in New York, elaborate Islamic designs were made in terracotta (plate 179), a fairly inexpensive and fireproof material for intricate ornamentation. Similar

174. FRANK FURNESS. Interior facing Tabernacle, Rodeph Shalom Synagogue, Philadelphia. 1869–71 (contemporary photograph); demolished 1927

theaters were built in Europe in the 1880s, such as the Eden Theater in Brussels by Alban Chambon (plate 180), who designed others in London and Amsterdam. Created to "gratify the taste for novelty and escape" of a wealthy, carefree aristocracy, the Eden was described in 1885 as follows:

> It's an Alcazar, the delight of Moorish Kings and of lots of others who are neither Kings or Moors. It's a composite Eden, motley, teeming, Kaleidoscopic, multicolored, appended to the architectural movement of a time that has no architecture because it has all the architectures, the movement of an electric, everchanging age that injects criticism even into its art. Stunning fantasy of a cosmopolitan art, artificial, brilliant improvisation that responds to the fever and paroxysm of the moment.[23]

Because the Transportation Building functioned as a temporary exhibition bazaar and of necessity was built of cheap materials, the Islamic mode seemed appropriate. Sullivan had already used a "somewhat Moresque" style in his terracotta designs for the Zion Temple in Chicago, 1884–85, as well as in his theater interior for the Chicago Auditorium Building of 1886–88 (plate 181).

Islamic art was not well enough documented in the nineteenth century to support a true historical "revival," but it was much used as a source for "exotic" effects in American architecture, and over a longer period than many other exotic modes.[24] Its popularity came in part from the breadth and eclecticism of its materials and structure, which afforded a particularly broad scope to American imaginations bent on "original" expression. It was important that ornament was a central feature in Islamic architecture, that large surfaces were covered with stucco carvings, polychrome ceramics, and red brick patterns; these designs were available to architects through numerous books on ornament: Owen Jones, besides including a great deal of "Moresque, Persian, Arabian, Turkish, etc." in his well-known *Grammar of Ornament* of 1856 (the American edition was published in 1880), had also brought out his two-volume *Plans, Elevations, Sections and Details of the Alhambra* in 1842–45.

175. FRANK FURNESS. Exterior of Rodeph
Shalom Synagogue, Philadelphia. 1869–71;
demolished 1927. Color lithograph by
Benjamin Linfoot, 1869. Historical Society
of Pennsylvania, Philadelphia

It is difficult, if not impossible, to find identifiable, specific, structural correlations between Sullivan's architecture and Islamic architecture, except for the cupola and "kiosks" on the Transportation Building and the dome of the Wainwright tomb in Bellefontaine Cemetery, St. Louis. Philosophically, however, the symbolic cosmology that is represented in the architecture and ornament of Islamic art offered a rich source for the metaphorical metaphysics that Sullivan sought to express.[25] In Oriental art, form is never divorced from meaning; it was this congruence of design and symbolic meaning that attracted many nineteenth-century artists—Post-Impressionists as well as Arts and Crafts designers—to what Maurice Denis called "the great decorative art" of the past.

Louis Sullivan continually exhorted his readers to "learn not only to look *at* a work of art, but *into* it . . . for you will see in an art work the identity and spiritual nature of the man who produced it."[26] To analyze bits and pieces of Sullivan's ornament from this or that building is an approach totally alien to his theories and practice of "organic" and "emotional" architecture. For Sullivan was, and was determined to be seen as, a poet. He exhorted his students and readers:

> . . . to vitalize building materials, to animate them with a thought, a state of feeling, to charge them with a subjective significance and value, to make them a visible part of the social fabric, to infuse into them the life of the people, to impart to them the best that is in people, as the eye of the poet, looking below the surface of life, sees the best that is in the people . . . such is the real function of the architect.[27]

Thus, instead of categorizing Sullivan's work into stylistic periods, or separating building morphology from ornament, form from content, and objectivity from subjectivity, one comes closer to appreciating Sullivan's achievement by considering his works as the dynamic union of these and other polarities. This goal is suggested by his own phrase, of desiring to create "an architecture of mobile equilibrium."

Louis Sullivan's ornament, his expressed intentions as well as his actual use of it, loses meaning when considered apart from the form and function of the individual building. Again and again he made clear statements, such as:

> The stately and all-comprehending truth that architecture, wherever it has appeared and reached spontaneous culmination, is not at all what we so stupidly call a reality, but, on the contrary, it is a most complex, a glowing and gloriously wrought *metaphor* [italics added].[28]

The expressive range of his ornament extends from the clarification of simple structural elements to the suggestion of mystical cosmic forces. Often it emphasized the traditional parts of a building to show their interweaving and to express their energy content of compression and weight-carrying, especially in bearing-wall constructions such as the Auditorium, in contrast to the skeletal constructions of the later skyscrapers. However, these conceptions were on a broad and deep level, much in keeping with widely held nineteenth-century theories of "correspondences." He considered "sympathy" one of man's greatest powers:

> Sympathy implies exquisite vision . . . a power to enter into communion with living and lifeless things; to enter into a unison with nature's powers and processes; to observe, in a fusion of identities, life everywhere at work—ceaselessly, silently—abysmal in meaning, mystical in its creative urge in myriad pollution of identities and their outward forms.[29]

In his later writings, published in 1924 as *A System of Architectural Ornament*, Sullivan set forth what he called a "Doctrine of Parallelism," in essence his personal version of the

176. RICHARD MORRIS HUNT. Tweedy and
Company Store, New York City. 1871–72
(after drawing by Hunt)

177. FREDERIC E. CHURCH and CALVERT
VAUX. Olana, Columbia County, N.Y. 1874
(photograph Wayne Andrews)

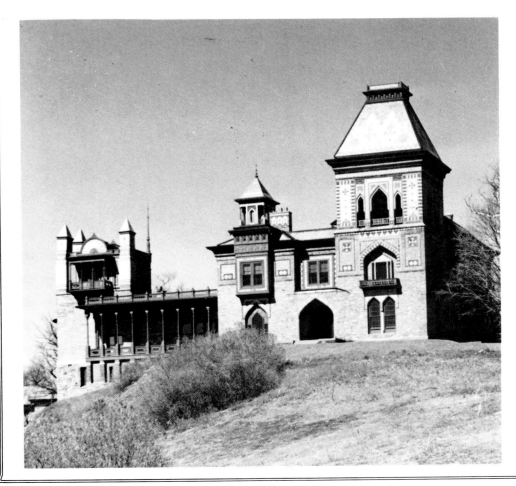

178. LOUIS COMFORT TIFFANY.
Laurelton Hall, Oyster Bay,
Long Island, N.Y. 1902–5
(contemporary photograph,
courtesy of Robert Koch);
destroyed by fire 1957

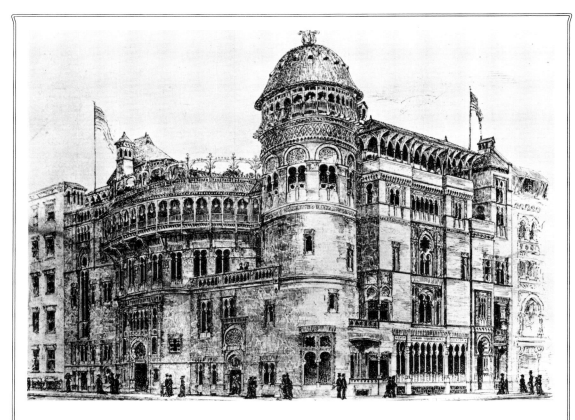

179. KIMBALL AND WISEDELL. Casino Theater, Broadway and 39th St., New York City. 1882 (contemporary illustration, courtesy Museum of the City of New York)

180. ALBAN CHAMBON. Interior of Eden Theater, Brussels. 1880 (contemporary photograph, courtesy Archives d'Architecture Moderne, Brussels)

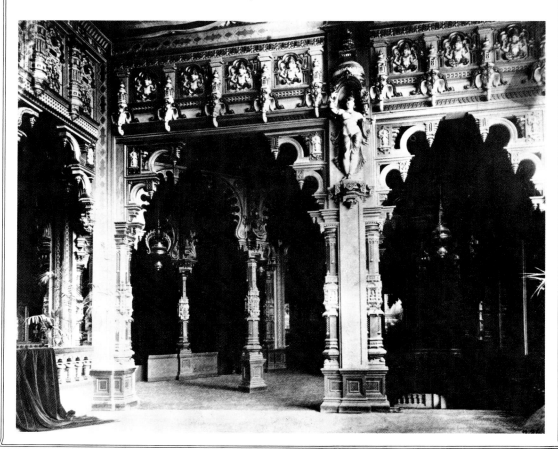

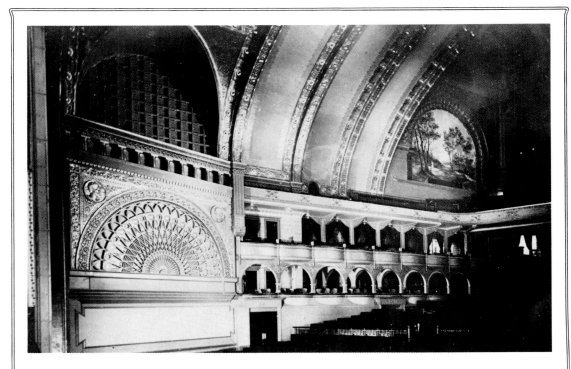

181. LOUIS H. SULLIVAN. Interior, Auditorium Theater, Chicago. 1886–88 (contemporary photograph)

pervasive transcendental concepts based on Swedenborg which many Europeans and Americans held in the nineteenth century. It is crucial to keep these concepts in mind in attempting to appreciate his achievement or to understand his organic ornament and its relation to his geometric forms.

> Parallelism . . . call this domain mystic, for within it art, science and philosophy fuse as it were into a single vital impulse. . . .
>
> Such considerations open to the view a still larger domain of parallelism: namely the parallelism between man and nature, and between man and his works. These are self-contained within the all-embracing domain of life, the universal power, or energy which flows everywhere at all times, in all places, seeking expression in form and thus parallel to all things.[30]

Thus when Sullivan dealt with structural forces of compression and weight-carrying, he intended these forces to be metaphors of more basic life rhythms. As he explained in *Kindergarten Chats*:

> . . . the static verticality of the pier balances within itself the two great forces, the simplest elemental rhythms of Nature, to wit, the rhythm of growth, of aspiration, of that which would rise into the air; which impulse we shall call the Rhythm of Life; and the counter-rhythm of decadence, of destruction, of that which would crush to the earth, of that which makes for a return to the elements of earth, the Rhythm of Death.

The lintel physically "raised by man" metaphorically stands for birth and new life, the emergence of art and value, the power of man. Finally, the arch, which is pier and lintel in motion, represents man's "own ephemeral span," his acceptance and transcendence of death, as the arch is a "crystallization of the abyss, and also triumph over the abyss. It is a form against Fate."[31]

Louis H. Sullivan and American Art Nouveau Architecture

In this transcendental symbolism, expressed as rhythms extending from the structure of a building to the efflorescence of the ornament, lies Sullivan's "affinity" with traditional, essentially Oriental, and especially Islamic concepts of expression in architecture. Rhythm and mathematics are the two fundamental elements interwoven in Islamic expression, whether in its arabesque-covered architecture or in its music and poetry.

Louis Sullivan's assimilation of orientalist concepts came from numerous sources: from the orientalism of Emerson's transcendental theories, from his own vast readings in the histories of religions and his particular interest in theosophy, and from his contact with the architectural ideas of many of his contemporaries—Owen Jones, Frank Furness, and John Edelmann, among others—who were themselves interested in Islamic art. Specific sources cannot be identified, but the conceptual bases of Oriental art as 1) an inherently symbolic expression, 2) a dynamic union of polarities, 3) an outgrowth of craftsmen who were expressing spontaneously the basic tenets of "the people" themselves, and 4) highly refined ornamentation—all of these affinities are related to Sullivan's art. A close look at a few of his buildings having different types and functions reveals an expressive consistency in his use of forms and their ornament for metaphoric meaning.

THE AUDITORIUM THEATER INTERIOR CHICAGO, 1886–88

"I should not wish to see a rose reduced to a syllogism"
—LOUIS H. SULLIVAN

In the interior of his Auditorium Theater Sullivan intended to express the excitement, the elegance, and the social glamour of a large audience attending theatrical, operatic, or musical productions. Its exuberance and elegance and his use of ornament, incorporating a "broad, simple and grand" gold-and-ivory color scheme, reflected the architect's awareness of this function. He explicitly described the allegorical murals enframed by great, decorated arches as representing poets communing with nature; as seen by Sherman Paul, they are a memorial to the young architect's two most important influences, H. H. Richardson and Walt Whitman.[32] The paintings take their themes from Sullivan's own 1886 Whitmanesque poem, "Inspiration":

The utterance of life is a song, the symphony of nature.

The Auditorium Theater decoration gave Louis Sullivan a perfect opportunity to synthesize his own romantic Wagnerian ideas of the interrelationship of the arts. An efflorescence of ornament, with complex rhythms relying on intertwining, counterpoint, and varied harmonies of form and color, presented analogies to music; the musical performances found visual correspondences in the repeated arches, the figural murals, and the ornament; all together, these created a complex metaphor of the "rhythms of life." This public entertainment hall became a symbol of Sullivan's ultimate ideal, that his art should carry man from physical or sensual elegance and richness to higher, transcendent states of awareness.

Given Sullivan's own statements of symbolic intent, it is fascinating to consider further possible metaphoric meanings of the theater's decoration. The great ceiling arches, the forms "against fate" which create the essence of his symbolism, are decorated with a linear, branched ornament ending in flower-like circular forms studded with bare electric light bulbs (plate 182). In using electric lighting Sullivan followed Louis Tiffany's pioneer work of 1885 in the Lyceum Theater, but he went further by setting the lights into a grand system of ornamentation. The bulbs are placed in rather nonspecific forms that generally suggest an image such as the tall-stemmed sunflower. The correspondence between these "sun" flowers and the "heavenly" effect of the multitude of electric lights glowing softly in the

182. LOUIS H. SULLIVAN. Detail of Ceiling
Arches, Auditorium Theater, Chicago.
1886–88 (contemporary photograph)

183. LOUIS H. SULLIVAN. Boxes, Auditorium
Theater, Chicago. 1886–88 (contemporary
photograph)

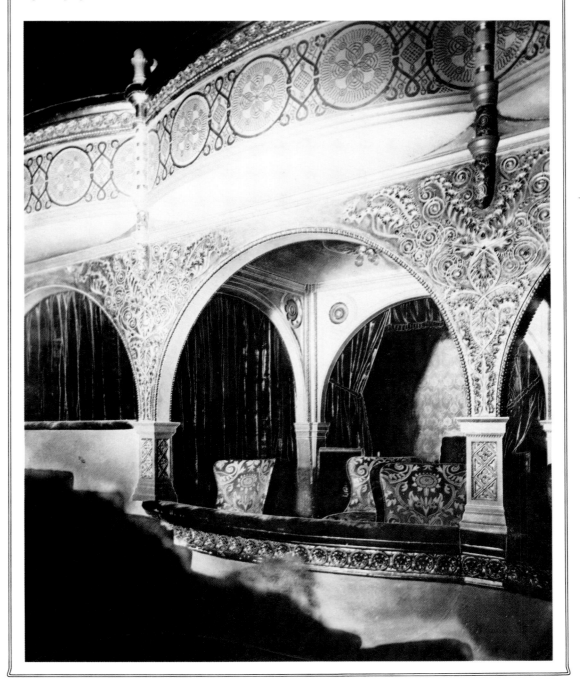

arched vault is an instance of the expressive unity of the artist's intent. This synthesis of structural and expressive purposes in a complex design characterizes the greatness as well as the essentially Art Nouveau–Post-Impressionist–Symbolist outlook of Sullivan's art.

In the decorations of the arched boxes can be seen another example of this unity (plate 183), these designs accentuating the various structural lines of movement. The gently curving bands below the rail have a horizontal continuity; the exterior walls above the boxes are emphasized by linear patterns of circular interlace; by contrast, covering the spandrels is a vertical, organic pattern which moves up from the almost seedlike geometric design on the low pillars through the crustlike capital to become a growing plant which opens with a natural symmetry that has structural order and an elegant complexity in its flowering. The plant form reaches out toward the emptiness at the apex of the arches, its movement then turning back toward the center, where the vertical thrust of the column reappears to support the next level of boxes. The ornamentation states in a new way the broad theme of the entire interior—the eternal continuity and rhythmical interrelationship of life's forces.

By 1893 the Auditorium Building was, as André Bouilhet put it, "known the world over." In his article on the Chicago Exposition Bouilhet discussed Sullivan's earlier work and reproduced several large photographs of the Auditorium interior—including the close-up of the boxes in our plate 183—and several detailed drawings of relief decoration of spiral interlace and spiky leaf forms. He approved of the typically American attention to "comfort" in the many rooms and the elegance of the reception galleries and the grand staircase, and especially of the theater interior, "plus grande" than that of the Paris Opéra.[33] The decoration of the Auditorium interior was completely new and original to Bouilhet; he admired its truthfully treated foliage, and sober coloration in a warm golden tonality that supported Sullivan's relief decoration in all its power. And he found the acoustics to be "marvelous" as well.

THE GETTY TOMB, CHICAGO, 1890

"Whispers of heavenly death . . . "
—WALT WHITMAN

In the Getty Tomb as in the interior of the Auditorium Theater, both so different in form and function, Louis Sullivan created another astonishingly rich metaphoric expression that integrated architectural forms and their ornament (plate 184). The sarcophagus-like form of the tomb in Graceland Cemetery suggests the eternal quietude of death, but this static perfection is combined with the dynamic continuity of the circles symbolizing life, its counterpart, which appears in the arches (the forms "against fate"), in the panels of the gatelike doors, in the three-part wave at the top of two sides of the tomb, and in the interlocked spirals and circles decorating the upper border. In Islamic as well as in other architectural styles the superimposition of the circle on the square, representing the cosmic heavens above the immutable earth, reflects the continuity of life in the course of upward and downward movement:

> The spirit descends and becomes earthly, the dead ascend to the infinity of the everlasting life of the spirit.

Since a number of aspects of the tomb relate to such Oriental concepts, we must assume that Sullivan purposefully used these designs for their metaphorical significance. The lower half of the façade is a simple, flat surface; the enlivenment progresses vertically, as the arches spring abruptly from this horizontal stack of blocks, the radiating voussoirs decorated with continuous bands of organic ornament (plate 185). A composite band of ornament surrounds the arch; the second band, similar but narrower, is in the center of the radiating pattern; the outer extent of the voussoirs is interrupted by a thin ring of geometric

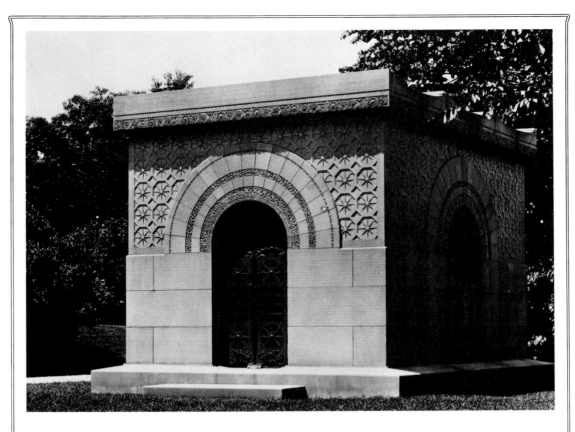

184. LOUIS H. SULLIVAN. Getty Tomb, Graceland Cemetery, Chicago. 1890

185. LOUIS H. SULLIVAN. Entrance to Getty Tomb, Graceland
Cemetery, Chicago. 1890.

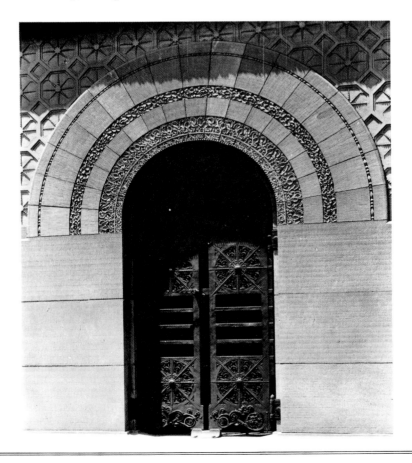

*Louis H. Sullivan
and American
Art Nouveau
Architecture*

decoration. The expanding movement of the archivolts takes place in the top half of the tomb, against a field of octagons filled with eight-pointed stars.

Throughout the tomb Sullivan uses divisions of three, the number referring in Islamic symbolism to the three fundamental movements of the universal spirit—descending, horizontally expanding, and ascending. The octagon, which is the intermediate form between a square and its mobilization into a circle, stands for resurrection, rejuvenation, and eternity in Christian as well as Oriental symbolism. The stars within traditionally represent divine

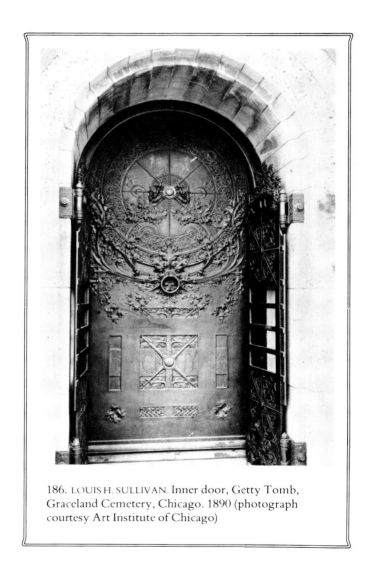

186. LOUIS H. SULLIVAN. Inner door, Getty Tomb, Graceland Cemetery, Chicago. 1890 (photograph courtesy Art Institute of Chicago)

lights, seen as transfigured souls. Even the proportional division of the surface decoration into halves and thirds creates rhythms that suggest the polarities and sequences of life.

Other details of the ornamentation confirm the essentially metaphoric treatment suggested above. The upper band of ornament along the projecting edge at the top is a highly intricate sequence of circles, tendril-like forms following a flower-like sunburst and a nautilus-like spiral, followed in turn by a reversed plantlike spiral. The play of these forms suggests with astonishing liveliness growth and movement, earth and water, geometry and nature—the continuous unity of natural polarities; their repetitions establish visual sensations of motion within timelessness. Symbols of life and death are united in the "mobile equilibrium" of the forms and ornament of the Getty Tomb.

Adding to this complex metaphor is the gatelike door, marked visually not with a closed stone but with two open, three-part grilles made of circles within squares overlaced

with eight-pointed stars and separated by four horizontal bars. On the inner door there are similar motifs (plate 186): a plant grows from the geometric forms of the base, bursts into efflorescence at midpoint at the circular handle, and rises to surround the free-floating circle above. Even the uncarved limestone has a part in the metaphor of interwoven Life and Death, for its surface is roughly dressed, unlike marble, and adds a suggestion of soft erosion to the timeless proportions of the cube. The cyclical patterns coalesce with their underlying geometry into a beautiful visual poem.

THE GUARANTY BUILDING, BUFFALO, 1894–95

> How shall we impart to this sterile pile, this crude, harsh, brutal agglomeration, this stark, staring exclamation of eternal strife, the graciousness of . . . higher forms of sensibility and culture . . .?
> —WALT WHITMAN

The skyscraper is the structure most widely associated with America, and with the Chicago School and Louis Sullivan in particular (plate 187). Each building that Sullivan designed is unique, with a specific personality, but his underlying attitude, his desire to transform utility into transcendent metaphor is always present. The Guaranty (now Prudential) Building in Buffalo, built in 1894–95, is one of the most richly ornamented of Sullivan's high buildings; later he was criticized for his attempt to transform a mundane building into "a proud and soaring thing," another Sullivan metaphor of life rhythms carried into a spiritual realm.

The relationship of function to design in the Guaranty Building is fairly straightforward in its three-part horizontal division: two lower floors with shops, ten floors of offices, and the top floor for the gears of the great elevators. Likewise, the new skeletal structure is visible to a large degree in the open grid of narrow piers and banks of window wells between, and although the light framework had to be covered for the sake of fireproofing, Sullivan's all-over ornamentation helped to reinstate the truth, that the walls were not load-bearing but only a coloristic skin. The form does, indeed, "follow function and express structure," but strictly practical functions were not the only ones Sullivan was trying to express. In "The Tall Office Building Artistically Considered"[34] he discussed this three-part division, using many expressive concepts: as the classic column with its base, shaft, and capital; as the mystical trinity; as a statement of logic, with its beginning, middle, and end; and as the organic growth of leaves, stem, and flower. He was aware that his forms and their ornament could operate simultaneously on at least these, if not more, levels.

The skeletal structure is covered with fireproof terracotta plaques. The terracotta surface functions as a skin rather than a weight-bearing wall, and Sullivan used it for its chromatic decorative potential and the malleability of its modeling, as well as for its economy and fireproof characteristics. Unlike the earlier, more austere Wainwright Building in St. Louis, all the surfaces of the Guaranty Building are luxuriously embellished with complex patterns in warm red tones.

Although the practical function of a skyscraper may seem as remote as possible from that of a theater or private tomb, many of the forms and themes from these works are developed in the Guaranty: the three-part division of the building's shape; the quiet geometry of the form gradually enlivened upward to the organic perfection of the floating arched circles at the top; and the profuse vegetation reaching into the heavy cornice that crowns the building. But now the ornament goes far beyond a clarification of structural forces, and in some areas seems even to contradict them (such as the horizontal motifs on the vertical shafts; the columns, however, are not in reality load-bearing). What, then, does the ornament express?

The "lofty, soaring" quality of the tall building's form is indeed apparent (plate 188); likewise the union of polarities, as expressed in Sullivan's term "mobile equilibrium,"

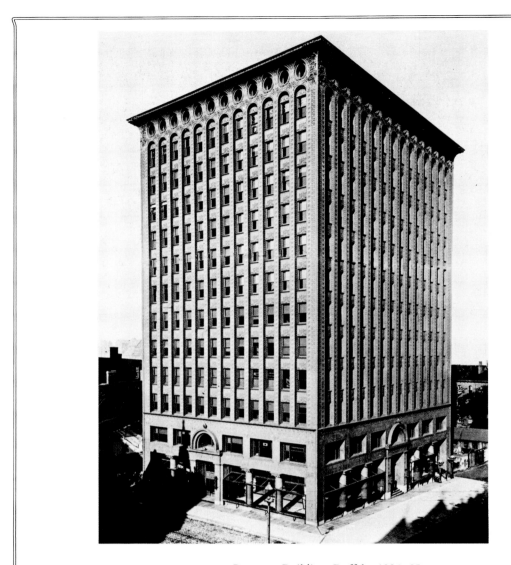

187. LOUIS H. SULLIVAN. Guaranty Building, Buffalo. 1894–95

can be seen in many guises: utility and beauty, geometry and organism, rising and falling. The patterns on the various surfaces are devised to reflect the essence or direction of energy within each form. Piers, those vertical elements that Sullivan described as representing the equilibrium of the two major forces of Nature—growth and decadence—have repeated patterns of vertically stacked hexagons leading up from the static base to the circular turning at the top, and back down on the adjacent pier. In the lower half of each hexagon organic growth bursts from a heavily modeled seed pod; the top half subsides into a flatter linear abstraction that feeds into the seed of the next hexagon, continuing the cycle of birth, flowering, decay, and regeneration. In contrast, each panel on the horizontal lintels, "raised up by man, representing birth," is filled with one large, three-dimensional, plantlike form (plate 189). Here is the birth of an accentuated organic form, not an abstraction of life and death forces. On the doorway there are analogous, though varied, patterns; the geometrically interlocked patterns on the piers support the separate lintel, where organically interlocked shapes and letters present the building's name. The arch uniting piers and lintel spreads out in radiating patterns. At the top of the Guaranty Building, where piers reach their full height and circular forms float freely, the surrounding moldings curve outward, smoothly suggesting continuity into infinite space.

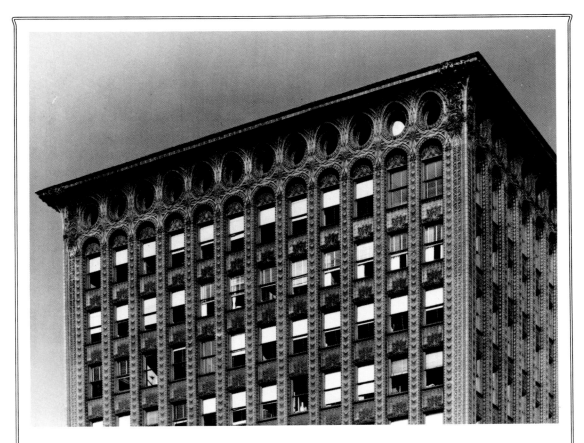

188. LOUIS H. SULLIVAN. Façade, Guaranty Building, Buffalo. 1894–95

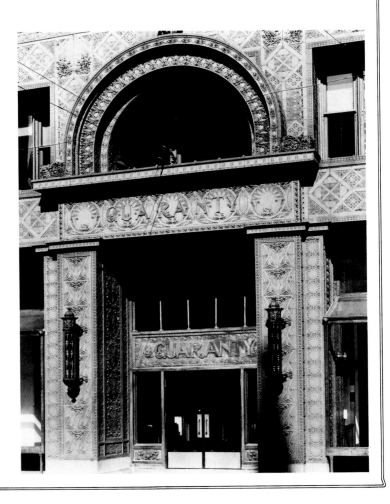

189. LOUIS H. SULLIVAN.
Entrance to Guaranty Building,
Buffalo. 1894–95

Louis H. Sullivan
and American
Art Nouveau
Architecture

By covering the surface with rich, coloristic ornament, Sullivan composed an extremely complex theme. The visual effect of the Guaranty's surface has been compared with Seurat's pointillist technique,[35] and there is an evident union of opposites organic and geometric, two- and three-dimensional, linear and coloristic, solid and ephemeral, static and moving. To transcend the massiveness of the sheer size of the building, Sullivan resorted to the traditional (and very Islamic) method of covering all the surfaces with arabesques in which geometry and nature are intertwined. The complexity of this surface does indeed suggest transcendence of the mercenary, sometimes sinister reasons for a skyscraper's existence, creating, as Sullivan wished, an artistic statement of "the graciousness of higher forms of sensibility."

SULLIVAN'S CONCEPT OF ORNAMENT

It is possible to see Sullivan as a "modern" architect, to strip the ornament from his buildings and consider only the pure "classical" lines of his beautifully crystalline forms. The ornament may then seem unnecessary, a "romantic" overflow which might better have been omitted. But this approach, in concerning itself with only half of his art, negates Sullivan's expressive message.

Louis Sullivan's art relies on geometry (inorganic) and on nature (organic), as he began to write in *A System of Architectural Ornament* in 1922 (plates 190, 191). Geometric forms had meanings which he recognized as much for their symbolic "reality" as for their qualitative value. The six inorganic forms "were given esoteric meaning and occult powers by the ancients . . . in an effort to control . . . the destiny of man amidst the powers of nature": the circle represented the infinite and illimitable world of the spirit; the square was a symbol of stability and completion; the octagon implied the transition between the two; and so on. Complementary to Sullivan's system of mathematical forms was his system of natural forms, seen as rhythm. In Islamic ornament the profusion of natural rhythms was shown in seemingly infinite patterns of simultaneous, staggered, or harmonious cycles having no beginning and no end. The profusion itself was meant to symbolize the inexhaustible multiplicity of nature, the effusion of "Being that emanates from the One"; Sullivan put it, "Life itself is manifested as a constant flow into countless multitudes of specific forms." For the Islamic artist, as for Sullivan, geometrical mathematics represented the "Unity within Multiplicity," and indeed, the union of these two reflected vital permanence within the world of temporal change.

How closely Sullivan's carefully developed statements resemble certain Islamic concepts of ornament is made clear in his *System*, but this contains one important difference: "organic" meant to Sullivan not merely geometry "harmonized" or overlaid with arabesque, but the fusing of the two, seeing them as "two phases of a single impulse," the natural rhythms developing directly from the rigid geometric form. The inorganic he saw as a "germ-cell," the source of energy which man's initiative can release so that its specific (one is tempted to say genetic) identity will be expressed in full through the "efflorescence" of the organic detail. Sullivan was a Darwinian; besides the study of botany, he urged students to read Professor Edmund Wilson's *Cell in Development and Inheritance* (first published in 1896).

Sullivan stated that his ideas involved a merger of art, science, and philosophy. This attitude was not unique with him; it pervaded the second half of the nineteenth century. Louis Sullivan's ornament is altogether original in its specifics, but it fits into the general international movement among late nineteenth-century architects who hoped to create a new "style" rather than copy directly either traditional or natural forms. Beginning in the 1840s the Englishman D. R. Hay published a series of books which contain ideas that recur with variations for the next sixty years: *The Natural Principles and Analogy of the Harmony of Form*; and *Original Geometric Diaper Designs, Accompanied by an Attempt to Develop*

PLATE 4

190. LOUIS H. SULLIVAN. Plate 4 in *A System
of Architectural Ornament . . . ,* Press of the
American Institute of Architects, 1924

191. LOUIS H. SULLIVAN. Plate 15 in *A System
of Architectural Ornament . . . ,* Press of the
American Institute of Architects, 1924

PLATE 15

and Elucidate the True Principles of Ornamental Design as Applied to the Decorative Arts; and *The Laws of Harmonious Colouring Adapted to Interior Decorations*; and *The Science of Beauty, as Developed in Nature and Applied in Art.*

The key concepts of these books are in their titles: "Natural Principles," "Analogy," "Laws," "True Principles," "Science." Ideas of natural analogies and the search in nature for lawful principles are part of nineteenth-century thought, best exemplified by the work of Charles Darwin. Books on design similar to those listed above continued to appear in the 1850s, the most important and influential ones being those by the architect-designer Owen Jones. His *Grammar of Ornament* of 1856, with its carefully outlined "principles of true ornamentation" and especially its hundred folio plates, many in color, was a constant source for others (see plates 7, 8, 173); it reflected Jones' own preference for Islamic designs, based on his 1842–45 publication of *Plans, Elevations, Sections and Details of the Alhambra.* He had also written *Designs for Mosaic and Tessellated Pavements* (1842), and *An Attempt to Define the Principles which should Regulate the Employment of Colour in the Decorative Arts* (1852). The section of the *Grammar* which outlined "Leading Principles in Composition of Ornament of Every Period" was particularly well known; first delivered as a paper to the Royal Society of Architects in 1856, it was printed as a separate pamphlet and quoted again and again, in, for example, George Sheldon's 1882–84 *Artistic Houses.*

The 1850s and 1860s also saw influential publications by John Ruskin (*The Two Paths: Being Lectures on Art, and its Application to Decoration and Manufacture*, 1859), Digby Wyatt (*Metal Work and Its Artistic Design,* 1852), and Christopher Dresser (whose lecture, "Botany, as Adapted to the Arts and Art-Manufacture," was published in the *Art Journal,* 1857–58). Decoration abstracted from botanical forms was stressed, as in James K. Colling's *Art Foliage,* 1865. Edward Garbett's *Rudimentary Treatise of Principles of Design* (1850) was beloved by architects Frank Furness and John Root (plate 192), as well as William Jenney, for whom Louis Sullivan first worked after arriving in Chicago.

By the 1870s these principles of design had spread widely, and many books on the subject appeared in France and England. The year 1873, when Sullivan worked for Frank Furness, saw the American publication of Colling's *Art Foliage for Sculpture and Decoration with an Analysis of Geometric Form and Studies,* and of Dresser's *Principles of Decorative Design* in London, Paris, and New York. These two books seem to have been responsible for Furness' change in the decorative style of floral ornament he planned for the Pennsylvania Academy of the Fine Arts façade (plates 193, 194). In the finished building the soft naturalistic plants he had sketched in 1873 had become curiously abstracted in a way which recalls Dresser's statement:

> If plants are employed as ornaments they must not be treated imitatively, but must be conventionally treated, or rendered into ornaments. A monkey can imitate, man can create.[36]

Colling's designs, with their combination of sculpturesque and stencil patterns, are also close to Furness' furniture and balustrade carvings. This creative abstraction attracted the young Sullivan, as we see in his fanciful sketch of 1874 (plate 195) and later in his decoration for the Wainwright Building (plate 196), and later still in the famous Sullivan-Elmslie ornament of 1903–4 on the Carson, Pirie, Scott Store (plate 197). All these designs show the "sprouting" outward, the turning in and out at the top, and the combining of natural and geometric in a way that is totally "original." It was this "originality" that Sullivan admired in Frank Furness, who created forms "out of his head," and that, in turn, brought much admiration to Sullivan in his own day.

Publications of the 1870s included: Victore Marie Charles Ruprich-Robert's *Flore Ornamentale, essai sur la composition, éléments tirés de la nature, principes de leur application,* of 1876; Viollet-le-Duc's *Histoire d'une Maison* of 1873; Charles L. Eastlake's *Hints on Household Taste,* in its fourth edition by 1878; and Edward Godwin's *Art Furniture* of 1877.

193. FRANK FURNESS. Drawing for window decoration, Broad St. façade, Pennsylvania Academy of the Fine Arts, Philadelphia. 1873. Pen and ink. Pennsylvania Academy of the Fine Arts, Philadelphia

192. JOHN WELLBORN ROOT. Carved ornament on west entrance, The Rookery, Chicago. 1885–86 (photograph Donald Hoffman) courtesy

194. FRANK FURNESS. Detail of window decoration, Broad St. façade, Pennsylvania Academy of the Fine Arts, Philadelphia. 1875 (photograph Will Brown)

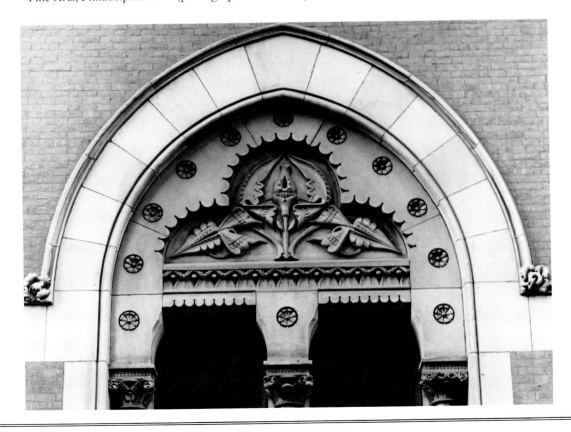

195. LOUIS H. SULLIVAN. Drawing for Architectural Ornament. 1874. Pen and ink. Avery Library, Columbia University, New York

A development in the 1880s which might account for the more curvilinear forms of Art Nouveau were several volumes on Japanese design, such as Thomas Cutler's *Grammar of Japanese Ornament and Design* (1880), Christopher Dresser's *Japan, Its Architecture, Art, and Art Manufacturers* (1882), and George A. Audsley's *The Ornamental Arts of Japan* (1885). These studies perhaps served to direct the abstraction of natural forms, previously based somewhat capriciously on geometry or Islamic art, toward a more curvilinear asymmetry suggesting the growth characteristics of plants and animals. Such a style can be found in English and European decorative arts after Arthur Mackmurdo's work in 1883. The Japanese element seems to have been less influential in America; Islamic arabesque forms dominated in overall symmetrical patterns based on geometry. Sullivan's ornament, in contrast to the subsequent Art Nouveau style of ornament made popular by the French architect Hector Guimard (plate 198), retains a balance of inorganic-organic, rather than becoming totally fluid in its organic form. His decoration is perhaps more closely allied with design principles of the Near East than of the Far East.

Louis Sullivan's designs are admirable for more than their originality: he achieved a high degree of unity by integrating the incredible complexity of his ornament with the simple forms of his buildings—a unity drawing upon his intelligent understanding of the geometric laws that underlie organic development, as well as on his fertile imagination and gifted hand. He was able to fuse the polarities of nature and geometry, of two and three dimensions, and of static order and continuous motion both in his ornament and in his architecture of "mobile equilibrium." A detail of the ornament of the Guaranty Building (plate 199) shows the wealth of his visual ideas about the nature of the universe as known in the late nineteenth century, ideas similar to those in the painting of Cézanne or Gauguin.

EUROPEAN AND AMERICAN ART NOUVEAU ARCHITECTURAL DESIGNS

American Art Nouveau

Although Americans at the turn of the century generally regarded Art Nouveau as a European style of ornamentation, in Europe itself one of the primary uses of the style was

150

196. LOUIS H. SULLIVAN. Carved
sandstone decoration on south
entrance, Wainwright Building,
St. Louis. 1890–91

197. LOUIS H. SULLIVAN and GEORGE
ELMSLIE. Ornamental iron decoration of
façade, Carson, Pirie, Scott Store, Chicago.
1903–4

198. HECTOR GUIMARD. Detail of iron railing of *Métro* station, Paris. c.1900

*Louis H. Sullivan
and American
Art Nouveau
Architecture*

architectural. In Belgium during the late 1880s and early 1890s, according to Maurice Culot:

> Art Nouveau architecture appealed to a clientele that was more open and dynamic than the *grande bourgeoisie*; engineers, lawyers, and artists were more receptive to new ideas. . . . Buildings became a medium for the expression of ideology. Free thinkers, socialists, and liberals had their buildings done in Art Nouveau style. Catholics, on the other hand, chose Gothic Revival or Flemish Renaissance. They condemned Art Nouveau on the ground that its sinuous curves appeared to be the mark of a totally pagan lubricity. . . .[37]

A somewhat similar statement might be made for America, although the "liberal," "free-thinking" clientele for the new American architecture was not politicians but businessmen who were willing to try new architectural ideas to show their faith in dynamic industrial and commercial ventures. No American architect or client sponsored curvilinear fantasies as advanced as those by the Belgian architect Victor Horta, but certain parallels occur in American and European works.

As individualists and determined expressionists within an eclectic historicism, Frank Furness and Antoni Gaudí might be compared in certain works, for both men merged Hispano-Moorish and Gothic styles, making unique combinations of strong, separate elements (plates 200–205). But the large interior space of Furness' National Bank of the Republic, built in 1883–84 in Philadelphia, its flat glass ceiling supported by horizontal beams that curve beneath toward the walls, responded to structural problems of light and space much as John Root's Rookery did in 1885 (plate 206; see plates 169, 170). The Rookery's heavy exterior masonry contrasts with its enormous, light-filled interior opened by glass and curvilinear ironwork, in its effect not unlike Victor Horta's famous Maison du Peuple built in Belgium ten years later (plate 207). Horta used glass and iron for both façade and interior (as Sullivan would do in 1899 for the Carson, Pirie, Scott Store), but the interior of his building has strong similarities with Root's. The unified and fluid space in The Rookery, as well as its complex Art Nouveau-style railings and light fixtures, holds its own beside the Maison du Peuple, although the curves of Horta's iron ornament and girders are the more organic.

Another interesting parallel can be discerned between the houses designed by John Root and domestic architecture in Europe (plates 208, 209). Root's "four party-wall houses" built in 1887–88 for James F. Houghteling, manager of a building and loan company in Chicago, are in an eclectic, individualistic style that is comparable to the houses designed by the Belgian architect Joseph Bascourt between 1894 and 1906. Bascourt's houses, built, like Root's, for upper-middle-class businessmen desiring pretentious exteriors, are marvels of borrowed bits and original Art Nouveau design, with ornamented oriels and mosaic decorations. Bascourt's original and personal Art Nouveau style was somewhat influenced by Arab architecture, as, in another way, was John Root's.

The Chicago house that Louis Sullivan designed in 1892 for his brother, and the house in Brussels that Paul Hankar designed in 1898 for his friend, the painter Léon Bartholomé, also share many characteristics (plates 210, 211). In both cases the clients were undoubtedly sympathetic to "new" architectural ideas. A geometric simplicity underlies each design: flat roofs, arches, asymmetry, and ornament strictly contained. The large fan-shaped window contributes to the greater expressionistic freedom of Hankar's "medieval tower house."

Overall, Louis Sullivan's architecture is most closely aligned with the Art Nouveau style of the Austrian Secession, a fact already recognized in 1912 by the American historian C. Matlack Price,[38] who refers to Sullivan's architecture as suggesting the Mohammedan, Frank Lloyd Wright's the Japanese (plate 212; see plate 187).

One aspect of American design particularly influenced and appealed to European archi-

199. LOUIS H. SULLIVAN. Detail of ornament
above entrance, Guaranty Building,
Buffalo. 1894–95

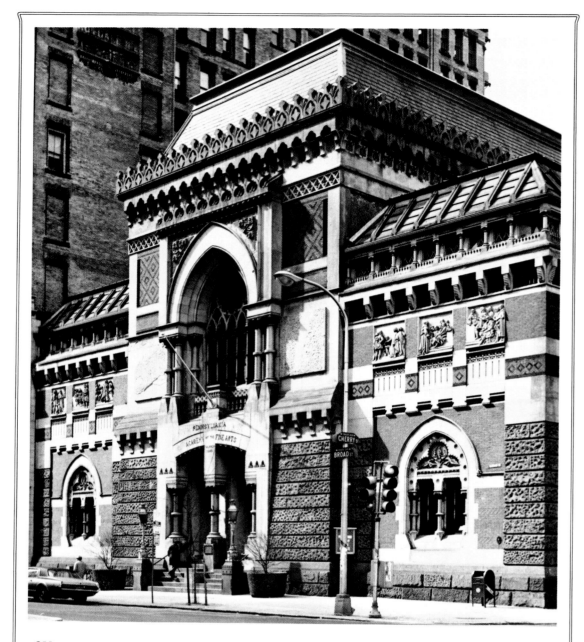

200. FRANK FURNESS. Broad St. façade, Pennsylvania Academy of the Fine Arts, Philadelphia. 1875

201. ANTONI GAUDÍ. Gatekeeper's Lodge, Finca Güell, Barcelona. 1887

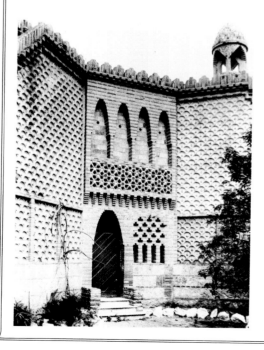

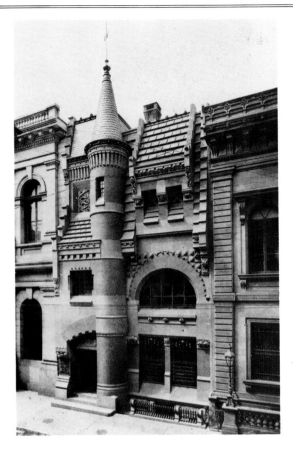

202. FRANK FURNESS. National Bank of the
Republic, Philadelphia. 1883–84; destroyed 1953

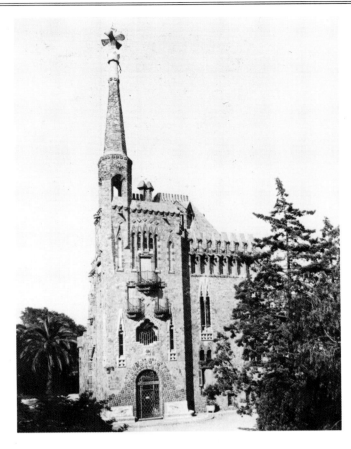

203. ANTONI GAUDÍ. Casa Figueras,
Barcelona. 1900–1902

204. FRANK FURNESS. Desk and Chair
designed for Horace Howard Furness.
c.1876. Wood. Collection George W.
Furness (photograph Cervin Robinson)

205. ANTONI GAUDÍ. Pew, side view. 1878. Wood.
Chapel of the Marquis of Comillas, near
Santander

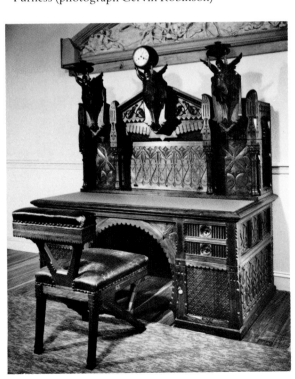

206. FRANK FURNESS. Interior of National Bank
of the Republic, Philadelphia. 1883–84; destroyed 1953

207. VICTOR HORTA. Interior of Auditorium, Maison du Peuple, Brussels. 1895–99

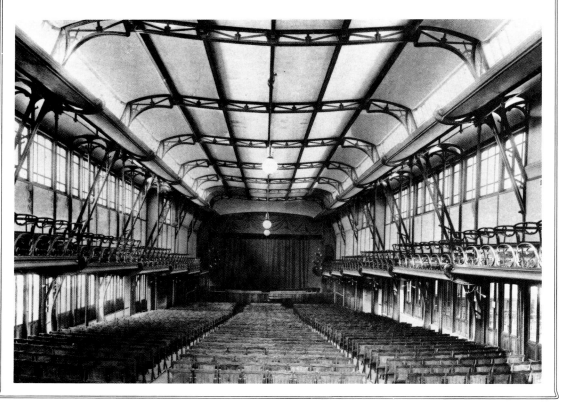

209. JOSEPH BASCOURT.
Design for house façade,
Brussels. 1897. Pen and ink
with watercolor (photograph
courtesy Archives
d'Architecture Moderne,
Brussels)

208. JOHN WELLBORN ROOT. James F.
Houghteling Houses, Chicago. 1887–88
(photograph courtesy Donald Hoffman)

211. PAUL HANKAR. Léon Bartholomé
residence and studio, Brussels. 1898
(photograph courtesy Archives
d'Architecture Moderne, Brussels);
demolished 1950

210. LOUIS H. SULLIVAN. Albert W. Sullivan
residence, Chicago. 1892

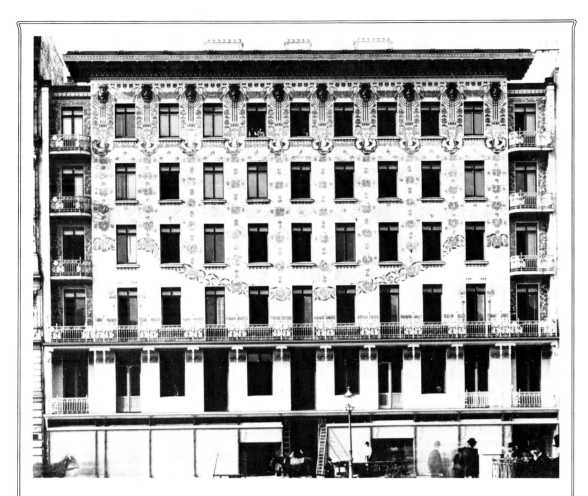

212. OTTO WAGNER. The Majolika House, Vienna. 1910

213. VICTOR HORTA. Emile Tassel residence, Brussels. 1893–95

tects: the creative American view toward functionalism in the planning of different rooms. That a building should accommodate the needs of its occupants rather than follow a long-prescribed formula was an idea greatly admired by European critics. Victor Horta's account of their questions about his Tassel House façade shows how startling to them was the concept of a plan determined by practical needs (plate 213):

> . . . after they laughed, they had to ask questions, why a door, why two little windows? For an entryway giving access to a cloakroom and lavatory on one side and to a waiting room on the other, three things unheard of in ordinary plans, yet so useful. . . . [39]

These few comparisons have been selected to show similar solutions to similar problems, rather than to suggest any direct influence. The work of these American architects and designers was known in Europe, however, and perhaps investigation will show that certain solutions by Furness, Root, Richardson, and Sullivan were as carefully noted by European architects as European works were by Americans.

SULLIVAN'S WORK AS ART NOUVEAU

Many writers have discussed the question of Sullivan's art in relation to Art Nouveau. Peter Selz has written that Sullivan's work of the 1880s "predicted" many characteristics of Art Nouveau, that in particular his "ornament prophetically heralded European trends of a decade later."[40] Henry-Russell Hitchcock states in the same book that Sullivan and Gaudí are "parallel to, not an integral part of, the international Art Nouveau movement."[41] Maurice Rheims regards Sullivan's Bayard Building in New York as "one of the finest monuments of American Art Nouveau" because of its "lean, elegant lines, and its perfectly integrated orientalist and medievalist decoration."[42] Robert Schmutzler claims Sullivan and Tiffany as the "North American contribution to Art Nouveau," but notes that each is distinct from the other and both from Europe.[43]

Most architectural historians who do not consider Louis Sullivan an Art Nouveau artist rely on one argument: in comparing Sullivan's work to that of Victor Horta and to other Belgian and French styles of the late 1890s, they generally conclude that Sullivan's ornament, "scantily connected to basic structures," is based on geometry rather than on the purely organic, and that it works within the traditional forms of surface and frame and thus cannot be called Art Nouveau.[44] Their definition of Art Nouveau style is limited to certain Japanese-inspired Belgian or French design of the 1890s and it leaves out much "new art"—the Scottish movement that drew heavily on Celtic decoration, or the German-Austrian Secession movement with its largely geometric patterns.

There is no one precise style that unites all of the new art of the 1880s and 1890s. This variety makes it preferable to see in Art Nouveau not a style of Belgian or French design but a group or set of artistic concepts, and to admit, with Maurice Rheims, that "so protean is Art Nouveau in its manifestations that it demands to be studied country by country"; he adds that there is "no single Art Nouveau style, but numbers of movements with a great variety of stylistic traits—even conflicts (as between Symbolism and Modernism)."[45] The common ground for these movements was the better understanding of ornament, and of the harmony—visual, expressive, and functional—of the object with its decoration.

Like the European Art Nouveau leaders, Louis Sullivan considered that his ornamental concepts extended beyond architecture. He made several designs for objects during 1894–96, the major years of American Art Nouveau, from elevator screens to ladies' combs and hairpins (plate 214). Perhaps the success of the ornament on his Transportation Building and his lengthy talks with André Bouilhet convinced him for a short while to widen

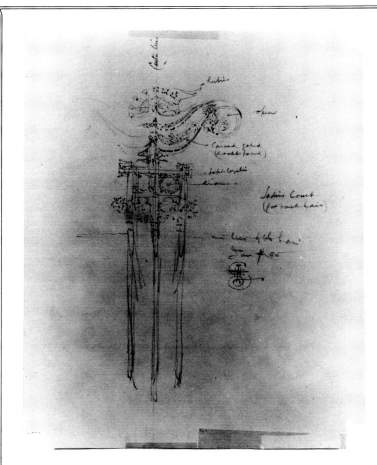

214. LOUIS H. SULLIVAN. Drawing for
Lady's Comb of gold and jewels. 1895.
Pencil. Avery Library, Columbia
University, New York City

215. LOUIS H. SULLIVAN. Drawing for
Cover of Sheet Music. 1896. Pencil.
Avery Library, Columbia University,
New York City

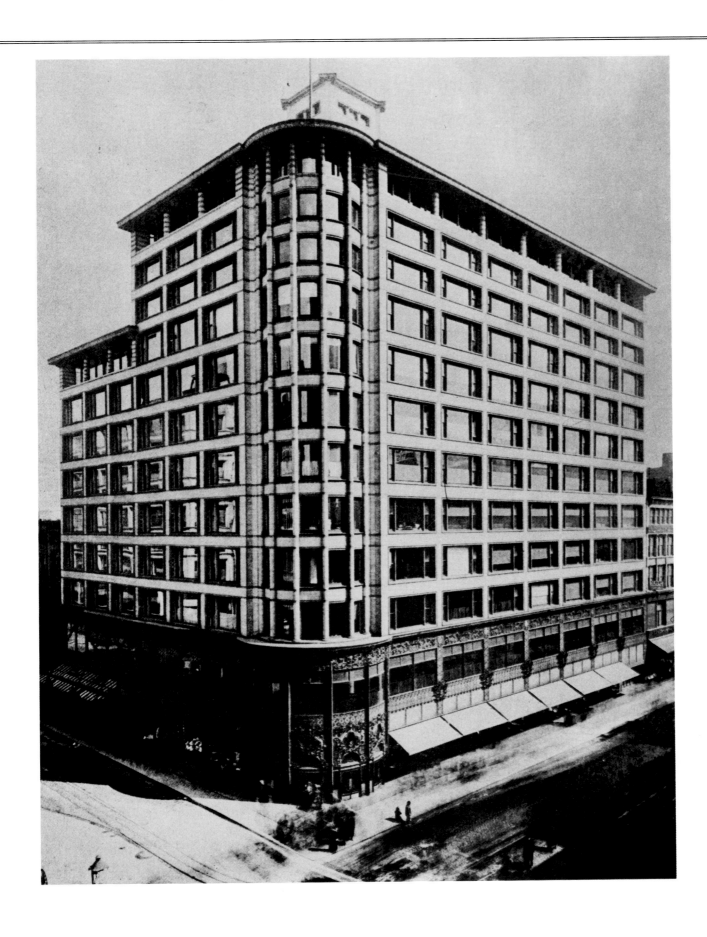

216. LOUIS H. SULLIVAN. Carson, Pirie,
Scott Store, Chicago. 9-story section at left,
1899; corner section, 1903–4 (contemporary photograph)

his talents, as many other artists did, into areas of applied art. He designed pieces of jewelry and several graphic works in addition: a cover for his own poem "Inspiration," and a memorial page in 1895 for the death of Richard Morris Hunt. These designs created at the height of the poster and periodical craze in America, and two in 1896—covers for an international magazine and a music magazine (plate 215)—give us insight into how the interrelation ship of the arts looked to Louis Sullivan, the architect.

The conviction that formal visual elements convey expressive meaning underlies Art Nouveau as well as most "new art" of the turn of the century. However shallow or deep the symbolic meaning intended by the artist or designer of a particular object, the quality ascribed to the work depended upon how that meaning corresponded to the content or function of the object—whether painting, building, or hairpin. Within this effort to understand quality in visually expressive design grew the general stylistic language of the period: an interweaving of line and color, of solid and space, of pattern and symbol, that became essential to concepts of twentieth-century art. Louis Sullivan made a powerful synthesis of these elements, yet by 1902, except for Wright and the Prairie School, American architecture was again entrenched in European traditions. European Art Nouveau artists such as Charpentier and Guimard continually stated that the "proper home of the 'New Art' is the new world," but Herbert Croly responded in *The Architectural Record*:

> The old world may or may not need a new art which violently breaks away from established forms, but the new world certainly needs in the beginning an old art, in which forms are not only preserved, but cherished. . . .
>
> American designers are now trying to materialize in this country the best available traditional models they can find . . . what American art needs most of all at present is the informing and refining presence of the best European models . . . the intentional striving after originality is always a dangerous thing; but considering the absence in this country of corrective traditions, it would be fatal to American artists, and would result in aesthetic extravagances, compared to which Whitman's experiments in versification might seem normal.[46]

H. W. Desmond described Louis Sullivan as America's "only modernist" in 1904, when Sullivan had just completed the Carson, Pirie, Scott Store (plate 216). This was to be his last major commercial building in Chicago, and he was largely ignored for the next twenty years. Desmond wrote:

> Here is "Art Nouveau" indigenous to the United States, nurtured upon American problems, and yet but scantily recognized or considered by a profession that busies itself with the importation of alien sources.[47]

Louis Sullivan continued to create eloquent "new" architectural statements in the small midwestern banks he designed during his last two decades, and it is no wonder that the embittered architect wrote so vehemently at the end of his career about the "great white cloud of poison" formed at the 1893 Chicago Exposition.

CHAPTER FOUR

WILL H. BRADLEY AND THE POSTER AND PERIODICAL MOVEMENTS, 1893–1897

As the opening of the Columbian Exposition neared, a twenty-four-year-old graphic designer in Chicago, Will H. Bradley, moved into a new office in John Root's Monadnock Building. Later he described himself as belonging to "the Turkish cozy-corner, gilt-framed-chromo-on-the-wall, portrait-on-a-bamboo-easel, silk-throw-on-the-piano Victorian period."[1] His reputation was well established among printing and publishing firms in the midwest, and he had been commissioned to design the Exposition souvenir booklet of Harriet Monroe's poem "The Columbian Ode" (plate 217).

For the cover, title page, frontispiece, headpieces, and figural initial of the poem Bradley borrowed from the two decorative styles illustrated in the influential Scottish periodical, the Century Guild's *Hobby Horse*: the Pre-Raphaelite–medieval, black-line style of drawing by Herbert Horne, and the planar, black-and-white design developed by Arthur Mackmurdo and Selwyn Image (plate 218; see plate 13). The latter style dominates Bradley's other work for the Exposition, a cover stamp design for the *Graphic History of the Fair*, using negative silhouettes in a two-dimensional design (plate 219).

Bradley's semiclassical female figures, as in his theater poster of 1894 for *The Masqueraders* (plate 220), show that the Chicago Fair left its particular impression on him. Meanwhile the Exposition created a burgeoning interest in art throughout the midwest, and study groups, art clubs, and craft societies sprang into existence by the hundred;[2] Chicago seemed particularly determined to become the "Athens of the West."[3] Together with this increase in culture came an expansion in the publishing business. From the day the Fair opened, publishers began to produce illustrated periodicals, brochures, and books on the arts as well as on literary subjects and topics of cultural concern,[4] and to meet this ever-growing demand the publishing houses grew in size and number. They began to use "artistic" posters to advertise their books and periodicals, and developed new methods of photoengraving for printing illustrations in their books. During the four years following the Chicago Exposition the poster and periodical business in America was phenomenally successful, and with its popularity rode Will Bradley.

217. WILL H. BRADLEY. Illustrated page with headpiece and first verse of Harriet Monroe's "The Columbian Ode." Souvenir booklet, World's Columbian Exposition, Chicago, 1893

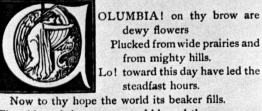

219. WILL H. BRADLEY. Cover of *The Graphic History of the Fair,* World's Columbian Exposition, Chicago, 1893

218. SELWYN IMAGE. Memorial Bookplate for Arthur Burgess, reproduced in *The Hobby Horse,* Vol. I, 1886

220. WILL H. BRADLEY. *The Masqueraders.* Drawing for theater poster. 1894. The Metropolitan Museum of Art, New York City (Gift of Fern Bradley Dufner, 1952)

The most decisive influence on Bradley's graphic design style was the startling work of his English contemporary, Aubrey Beardsley. Unerringly alert to the best in the new styles, Will Bradley responded immediately to the decorative massing of black and white in Beardsley's remarkable drawing, "J'ai Baisé Ta Bouche, Jokanaan" (plate 221). Published in the first issue, April 1893, of *The Studio* (a magazine later extremely influential in the United States but having limited circulation in its first year), the drawing was reproduced in the avant-garde American magazine *Modern Art* in the fall of 1893, and in November in *The Inland Printer*, the Chicago journal which employed Bradley. Irving Way, who commented each month on Beardsley's new works, wrote a major article on him in *The Inland Printer* in April 1894, comparing his work to that of the Japanese, and praising his "wonderfully imaginative designs."[5]

In Will Bradley's first and most popular poster, designed for a publication by Stone and Kimball of Thomas Hall's *When Hearts Are Trumps* (plate 222), he used several elements from the Beardsley drawing—the decorative motif of curving hair, the general composition, and the flat patterned background. Evidently Bradley had seen and assimilated Beardsley's overall planar simplification, yet he does not take over the element of the sinister, that decadent dynamism so often present in Beardsley's drawings. Bradley, of course, was concerned that his poster should "correspond" to the object being sold, and Tom Hall's little book of sentimental love poems in no way resembles Oscar Wilde's *Salome*, the dark, bloody tale illustrated by Beardsley's drawing. For this softer element Bradley turned to another English artist whom he and many other Americans considered to be one of the greatest of the day, Sir Edward Burne-Jones, who often painted scenes of sentimental love. This Pre-Raphaelite artist's *Pan and Psyche*, one of many reproduced in 1892 in a popular book on the artist by Malcolm Bell, apparently provided Bradley with the basic composition and theme for his poster (plate 223). The background of *When Hearts Are Trumps* does not have Beardsley's ornamental abstraction, but naturalistic foliage patterns familiar from the work of Walter Crane.

In this and subsequent posters Bradley played constantly on these three styles: Pre-Raphaelite works, especially Burne-Jones', often supplied the theme and mood; Crane, the naturalistic, overall patterns; and, most important, Beardsley, the pictorial vision of form and background simplified and integrated into an indissoluble whole and accentuating the decorative surface.

In Bradley's early designs these elements may or may not be integrated with one another. The large poster for *The Masqueraders* (see plate 220), a play opening in Charles Frohman's new Empire Theater in New York, is an incongruous *pastiche*: in the center, a large classicizing figure; Beardsleyesque masked figures at the left; and in the background, swirling vines, masks, and chrysanthemums.[6] Bradley must have studied Beardsley's fascinating cover for *The Yellow Book* (plate 224), reproduced in *The Inland Printer* in June 1894, for his masked man and woman above certainly resemble that cover: the masked figure kneeling at far left may reflect the *Salome* drawing. Bradley adapts the festive, masquerading mood of Beardsley's cover and his soft, curved forms and large areas of black and white. The composition of *The Masqueraders* is not fully successful as a whole, the swirling vines and flowers giving it only a superficial decorative unity. This was Bradley's only theater poster; indeed the poster movement in the United States, unlike that in France, was not much used by the theater world. It was publishing companies and commercial firms that turned to posters for pictorial advertising.

DEVELOPMENT OF THE POSTER

Advertising developed in mid nineteenth-century America in response to expanded industrial production. Lithographic posters in the 1860s and '70s were produced mainly by large businesses which could afford numerous draftsmen and the new, steam-powered

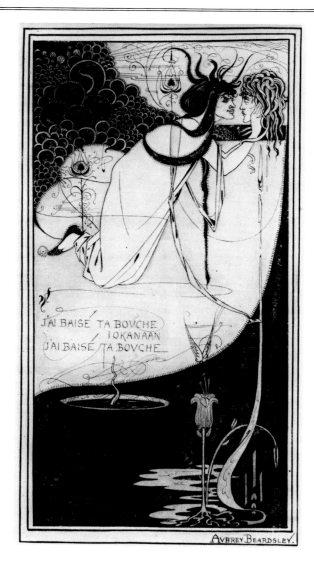

221. AUBREY BEARDSLEY. *"J'ai Baisé Ta Bouche, Iokanaan."* 1893. Drawing, later used as illustration for Oscar Wilde's *Salome*; pen and ink (green watercolor wash added), 11½ x 6⅛". Art Museum, Princeton University, Princeton, N.J.

222. WILL H. BRADLEY. Poster for *When Hearts Are Trumps,* book of poems by Tom Hall. 1894. Zincograph. Art Institute of Chicago (Gift of George F. Porter, 1927)

223. EDWARD BURNE-JONES. *Pan and Psyche*. 1872–74(?). 25⅝ x 21⅜". Fogg Art Museum, Harvard University, Cambridge, Mass. (Grenville L. Winthrop Bequest, 1943)

224. AUBREY BEARDSLEY. Design for Cover of *The Yellow Book*, Vol. I, 1894

printing machinery.[7] Currier and Ives in New York City supplied scenic views for the home; the Strobridge Company in Cincinnati produced theater and circus posters; and L. Prang and Company of Boston made the Christmas card into an American institution. Designed by anonymous craftsmen, these prints were usually realistic representations of scenes and objects. By 1881 the visual pollution caused by advertising posters pasted across the American continent had become a source of concern to many; an irate Englishman wrote:

> Of the unspeakably vulgar advertisements which deface the hills and glens of the United States much has been said—so much that the very protest against it has become vulgar and has been burlesqued. "I have desecrated more nature," said one honest comic ruffian who, paintpot in hand, had daubed "Jones Bitters" on some thousands of miles of scenery, "than any other man in the States."[8]

Facing a similar situation in England, a group of men from the Arts and Crafts Society began to take note of what they thought were the "de-civilizing" effects of degraded visual designs on everyday lives:

> But what about the great outside population—Do not these need also to be trained, delighted, given an expanded faculty for pleasure? The pictorial advertisement is, let it be remembered, the picture of the poor. The matter of the advertisement appeals to all, but their aspect is of most importance to those who have no pictures at home. We should not therefore allow the taste of the poor to be thus condemned to vulgarity. Nor can our own love of beauty be considered sincere if we are apathetic to the existence of the most hopeless kind of ugliness day by day before our own eyes.[9]

An early attempt to improve commercial design was taken in 1880 in America when Louis Prang decided to raise the artistic level of his pictorial Christmas cards and thereby help to educate popular taste and stimulate artists and art students to work in the decorative arts.[10] In the spring of that year he offered large prizes in a competition ($2,000 was awarded to Dora Wheeler in 1881; plate 225) judged by men prominent in the arts, such as Samuel Colman, Richard M. Hunt, and Edward C. Moore. The following year the judges John La Farge, Samuel Colman, and Stanford White awarded first prize to a design by the well-known painter Elihu Vedder (plate 226). The New York *Evening Post* remarked, "It is easy to see that art is advancing in this country, when Elihu Vedder makes our Christmas cards."[11] At first Prang's contests attracted artists to commercial design, but interest soon wore off and the last contest was held in 1884.

In Europe the world of the theater made the first move toward correcting the poor quality of pictorial advertising. Jules Chéret turned the colored lithograph into the "artistic" poster and this at once became a successful medium for advertising Parisian theaters and night cafés. It has been suggested that the startling and somewhat violent-colored American circus posters that were pasted up in Paris during the Exposition of 1867 may have stimulated interest in this form of advertisement.[12]

American publishers, however, were not so impressed by the work of Chéret as by that of the Swiss-born artist Eugène Grasset. Like Chéret, Grasset was widely popular in Paris in the 1880s for his works in the applied arts, from stained-glass windows and tapestries to book illustration and posters.[13] His style was a conservative blend of the Pre-Raphaelite, Celtic medieval, and Japanese decorative, and since most of his graphic work was in book illustration and advertisement (plate 227), he was a logical choice when American periodical publishers decided to develop posters as a new mode of advertising. In the 1880s periodicals such as *Harper's* frequently announced holiday issues by small shop-window posters. Like the earlier circus lithographs, these were usually enlargements of realistic

225. DORA WHEELER. Christmas Card.
1881, first prize in L. Prang and Company
competition. Chromolithograph on
paperboard. Hallmark Historical
Collection, Kansas City, Mo.

illustrations made by draftsmen employed as illustrators on the magazine. This limited use of small posters set a precedent, nevertheless, and in 1889 the publishers of *Harper's* commissioned Grasset for a cover for their *Bazaar* and a Christmas poster for their *Magazine* (plate 228); his work reflected modern taste, but was not so avant-garde as to offend America's largely conservative public.

In November 1890 the Grolier Club of New York held the first exhibition in the United States of "French Illustrated Bill-Posters," including thirty-eight posters and seven book covers by Chéret, five posters by Grasset, an assortment of works by other French artists, and a few American posters.[14] The introduction to the catalogue described the arrival of the "illustrated artistic poster" in the domain of the collector, and mentioned two recent and successful exhibitions of illustrated posters in Paris (1888) and Nantes (1889). Works by Chéret and Grasset were described as "masterpieces of high artistic merit and taste."[15]

Although the Grolier Club catalogue expressed "surprise that such a collection could be got together in New York," the collecting of French posters had become an important factor in the poster business by the late 1880s. Publishers and artists gradually began to acknowledge the collector as a consumer, and, accordingly, to issue posters with an eye to his demands. Editions were limited, each print numbered as it came from the press, and the cant of the graphics trade was appropriated, carefully distinguishing "proofs," "signed copies," and prints in various "states." In 1886 Ernest Maindron's *Les Affiches Illustrées* was published, a comprehensive history of pictorial advertising since antiquity, and poster collecting grew in America as well as in Europe. The 1891 catalogue of a major French dealer, Edouard Sagot, listed over 2,200 items for sale.

The poster movement began as an essentially French activity; Brander Matthews, in an article for *The Century Magazine* in 1892, had nothing good to say about British art or poster design:

> British art is lifeless. . . . The triviality of most of it, and its dominant note of domesticity, are to be observed also in its posters, which are devoted chiefly to things to eat, and to things to drink. . . . Oddly enough, the poster is still outside the current of decorative endeavor which has given us the Morris wallpapers, Walter Crane bookcovers, and the Cobden-Sanderson bindings.[16]

But French posters, despite their predominance, had not much influence in America except for Grasset's work, and his medievalism was more in keeping with the English school of Morris and Crane. Chéret's posters (plate 229), like those by Toulouse-Lautrec and by certain other French designers, were often considered "lewd" by Americans:

> Chéret has not a particle of design; his compositions are bad, and he takes the lowest and lewdest type of womanhood for his ideal. . . . His gaiety is the gaiety of an empty mind, of abandoned license and wild madness. . . . His color is loud and attractive, but not decorative or well-placed.[17]

The poster's role, according to this American author, was:

> . . . to begin aright, with high ideals and aims, to educate, ennoble and make men and women think of life not as a silly dream, but as earnest and sublime.[18]

More in keeping with this ideal and with the American interest in the British Arts and Crafts movement were the designs of the English-born Louis Rhead, who soon became one of the most popular designers in the poster style in America (plate 230). Rhead had received his training at the South Kensington Art School and made his reputation as a designer of bookbindings; he was invited to the United States in 1883 by the Appleton Publishing Company of New York, and stayed on to illustrate and design for American

227. EUGÈNE GRASSET. Page 16 of *Histoire des Quatre Fils Aymon,* Launett, Paris, 1883

226. ELIHU VEDDER. Christmas Card. 1882, first prize in L. Prang and Company competition. Chromolithograph on paperboard with fringe and corner tassels, 8⅞ x 6″. Hallmark Historical Collection, Kansas City, Mo.

228. EUGÈNE GRASSET. Christmas Poster for *Harper's Magazine.* c.1882. Engel Collection, Columbia University Libraries, New York City

publishers. In 1889 *St. Nicholas*, a children's magazine, commissioned a poster from Rhead, and the following year Harper's obtained another one for their *Magazine*. Rhead's style, based on images of Pre-Raphaelite idealism, used strong linear contours and flat areas of patterned color, and he was well received by an American public already delighted with the work of Walter Crane and Kate Greenaway.

Between 1889 and 1893 Rhead and Grasset continued to supply artistic posters, still relatively few, for the holiday issues of the well-established periodicals: *Harper's Bazaar, Harper's Magazine, The Century Magazine, St. Nicholas*. Apparently these advertising posters stimulated sales effectively, for in spring 1893 Harper and Brothers decided to issue a new poster each month. This commision went to Edward Penfield, a young American artist employed by Harper's as illustrator and art director (plate 231). Herbert Stone wrote in *The Chap-Book* about the impact of Penfield's April 1893 poster for *Harper's*:

> It was unlike anything seen in the land before. It was a poster which forced itself upon one: in design and colour it was striking, and yet it was supremely simple throughout. A very gentlemanly man walked down the salmon foreground arrayed in all the gorgeousness of a green driving coat. On his head was a light fore-and-after and his gloves were "London Tan." The rain was falling all round him, but with charming nonchalance and flattering intentness he read a copy of *Harper's*.
>
> The poster was distinctly successful; it was theoretically as well as practically good. The artist had attained his ends by the suppression of details: there were no unnecessary lines. . . .[19]

Most often likened to the posters of Théophile Steinlen, a French artist using color masses with simplified but fairly literal draftsmanship, Penfield's posters usually depicted an idealized young American man or woman, unmistakably upper-class, aloof, and slightly bored (plate 232). During the next year these became so popular that often more copies of the poster were printed than of the magazine itself. Several American artists created similar images, such as Will Carqueville for *Lippincott's* (plate 233).

THE "POSTER STYLE"

The major impetus for the poster movement in the United States came in 1894 with the advent of the miniature periodicals. Between 1890 and 1895 the number of regular buyers of monthly periodicals increased from 250,000 to 2,000,000, and former readers of a single magazine came to devour devotedly half a dozen or more.[20] The main reason behind this explosion was the new low price of the magazines. In 1892 Frank Munsey, for example, after several publishing failures, analyzed the market and decided that if his *Munsey's Magazine* could sell for ten cents and be made light, bright, and timely, it would reach a wide circulation; he was chiefly aided in reducing costs by the photoengraving process, which had come into common use in the publishing industry in the late 1880s.[21] Two factors affected the evolution of Art Nouveau graphic design in America, according to John Sloan, well known as an illustrator in the 1890s (plate 234):

> The "poster style" (which later developed into Art Nouveau) was just beginning to be fashionable. It was becoming familiar through magazine and book illustrations which adapted ideas borrowed from *Japanese woodcuts* to the *photoengraving process* for making linecuts [italics added].[22]

Aubrey Beardsley was the first artist to make popular illustrations in the "poster style" for reproduction by photoengraving. His work for John Dent's edition of *Le Morte d'Arthur* (see plates 254, 258), intended to rival Morris' Kelmscott Press books in quality but not in price, was praised highly by Joseph Pennell in the April 1893 *Studio*:

229. JULES CHÉRET. Sketch for Poster. Illustration in *The Studio*, Vol. I, 1893

230. LOUIS RHEAD. Poster for *The Century Magazine,* midsummer 1894. Library of Congress, Washington, D.C.

231. EDWARD PENFIELD. Poster for *Harper's
Magazine,* April 1893. Kunstbibliothek,
Staatliche Museen Preussischer
Kulturbesitz, Berlin

232. EDWARD PENFIELD. *Lady on Sofa with Cat.* Poster for *Harper's Magazine,* Christmas 1894. The Metropolitan Museum of Art, New York City (Museum accession, 1957)

233. WILL CARQUEVILLE. Poster for *Lippincott's* magazine, January 1895. Library of Congress, Washington, D.C.

Mr. Beardsley has recognised and shown by his work that decoration means, not the production of three or four fine stock designs, and the printing of these in books, to which they have no earthly relation, on a hand-press; but that decoration should be the individual and separate production of designs which really illustrate or decorate the page for which they were made, and that the artistic value of such design is not lessened by the fact that they are quite as well, if not better, printed by steam than they have ever been by hand.[23]

American artist-illustrators such as John Sloan and Will Bradley began to exploit the dramatic, flat, decorative possibilities of photoengraving in their illustrations and adapted that style for their posters, although ordinarily these were printed by color lithography.

THE PERIODICAL AND POSTER "CRAZE"

In April 1894 there came from England the strongest impetus for the miniature periodicals and the poster style, John Lane's journal *The Yellow Book* (see plate 224). Percival Pollard, an American author who founded a miniature magazine in the 1890s, described the reaction of American publishers:

> The long smoldering passion of revolt at conservatism in English art and literature had lately resulted in a bilious explosion, the *Yellow Book.* With the help of the notoriety then enjoyed in England by a certain prophet of the unconventional, Oscar Wilde, and the horribly fascinating drawings of an uncannily clever boy, Aubrey

Beardsley, the *Yellow Book* quickly attained the success that follows on the heels of scorn.[24]

That June the Chicago-based *Inland Printer* told of the public interest in the new British publication:

> Periodical literature on both sides of the Atlantic has been literally teeming with references to and reviews of this novel publication for the last three weeks. . . . The public appears to be single-minded in its verdict, as the first edition of 5,000 copies was exhausted in five days, while a second large edition went out of print in five more, and a third edition had to be prepared immediately.[25]

The immense popularity of *The Yellow Book* led to a similar explosion in America:

> The seed fell, as British seed usually does, upon America; it grew, and began to flourish . . . its growth was now independent of its origin. Strangely fashioned periodicals, preaching fantastic doctrines, uttering weird thoughts, began to appear like mushrooms after a shower.[26]

The first American "mushroom" appeared only one month after *The Yellow Book*. In May 1894 Herbert Stone and Ingalls Kimball, two Harvard students interested in publishing avant-garde American literature, produced *The Chap-Book*, "being a miscellany of curious and interesting songs, ballads, tales, histories, etc; adorned with a variety of pictures and very delightful to read; newly composed by many celebrated writers; to which are annex'd a large collection of notices of books."[27] *The Chap-Book* was at first a small literary review, intended as an attractive kind of advertising circular for the books published by Stone and Kimball. Both in price, five cents, and in size, 7 1/2 by 4 1/2 inches, it was small, which perhaps contributed as much to its success as anything it had to say. *The Chap-Book* was in such demand that when the early numbers went out of print they soon became collector's items at twenty to fifty times their original price.

The Chap-Book seems to have started the American "craze" for collecting posters, and before long its advertising pages carried a standing pricelist of its own posters. Herbert Stone encouraged the collecting by word as well as deed, publishing appreciations of Penfield's and Bradley's posters in the periodical and promoting them into becoming a considerable part of the company's business.

> The watchword of the *Chap-Book* was: Fads! If there was no fad in existence, it created one. It made a fad of artistic posters; it created Mr. Will H. Bradley into a cult. True, both of these subjects of appreciation had long before been recognized by the discerning few. But the pigmy from Harvard "pushed" its fads at the top of its voice; nowadays it is the shouting man who wins.[28]

Soon Stone and Kimball began to import French posters, selling them too through *The Chap-Book*. In the October 1895 issue the definitive list of importations totaled 156, with all the contemporary masters represented. Thus the two "crazes" of the 1890s, periodicals and posters, developed together. H. L. Mencken described the ensuing "pianissimo revolt":

> Suddenly without warning, the storm broke and a flood of miniature periodicals began to pour over the land. The success of the *Chap-Book* incited the little riot of Decadence, and there was a craze for odd sizes and shapes, freak illustrations, wide margins, uncut pages, Janson types, scurrilous abuse and petty jealousies, impossible prose and doggerel rhyme. The movement asserted itself as a revolt against the commonplace; it aimed to overthrow the staid respectability of the larger magazines

234. JOHN SLOAN. *Sand Larking*. Drawing for illustration in *The Inquirer*, Atlantic City, N.J. c.1894. Brush, pen and ink over pencil, on board; 18⅝ x 8½". Private collection

and to open to young writers opportunities to be heard before they gained recognition from autocratic editors. It was a wild, hap-hazard exploration in search of a short-cut to Fame; it proposed to carry Prestige by storm. By 1896 Elbert Hubbard could write with only mild exaggeration that: "We now have the *Lotus*, the *Lotos*, and the *Lettuce*. The latest is the *Prairie Dog*. Its hole is in Lawrence, Kansas, and it is patterned after the *Chip Monk*. Verily, like begets like."[29]

Well over one hundred of these "ephemeral periodicals" had been launched by 1898, and most were already defunct by then—including Will H. Bradley's own publication, *Bradley: His Book*.[30] Between 1894 and 1896 the poster movement, together with the periodicals, had reigned supreme. Every magazine started in the wake of *The Yellow Book* and *The Chap-Book* had its own "poster artists," until the country was flooded with bright, flat designs. Many writers took the situation quite seriously; the English publisher Charles Hiatt commented:

> Art is generally supposed to be inimical to commerce, and commerce inimical to art, yet here [in the poster] we have the two combining to the advantage of both, and succeeding in making the beautiful an incident of the necessary.[31]

Likewise Claude F. Bragdon, in an 1896 issue of the American *Poster Lore*, warned disbelievers:

> The people who still scoff at posters and poster collecting should bear in mind two things: First, that the great periods of art were those in which it allied itself most intimately with the daily life of the people, and that in this craze for posters . . . is seen almost the *first sign of a renaissance in which the spirit of the century which is so largely a commercial one, will find an utterance in beauty instead of ugliness*. Second, that many of the best artists have devoted their serious attention to the subject of posters and that therefore we laymen should give serious attention and intelligent appreciation to their work in this line [italics added].[32]

WILL H. BRADLEY AND AMERICAN ART NOUVEAU GRAPHIC DESIGN

Will Bradley had immediately recognized in Beardsley, his slightly younger contemporary, "a successful worker," and set out to learn his "method."[33] Indeed, many of the changing features in Beardsley's highly synthetic style for the next five years are reflected in Bradley's works, although the American artist also turned to others around him and blended numerous styles of the 1890s into his own ingenious, rather eclectic designs.

The popularity of Bradley's poster for Stone and Kimball's *When Hearts Are Trumps* led to a second commission that thoroughly established his reputation. In 1894, when Stone and Kimball, stimulated by John Lane's *Yellow Book* and by the short-lived periodical *The Knight Errant* (see plate 12), prepared to publish *The Chap-Book*, they advertised its coming with posters in the newest style. *The Chap-Book's* bow on May 15 was heralded by a startling poster by Will Bradley called *The Twins*, considered by Robert Koch to be the "first American Art Nouveau poster" (plate 235).[34] In its genesis *The Twins* is probably a further abstraction of Bradley's design called *The Black Parasol*, which he soon used for the August cover of *The Inland Printer*.[35] The figure in *The Black Parasol* retains autonomy to a large degree, despite some figure-ground interplay, and anatomically she is clearly depicted, whereas continuous, decorative surface designs dominate the figures in *The Twins*, the features and limbs now deformed along lines of interlocking rhythm.

Throughout 1894 Bradley continued to follow Beardsley's designs in *The Yellow Book*, but he also turned to the "shocking" posterwork of the French artist Toulouse-Lautrec, whose *Jane Avril* poster of 1893 stimulated several *Chap-Book* illustrations. *The Skirt Dance*,

American
Art Nouveau

especially, shows a naturalistic simplification that is distinctive with Lautrec, rather than Beardsley's ornamental abstractions (plates 236, 237). Bradley's style had not yet attained consistency, and he relied on superficial linear elaborations, the figures distorted rather haphazardly.

Late in 1894 or early in 1895 Will Bradley began to take notice of the work of Louis Rhead and Eugène Grasset, both recently risen to international prominence as poster designers. Grasset had a one-man show at the *Salon des Cent* in the summer of 1894, and Rhead a large exhibition in New York in January 1895, about when Bradley came back east from Chicago. Bradley's poster of *The Poet and His Lady* for the January 1895 *Chap-Book* is a reflection of Rhead's rather naturalistic style in the 1894 midsummer poster for *The Century Magazine* (plate 238; see plate 230); frequently, as here, he simplified Rhead's images into powerful, two-dimensional designs (plates 239, 240). In its turn Bradley's art stimulated other designers, such as E. B. Bird (plate 241), whose *Inland Printer* and *Chap-Book* covers of 1895 and 1896 show several Bradley elements, not, however, pulled together into integrated designs.

By the time Bradley had moved to Massachusetts he was becoming familiar with Japanese prints, constantly on display in Boston, or, by way of Arthur W. Dow's work (plate 242), at least with Japanese art. The March 1895 issue of *The Inland Printer* carried Bradley's first landscape design on the cover (plate 243), a tree done as a highly abstracted silhouette, while the title page illustration seems a simplification of Dow's cover for the 1895 issue of *Modern Art* (plates 244, 245). Another graphic artist, Florence Lundborg, relied on Japanese woodcut designs for her cover of *The Lark*, an "ephemeral" of the mid-1890s, and for a *Chap-Book* poster (plates 246, 247).

The "poster mania" reached its height in the United States in 1895. Literally hundreds of exhibitions, articles, and books presented "the art of the poster," and by the end of the year over six thousand Americans were collecting the new art form.[36] Bradley himself was becoming world famous. In the autumn of 1894 the London *Studio* published an article, "On Some Recent Designs by Will H. Bradley of Chicago," by Charles Hiatt (plate 248):

> In Chicago a decorative artist of some power and distinction, who has of late worked in the Beardsley manner, has arisen.[37]

Hiatt stated that Bradley's work had "classical roots," and that the young Chicago artist had made fine use of the decorative massing of blacks before Aubrey Beardsley's work had appeared. The author went on, however:

> It is not easy to state with precision at what moment in the evolution of Mr. Bradley's art he came in contact with Mr. Beardsley's work. The immense influence which that work exerted over him, immediately he saw it, is so obvious that the uninformed may well be excused for mistaking a Bradley for a real Beardsley.

Perhaps it was this continual comparison with Beardsley that persuaded Bradley to turn to new sources, Rhead and Grasset; perhaps Oscar Wilde's trial in April 1895 and the ensuing disparagement of Beardsley influenced those commissioning Bradley's works. For whatever reason, Bradley's art began in 1895 to reflect the more purely decorative and highly "moral" circle of the English Arts and Crafts artists, such as William Morris, Walter Crane, Louis Rhead, and the recent work of Charles Ricketts, as well as Japanese art and Grasset's Arts and Crafts-like style.[38] He also developed a new technique, establishing areas of textured tone by repetitious linear patterns rather than relying on the interplay of solid black and white. Most of his designs from the first half of 1895 show this change, including his *Echo* poster of June (plate 249). In using these vertical lines Bradley was adopting the method of a rival designer for Stone and Kimball, Henry McCarter, whose poster and cover designs for the Green Tree series of books began to appear in December 1894; the

235. WILL H. BRADLEY. *The Twins*.
Poster for *The Chap-Book*,
May 15, 1894. The Metropolitan
Museum of Art, New York City

237. WILL H. BRADLEY. *The Skirt Dance*. Illustration in
The Chap-Book, 1894. The Metropolitan Museum of
Art, New York City (Gift of Fern Bradley Dufner,
1972)

236. HENRI DE TOULOUSE-LAUTREC. Poster for *Jane
Avril au Jardin de Paris*. 1893. Color lithograph

238. (right) WILL H. BRADLEY. *The Poet and His Lady.* Poster for *The Chap-Book,* January 1895. The Metropolitan Museum of Art, New York City (Gift of Mrs. Bessie Potter Vonnoh, 1941)

239. (far right) LOUIS RHEAD. Christmas Poster for *Scribner's* magazine, c.1895

240. WILL H. BRADLEY. *The Blue Lady.* Poster for *The Chap-Book,* 1894. The Metropolitan Museum of Art, New York City (Gift of David Silve, 1936)

241. ELISHA BROWN BIRD. Cover of *The Chap-Book,* c.1895. Engel Collection, Columbia University Libraries, New York City

242. ARTHUR W. DOW. Exhibition Poster,
"Japanese Color Prints," 1896 (now in two
parts). Engel Collection, Columbia
University Libraries, New York City

243. WILL H. BRADLEY. Cover of *The Inland Printer,*
March 1895. The Metropolitan Museum of Art, New
York City (Gift of Fern Bradley Dufner, 1952)

244. WILL H. BRADLEY. Heading of title page, *The Inland
Printer,* March 1895. Library, University of Kansas,
Lawrence

245. ARTHUR W. DOW. Cover of *Modern Art,* 1895.
Library of Congress, Washington, D.C.

composition, however, and the mood of the figure with the flowing hair recall Elihu Vedder's illustrations for the *Rubáiyat*, designed a decade earlier (plate 250).

A mature and individual style emerges in Will H. Bradley's illustrations for the American edition of *Fringilla—or Tales in Verse* by Richard Doddridge Blackmore, published by Burrows Brothers Company in Cleveland in 1895; Elkins and Mathews brought out the London edition of the book, commissioning the elderly Arts and Crafts artist, Louis Fairfax-Muckley, to design it. In comparison with Muckley's rather crude and derivative illustrations Bradley shows himself an elegant master of all aspects of book design (plates 251, 252), from illustrating the verses to placing them on the page. His *Fringilla* proves his assimilation of Morris' work, as well as his unique and refined blend of Beardsley and Ricketts with Japanese design. In particular, Bradley seems to have examined with care Beardsley's *Morte d'Arthur*, for certain designs in *Fringilla* echo the Englishman's version of the Morris ideal. The double title page reflects Beardsley's massed blacks and his double-page designs (plates 253, 254), and the abstraction in Bradley's *Expulsion* comes from the delicate interplay of figures and ground created by the ambiguous curves of the flaming swords—a spectacular device that Beardsley had introduced in *The Eyes of Herod* in 1893 (plates 251, 255). Apart from these two references to Beardsley, most of Bradley's *Fringilla* designs are his own blend of intricate Pre-Raphaelite ornamentation with Japanese spatial arrangement. He developed a variety of textural patterns to establish tonal values in different areas of the scenes. The finely balanced tonalities are effectively set off against the decorative black-and-white borders: the same rather naturalistic leaf-and-flower motif unifies the pictorial illustrations, but the design of the chapter headings displays a fascinating variety of invention that approaches, yet never copies, the dynamic borders in Beardsley's *Morte d'Arthur*.

Bradley's concept of space in many of the *Fringilla* illustrations is likewise different from Beardsley's: his *Lita of the Nile, The Stream Kadisha* (plate 256), and *Mount Arafa* have each a diagonal, isometric perspective and a very high horizon line, the rhythm of the zigzag movement pinned by a series of verticals, elements all decidedly Japanese in origin. In particular the pattern of swirls in *The Stream Kadisha* resembles Oriental decorative devices, as in Ogata Korin's famous Plum Tree screens.

Bradley captures beautifully the refinement, elegance, and exotic romance of Blackmore's verse, which is set in text as follows:

> Kadisha is a streamlet fair, Which hurries down the pebbled way As one who hath small time to spare, So far to go so much to say To summer air. Sometime the wavelets wimple in O'er-lapping tiers of crystal shelves, And little circles dimple in, As if the waters quaffed themselves, The while they spin. Thence, in a clear pool, overbent With lotus-tree and tamarind flower, Empearled, and lulled in golden bower, Kadisha sleeps content.

Continuing to absorb suggestions from Beardsley's ever-changing style, Bradley made for his New Year's *Inland Printer* cover a fascinating transposition of Beardsley's *Queen Guenever* (plates 257, 258). He regularized the border elements into a delicate, Morris-like vine, reversing Beardsley's black-and-white relationships in the general composition and simplifying all detail into large, decorative areas of black, white, and textural tone. Ornamental rhythms of line and plane create an elegant and vital decoration. A generally simpler design with more regular ornament characterizes Bradley's works of late 1895.

In spring 1896, buoyed by fame and popularity, Bradley decided to emulate William Morris and establish a private press of his own:[39]

> . . . favorable publicity, plucking me long before I am ripe, cultivates a lively pair of gypsy heels; and believing myself, perhaps excusably, equal to managing a printing business, editing and publishing an art magazine, designing covers and posters, I

246. FLORENCE LUNDBORG. Cover of *The Lark,*
November 1895. Kunstbibliothek, Staatliche Museen
Preussischer Kulturbesitz, Berlin

247. FLORENCE LUNDBORG. Poster for *The
Chap-Book,* 1895. Kunstbibliothek, Staatliche
Museen Preussischer Kulturbesitz, Berlin

248. WILL H. BRADLEY. *The Serpentine
Dance.* Illustration in *The Chap-Book,*
1894. Lithograph. The Metropolitan
Museum of Art, New York City (Gift
of Fern Bradley Dufner, 1972)

249. WILL H. BRADLEY. Poster for *The Echo,* 1895.
The Metropolitan Museum of Art, New York
City (Gift of Mrs. Bessie Potter Vonnoh, 1941)

return to Boston, then settle in Springfield, start the Wayside Press, and publish *Bradley: His Book.*

Bradley goes on, in his autobiography, to explain the name of his press and the purpose it was to serve:

> The Wayside Press which I opened in this year of transition was so named for a very real reason. I had worked in Ishpeming and Chicago so as to earn money to take me back to Boston where I hoped to study and become an artist, the profession of my father. I had always thought of printing as being along the wayside to the achieving of my ambition. And I chose a dandelion leaf as my device because the dandelion is a wayside growth. . . . The Wayside Press was being established for the printing of *Bradley: His Book*, an art and literary magazine, and for a few booklets and brochures —publications to which I planned to give my personal attention throughout all details of production.

The format of the magazine at first was small and rectangular, 10 by 4 3/4 inches. The price was equally small, ten cents per issue or one dollar per year. Contents and format were changed several times as Bradley became more ambitious about the project:

> There being no joy in doing today what one did yesterday, or what another did yesterday; and creative design in which there is no joy or laughter being of little worth, a new lay-out and change of stock were provided with each issue.

The first number of *Bradley: His Book* appeared in May 1896. Its contents were an opening poem, "The Garden of Genius" by Nixon Waterman, followed by two stories or sketches, "At the Opera" and "A Veteran," by the popular writer Richard Harding Davis.[40] Next came a poem by Harriet Monroe, "The Night-Blooming Cereus," beginning with the lines:

> Flower of the moon! Still white is her
> brow whom we worshipped on earth long ago.

Bradley's first number was greatly aided by these contributions from his poet friends. The only article in this comparatively short issue—in all some ten pages of text—was his own piece, "Edward Penfield: Artist"; he praised Penfield as a true "artist," calling him a "master" who used the poster "wholly as a medium of expression peculiarly adapted to his own line of thought," not merely "to satisfy the craze for collecting them."

The numerous illustrated advertisements throughout the magazine were mainly for companies connected with the printing business—Whiting Paper Company (plate 259), Ault and Wiborg Printing Inks—and a few others, such as CopCo Soap and the Royal Baking Powder Company. Each advertisement was designed by Bradley himself, and printed in colors. The basic scheme in this issue was two complementary or near-complementary colors, and the mixtures obtained by printing one over the other. A favorite combination was dark green with red-orange, and their mixture, dark brown; another was dark red and deep blue, which made a purple tone when overprinted.

Most of the headings were in the American Type Founders' version of Morris' Golden typeface. Bradley enlivened the pages by printing in red ink the titles of the literary contributions. For Harriet Monroe's poem he designed a double page with elaborate Morris-like borders, and illustrations in the style of his *Fringilla*.

At the end of the issue Bradley listed in a note his sources of supply for inks and papers, explaining that "each number will be as widely different from the previous one, in colors, paper, and types, as it is practical to make it." *Bradley: His Book* was to be a continuous display of his own ideas about artistic printing.

250. ELIHU VEDDER. *The Long Rest.* Illustrated page with verses 22–24, *Rubáiyat of Omar Khayyám.* Heliogravure. Houghton, Mifflin and Company, Boston, 1884. Harvard College Library, Department of Printing and Graphic Arts, Cambridge, Mass.

251. WILL H. BRADLEY. *The Expulsion of Adam and Eve.* Illustration for Richard D. Blackmore's *Fringilla,* Burrows Brothers Company, Cleveland, 1895

252. LOUIS FAIRFAX-MUCKLEY. *The Expulsion of Adam and Eve.* Illustration for Richard D. Blackmore's *Fringilla,* Elkins and Mathews, London, 1895. Harvard College Library, Department of Printing and Graphic Arts, Cambridge, Mass.

253. WILL H. BRADLEY. Double title page of Richard D. Blackmore's *Fringilla,* Burrows Brothers Company, Cleveland, 1895

254. AUBREY BEARDSLEY. *La Belle Isoud.* Double-page illustration for Malory's *Le Morte d'Arthur,* J. M. Dent and Company, London, 1893–94

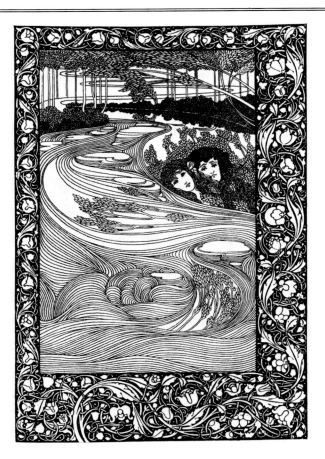

255. AUBREY BEARDSLEY. *The Eyes of Herod.* Illustration for Oscar Wilde's *Salome,* London, 1893

256. WILL H. BRADLEY. *The Stream Kadisha.* Illustration for Richard D. Blackmore's *Fringilla,* Burrows Brothers Company, Cleveland, 1895

257. WILL H. BRADLEY. Cover design for *The Inland Printer,* January 1896. The Metropolitan Museum of Art, New York City (Gift of Fern Bradley Dufner, 1952)

258. AUBREY BEARDSLEY. *Queen Guenever.* Illustration for Malory's *Le Morte d'Arthur,* J. M. Dent and Company, London, 1893–94

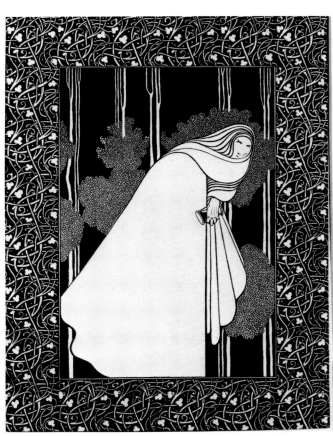

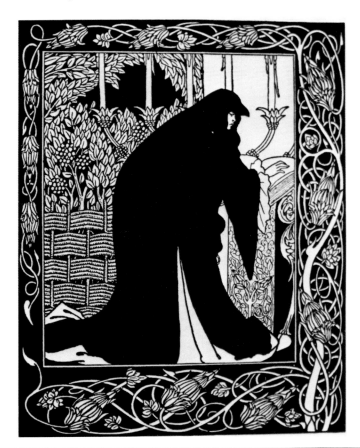

A final note lists seven new posters designed by Bradley and offered for sale through the magazine: *The Kiss*, done for the magazine (see plate 272); the *Knickerbockers*, an advertisement for Victor Bicycles; *In Purple and White*, also for Victor Bicycles; *Acorns*, for Whiting Paper; *Tivoli*; Hood's Sarsaparilla (Frontispiece, plate 260); and *Field Flowers*, for a memorial edition of the works of Eugene Field. These, unlike his photoengraved Chicago posters, were color lithographs. Bradley explained their preparation, stressing that they were to be "lithographed in subdued and delicate tints." He added, "Mr. Bradley has drawn the colors on the stones, therefore the posters are a reproduction of the artist's own work." The colors in these posters are much more complex than in Bradley's earlier works, but apart from a desire for more elaborate combinations, Bradley may have used lithography because he had no facilities at his Wayside Press for printing large posters by photoengraving. He may also have wished to try the print-making method used by French artists such as Toulouse-Lautrec, whose *Divan Japonais* poster of 1892 evidently inspired Bradley's Sarsaparilla advertisement (plate 261).

Thus *Bradley: His Book* presented in its Volume I, Number 1, many of the publisher's own ideas on the uses of art in printing and advertising (plate 262). Widely praised, the publication was described as one of the most recent in the "rage for the aesthetic in printing"; writers called it "the most artistic of periodicals," and a "model of neatness and literary quality."[41] Indeed the expert craftsmanship of *Bradley: His Book* distinguishes it from many other "ephemeral periodicals," which took license from *The Chap-Book's* casual spontaneity to degenerate into careless production.

In June the second issue appeared, with twice as many pages; the frontispiece reproduced what was to be Joseph Leyendecker's winning entry in *The Century's* poster contest, held in August and judged by Elihu Vedder, among others (plate 263). A long article by August F. Jacacci commented on the interesting art movements in Paris, including the recent "fashion" for "L'Art Nouveau":

> Paris is a maelstrom. . . . Nowadays there are Parisian fashions in art as well as in gowns. A recent venture, the last creation of one of the cleverest French dealers, is significantly dubbed, "L'Art Nouveau." As if art could be *new!* It is the typical shop of the period; showy, tawdry, filled with the oddest jumble of *fin-de-siècle* art; the decorative and industrial side by side with the "grand" art.

Jacacci spoke of "truly great individuals like Rodin"; mentioned that "Grasset has given up posters for the present and makes compositions for large tapestry panels"; praised Toulouse-Lautrec as "one of the young men most talked about in Paris, whose posters are remarkable for their simplicity of execution"; and concluded:

> Degas's failing eyesight permits him to work but an hour or two a day. . . . The artist lately purchased two superb portraits by Ingres and a beautiful El Greco. . . . Degas is undoubtedly one of the giants of nineteenth century art.

Illustrating this article were reproductions of Mucha's *Salon des Cent* poster, a color lithograph by Henri Rivière, Toulouse-Lautrec's *Salon des Cent* poster, and Penfield's June cover for *Harper's Magazine*.

Bradley: His Book met with kind reception. Advance orders for the second issue had come "from Brentano's in New York, 600 copies, and the Old Corner Bookstore in Boston, 400 copies, among others." The first issue was "out of print except for the supply being held for new subscribers." The magazine had an auspicious start.

The price of the July 1896 number was raised to twenty-five cents, and it was designed as a woman's issue, "printed most daintily on enameled paper and illustrated with designs pleasing to women." The elegant peacock motif on the cover was related to Bradley's poster for Scribner's *The Modern Poster* of the year before (plates 264, 265), but decorative

abstraction has given way to naturalism in rendering this favorite Aesthetic motif, made so popular by Whistler's Peacock Room. The speed and ease with which a work could become known and influential, either directly or through reproductions, is a factor which we now must weigh in establishing an "evolution" in Art Nouveau graphic design: the Peacock Room shows up again in Rhead's *Le Journal de la Beauté* (plates 266, 267), while Bradley's *Modern Poster* poster follows a design from a set of Peacock Room shutters (plates 265, 268).

In his introduction to the July issue Bradley wrote of his future plans. His enthusiasm was justified, since he also mentions that "this third edition was sold out before the last forms left the presses." August was to bring "a newspaper issue with every contribution from the pen of an active newspaper worker"; September, "a poster number, all designed in the manner of a poster, as well as consisting of reproductions and articles dealing with posters." Three separate departments would handle the major concerns of the magazine: "first an art magazine, second a literary magazine, and third a technical journal," each department to be directed by "a competent editor"—apparently there was more work in publishing the periodical than Bradley could handle alone. Yet his plans went on expanding; to the art department would be added a section for painting, sculpture, and architecture, including the "planning of interiors," and another for suggestions for "the artistic arrangement of the home," the first indication that Bradley's interests were widening beyond poster and print design toward the decorative arts; already this issue contained two of his wallpaper designs (see plate 75).

In keeping with the woman's point of view, the July number opened with a poem by Harriet Monroe, followed by an allegorical story by Bradley called "The Vengeance of the Female" (see plate 278), with illustrations that recall Beardsley's drawings for *Das Rheingold* recently published in the *Savoy*. Bradley was still keeping an eye on the Englishman's new designs. He also wrote an article in praise of the poster designs of Ethel Reed, the only well-known woman poster artist in the 1890s, describing her work as "controlled in a measure, as most poster makers are, by French or Japanese methods of treatment" (plates 269, 270), although she was evidently influenced by Beardsley as well as by the graphic art of Mary Cassatt (plate 271).

The August edition was the last number in Volume I; it was to have been a newspaper issue, but this theme was changed—perhaps Bradley was ill, or having trouble arranging all his plans. The issue seems rather hastily put together, and a small note adds that only the cover was printed at the Wayside Press. Dominating the number is an illustrated synopsis of "Beauty and the Beast, an Extravaganza with numerous songs and pictures," the story by Bradley, seven songs by Nixon Waterman, and music by Edmund Severn and Wells R. Hosmer, the "whole being pictured with many poster drawings." There were numerous illustrations in black and white, most of them narrow vertical panels in decidedly Japanese perspective.

This fourth number was much less elaborate than announced, and no issue appeared in September or October; Bradley's growing projects were apparently raising difficulties. But Volume II, Number 1, was published from the Wayside Press in November (plate 272). Its format was larger, 11 by 8 1/2 inches. For the cover design, which is no longer in diagonal Japanese perspective, Bradley returned to his earlier frontal, linear abstractions: the woman and peacock are similar to the motif in a prize-winning design for the opening contest that *The Studio* held in 1893 (plate 273). The languorous attitude of the female figure and the repetitious linear elements are also close to the style of Charles Ricketts, whose Vale Press frontispiece for *Milton: Early Poems* (plate 274) was reproduced in this November number.

The issue contained one short story by George W. Cable and Van Der Dater's section on "Current Literature," but the rest of the text was written by Bradley. His articles were entitled "William Morris, Artist, Poet, Craftsman," in honor of the great man who had just died; "George Du Maurier, Artist and Author"; and "Maxfield Parrish." The latter

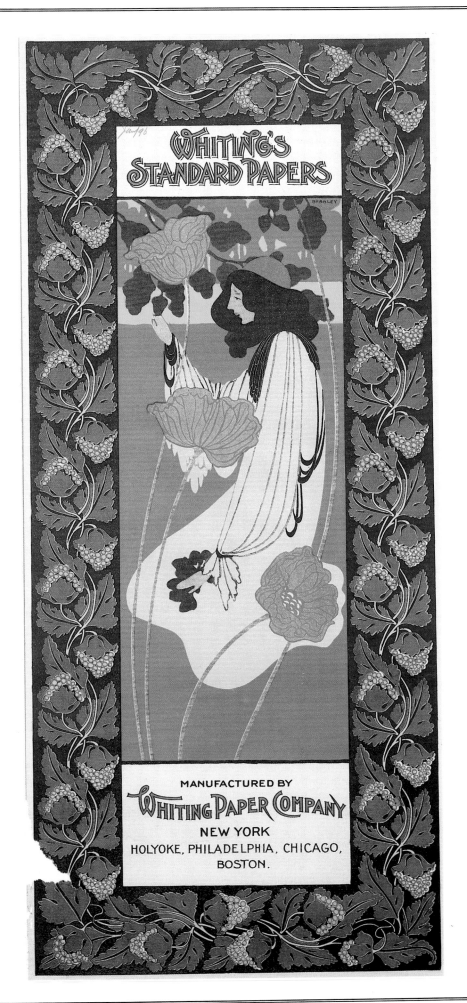

259. WILL H. BRADLEY.
Advertisement for Whiting
Paper Company in *Bradley:
His Book,* Vol. I, No. 1,
May 1896. Lithograph.
Engel Collection, Columbia
University Libraries, New
York City

is particularly interesting for the accompanying reproductions of that young American's strong, cartoon-like designs (plate 275), very like the style Bradley himself would adopt about 1900. Bradley described Parrish's stiff little figures as "quaint and original."

The remainder of the issue was given to a "Primer of Design" (plate 276), written by Bradley "with a feeling akin to fear." He discussed typographical ornament, explaining that the designer should start with a "natural element" such as a flower, and "interpret, not copy" it in his floral design.

The Christmas issue, Number 2, bore a simple sprig of holly on the cover, and in a special note Bradley states that the text was set in a new Gothic type he had designed, not the "Old Style Roman" used in the previous issues. A major story was "The Secret History of the Rescue of the Duchess de Dragonflies, extracted from the unpublished memoirs of Sir John Beetleback, here writ down by Tudor Jenks," a fantasy accompanied by four illustrations "designed and cut on wood by Will Bradley."

Volume II, Number 3, published in January 1897, was to be the last issue of *Bradley: His Book*. It contained no hint of this; Bradley's breakdown must have occurred suddenly, in the midst of his preparations for the February number.[42] In his autobiography he explained that he was "eventually overwhelmed and broke under the strain and had to go away for a complete rest. With no one trained to carry on in my absence, it was necessary to cease publication of *Bradley: His Book*."[43] The production of the magazine was not so much the cause as the extra work he took on to support it, filling many commercial printing commissions during the same time.

> As a business tycoon Will Bradley was a lamentable failure despite an auspicious start.[44]

Nevertheless, Bradley developed in his magazine many ideas concerning fine printing and the use of art in advertising that were expanded and later published in a series of twelve *American Chap-Books*, commissioned in 1904 by the American Type Founders. His thoughts for house interiors were published in 1901, in a series of drawings for the *Ladies Home Journal*.

Bradley's varied work for his periodical developed his extreme facility and maturity in pictorial design: he used black and white in strictest economy for a simple advertisement for *The Dry Goods Economist* (plate 277), creating an image that is readable, yet totally abstract and dynamic; an illustration for "Beauty and the Beast" contains elegant textural patterns in a collage-like composition not unworthy of a Japanese print master; in a strangely imaginative illustration for "Vengeance of the Female" (plate 278), the numerous linear textures lend a tangled unearthliness to his weird creatures. He translated the Morris ideal into up-to-date terms, and in the quantity and quality of his ideas and execution, *Bradley: His Book* forcefully affirms its creator's tremendous energy and impressive talent.

Three covers that Bradley designed in December 1896 for the *International Studio*, shortly before closing down the Wayside Press, indicate the strong shift in his style toward the later works of Charles Ricketts in England.[45] Bradley's illustrations in 1899 for Stephen Crane's *War Is Kind* (plates 279, 280) are dominated by Ricketts' style. In particular the title page relies on strong vertical and horizontal divisions that Ricketts had used as early as 1894 for the cover of Wilde's *Sphinx*, a design reproduced and acclaimed by *The Chap-Book* and *The Studio* (plate 281).

Bradley's originality and visual inventiveness rose to the challenge of E. I. Stevenson's satirical poems in *Harper's Magazine* in 1896 and 1897 (plates 282, 283). His two illustrations, excellent counterparts of the poems, contain several visual puns on the esoteric art of the 1890s (such as Thorn-Prikker's *The Bride*).

War Is Kind was Bradley's last book in his Ricketts-Beardsley style. During 1897 and 1898 he developed an entirely different manner of illustration: he had studied the Caslon type-

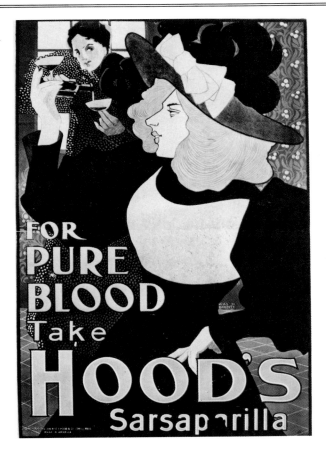

260. WILL H. BRADLEY. Advertising Poster for Hood's
Sarsaparilla. 1895. Color lithograph.
Kunstbibliothek, Staatliche Museen Preussischer
Kulturbesitz, Berlin

261. HENRI DE TOULOUSE-LAUTREC. Poster for *Divan
Japonais*. 1892. Color lithograph, 31⅞ x 24⅝"

262. WILL H. BRADLEY. Cover of *Bradley:
His Book,* Vol. I, No. 1, May 1896.
Lithograph. The Metropolitan Museum
of Art, New York City (Gift
of Fern Bradley Dufner, 1952)

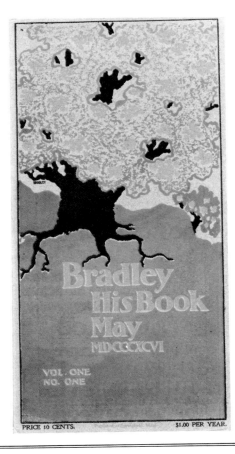

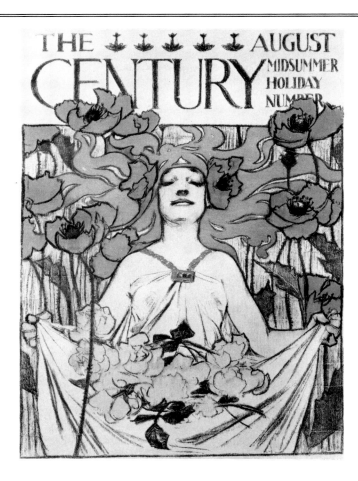

263. JOSEPH C. LEYENDECKER. Design for cover of *The Century Magazine,* August 1896 (first prize in *Century* poster contest, 1896). Illustration in *Bradley: His Book,* Vol. I, No. 2, June 1896. Aluminograph. The Metropolitan Museum of Art, New York City (Gift of Mrs. Bessie Potter Vonnoh, 1941)

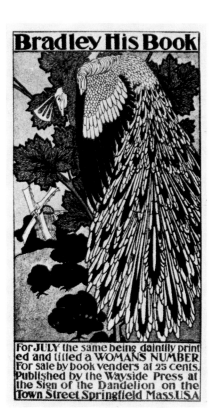

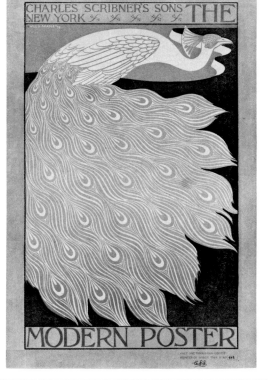

264. WILL H. BRADLEY. Cover of *Bradley: His Book,* Vol. I, No. 3, July 1896. Color lithograph

265. WILL H. BRADLEY. Poster for *The Modern Poster,* Scribner's, New York, 1895. Zincograph. Art Institute of Chicago (Gift of George F. Porter, 1927)

266. LOUIS RHEAD. Poster for *Le Journal de la Beauté*. c.1896.
Color lithograph. Museum Folkwang, Essen

267. JAMES MCNEILL WHISTLER. Wall of Peacock Room. 1876–77.
Frederick Leyland residence, London; now installed in Freer
Gallery of Art, Smithsonian Institution, Washington, D.C.

268. JAMES MCNEILL WHISTLER.
Center Shutters of Peacock
Room. 1876–77. Frederick
Leyland residence, London; now
installed in Freer Gallery of Art,
Smithsonian Institution,
Washington, D.C.

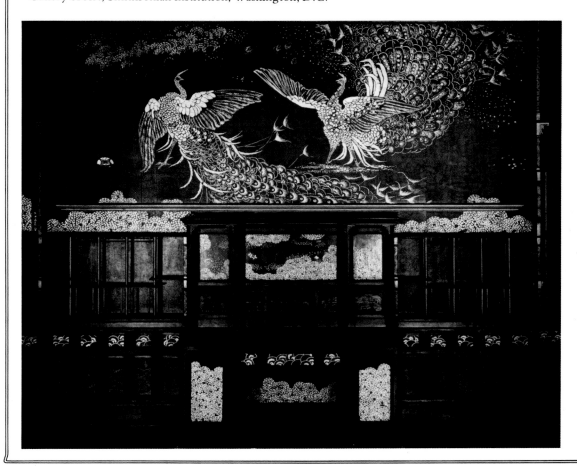

269. ETHEL REED. Poster for Albert
M. Bagby's *Miss Träumerei,* Lamson,
Wolffe and Company, Boston, 1895. The
Metropolitan Museum of Art, New York
City (Gift of Mrs. Bessie Potter Vonnoh,
1941)

270. ISHIKAWA TOYONOBU.
Girl with Lantern and Fan. 1740s.
Color woodcut. The
Metropolitan Museum of Art,
New York City (Dick
Foundation, 1949; Ledoux
Collection)

271. MARY CASSATT. *The Lamp.*
1891. Lithograph. Art Institute of
Chicago

272. WILL H. BRADLEY. *The Kiss.* Poster for *Bradley: His Book,* Vol. II, No. 1, November 1896. Woodcut. The Metropolitan Museum of Art, New York City (Gift of David Silve, 1936)

273. Unidentified artist. *Athenian.* Prize-winning design in competition for cover of *The Studio,* Vol. I, 1893

274. CHARLES RICKETTS. Frontispiece of *Milton: Early Poems,* reproduced in *Bradley: His Book,* Vol. II, No. 1, November 1896

275. MAXFIELD PARRISH. Advertisement for N. K. Fairbank Company, in *Bradley: His Book,* Vol. II, No. 1, November 1896. Library of Congress, Washington, D.C.

276. WILL H. BRADLEY. Drawing for *A Primer of Design,* part-title page in *Bradley: His Book,* Vol. II, No. 1, November 1896. Pen and ink. The Metropolitan Museum of Art, New York City (Gift of Fern Bradley Dufner, 1952)

277. WILL H. BRADLEY. Advertisement for *The Dry Goods Economist,* in *Bradley: His Book,* Vol. I, No. 1, May 1896

face of early American books in the Boston Public Library in 1895, and became interested in the colonial woodcut designs decorating these books.[46] These traditional designs stayed in his head. After giving up *Bradley: His Book* he worked in 1897 for the Harvard University Press in Cambridge, and he was commissioned to illustrate two books on a subject that seemed to call for exactly such old-style decorations: Washington Irving's *The Legend of Sleepy Hollow* and *Rip Van Winkle* (plate 284). Bradley used ornamental designs in the colonial style in conjunction with his favorite Caslon type, and the revival was extremely influential:

> Bradley's bold and original interpretation of the Colonial style in typography had an immediate influence on American printing. He was responsible for the widespread revival in the use of Caslon Old Style type in the printing trade, and set the style for lettering and ornament for many a year.[47]

He continued to use this style through the first decades of the twentieth century and American Type Founders, the company Bradley began to work for in 1900, promoted it especially. *The American Chap-Book* series, published by that company in 1904, carried Bradley's designs to an international audience.

For children's book illustrations in 1901, Will Bradley returned to a favorite English source. John Lane in London, and Stone and Kimball in America, had started in 1895 to reprint Walter Crane's Toy Books of the 1870s, *This Little Pig*, *The Fairy Ship*, and *King Luckie-Boy's Party* appearing at Christmas 1895 (plate 285); in 1896 there were three more, and three in 1899. When Bradley began to illustrate his own children's stories (plate 286), including *Castle Perilous*, a short tale based on King Arthur and published serially in *Collier's* in 1905, he developed an appropriate cartoon-like style similar to Crane's *King Luckie-Boy's Party*. Bradley's later works uniquely combined the styles of Walter Crane and the colonial broadside.

The revival of a colonial style in typography and ornament coincided with the colonial revival in architecture and interior design, a movement sparked by Gustav Stickley, who began to publish the influential periodical *The Craftsman* in 1901. Architecture and interior design in this so-called American Craftsman style had evolved slowly toward the turn of the century; it was tirelessly promoted in lectures by Frank Lloyd Wright, whose Prairie House designs appeared in the *Ladies Home Journal* in the issue preceding Will H. Bradley's series of eight designs for a house and its interior rooms (plate 287; see plate 45). Bradley's interiors conform to the Craftsman ideals in their woodbeam construction, brick and wood materials, and concepts of built-in furniture, all tightly fitted into a unified, rectilinear plan much resembling Baillie Scott's "English country house" designs, so popular at the turn of the century and published in *The Studio* in 1897 and 1900 (plate 288).[48] The exterior elevation of the "Bradley House" resembles those by the Glasgow School, in particular Voysey's house designs (plates 289, 290), which, like Baillie Scott's, were also internationally known in the late 1890s. Through the wide dissemination by the *Ladies Home Journal* of Bradley's as well as Wright's designs, the new style in architecture and interior design spread across the United States:

> Bradley's plans served as the basis for many of the homes that were built and furnished by architects and individual builders in America in the decade after 1900.[49]

Stickley's Craftsman style was similar to Bradley's ideas but more "roughly honest and sincere"; its immediate popularity was one of the early and successful coordinations of a periodical with "do-it-yourself" projects which have regularly served United States homeowners.

Will Bradley was steadily and actively employed as the country's highest-paid art editor for the first quarter of the new century. His reputation, solidly established during the

*Will H. Bradley
and the Poster
and Periodical
Movements,
1893–1897*

201

278. WILL H. BRADLEY. *"They Were Both Shaggy Toys."* Drawing for illustration of "Vengeance of the Female" in *Bradley: His Book,* Vol. I, No. 3, July 1896. Pen and ink and wash. The Metropolitan Museum of Art, New York City (Gift of Fern Bradley Dufner, 1952)

279. WILL H. BRADLEY. Title page of Stephen Crane's *War Is Kind,* Frederick A. Stokes, New York, 1899

280. WILL H. BRADLEY. Illustration for Stephen Crane's *War Is Kind,* Frederick A. Stokes, New York, 1899. Harvard College Library, Department of Printing and Graphic Arts, Cambridge, Mass.

281. CHARLES RICKETTS.
Design for cover of Oscar
Wilde's *The Sphinx*,
London and Boston, 1894

282. WILL H. BRADLEY. *Barren Triumph.* Illustration for E. I.
Stevenson's "Artian" sonnet, *Harper's Magazine*, December 1896

283. WILL H. BRADLEY. *Immolation.* Illustration for E. I.
Stevenson's "Artian" sonnet, *Harper's Magazine*, December 1897

284. WILL H. BRADLEY.
Jacket of *Rip Van Winkle,*
Harvard University Press,
Cambridge, Mass., 1897

Aesthetic Movement of the 1890s, grew ever wider. From being a specialized graphic designer of the esoteric "new art" he developed into a popular "tastemaker," combining art, crafts, and architecture in a style which was "artistic" yet accessible on a "democratic" basis to the majority of Americans. This transformation in Bradley's work and American "taste" was generally approved, as we are told by the industrial designer Walter Dorwin Teague, who wrote in 1954 in his introduction to Bradley's autobiography:

> There were derivative traces in Bradley's early work—and whose hasn't?—but when he hit his stride it wasn't Europe's leadership he followed. He discovered American colonial typography, bold and free, and from that springboard he took off into a career of non-archaic, non-repetitive, exuberant and exhilarating design. In its way it was as American as the Declaration of Independence. In this field we have never had a more indigenous art than Bradley's.
>
> He was a native, corn-fed American in another way, too. It was a time when Kelmscott House had set a pattern, and the only pious ambition for a serious typographic designer was to produce meticulous limited editions for equally limited collectors. Bradley may have had some such idea in mind when he started the Wayside Press, but thank God it didn't work. There was a lusty democratic ambition in that slight body, and it thrilled him to speak to thousands, even millions, instead of just scores. The turbulent current of American commercial and industrial life appealed to him more than any exquisite backwater.[50]

THE DECLINE OF THE AESTHETIC

*American
Art Nouveau*

While many praised the poster artists of the mid-1890s and prophesied a grand renaissance in taste, the artists themselves seem to have had no such illusions. Both Beardsley in

285. WALTER CRANE. Illustration for *King Luckie-Boy's Party*,
London and New York, 1895 (first published 1870)

286. WILL H. BRADLEY. Cover of *Collier's* magazine,
"Dramatic Number," November 1901

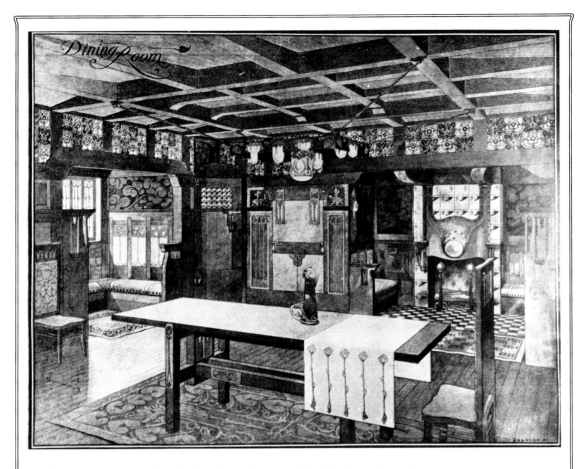

287. WILL H. BRADLEY. Design for Dining Room of the "Bradley House."
Illustration in *Ladies Home Journal*, 1901

288. M. H. BAILLIE SCOTT. Drawing of Dining Room of House in Crowborough, Sussex. 1870.
Illustration in *The Studio*, 1900

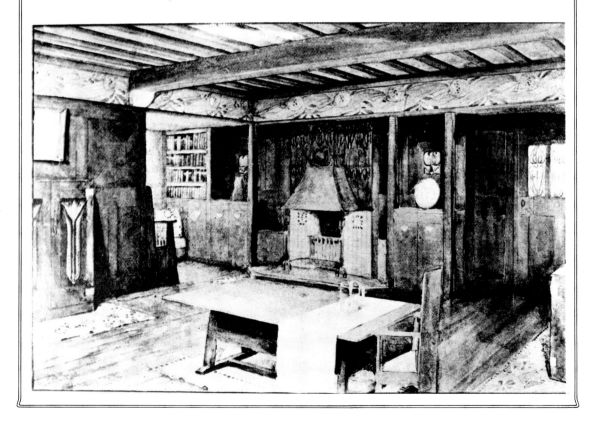

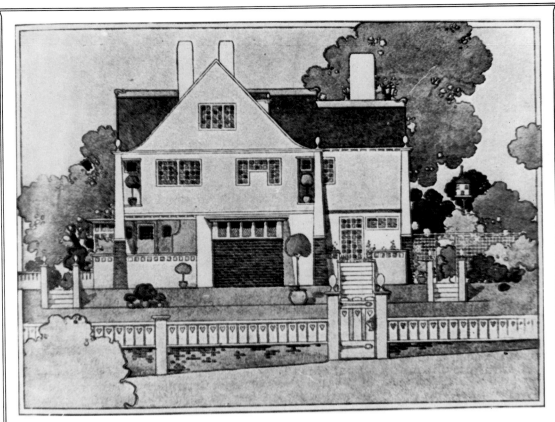

289. WILL H. BRADLEY. Front view of the "Bradley House." Illustration in *Ladies Home Journal*, 1901

290. C. F. A. VOYSEY. Design of house in Puttenham, Surrey. Illustration in *Architetural Review*, 1900

England and Bradley in America plainly stated their understanding of the poster movement. As early as July 1894, in a series of articles on "The Art of Hoarding" in the *New Review*, Chéret and Dudley Hardy discussed at length the size, shape, and color of posters, but Beardsley began a clear-sighted philosophical discussion of the whole question:

> Advertisement is an absolute necessity of modern life, and if it can be made beautiful as well as obvious, so much the better for the makers of soap and the public who are likely to wash.[51]

He continued with an argument comparing the poster designer with the painter:

> Now the poster first of all justifies its existence on the ground of utility, and should it further aspire to beauty of line and colour, may not our hoardings claim kinship with the galleries, and the designers of *affiches* pose as proudly in the public eye as the masters of Holland Road or Bond Street Barbizon (and, recollect, no gate money, no catalogue)?

In the end the young English artist concluded sarcastically:

> There is a general feeling that the artist who puts his art into the poster is *déclassé*— on the streets—and consequently of light character. The critics can discover no brushwork to prate of, the painter looks askance upon a thing that achieves publicity without a frame, and beauty without modelling, and the public finds it hard to take seriously a poor printed thing left to the mercy of sunshine, soot, and shower, like any old fresco over an Italian church door.

Beardsley's awareness that public and critical acceptance of the poster as a work of art was ephemeral was matched by Will Bradley's statements in an interview published in *Paper World* in November 1895,[52] when the poster fad and his own fame were at their height. Bradley's posters had been exhibited several times in Europe and praised in numerous articles, and his work was to be included that December in Bing's *Salon de l'Art Nouveau*; Adolf Loos, far away in Vienna, mentioned only one American artist in his 1898 reviews for *Die Neue Freie Presse*—the graphic designer Will Bradley, about whom he had much good to say. But when the enthusiastic American reporter asked "if these posters would not eventually give us a new school of art, founded on the principles now popular in this class of productions," Bradley replied:

> Posters alone can never give us anything dignified enough to be worthy of the name of a new school of art. If we are to have a real new school in art it will be *the work of these artists as a whole*, not posters alone, that will give it to us. . . . In candor, I am puzzled to know what can be termed the new school. It is true that there are some men abroad, members of the Pre-Raphaelite and Rose + Croix schools, who have exerted and are now exerting a strong influence over the younger artists of today: A certain amount of color, some meaningless lines, and more or less bad drawing may be massed together, and if it only be termed a "poster," it is sufficient to ensure its being talked about.

Beardsley criticized the attitudes of the critics as well as of the public:

> Today a gallery is devoted to an exhibition of paintings, and how one wishes he was represented, but the jury has said "no." Tomorrow the same gallery opens its doors to a poster exhibit, and behold, one's work is there; it blazons forth in all colors of the rainbow. The public flock to see it. They comment upon it. It is criticised and praised. Result is more or less notoriety.

Somewhat sadly, Bradley explained:

> We try hard to believe it is fame, but in our quiet thoughtful moments we realize that we are but as the clown in the circus. We have skipped and danced around the sawdust ring; we have entertained and amused our audience; perhaps we have done one or two clever tricks; but after all, the real, true thoughts of the public are with the daring performers away up in the top of the tent.

The "fever heat" of the poster and periodical craze soon cooled. Two factors in particular turned public opinion away from the "new" in art and literature. In April 1895 Oscar Wilde was tried and found guilty of "decadent" crimes, and this official condemnation seemed to support the theories in Max Nordau's widely read novel *Degeneration*, published in English in 1895.[53] The author, a Hungarian physician, explained in his preface that he was investigating certain tendencies in art and literature to prove that such works had their source in degeneracy, and that "the enthusiasm of their admirers is for manifestations of more or less pronounced moral insanity, imbecility, and dementia"; in his chapters are mentioned nearly all the avant-garde art movements and artists of the second half of the nineteenth century: the Pre-Raphaelites, Symbolism, Tolstoyism, Richard Wagner, Mysticism, Parnassians and Diabolists, Decadence and Aestheticism, Ibsen, Nietzsche, and Zola. Harry Thurston Peck describes the impact of this book on the American public:

> There was a moment when it appeared as though a great light had flashed upon the dark corners of society, displaying abysmal depths of foulness and corruption lying all about us; as though for an instant there had been revealed a ghastly spectre hovering over the modern world and, like the Erl-King of German legend, reaching out a hideous paw to destroy all that is dearest and holiest in the lives of mortal men.[54]

Soon attitudes and phrases from *Degeneration* were used to attack the poster fad. In 1896 an American writer condemned posters in general, and Beardsley in particular:

> This poster craze, and a certain trend this poster designing has taken, brings Max Nordau and his theories prominently to mind. . . . Most of the examples . . . are admirable designs . . . but room is given, of course, for some work by Aubrey Beardsley and his likes. Nothing but Nordau's degeneration theory will explain why a man who can draw well deliberately chooses to draw ill—nay, why he draws worse than anybody ever could draw before, and then calls upon the world to see that he had made a discovery in art, and founded a new school.[55]

Aubrey Beardsley's reputation was dealt a drastic turn by the critical events of April and May 1895. Oscar Wilde's libel suit that brought on his trial and imprisonment cost Beardsley his art editorship of *The Yellow Book* and also his American following. The American public found justification in the fall of Wilde for identifying moral degeneracy with all writers and artists who worked in avant-garde styles. Liberal periodicals such as *The Chap-Book* at first bravely defended the autonomy of a work of art, insisting that it be judged separately from its author's personality or morals:

> If there ever was in any of Mr. Wilde's writing literary merit and beauty, the same merit and beauty still exist and will continue to exist. Once and for all, a book printed and given to the public has a life wholly its own and independent of the fortunes of its author.[56]

Yet pressures grew as the years passed, and *The Chap-Book* began to call attention to hidden perversities in Aubrey Beardsley's drawings, confessing that it was "glad for the change" that carried *The Yellow Book* from "strong drink to tea." The American literary journal

Will H. Bradley and the Poster and Periodical Movements, 1893–1897

The Critic expressed increased hostility toward *The Yellow Book* that spring, declaring that it "pandered to depraved tastes"[57] in its fourth number (and Beardsley's last). The condemnation of Wilde spread to Beardsley, and to art in the "Beardsley style." John Sloan, who, like Bradley, rose to fame though his Beardsley-type posters and illustrations, wrote:

> Beardsley's remarkable work for the *Yellow Book* created a tremendous interest in the poster style, which helped us in this country. . . . But when the scandal about Oscar Wilde cast a cloud on Beardsley, our innocent little efforts here in the United States suffered.[58]

Just as Wilde stood for a great sinner in the United States in the late 1890s, so Aubrey Beardsley bore the brunt of many character assassinations. A particularly vituperous article by W. J. Randall entitled "Aubrey Beardsley: Artist of Decadence" appeared in *Metropolitan Magazine* in August 1896, written as news was received that the young artist lay near death; the writer had no sympathy, and insisted, "only the good die young—and Beardsley isn't good,"[59] although he claimed to speak only of Aubrey's art, not his character:

> Regarded from the point of view of the ethics of honest art, the lad is a monster—a degenerate of the most heartrending perversity. . . . He makes a mock of beauty, a scandal of form. He distorts the natural features of beauty and twists the sweetest lines of sympathy into the semblance of barb-wire. In his hands *even the sigmoid curve itself takes on the indelicacy of a "double entendre"* [italics added].[60]

Long after the demise of the poster movement in America and abroad, disapprobation continued of Beardsley and his works. In 1904 the critic Roger Fry wrote that even Beardsley's childhood works showed "his proclivity to the expression of moral depravity."[61] Referring to him as "the arch-priest of a Satanic cultus," Fry ended with the following:

> He has, indeed, all the stigmata of the religious artist, the love of pure decoration, the patient elaboration and enrichment of surface, the predilection for flat tones and precision of contour, the want of mass and relief, the extravagant richness of invention. It is as the Fra Angelico of Satanism that his work will always have interest for those curious about this recurrent phase of complex civilizations. But if we are right in our analysis of his work, the finest qualities of design can never be appropriated to the expression of such morbid and perverted ideals; nobility and geniality of design are attained only by those who, whatever their actual temperament, cherish these qualities in their imagination.

How remote are these words from Oscar Wilde's exhortation to critics in 1882—"never talk of a moral or an immoral poem—poems are either well written or badly written, that is all."[62]

In January 1897, when Beardsley was dying at twenty-five and the last issue of *Bradley: His Book* had come fromWill Bradley's private press, *The Chautauquan* ran an indicting article called "The Age of the Poster" which begins with the flat statement:

> Posters are fantastic, disjointed, perverse, bedaubed, uniquely new, and diabolically modern. . . .[63]

The essay, written by a Frenchman, Maurice Talmeyer, and translated for *The Chatauquan*, continued:

> The poster is a terrible agent of perversion. It exalts all that is frivolous and sensual, dissolves every high idea and strong sentiment. . . . The poster speaks to us only of

291. JOHN SLOAN. Snake
Charmer Puzzle, *Philadelphia
Press,* May 5, 1901

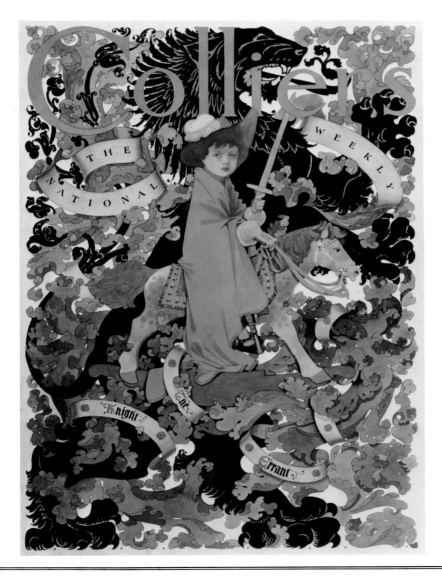

292. WILL H. BRADLEY. *The
Knight Errant.* Drawing for
cover of *Collier's* magazine,
1907. Pen and ink with
watercolor. The Metropolitan
Museum of Art, New York
City (Gift of Fern Bradley
Dufner, 1952)

ourselves. . . . It whispers to us, "Amuse yourself, take care of yourself, feed yourself, go to the concert, read romances, buy good soup, eat good chocolate, take a hand at the carnival, keep yourself fresh, handsome, strong, good-humored, paint yourself, comb yourself, perfume yourself, take care of your clothes, your teeth, your hands, and take pills if you have a cold. . . ."

The poster is indeed the art and almost the only art of this age of fever and of laughter, of struggle, of ruin, of electricity, and of oblivion. Nothing of it will remain.

The recurrent financial depressions of the late 1890s and the outbreak of the Spanish-American War in 1898 set the public attitude against frivolous books and periodicals of "aestheticism" or "decadence" and made investors wary of publishing ventures that had little hope of success. To Frederick Faxon, who compiled a list of the "ephemeral bibelots" in 1903, the cause of their decline was clear:

> . . . lack of support, or unwillingness on the part of the editor to be the only support, caused the untimely death of the majority. One editor, who issued two volumes, has confided to the compiler that he made $75 on volume one and lost $300 on volume two.[64]

THE PHILISTINE

The only magazine begun in the wake of *The Chap-Book* that continued well into the present century was Elbert Hubbard's *The Philistine*, an appropriate title for a periodical appearing two months after Wilde's downfall in 1895. Hubbard, formerly sales manager of the Larkin Soap Company, achieved national fame through *The Philistine* as a home-spun philosopher and moralist, drawing into its circle some 275,000 readers by 1910. The people he attracted were those solidly backing the new "strenuous life" preached and practiced by Theodore Roosevelt.[65] Roosevelt had spoken out against the attitude of inaction so well described in 1893 in the small book entitled *The Decadent: Being the Gospel of Inaction*, by Ralph Adams Cram, a founder of *The Knight Errant*. Cram speaks of the change of heart of a young socialist who gives up his active revolutionary attitudes for a retreat into art and opium:

> The era of action is over. . . . Action has striven and failed, and wreck and ruin are the ending thereof. . . . I thought once that through art we might work a revolution. . . . That was because I did not know the nature of art. Art is a result—not an accident, a result of conditions that no longer exist. We might as well work for the restoration of chivalry, of the House of Stuart, or the spirit of the Cinquecento, or any other equally desirable yet hopeless thing. What we are, that our art is also. Every school of art, every lecture on aesthetics, every art museum is a waste and a vanity, their influence is nothing. Art can never happen again. We who love it know it for what it is, a stately pleasure-house in Xanadu. . . . Intelligence and erudition may create a creditable archaeology, and a blind generation may—nay, has—mistaken this for art.
>
> But beyond these fortress hills lies the world, the nineteenth century, seething with impotent tumult, festering towns of shoe factories and cotton mills, lying tradesmen and legalized piracy; pork-packing stock-brokers, quarrelling and snarling secretaries, and railroads; politicians, mammonism, realism, and newspapers. Within my walls . . . I have gathered all my treasures of art and letters; here may those I love find rest and refreshment when worn out with hopeless fighting. Suffer me to live here and forget.[66]

The tremendous response that greeted Roosevelt's fight against this philosophy of inaction has been explained by Richard Hofstadter:

A citified, commercial civilization bedeviled by serious depression and troubled for the first time by the fear of decadence, greeted Roosevelt as the harbinger of a new and more rigorous and masculine generation.[67]

Elbert Hubbard appealed on his own level—through lectures, writings, and publications—to this same desire. In England Hubbard had visited William Morris, and he sought to bring Morris' ideals to all Americans in a "robust" and "honest" form. Needless to say, Hubbard was abhorred by avant-garde publishers such as Stone and Kimball, who greeted *The Philistine* with:

> It had his [Hubbard's] usual overwhelming dullness and paucity of idea, while the style has all the deftness which we have learned to know as peculiarly his own, a delicacy of touch as of a hippopotamus on a tight rope or a Nordau forging *vers de société*.

The series of "Little Journeys" published by Hubbard were mentioned in *The Chap-Book* with the following comment:

> Mr. Hubbard writes in a spirit of bland contentment with the commonplace worthy of the *Ladies Home Journal* at its best. . . . And as to his literary style, "ça n'existe pas."[69]

Editors like Stone and Kimball thought that Hubbard, through his *Philistine*, was vulgarizing the literary aspect of the periodical revolt just as they saw parodies of Morris' Kelmscott Press ideals in the books published by Hubbard's Roycroft Press. Yet he and his magazine were both immensely popular, and their moralistic attitude was echoed in the general revival of "colonial" architecture during the late 1890s and into the early twentieth century. This revival had been furthered by Gustav Stickley, the second "disciple of William Morris," who strove with missionary zeal in his *Craftsman*, first published in 1901, to provide the working-class, farmer, and middle-class population with "sensible, honest, sturdy" furniture for "wholesome" Craftsman houses, based on the "big fundamental principles of honesty, simplicity and usefulness."[70] Stickley, too, was extremely successful, and by 1910 the heavy forms of his so-called Mission furniture and Craftsman houses could be found throughout the United States.

Thus the Arts and Crafts message from England finally became freed in America from the "Aesthetic" entanglement it had originally acquired through the lectures of Oscar Wilde. The sinuous, snakelike females were now relegated to newspaper puzzles (plate 291). The most famous American artist of "decadent" posters, Will Bradley, had turned to colonial woodcut decorations, and his "Craftsman-like" house and furniture designs for the *Ladies Home Journal* reflected the changing taste in America for a "patriotic" and "democratic" artistic style. By 1907 the charging *Knight Errant* of 1892 had degenerated into a small boy with droopy eyes, riding his rocking horse (plate 292).

1900 was the year that *L'Art Nouveau* triumphed in Europe. But Americans had largely forgotten Oscar Wilde and Aestheticism by then as they turned to practical concerns, following the words and deeds of the new leader, Theodore Roosevelt. He exhorted Americans to "commit themselves to an active, hardy, practical, idealistic engagement in the country's struggles," to devote themselves to "the strenuous life," to develop the "rougher, manlier virtues," and not to become "cultivated, ineffective men with a taste for bric-à-brac."[71]

CHAPTER FIVE

DECORATIVE PAINTING AND SCULPTURE IN AMERICA

Like architecture, the arts of painting and sculpture in nineteenth-century America were much more bound by tradition than were the newly fashionable applied arts. In his 1895 report on *Artistic America* Samuel Bing noted this fact when he concluded that painting offered the most difficult area in America for the development of any originality. Referring to the long allegiance paid by American painters to traditional European forms, Bing wrote:

> . . . artists accepted them as immutable dogma to be transmitted to succeeding generations. And when finally the winds of innovation and change came to nationalize art and imbue it with new sensations, they came too late.[1]

Bing, with his European point of view, saw the "Contemporary Period" of American painting to be associated almost exclusively with modern French art, with "a few rare dissidents turning to Munich." As an example he cited the 1894 retrospective exhibition in Boston of William Morris Hunt, whose landscapes were reminiscent of Millet (plate 293) while his nudes and figure groups recalled Couture.

Beginning with the Philadelphia Centennial Exhibition of 1876, where the grand realism of the Hudson River School was first acclaimed, American painting, like its architecture and decorative arts, had opened into numerous avenues related to European trends: Pre-Raphaelitism, academic idealism, Orientalism, literary symbolism, Romanticism (especially in landscape art), and greater realism. Consequently its later development in the nineteenth century had no overall unity. The art biographer Royal Cortissoz emphasized:

> American art flows not from tradition but, in a specially marked sense, from the individuality of the artist.[2]

293. WILLIAM MORRIS HUNT. *Reflections of a*
River Bank. c.1860. 23½ x 33¼". Collection
Robert C. Vose, Jr., Boston

The three individuals whom Charles Caffin noted as innovators in 1902 in his *American Masters of Painting* were James McNeill Whistler, John La Farge, and George Inness. Caffin cited Whistler for having influenced the whole world of art, La Farge for creating totally new art forms, and Inness as a pathfinder for America's own expressive tendencies. These three men can serve as our focal points in drawing together many aspects of late nineteenth-century American painting.

The sudden growth of interest in the visual arts that the Centennial had aroused was closely tied to the great theme of that exposition—industry. Of the three artists just named, John La Farge (along with Elihu Vedder) was successsful largely because he applied his talents so accurately to the needs of new art industries—whether illustrated books, mural decorations, or stained glass. The painters who "succeeded" in America were precisely those connected with the decorative arts. In particular, pictorial advertising, illustration, and large-scale decoration schemes for the buildings designed by the powerful architects of the period offered the road to fame and fortune to many painters, for the "fine art" of easel painting was of relatively little interest to most Americans. As early as the 1860s John La Farge gave up trying to make a career in painting when he found no understanding for this work, but he reaped considerable financial success from his illustrations; and it was La Farge who later advised young Stanford White to follow suit and turn to architectural and interior design. In the 1890s, when interest and support for the decorative arts was at its height, the astute career artist Elihu Vedder expressed dissatisfaction with this one-sided interest in the arts. Vedder suspected that his talents were being exploited by architects like McKim, Mead, and White, and he was incensed that entrepreneurs had led the Pabst Brewing Company to use his 1863 *The Questioner of the Sphinx* (see plate 296) to advertise their beer in 1895; in 1896, while receiving offers of large decorative commissions, he wrote back to his wife in Italy that "art [in America] is absolutely flat, apparently no one is selling anything. . . . The fact is, they don't want to spend money on art."[3] Elihu Vedder's work that brought him lifelong fame and financial success was his illustrated edition of the *Rubáiyat of Omar Khayyám* (see plates 305–8). Art allied with the American genius for invention and business—Art and Industry, as the Centennial had declared it—offered the way to success in America, success in making money and winning fame. Art alone, apparently, was not enough.

In considering American painting three fields must be distinguished, though they often overlap. First, the international movements in the aesthetics of painting, to which Whistler contributed heavily. Second, the field of pictorial decoration; painters such as La Farge and Vedder were often concerned with the technical inventions and artistic developments that affected illustration and architectural decoration. Third, the individual artists, typi-fied by George Inness, who were often relatively isolated and unappreciated and developed inherently personal and subjective painting styles based on Romantic art and the French Barbizon School.

PHOTOGRAPHY AND JAPANESE PRINTS: THE NEW CLASSICISM

In the realm of the applied arts we have already seen that certain American painters tended to spread their talents into decoration. Artists like La Farge and Louis Tiffany (see chapter 2) turned to almost entirely other media; other American painters, trained in the Beaux-Arts ideal, applied themselves more specifically to mural painting and frequently to illus-tration. These areas both called for a style emphasizing two-dimensional, linear design, and any discussion of American Art Nouveau painting must take account of the ideals set for these seemingly distant yet related forms of art.

During the last quarter of the nineteenth century many American painters moved in directions similar to their avant-garde European contemporaries, such as the Nabis, the group of French painters who designed the Tiffany windows for Samuel Bing's first *Salon*

American Art Nouveau

de l'Art Nouveau in 1895. These artists, admirers of the great French muralist Puvis de Cha-vannes and followers of Paul Gauguin, firmly believed in "the painter as decorator" and in the evoking of symbolic meanings through simplified, two-dimensional patterns of line and flat color. One of them, Jan Verkade, expressed the outlook of many painters in the Nabi group when he described the attitude of French artists about 1890:

> No more easel paintings! Down with these useless objects! Painting must not usurp the freedom which isolates it from the other arts. . . . Walls, walls to decorate. . . . There are no paintings, there are only decorations.[4]

American artists, especially those trained in the "grand manner" of the Ecole des Beaux-Arts, also attempted to revive the role of the painter as decorator, and constantly referred to great artists of the past as "great decorators." In general, the "Renaissance" complex held by American artists at the end of the century stimulated the conviction that good "public art" was important for raising standards of taste and getting grand art "to the people." Similar attitudes sponsored the great interest in illustration and "commercial art" during that period. Consequently painters such as Elihu Vedder, Edwin Abbey, Will H. Low, Mary Cassatt, and James McNeill Whistler belong to the history of decorative mural painting and of graphic art and design. The requirement that the arts of mural painting and illustration must be decorative as well as representational led many artists closer to the two-dimensional concepts of Art Nouveau and Post-Impressionist design. In America this new style was part of the desire to return to "classicism" or to invent a "modern Renaissance" style.

Whistler was extremely important as a forerunner of the tendencies which underlay decorative painting in Europe and America by the 1890s. Two decades earlier, Whistler had already seen the direction that painting would take. An American artist paraphrased Whistler's ideas:

> The photograph has killed the doctrine of "realism." But neither will the old doc-trine of "idealism" answer any longer. The realist taught that you should paint nature as it is, the idealist that you should paint nature as it ought to be. But the photograph shows us that nature is no more like Rembrandt than like Raphael, and that the something which is art exists in the work of Terburgh as unmistakably as in that of Titian, while it does not exist in nature itself or in the impersonal record of nature. What is this something? The shortest word for it is *arrangement*. It is some form of order, harmony, proportion. It is arrangement of line, arrangement of color, ar-rangement of light and shade, for the sake of forming a harmoniously ordered whole which shall express some phase of human emotion and satisfy some vague desire of the human heart. There is even an arrangement of graven lines or of the strokes of a brush, so that "mere technique" may also be artistic and have its reason in the crea-tion of harmonies, though they be not harmonies of the highest order of importance.[5]

By the mid 1890s Whistler's art and his ideas were well known in England, America, and on the Continent, and the artistic world was everywhere discussing the new directions to be taken in response to the "death of realism." In 1898 Kenyon Cox (an influential, con-servative painter, author of numerous Beaux-Arts classicist murals at the Chicago Exposi-tion) wrote in *Scribner's* that the times he was living in might well become known as the "age of photography." In the camera he saw more far-reaching effects on art than in any invention since the printing press. Although he judged the influence of photography to be largely evil because it invited artists to match its mechanically achieved verisimilitude, Cox pointed out other signs which seemed to him symptomatic of revolution in the visual arts:

> Are not these the days, or rather, was not yesterday the day, of the poster fad? The poster is as far as possible from photographic; has as little as possible to do with fact or nature; is, in its extremest form, pure decoration run mad. Yet the day of the

poster is coincident with the day of the photograph. The crisis of that fever is passed, but look at the current number of the "up-to-date" art-periodicals and observe the dominance of personality in the work they publish and comment upon, its *decorativeness, its subjectivity, the variety of "tendencies" and "movements,"* of alitys and isms, that are represented. Never have there been so many schools and groups and secessions. Impressionists and symbolists and the Rose + Croix, tonalists and colorists and luminists are rampant. In art this is preeminently a period of anarchy and revolt, and the revolt is precisely against the photograph and the photographic though it has seemed at times that the revolutionaries would batter down many good things also, including sound drawing and common-sense. No, the real danger at present is hardly that art will submit to the sway of photography, but that it will go too far in its rebellion and forget truth as well as mere fact [italics added].[6]

Graphic art, especially illustrations and posters, helped artists and the public to understand the "true nature of art" by allowing pictorial art to take its first strong steps away from three-dimensionality toward surface design. Likewise the growth of mural painting, which dominated the ideals and visions of many late nineteenth-century Americans and Europeans, stimulated further redefinitions of painting. In 1895 Frank Fowler discussed the need for more such "decorative art" in America:

> In a word, we have passed the period in architecture of accepting only what is necessary . . . there is at present a disposition on the part of the public to go beyond the obviously practical in the art of building, and to recognize the practicality of appealing to the mind. . . . The discrimination in presenting what is most salient and typical, while leaving realistic studies for the portfolio, is taking art out of the sphere of the pictorial and definite, and into the realm of the imaginative and suggestive.
>
> Now it is this power of abstraction, so valuable, and indeed so essential in all decorative composition, which makes the expression "le grand art" in France a synonym for decoration, and its pursuit and practice there of the highest importance.[7]

The "power of abstraction" that graphic designers and mural painters were seeking they largely found in two curiously interrelated sources—"classical" art and Japanese art. Walter Cabot, writing in 1905 on "Some Aspects of Japanese Painting," described Japanese art as essentially classic, and found strong relationships between it and Raphael or the art of Greece.[8] The understanding of art as a visual arrangement that he expressed so clearly— a "visual symphony, which like the musical, shall produce its effect to a large extent independently of external aid" and suggest thoughts or moods of a symbolic nature— reads like a paraphrase of Whistler's words three decades before. To Cabot the fertility of formal possibilities in Japanese art came through the balance achieved by "contrast" and "harmonies of opposites" rather than through bilateral symmetry and closely related colors (plates 294, 295). His article provides us with a good idea of how the essential attitudes held by American artists were related to Art Nouveau, Symbolist, or Post-Impressionist concepts:

> The Oriental artist does not so much seek to transcribe nature as to suggest her moods. His interest is centered in the poetic sentiment which she elicits. . . . Another striking quality of Japanese, as of all the best classic art, is the perfection which it attains within its self-imposed limits. This perfection is due, not merely to the technical ability of the Oriental artist, which makes it possible for him to give us the peculiar pleasure which we always take in the things most directly and perfectly expressed, but also to a very pure and delicate aesthetic feeling. The way, for instance, in which line and color, light and dark, are made to echo, and thus intensify, the dominant emotional note of a picture, illustrates the sensitiveness of this Eastern people to the most subtle aesthetic effects. . . .

294. HOKUSAI. *A Gust of Wind at Ejiri, Suruga Province*, from *Thirty-six Views of Mount Fuji*. 1823–29. Color woodcut. The Metropolitan Museum of Art, New York City (Rogers Fund, 1936)

295. ISODA KORYUSAI. *The White Falcon*. Edo Period. Color woodcut. Art Institute of Chicago (Clarence Buckingham Collection)

Perhaps the most remarkable quality of Japanese painting, however, is its decorative beauty—its value as "pure design." That certain immutable laws of composition determined by equally immutable properties of the human organism, are discoverable, and are to be implicitly obeyed by the artist, is an idea which seems to have found root in the East as far back as the fifth century. . . .[9]

American artists had been introduced to Japanese prints as early as the 1860s through the influential John La Farge, but, as in Europe, a broad awareness of Oriental art developed for many artists and the public only in the 1890s, along with the Art Nouveau poster movement that was based so directly upon it. As Arthur Dow would do in 1895 and Cabot in 1905, La Farge had early understood the lessons of the Japanese color print:

> Bancroft and myself were very much interested in Japanese color prints and I imported a great many in the early 60s for us both through A. A. Low. . . . The very serious point to me was the display in certain of these color prints of landscape relations in color. . . . The Japanese thing . . . is not new . . . the merit of these things, in the way of color, line, and space and the arrangement of the three is exactly what it has always been in the best work of every nation and every clime. . . . But in the Japanese prints . . . it is more obvious because it is less covered up. It is like a child's book in words of three syllables. . . .[10]

For the American, whose interest in reality was so great, the art of Japan presented another path beyond photographic illusionism by offering everyday scenes through a new version of "classical" line, space, and balance; and, more important, it conveyed symbolic meanings through its rich, aesthetic arrangements of color, line, and flat areas of space.

THE SYMBOLIST ATTITUDE

Side by side with the continuing naturalism and academic idealism of American painting during the 1870s–1890s, several trends were exploring methods of subjective expression. No one style unified these artists, other than the active search of each for spiritual identity. Today we are frequently at a loss to understand the symbolic meanings in late nineteenth-century art; the religious, literary, and mythological traditions that were then still viable and generally known to the public at large are not familiar any longer. Consequently their content now becomes quite as important as their formal elements in any attempt to understand these works in historical perspective.

In a century overwhelmed by materialism, Americans who sought deeper and more permanent meanings in life found a major avenue to follow in the concepts offered by the eighteenth-century Swedish philosopher, Emanuel Swedenborg. His writings were widely known to Americans, from Ralph Waldo Emerson to George Inness and Louis Sullivan, either directly or through such explications as Reverend Edward Madeley's *The Science of Correspondences Elucidated*, already in its seventeenth American edition by 1883. The intense desire to synthesize objective and subjective realities dominated all spheres of the last half of the nineteenth century.

The earlier vein of American mysticism and spiritualism found in the painting of Washington Allston and the writing of Poe, Melville, and Whitman also gathered new strength and disciples. Hand in hand with Swedenborg's ideological influence went the revival of visionary artists such as William Blake. America's leading painter of the imaginary, Elihu Vedder, was among the many who saw the large Blake exhibit in London in 1876; another major Blake exhibit was held in Boston in 1880. Similarly, the symbolist writings of Edgar Allan Poe were translated into French by Charles Baudelaire. The emphasis on nature and the senses came to be turned toward the validity of private emotion, imagination, and

mystical experience, and this led to an awareness of the oneness of man and the universe, a concept reinforced in the second half of the century by a growing interest in Oriental religions and philosophies. The so-called symbolist movements in art represent this attitude rather than any specific pictorial style. For American artists symbolism was an intellectual more than an emotional attitude. As Henry Adams wrote in 1912:

> Symbolism is a wide field. It is, in fact, the whole field of art. . . . Most works of art are symbolic embodiments of an idea or a number of ideas. The primary pleasure art gives lies not in the aesthetic contemplation of its form, but in intellectual penetration through the work considered as symbol to its animating concept.[11]

The intellectual concern to understand and delineate as clearly as possible the unanswerable mysteries of life underlies much avant-garde art of the late nineteenth century.[12] Spiritual content was extremely important, but it had to be represented clearly in line and composition. Yet unclarity—that is, a painterly, nonlinear mode—would best visualize the unknowable, the intangible. Indeed the major battle of nineteenth-century art was waged over the search of artists (and poets and architects) for a style that would be evocative yet compositionally clear. The inwardness of expressive content, the visionary glimpse of spiritual realities beyond the material, could not be shown merely by depicting unreal subject matter, but needed a new visual style, a style which merged the painted images with abstract patterns suggesting a reality of the spirit.

In America, as in Europe, two interrelated directions were open to artists attempting to respond to this attitude: one led back to mythological, religious, and literary subject matter, the other toward the gradual creation of a visual language which, however simple or complicated the subject, would elicit appropriate emotional and intellectual responses.

DECORATIVE PAINTING, GRAPHIC ILLUSTRATION, AND SYMBOLIST THEMES

Elihu Vedder's *Questioner of the Sphinx* was completed in 1863 (plate 296), a year before Gustave Moreau's *Sphinx* appeared in the Paris *Salon*. Vedder's other early "weird" subjects, such as *The Fisherman and the Genie*, drawn from the *Arabian Nights* (plate 297), served like Moreau's to create a modern, poetically bizarre iconography based on ancient myths and depicting man's uncertainty, his questioning. (Albert Ryder's *Siegfried and the Rhine Maidens*, 1888–91, persisted in this vein; plate 298.) By 1865 Vedder at twenty-nine was already a full academician of the National Academy of Design and was looked upon as a "prophet" of American art. He had painted and exhibited two works that would make him famous, the *Questioner* and *The Lair of the Sea Serpent* (plate 299), and he had encouragement and support from artists whose goals were not unlike his own: George Inness, Samuel Colman, William Morris Hunt (brother of the New York architect Richard Morris Hunt), William Furness (brother of the Philadelphia architect Frank Furness), and John La Farge. In 1864 Vedder and La Farge illustrated the first American edition of Tennyson's *Enoch Arden*, an early venture of "fine" artists into the applied-art field. Since La Farge's works for the book clearly show his knowledge of Japanese prints (plate 300), he surely introduced Vedder to the Oriental design concepts he considered so important.

Thirty years later La Farge wrote to Samuel Bing, in 1895:

> I had always been interested in decoration, that is to say the appliance of art in any shape to buildings and objects made for use. . . . I was led to form very early an admirative appreciation of what between 1856 and 1859 we were able to know about Japanese art.[13]

296. ELIHU VEDDER. *The Questioner of the Sphinx.* 1863. 35¾ x 42″. Museum of Fine Arts, Boston (Bequest of Mrs. Martin Brimmer)

298. ALBERT PINKHAM RYDER. *Siegfried and the Rhine Maidens.* 1888–91. 19⅞ x 20½″. National Gallery of Art, Washington, D.C. (Andrew W. Mellon Collection, 1946)

297. ELIHU VEDDER. *The Fisherman and the Genie.* 1861. Oil on panel, 6¾ x 11½″. Museum of Fine Arts, Boston (Bequest of William Sturgis Bigelow)

299. ELIHU VEDDER. *The Lair of the Sea Serpent.* 1864. 21 x 36″. Museum of Fine Arts, Boston
(Bequest of Thomas C. Appleton)

300. JOHN LA FARGE. Illustration for Tennyson's *Enoch Arden,* Ticknor and Fields, Boston,
1865. Wood engraving. Harvard College Library, Department of Printing and Graphic Arts,
Cambridge, Mass.

The collaboration of Vedder and La Farge reinforced each other's interest in applying decoration to book illustration and in subjects of "fantasy." La Farge had begun to think about illustration in 1861, with the drawings he intended for an edition of Robert Browning's *Men and Women* (plate 301). These illustrations were never published because methods of photographic reproduction and engraving were not then sufficiently developed. But he responded to this situation as he did later, when lacking the technical knowledge needed to complete his glass windows for Memorial Hall at Harvard, and experimented for the Browning frontispiece design with a newly developed process, the *cliché verre,* drawing with a stylus on a coated glass plate from which a negative was produced for photographic printing.[14]

The *Enoch Arden* illustrations, however, were reproduced by traditional wood engraving. The financial success of the book spurred both artists' interest in the applied arts, and confirmed their reliance on literary themes. La Farge illustrated works by Longfellow, Emerson, and Heine, among others, during the 1860s, and in 1867 he created a "series of fantasy" drawings for *Riverside Magazine for Young People*, of which one, *The Wolf Charmer* (plate 302), exuded a supernatural atmosphere similar to Vedder's "weird" paintings of the same decade. Likewise La Farge's *Fisherman and the Djinn* (plate 303), a wood engraving of 1868 for *Riverside*, is clearly related to Vedder's painting of 1863 (see plate 297), although La Farge borrowed more from Japanese art in simplifying the composition and dividing the space of the page in half with a sweeping arabesque.

Deep in Vedder's nature was his lifelong search for answers to the questions of existence —the source of life, the nature of death. Especially after the fatal illness of his beloved son in 1875, Vedder turned to themes conceived in a Gothic mood of despair at the inevitability of death: *The Cumean Sibyl* (plate 304), *The Phorcydes*, and *Medusa*.

His trip to England in 1876 made Vedder turn to the pseudo-Greek and Victorian style of Laurence Alma-Tadema, adding this to his other great admirations, Blake and the decorative art of the Pre-Raphaelites. When he returned in 1879 Vedder began to work on what would be his most influential and well-conceived achievement, his illustrations of the immensely popular *Rubáiyat of Omar Khayyám* (plates 305–8). The first edition of this Persian poem (Quaritch, 1859), translated by Edward Fitzgerald, had been largely ignored, but the growing mysticism among the Pre-Raphaelites stimulated a flood of subsequent editions, and by 1872 William Morris, Edward Burne-Jones, and Charles Fairfax-Murray were working together on a handmade book version. Many Englishmen viewed Persia as the home of mysticism; A. J. Arberry stated in his book *British Orientalists*:

> The mystical element inherent in Islam among the Persians broke all bounds, so that no other literature can compare with theirs for both richness and profundity of mystical imagery.[15]

With respect to Art Nouveau, certain aspects of Vedder's *Rubáiyat* illustrations are important: the complex technical achievement of using a heliotype photographic printing process; the artist's entire page layouts, the script handwritten like Blake's to ensure unity of design; the concept of illustration as the "accompaniment" to verse; the flattened space, associated with Blake's weightless ethereality; and, above all, the symbolic content of the designs, the subject matter merged with decorative patterns. Called by a contemporary critic "a modern interpretation of the problems of existence,"[16] Vedder's drawings were compared to Blake's illustrations for Edward Young's *Night Thoughts* (plate 309). During the summers of 1871–73 in Perugia, Vedder and George Inness talked often with Edwin J. Ellis, who was to become a famous commentator on Blake and introduced Vedder to the *Rubáiyat*. Their conversations turned on "glimpsing at the supernatural" through Blake and Swedenborg.[17] Vedder was influenced by Blake in many ways, but in his autobiography he readily admitted that he found the English artist too pessimistic, too esoteric:

301. JOHN LA FARGE. *"This Was a Spray the Bird Clung To."*
Study for frontispiece of Robert Browning's *Men and Women*.
1861. Pencil on glass, 10¾ x 8⅝". National Collection of Fine
Arts, Smithsonian Institution, Washington, D.C.

302. JOHN LA FARGE. *The Wolf Charmer*. Illustration in *Riverside
Magazine for Young People,* 1867. Wood engraving. Engel
Collection, Columbia University Libraries, New York City

303. JOHN LA FARGE. *The Fisherman and the
Djinn.* Illustration in *Riverside Magazine for
Young People,* 1868. Wood Engraving. Engel
Collection, Columbia University Libraries,
New York City

304. ELIHU VEDDER. *The Cumean Sibyl.* 1876. 38 x 59". The
Detroit Institute of Arts (Purchase, The Merrill Fund)

305. ELIHU VEDDER. *Omar's Emblem.* Illustration in *Rubáiyat of Omar Khayyám,* Houghton, Mifflin and Company, Boston, 1884. Heliogravure. New York Public Library

306. ELIHU VEDDER. *The Inevitable Fate.* Illustrated page with verses 55–58, *Rubáiyat of Omar Khayyám,* Houghton, Mifflin and Company, Boston, 1884. Heliogravure. New York Public Library

307. ELIHU VEDDER. *The Soul's Answer.* Illustrated page with verses 70–71, *Rubáiyat of Omar Khayyám,* Houghton, Mifflin and Company, Boston, 1884. Heliogravure. New York Public Library

308. ELIHU VEDDER. *The Fates Gathering In the Stars.* Illustrated page with verses 72–74, *Rubáiyat of Omar Khayyám,* Houghton, Mifflin and Company, Boston, 1884. Heliogravure. New York Public Library

309. WILLIAM BLAKE. Illustration for Edward Young's *The
Complaint or Night Thoughts on Life, Death, and Immortality*,
folio 81. 1797. Engraving with color wash, 17⅜ x 13½".
British Museum, London

. . . it is only by the fitful gleams of his dawns or sunsets over seas of blood that we
see but cannot understand the workings of his wayward spirit. And what is it all
about? It is, that what seems real is not real, and what seems not real is real, and that
all is imagination. . . . Blake thought that Swedenborg and Christ were right
enough when explained by Blake. . . .[18]

A contemporary critic noted the affinity between the content of Vedder's previously
admired "imaginative works" and the mysticism of the *Rubáiyat*, and proceeded to com-
ment:

The present century has given us at least four great artist individualities preeminent
in imaginative power: William Blake, Arnold Boecklin, William Rimmer, and
Elihu Vedder.[19]

And as late as 1923 Royal Cortissoz wrote of Vedder's work for the *Rubáiyat*:

He had the mind and the spirit of a poet and responded to the magic of Fitzgerald's
quatrains with a clairvoyant sympathy, leaving in his pictorial accompaniments one
of the greatest monuments in modern illustration.[20]

*Decorative
Painting
and Sculpture
in America*

227

In the closing pages of his *Rubáiyat* Vedder explained some of his visual symbols: in particular, the volute swirl represented the transitory nature of life; forms in floating motion visualized an evolutionary concept, the continual transformation of life forms. Throughout, he represented wind, water, and flying forms by linear rhythms and patterns, and his *Rubáiyat* illustrations prefigure later nineteenth-century Symbolist and Art Nouveau works: the destructive Sphinx (for him "the all-devouring Sphinx typifies Nature, the Destroyer, eminent above the broken forms of life"); the spiral composition; the "ideal" enigmatic profile (plates 310, 311). Likewise John La Farge's "The Seal of Silence" for *Enoch Arden* prefigures Symbolist representations of reverie (plates 312, 313).

William Rimmer—sculptor, painter, draftsman, art teacher, and physician—was also an artist of linear illustrations of mythology and psychological mysticism. Stimulated by Shakespeare, Beethoven, and Blake, Rimmer created strange and evocative works, such as the full-page drawing *The Call to Arms* for his *Art Anatomy*, published in 1877 (plate 314). His work often recalls themes and styles of Neoclassical Romantics, such as Blake, Ingres, and the Nazarenes, and of Dutch Mannerist engravings and other European sources (plates 315, 316). He never traveled in Europe; one of his students remarked that it would have been good if the artist had "seen the pictures and sculpture which he knew by heart from engravings and copies."[21]

Doctor Rimmer's multifaceted career reflected several artistic developments in the American socio-economic atmosphere of 1860–90. Desperately poor for most of his life, Rimmer ventured into one scheme after another in pursuit of the great American dream of wealth and fame. In 1864 he wrote *Elements of Design*, and proposed the formation of a school of textile design in Boston; stimulated by optimism for new inventions, he applied for patents for projects as diverse as a large public aquarium for the city of Boston, and an improved gun-lock. But his plans and schemes brought only further financial trouble. In the face of death and neglect, his mood became tragic and despairing:

> But what better am I than other men in this hard world, where Nature holds dominion, and Nature alone,—where the cold wind has no mercy, the storm no feeling; where all the elements do their will, and all the powers move at pleasure? We are but mites who live in spite of forces that do their spite as they are moved, as they must do at all times. What better am I than others, who as atoms crawl by the force that is in them beneath the clouds, in sunshine and rain, heat and cold, upon this damp crust? . . . I believe in the existence of a spirit world and of immortality: but what good does that do us?[22]

How well the poetry of Omar Khayyám suited his thoughts:

25

Alike for those who for to-day prepare,
And those that after some to-morrow stare,
A Muezzin from the Tower of Darkness cries,
"Fools! Your reward is neither here nor there."

. . .

28

With them the seed of wisdom did I sow,
And with my own hand wrought to make it grow.
And this was all the Harvest I reap'd—
"I came like Water, and like Wind I go."

. . .

310. RAOUL DE GARDIER. *The Sphinx and the Gods*. 1894. Musée des Beaux-Arts, Orléans

311. ODILON REDON. *Woman in Profile with Wreathed Head*. c.1890–95. Charcoal on paper, 19⅝ x 14½″. Rijksmuseum Kröller-Müller, Otterlo

A moment's halt—a momentary taste
Of Being from the Well amid the Waste—
And Lo!—the phantom Caravan has reach'd
The Nothing it set out from—Oh make haste!

Rimmer and William Morris Hunt were among the principal artists in Boston from 1861 until the year they both died, 1879; retrospective exhibits for each were held in 1880. Teachers (John La Farge referred to Rimmer as "my old professor in anatomy") and lecturers as well as practicing artists, these two men differed greatly in their training, attitude, and personality. Yet the French-trained Hunt, on receiving his mural commission for the New York State Capitol in Albany, consulted with Rimmer, who redrew for him the composition of *The Discoverer*.[23]

The tightly woven story of decorative mural painting in the last quarter of the nineteenth century developed from the continual interaction of men like Hunt, La Farge, and Vedder (although Vedder lived mostly in Italy) with one another, and with architects like H. H. Richardson and later the firm of McKim, Mead, and White. Just as Richardson had engaged La Farge to create successful interior decorations for Trinity Church, so that architect, when called upon in 1878 with Leopold Eidlitz to advise on completing the New York State Capitol in Albany, commissioned Hunt to paint two murals for the arches in the Assembly Chamber. Hunt chose for one mural a theme based on a Persian poem given to him by his brother in 1846, *Anahita, the Queen of Night* (plate 317), and for the other, Christopher Columbus as *The Discoverer* (plate 318). Hunt was very eager to begin, but he faced the usual problem plaguing American mural painters: architects and construction teams were not prepared to make way for decorators. He received the commission in June, but the scaffolding was not ready until September, leaving about two months for the artist to accomplish his work. Hunt eschewed the French muralists' method, to paint on canvas which was then applied to the wall, and insisted on "direct painting" in oil on stone. His completed murals received high praise and the state legislature voted $100,000 for more work by him. But the artist's elation was short-lived for the governor vetoed the bill, citing the general lack of public interest in art and the tax money already wasted by previous architects.[24] This blow, compounded with feverish exhaustion after painting the murals, which began to disintegrate almost immediately, stunned Hunt. He was found drowned a few months later.

Hunt's painting style was broadly simplified, resembling that of his idol, the French Barbizon artist Millet, and he attempted to align his compositions inside the arches without relying on classical symmetry. He suggested rhythmic dynamism in an atmospheric but undefined space by the sweeping curves of the canopied mother and child, the crescent form of Anahita, and the repeated curves of the plunging horses. Continuous curves and dramatic contrasts of large areas of light and dark created a surface pattern within the essentially naturalistic, "painterly" handling, still clearly to be seen in the figure of Fortune in the study for *The Discoverer*.

In contrast to the tragic outcome of Hunt's murals, John La Farge's work in Trinity Church had solidly established the principle of having painted decorations in large buildings. La Farge continued, however, to combine Byzantine-inspired decorative forms with figural images in a broad, Venetian sixteenth-century style. In his successful mural of 1888, *The Ascension of Christ* in the Church of the Ascension in New York (plate 319), he used the monumental Renaissance tradition of Masaccio and Raphael as well as Japanese landscape concepts, the combination held together by pervasive color and light. During the rest of his life La Farge received more commissions than he could accept; ill health required him to leave most of the actual painting to assistants, who worked from his small watercolor sketches. As early as the 1870s his venture into large-scale mural decoration, as well

312. JOHN LA FARGE. *The Seal of Silence.*
Illustration for Tennyson's *Enoch Arden,* Ticknor
and Fields, Boston, 1865. Wood engraving.
Harvard College Library, Department of Printing
and Graphic Arts, Cambridge, Mass.

313. FERNAND KHNOPFF. *Le Silence.* 1890. Pastel on paper, 33½ x 16⅛".
Musées Royaux des Beaux-Arts de Belgique, Brussels

314. WILLIAM RIMMER. *The Call to Arms*. 1876. Pencil drawing for illustration in *Art Anatomy*, Little, Brown, and Company, Boston, 1877. Museum of Fine Arts, Boston (Stephan Bullard Memorial Fund)

as into graphic illustration, had proved successful, and was therefore influential; but his own style remained a "compromise between the natural and the conventional,"[25] apart from a certain amount of Japanese patterning and symbolist subject matter (plate 320).

The World's Columbian Exposition of 1893 in Chicago presented major opportunities to artists wishing to establish a reputation in the field of monumental decoration. During the 1890s converged the previous developments in the applied arts; in the two-dimensional decorative language of Art Nouveau, with its frequently symbolist literary content, many American painters found a new vocabulary for mural painting as well as for poster design and graphic illustration. Mary Cassatt's large mural in the Woman's Building, *Modern Woman*, consisted of a shallow space created by flattened figures and decorative elements of clothing and landscape (plate 321).

Francis D. Millet, who had worked with La Farge at Trinity Church, was in charge of assigning the Exposition's mural decorations. Since America had no "school" of monumental decorators and few experienced artists, Millet selected a group mostly of young artists, nearly all of them from the East; Elihu Vedder, invited from Rome to be one of the eight decorators for the Manufacturers' and Liberal Arts buildings, was treated with a certain reverence as a "grand old man" by the younger painters, Robert Reid, J. Alden Weir, Edwin Blashfield, and Kenyon Cox. Vedder was beset with panic, fear, and depression, however, at the seemingly insurmountable problems of the job—too little time, no preparations for the painting, dangerous working conditions—and when offered $20,000 by the railroad magnate C. P. Huntington for a decorative mural scheme for his Fifth Avenue mansion, Vedder hurried back to Rome and created an allegorical series on the theme of Abundance (plate 322), appropriate enough for a man of Huntington's wealth. Displaying Raphaelesque concepts of classical figures within clear architectural forms, Vedder's dec-

315. WILLIAM RIMMER. *Flight and Pursuit*. 1872. 18 x 26¼". Museum of Fine Arts, Boston (Bequest of Miss Edith Nichols)

316. WILLIAM RIMMER. *Dying Centaur*. 1871. Museum of Fine Arts, Boston (Bequest of Miss Caroline Hunt Rimmer)

317. WILLIAM MORRIS HUNT. *The Flight of Night*. 1878. Oil sketch for *Anahita, the Queen of Night*, deteriorated mural in Assembly Chamber, New York State Capitol, Albany. Museum of Fine Arts, Boston (Gift of H. N. Slater, Mrs. E. S. Kerrigan, and Mrs. Ray Slater Murphy)

318. WILLIAM MORRIS HUNT. *The Discoverer*. 1878. Sketch for Christopher Columbus and Fortune, deteriorated mural in Assembly Chamber, New York State Capitol, Albany. Black chalk, 11⅜ x 17½". Fogg Art Museum, Harvard University, Cambridge, Mass. (Purchase, Louise E. Bettens Fund)

319. JOHN LA FARGE. *Ascension of Christ*. 1888. Mural in apse of Church of the Ascension, New York City.

320. JOHN LA FARGE. *Bridle Path, Tahiti*. 1891. Watercolor, 18 x 20″. Fogg Art Museum, Harvard University, Cambridge, Mass. (Gift of Edward D. Bettens to the Louise E. Bettens Fund)

321. MARY CASSATT. *Modern Woman*. 1893. Portion of panel of mural in Woman's Building, World's Columbian Exposition, Chicago (photograph courtesy Chicago Historical Society)

oration was successful if thoroughly traditional. He went on to paint a mural of *Rome* for the Bowdoin College Museum of Art (plate 323), a commission of the Walker sisters procured by his architect friend Charles McKim, recently Vedder's guest in Rome. In these murals contemporary writers found form and flowing line (Vedder was consistently criticized for his poor color sense; as Cortissoz put it, he was a "good draughtsman, but never learned how to paint"[26]), and satisfying design which "illustrates the spiritual qualities which underlie all art." The final event in Elihu Vedder's career as a muralist was his work in 1896 for the Library of Congress in Washington, D.C., a commission first refused by John La Farge. These murals rely on academic classicism, Vedder's usual decorative curves adding a certain note of Art Nouveau "modernity." His greatest delight came in completing the staircase mosaic, a six-by-twelve-foot *Minerva*, because the commission had been given up by Abbott Thayer and offered to and refused by La Farge before the award to Vedder in 1896 (plate 324).[27] He received other offers, but the aging artist was discouraged by the absence of interest in his easel paintings and returned to his quiet life in Rome.

The success of the Chicago Exposition effected one great gain that was psychological rather than artistic. In 1893 New York City established a Municipal Art Society intended to "raise public taste," and in support of it Edwin Blashfield wrote "A Plea for Municipal Art." The social movement to bring art to the public culminated in the National Society of Mural Painters, founded in 1895, having as its objective:

> . . . to promote the delineation of the human figure in its relation to architecture, whether rendered in pigment, stained glass, mosaic, tapestry, or other medium, and at the same time to foster the development of its ornamental concomitants.[28]

Private patrons of mural painting in the 1890s included Huntington, the Walker sisters, and Henry Hardenberg, who engaged Frederick Crowninshield and Will H. Low to decorate the first Waldorf-Astoria Hotel. But greater support was sought for public architectural decoration. A high point in the ideal "marriage of the arts" in the nineteenth century was the design of the Boston Public Library as a Renaissance palace.[29]

Charles Follen McKim, a Paris-trained architect who worked with Richardson on drawings for Trinity Church, completed his Neoclassical design of the Boston Public Library in 1888. McKim had planned from the first to have sculptural and painted decorations for the building. Calling upon close friends, McKim gathered in Augustus Saint-Gaudens, his brother Louis Saint-Gaudens, and Daniel Chester French to provide the sculpture. To paint the murals Augustus Saint-Gaudens argued for John Singer Sargent, Edwin Abbey, and, through Sargent, James McNeill Whistler, together with the famous French artist Puvis de Chavannes.

For Sargent and Abbey, young men living in London and totally inexperienced in mural design, the challenge was great. Abbey had made a name in magazine and book illustrations; Sargent's reputation rested on his portraits. Sargent arranged a dinner in Paris in 1890 with McKim and Whistler, hoping to attract the latter into the mural project. Whistler's experience in interior design made him a logical choice, and informally a large panel in Bates Hall was reserved for him.[30] Contract negotiations with Whistler collapsed in 1895 and the work was never completed, but he painted a small sketch of his idea in watercolor; choosing the familiar theme of the "discovery," Whistler sketched *The Landing of Columbus* flanked by the queens of Spain and England as the patronesses of exploration (plate 325). This blue and gray study has a delicate, active symmetry which would have made an excellent mural for the gray walls of Bates Hall.

The library was opened in March 1895, the mural decorations being added over the next two decades. Abbey and Sargent installed the first sections of their work in April, to extremely favorable critical reaction. Abbey's *Holy Grail* scenes were largely illustrative, and relied on a professional format to keep intact the two-dimensionality of the walls; the scarlet and gold color scheme echoed the "rouge antique" marble of the door frames and man-

322. ELIHU VEDDER. *Dea Fortuna Resta Con Noi (Goddess of Fortune, Remain with Us).* Mural in series *Allegory of Abundance,* for C. P. Huntington mansion, New York City. 1893. 30¾ x 58¾". Yale University Art Gallery, New Haven (Gift of Archer M. Huntington, B.A., 1897)

323. ELIHU VEDDER. *Rome* or *The Art Idea.* 1894. Mural in Walker Art Building, Bowdoin College, Brunswick, Maine (Gift of the Misses Walker)

324. ELIHU VEDDER. *Minerva.* 1897. Copley print of mosaic on staircase, Library of Congress, Washington, D.C.

tels. This illustrator-turned-muralist was immediately elected an honorary member of the American Institute of Architects. Sargent's paintings on the theme of the World's Religions were also highly praised as "powerful and most original works, which will hold their own with any decorative masterpiece of modern times" (plates 326–28).[31] Both artists' murals became well known to a broad public through "Copley prints," distributed by Curtis and Cameron. Ernest Fenollosa claimed in 1896 that "by this first blaze of achievement we set Boston as the earliest of the seats of public pilgrimage, the veritable Assisi of American art."[32]

In contrast to Puvis de Chavannes' "intellectual" allegories of *Poetry, Philosophy, History,* and *Science* (plate 329), Abbey's subject matter, drawn from Tennyson's familiar *Idylls of the King,* and the exhaustive religious symbolism in Sargent's *Judaism and Christianity* appealed more strongly to many Americans. In *American Mural Painting* (1902), Pauline King praised the "striking originality" and "spirit of grandeur" of Sargent's works, referring to his theme as *The Triumph of Religion* and declaring that the subject "reflects the thought of our own time as strongly as [Michelangelo's] *Last Judgement* does that of the earlier period."[33]

In its intellectual and pictorial complexity Sargent's work does seem an attempt to rival the great fresco series of the High Renaissance. Sargent abandoned his famous realistic style and kept well in mind the decorative, hieratic function of his paintings, relying on his vast, eclectic studies of sources, from Egyptian to medieval. He wrote to a friend in 1890:

> This Boston thing will be *(entre nous)* Medieval, Spanish, and religious, and in my most belly achey mood—with gold, gore and phosphorescent Hellens. What a surprise to the Community![34]

The tone of this letter suggests the artist's curious attitude toward conservative Boston. It is hard to imagine that the many non-Christian themes and heavily "anti-classical" style do not partly reflect his Continental condescension toward the poverty of appreciation for "modern" art in America, particularly in Boston. The *Astarte* fresco, according to a biographer in 1925, was an example of Sargent's European-based eclecticism: he "derived his ideas of Astarte's character from Flaubert's *Salammbô,* while he utilized as a model for the moon goddess' personal appearance an archaic statue in Athens."[35] When Sargent gave a sketch of *Astarte* to Sir Frederick Leighton he accompanied it with a quotation from Milton's *Paradise Lost:*

> Came Ashtoreth, whom the Phoenicians
> Called Astarte, queen of heaven, with crescent horns;
>
> . . .
>
> Her temple on the offensive mountain, built
> By that uxorious king whose heart, though large,
> Beguiled by fair idolatresses, fell
> To idols foul. . . .[36]

Surrounding this hieratic "queen of heaven" are esoteric symbols, vague souls, and serpents. The linearity, frontality, and curvilinear forms with their symbolic intent, together with extremely rich ornament and Byzantine decoration, suggest both Gustave Moreau and Jan Toorop (plate 330), as well as Rossetti's 1877 precursor, *Astarte Syriaca* (plate 331).

The image of woman as idol is related to Sargent's earlier famed portrait of Madame Gautreau (*Mme. X;* plate 332). This work was exhibited in Paris in 1884; the tiny crescent in her hair was a recognizable symbol of Diana the Huntress, while the refined contour and unnatural coloring were seen by a contemporary French writer to depict a type of woman, the professional beauty, who often became idolized in late nineteenth-century society;[37] Sarah Bernhardt was another such figure. As the same critic put it, "the design was his

325. JAMES MCNEILL WHISTLER. *The Landing
of Columbus*. 1890–95. Watercolor and
gouache on panel. Study for unexecuted
mural, Bates Hall, Boston Public Library.
Collection Boston Public Library (Gift of
Miss Rosalind Birner-Philip, 1950)

326. JOHN SINGER SARGENT. *Astarte*. 1890s–1916. Mural in vault above upper landing, Boston Public Library

327. JOHN SINGER SARGENT. *Mater Dolorosa*. 1890s–1916. Mural, Boston Public Library

328. JOHN SINGER SARGENT. *Hell*. 1916. Cartoon for one of six lunettes in Boston Public Library; 33¼ x 66¼". Smith College Museum of Art, Northampton, Mass. (Gift of Mrs. Dwight W. Morrow, 1932)

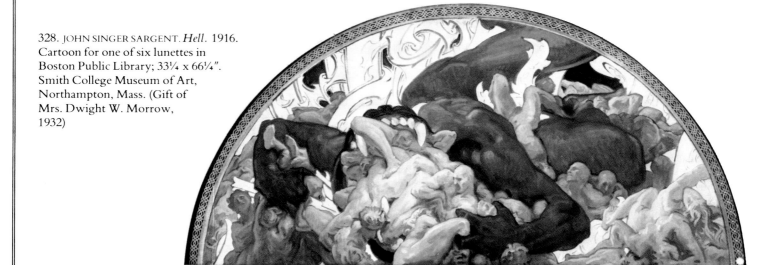

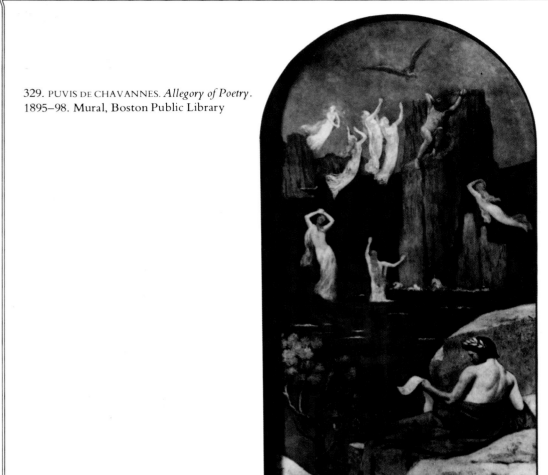

329. PUVIS DE CHAVANNES. *Allegory of Poetry.*
1895–98. Mural, Boston Public Library

chief objective . . . as a result of his perseverance in observing and fixing the manner of being of the idol, we have a work not only of refinement, but also of great carrying power." The Egyptian or Assyrian goddess *Astarte* in Boston continued Sargent's symbolist concept of the female as goddess, bewitching and destructive. And the similarity shared by *Astarte* and the Virgin, in Sargent's mural *Mater Dolorosa,* implies that the artist was aware also of the complex, decadent symbolism of the female as virgin and seductress combined (see plate 327). He described Astarte (in contrast with her counterpart, Moloch, "god of material things") as "the beautiful, soulless figure . . . goddess of sensuality, veiled in blue, standing upon the crescent, and surrounded by enticing female figures and prostrate victims."[38]

Sargent frequently changed his style as the murals progressed over a sixteen-year period. The earlier solidity and realism of the *Prophets* gave way to an Art Nouveau vocabulary in the *Astarte* murals and the grotesque *Hell* lunette, where monster and flames merge in decorative continuous curves (see plate 328).

The mural tradition that began in Chicago in 1893 continued uninterrupted by the artistic innovations of Post-Impressionism abroad and the avant-garde revolutions of Expressionism and Cubism. Robert Reid's decorations at the Panama–Pacific International Exposition in San Francisco in 1915 are still unified by facile Art Nouveau, Japanese-inspired curves, the pale pastel colors now borrowed from Puvis de Chavannes (plate 333).

Decorative
Painting
and Sculpture
in America

Besides Reid's murals, the works hanging in the Palace of True Arts included many names of those gathered together in Chicago twenty-two years before: Weir, La Farge, Whistler, Sargent, and Chase. For most Americans, living with a thirty-year artistic time lag, the modernism exhibited in 1913 at the Armory Show in New York was a brutal shock (plate 334); the majority were just beginning to absorb Whistler's concept of a painting as an "expressive arrangement" of formal elements rather than a literary illustration.

After 1900 the themes and images of the mythological tradition were mostly relegated to actual illustrations of literature, such as Leyendecker's Blake-inspired illustrations for "Love Songs from the Wagner Operas" in *The Century Magazine* in 1902 (plates 335, 336). As late as 1920 the American illustrator Dorothy Lathrop still used the flat, curvilinear Art Nouveau style for her imaginary, psychologically disturbing sea and snow creatures; Elihu Vedder's *Sea Serpent* is their ancestor, though far removed.

In American portraiture, as opposed to literary art, there was more awareness of Whistlerian concepts of aesthetic composition and expressive arrangement; Whistler's greatest impact on American painters was perhaps in this area. Sargent was ranked with Whistler by Charles Caffin in 1902, the two described as "the very few distinctly notable painters of the present day." Similarities in both symbolism and style can be found in works as far apart in time as Whistler's *Symphony in White, No. 1: The White Girl* of 1862 and Sargent's *Mme. X* of 1884 (plate 337; see plate 332). Whistler's portrait was interpreted at the time of its success at the *Salon des Refusés* as "an allegorical representation of the morning after the wedding night"; to a recent critic the title itself "reveals a special attitude; it underlines his sympathy for the idea of virginity, which is discernible in the cult of the 'stunners' then current in mid-Victorian artistic circles. The concept of idolising one's mistress . . . is clearly connected with the romantic imagery of the Pre-Raphaelites."[39] The artist's portrait "arrangements" established a line of similar works in American art for the next half century, using symbolic and decorative elements to heighten physical and psychological realities. When Whistler expanded his interest in Japanese art, he also turned to the "classical" artists of his day—Ingres and Puvis de Chavannes—and to ancient Hellenistic works, formulating what has been called "a latter-day Hellenised Orientalism."[40]

Japanese woodcut prints of elegant ladies of the "floating world" of courtesans and actresses taught Western artists much about representing the single figure (plate 338). Together with the striking single-figure paintings by seventeenth-century Spanish artists, Japanese art provided Whistler with a radically linear decorative style which abstracted the figure into flat patterns. As early as 1859 John La Farge (married to Margaret Perry, niece of Commodore Perry, who had opened Japan to the West in 1853) used in his self-portrait a vertical format and a pose taken directly from a Japanese print (plate 339). The landscape tilts upward in space, the diagonal of the hat matches that of the horizon line, and the silhouette of the body accompanies the curve of the path; much the same tensions are created between the second and third dimensions as in Manet's work. In 1885 La Farge's friend William Merritt Chase portrayed Whistler in terms even more simplified (plate 340), the curves of the form taking on a truly Art Nouveau sense of abstract movement and of interplay with negative areas.

Decorative simplification became steadily more abstract and more symbolic, however, in the characterization of women. The figure in Whistler's "arrangement" of 1873, *Symphony in Flesh Color and Pink: Mrs. F. R. Leyland*, merges in and out of the incisive outline and the play of surface pattern (plate 341). The sweeping gown, profile view, and dreamy yet above-it-all expression of self-containment are also found in works by American painters influenced more or less by Whistler, such as John White Alexander's *A Quiet Hour* and, later, Robert Reid's *The Mirror* (plates 342, 343). Alexander met Whistler in Venice about 1880, and continued to admire him for the next twenty years. By the late 1880s Alexander was a well-known portraitist who had traveled frequently between America and England, Spain, and Morocco. He settled in Paris in 1890, and for the next eleven years he exaggerated the "aesthetic" qualities of his works. Three portraits entitled *Portrait Gris,*

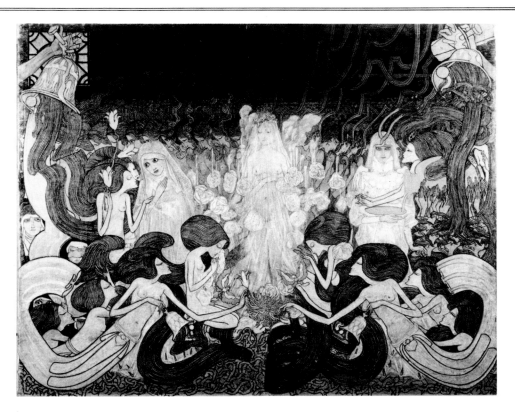

330. JAN TOOROP. *The Three Brides*. 1893. Chalk and pencil with white and color, on brown paper; 30¾ x 38⅝". Rijksmuseum Kröller-Müller, Otterlo

331. DANTE GABRIEL ROSSETTI. *Astarte Syriaca*. 1877. City Art Galleries, Manchester, England

332. JOHN SINGER SARGENT. *Portrait of Madame X (Mme. Gautreau)*. 1884. 82⅛ x 43¼". The Metropolitan Museum of Art, New York City (Arthur H. Hearn Fund, 1916)

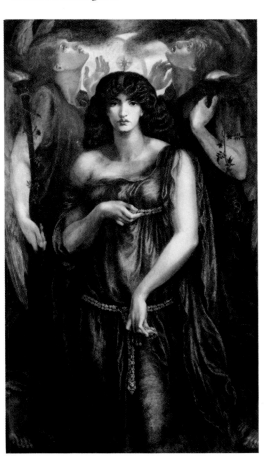

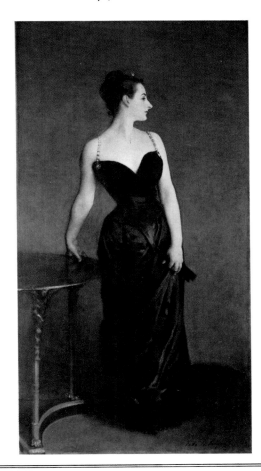

333. ROBERT REID. *Oriental Arts*. 1913. Oil sketch for mural decoration, Panama–Pacific International Exposition, San Francisco, 1915. Collection David David, Inc., Philadelphia

334. MARCEL DUCHAMP. *Nude Descending a Staircase, No. II*. 1912. 58 x 35″. Philadelphia Museum of Art (Louise and Walter Arensberg Collection)

335. WILLIAM BLAKE. Illustration for Edward Young's *The Complaint or Night Thoughts on Life, Death, and Immortality*, folio 349. 1797. Engraving with color wash, 17⅜ x 13½″. British Museum, London

336. JOSEPH C. LEYENDECKER. *Siegfried's Song*. Illustrated page for "Love Songs from the Wagner Operas," *The Century Magazine*, 1902(?)

337. JAMES MCNEILL WHISTLER. *Symphony in White, No. 1: The White Girl.* 1862. 84½ x 42½". National Gallery of Art, Washington, D.C. (Harris Whittemore Collection, 1943)

338. KWAIGETSUDŌ ANCHI (YASUTOMO). *Courtesan Walking.* 1st quarter 18th century. Woodcut, 22¼ x 12½". Art Institute of Chicago (Gift of Miss Katherine Buckingham to the Clarence Buckingham Collection)

339. JOHN LA FARGE. *Portrait of the Artist.* 1859. Oil on wood, 16 x 11½". The Metropolitan Museum of Art, New York City (Samuel D. Lee Fund, 1934)

340. WILLIAM MERRITT CHASE. *Portrait of James A. McNeill Whistler.* 1885. 74⅜ x 36¼". The Metropolitan Museum of Art, New York City (Bequest of William H. Walker, 1918)

341. JAMES MCNEILL WHISTLER. *Symphony in Flesh Color and Pink: Mrs. Frederick R. Leyland.* 1873. 77⅛ x 40¼". © The Frick Collection, New York City

342. JOHN WHITE ALEXANDER. *A Quiet Hour.* c.1900. 48 x 36". Pennsylvania Academy of the Fine Arts, Philadelphia (Temple Fund Purchase, 1904)

343. ROBERT REID. *The Mirror.* c.1910. 37⅜ x 30⅜". National Collection of Fine Arts, Smithsonian Institution, Washington, D.C. (Gift of William T. Evans)

344. JOHN WHITE ALEXANDER. *The Crowning of Labor,* one of four mural panels representing
The Apotheosis of Pittsburgh. 1906–7. Museum of Art, Carnegie Institute, Pittsburgh

Portrait Noir, and *Portrait Jaune* were featured at the 1893 Société Nationale des Beaux-Arts and he was elected an associate of the society; two of the portraits were exhibited at the Grafton Gallery in London. His fame assured, Alexander continued to win gold medals, awards, and commissions for murals in America, including the Library of Congress in Washington and the Museum of Art, Carnegie Institute, in Pittsburgh (plate 344).

In 1914 Margaret Steele Anderson described Alexander's female portraits in her *The Study of Modern Painting*. She considered one of these to be:

> . . . much less a figure than an arrangement. As a rule it has nothing to say, it is only a decorative thing with a long, sweeping line, so much longer and more sweeping than others that it has become known as "the Alexander line."[41]

She continued, "it is this trend towards the decorative design that makes the man far better in mural work than in figure painting."

Robert Reid's *The Mirror* is almost identical in concept. Called a "decorative Impressionist" by Christian Brinton in 1911, Reid was known in America for his mural paintings in the Liberal Arts Building of the Chicago Exposition; in the Library of Congress (plate 345); in the U.S. Pavilion at the 1908 Paris Exposition; and others, up to the San Francisco Fair of 1915 (see plate 333). He had absorbed artistic atmosphere at the Académie Julian in the 1880s, and then assimilated the floral-female imagery of Art Nouveau, adding a "broadly decorative and delicately sentimental" touch. His favorite theme was "young and radiant womanhood seen amid variegated clusters of leaf, bud, and blossom." As Brinton put it in 1911:

> None of our painters have shown more sympathy with French aesthetic ideals than Mr. Reid. His work is devoid of any spiritual, philosophical or philanthropic pretensions. It exists for itself alone, and persistently sings of youth, sunlight, flowers, and supple rhythmic forms and contours.[42]

Reid's *The Mirror* is even less abstract than Alexander's portrait, especially in the treatment of arms and hands; as here, a Japanese screen supplies an exotic background, and Reid applies his paint over all in a free, "sometimes even careless" manner. His mural painting perhaps shows some effects of his work in stained glass, as well as of the linear design of French posters. The figures in his Library of Congress murals are similar to the French floral-females by the famed Alphonse Mucha, whose *Rêverie du Soir* became available in a chromo-panel by the Taber-Prang Art Company of America shortly after 1900 (plate 346). One need only compare these works with the stained-glass window made in 1895 by Tiffany after Pierre Bonnard's design (see plate 87) to see how different are Bonnard's radically abstracted forms from the smooth, conventionalized naturalism of Mucha and Reid. Another decorative artist is Frederick Frieseke, considered an American Impressionist, who also went through the Académie Julian in the late 1890s and was said to have worked with Whistler ("for at least a week"!). He exhibited in Paris *Salons*, decorated the Shelbourne Hotel in New York, and became an associate of the Société Nationale des Beaux-Arts in 1910. A French critic described the artist's work in 1904 as "impregnated" with the French school and reflecting the style of Degas, Fantin-Latour, and "*chose curieuse*," Jules Chéret (plate 347).[43]

Earlier critics had insistently read symbolic meaning into Whistler's and Sargent's portraits; twentieth-century American critics were equally insistent that works by Alexander and Reid were decorative arrangements. This change in attitude clearly reflects the turn away from nineteenth-century literary symbolism. Sargent's *Astarte* compares most readily with Rossetti's earlier transcendental version of the subject (see plates 326, 331), while his *Mme. X* seems to foreshadow Art Nouveau posters, such as Bradley's famous *Blue Lady* poster for *The Chap-Book* and John Sloan's for *The Echo* (plate 348; see plates 240, 332).

345. ROBERT REID. *The Sense of Touch,* one of a series of murals. c.1895. Library of Congress, Washington, D.C.

346. ALPHONSE MUCHA. *Rêverie du Soir.* c.1900. Chromo-panel by Taber-Prang Art Company of America. Hallmark Historical Collection, Kansas City, Mo.

347. FREDERICK
FRIESEKE. *The Yellow
Room, Afternoon.*
1910. 32¼ x 32".
Indianapolis Museum
of Art

348. JOHN SLOAN. Poster for *The Echo.*
c.1895. Philadelphia Museum of Art

But Alexander's famous literary picture of 1897, *Isabella and the Pot of Basil*, has little in common and makes a curious comparison indeed with the earlier naturalistic treatment of this weird necrophiliac theme by the Pre-Raphaelite Holman Hunt, and so does that by Alexander's contemporary, the Englishman William MacDougall (plates 349–51).

Far from the bustling world of fashionable portraits and fabulous commissions for decorative art, a few American painters, among them George Inness, Ralph Blakelock, and Albert Pinkham Ryder, remained individualists, their work largely ignored or rejected by the public and by wealthy collectors. Closely allied to Romanticism, these American painters expressed intense mystical or transcendental attitudes toward nature that carried their paintings beyond merely transcribing their perceptions.

George Inness, the oldest among American symbolist landscape painters (1825–1894), based his style on the Barbizon School while studying in France in the early 1850s, citing Rousseau, Daubigny, and Corot as his particular influences. His early work has an atmospheric naturalism in sharp contrast with the later flat, silhouetted, linear structure of *The Monk* (plates 352, 353), painted in 1873 in Italy. The patterns and simplified colors of *The Monk* evoke a haunting reflective rhythm that calls to mind the Romantic "monk on the seashore" paintings by Caspar David Friedrich (plate 354). Inness himself recognized two tendencies in his work:

> I have always felt that I have two opposing styles, one impetuous and eager, the other classical and elegant. If a painter could combine the two he would be the very god of art.[44]

This driving goal, to merge painterly with linear, romantic with classical, lay behind much of nineteenth-century French art; it was attempted by Géricault, Chassériau, Manet, and Whistler, and variously achieved by the great Post-Impressionists. The abstract, two-dimensional character of *The Monk* may reflect "some contact with Japanese art or with Western Art influenced by it, such as work by Whistler, for example,"[45] but Inness' moonlit darkness and intense emotion are wholly unlike Whistler's aesthetics and muted color harmonies. Nevertheless, the asymmetrical patterning of horizontal elements on a diagonal that curves upward has a similarity with Japanese art. *The Monk* is an anomaly among Inness' early works; only in his last decade, in 1884–94, did he synthesize atmospheric mystery with formal unity (plate 355), his painterly strokes used in geometric grid constructions and the intensity of his content bringing him into the realm of the Post-Impressionists. Unlike the Symbolists, who avoided natural realities, Inness declared that "art must appeal to the mind through the senses."[46] As an American landscapist he battled for the forces of spiritual truth (idealism, imagination) against materialistic (realistic) concerns. Like many others, Inness believed strongly in Swedenborgian correspondences between the natural and spiritual worlds (a topic he had discussed with Vedder and Ellis in Perugia, two years before he painted *The Monk*), and he continued to pursue that philosopher's ideas whenever the chance arose. In 1894 the *New York Times* described the memorial ceremony held for Inness at the Academy of Design:[47]

> Those who knew Inness knew how impatient of contradiction he was in his religious faith. He talked for hours of the Swedish philosopher, . . .
> In Swedenborg, Inness found the basis for his theory of art. . . . To him all nature was symbolic—full of spiritual meaning. He prized nothing in nature that did not stand for something. . . . He cared for no pictures that did not tell a story; not necessarily to common minds by this kind of symbolism, but telling a story to the feelings which it suggested, and to the thought to which it gave expression.

Needless to say, George Inness considered what he knew of Impressionism to be "humbug." He wrote in 1884:

349. JOHN WHITE ALEXANDER. *Isabella and
the Pot of Basil*. 1897. Museum of Fine Arts,
Boston (Gift of Ernest Wadsworth Longfellow)

350. WILLIAM HOLMAN HUNT. *Isabella and the Pot of Basil*. 1866. Laing Art Gallery and Museum, Newcastle upon Tyne, England

351. WILLIAM BROWN MACDOUGALL. Illustration for John Keats' *Isabella or the Pot of Basil,* Kegan Paul, Trench, Trübner and Company, London, 1898. Harvard College Library, Department of Printing and Graphic Arts, Cambridge, Mass.

352. GEORGE INNESS. *Christmas Eve*. 1866. 22 x 30″. Montclair Art
Museum, Montclair, N.J. (Museum purchase, Lang Acquisition Fund)

353. GEORGE INNESS. *The Monk*. 1873. 39½ x 64″. Addison Gallery of American Art, Phillips
Academy, Andover, Mass. (Gift of Mr. Stephen C. Clark)

354. CASPAR DAVID FRIEDRICH. *Sea with Sunrise*. 1826. Drawing, sepia with pencil. Kunsthalle, Hamburg

355. GEORGE INNESS. *Moonlight in the Village*. 1893. 22 x 27″. The Fine Arts Museums of San Francisco (Gift of H. K. S. Williams)

It appears as though the Impressionists were imbued with the idea to divest painting of all mental attributes and, overlapping the traveled road which art has created by hard labor, by plastering over and presenting us with the original pancake of visual imbecility, the childlike naïveté of unexpressed vision.[48]

Especially in his late work the interplay of three-dimensional reality with two-dimensional pattern can be seen as a visual reflection of the fluctuating correspondence of the material with the spiritual. In his own words:

> In the art of communicating impressions lies the power of generalizing without losing that logical connection of parts to the whole which satisfied the mind.
> The elements of this, therefore, are the solidity of objects, and transparency of shadows in a breathable atmosphere through which we are conscious of spaces and distances. By the rendering of these elements we suggest the invisible side of visible objects. These elements constitute the grammar of painting, and the want of that grammar gives to pictures either the flatness of the silhouette or the vulgarity of an overstrained objectivity or the puddling twaddle of Pre-Raphaelitism.

Inness' imagery, simple landscapes that include water, shorelines, sky, moonlight, sunrise or sunset, and trees, belongs directly to the northern Romantic tradition of Caspar David Friedrich and his followers, and shows a fundamental need to "revitalize the experience of divinity in a secular world that lay outside the sacred confines of traditional Christian iconography."[49] In many of the works discussed here, "landscape is a continued repetition of the same thing in a different form and in a different feeling," as Inness expressed it.

Close to Friedrich in its absolute frontality is Elihu Vedder's strange sea-sky painting entitled *Memory* (plate 356), painted in 1870 and based on a small sketch made four years earlier in Dinan. The Mondrian-like symmetry of the repeating waves merging imperceptibly into the dark heavens is disrupted for the modern viewer by the vague frontal face of a child in the cloud forms. Vedder's contemporaries saw the "spiritual" implications of this work; one of them wanted a painting of "our little one that we lost this summer . . . taken in some way like your *Memory* [it] would be better than a regular portrait." In his autobiography Vedder remarked that the sketch was "a mixture of Tennyson's 'Break, break, break' and memory of those left behind."[50] The following summer, when Vedder and Inness lived next door in Perugia, is described by Vedder's biographer:

> The summer of 1871 was even more crucial in Vedder's spiritual and artistic development because of the presence of Inness. There is no record, so far, of their conversations, although the influence of the mystic landscape is surely evident in their paintings. We can assume that philosophical topics were in order, that Swedenborg and Blake were discussed because of the presence of Edwin J. Ellis.[51]

Inness' late works rely more completely on nature itself, and in *A Silver Morning* of 1884 or *Moonlight* of 1893 his subject is the same as Ralph Blakelock's *Moonlight Sonata* of 1873–99 (plates 357, 358; see plate 355). Blakelock, one of the most reclusive individuals in American art, was, according to Elliott Daingerfield, an intense lover of the Old Masters, which he probably knew through photographic reproductions. His extreme subjectivity was reflected in "his habit of seeing pictures, compositions in everything—the markings of old boards; the broken or worn enamel in the bathtub being a field of great suggestiveness."[52] Besides noting Blakelock's subjective expression, his biographer wrote in 1914 of the design of the painting:

> The composition would give joy to a Japanese. It is definitely a design—a thing rare in our art—and depending for its balance upon the flat silhouette of a tree which fills the upper half of the canvas.[53]

356. ELIHU VEDDER. *Memory*. 1870. Oil on panel, 21 x 16". Los Angeles County Museum of Art (Mr. and Mrs. William Preston Harrison Collection)

357. GEORGE INNESS. *A Silver Morning*. 1884. 35½ x 45½". Art Institute of Chicago (Gift of Mr. and Mrs. Edward B. Butler)

358. RALPH BLAKELOCK. *Moonlight Sonata*. 1880s–90s. Museum of Fine Arts, Boston

The symbolism of Blakelock's moonlight scenes stemmed from the Romantic tradition of relating earth and water, water and sky, and tall trees, all seemingly impregnated by suffused moonlight. He often exaggerated the sense of mystery in his compositions by centering the full moon. Within Blakelock's scenes the enclosed, rhythmic movement drifts through a sequence of two or three frontal planes. His impasto has a rich texture, and suggestions of the infinite are fused by his layered brush strokes into finite, flat patterns.

Continuously and inhumanly cheated by wealthy "patrons," Blakelock tried desperately to care for his large family. He suffered a mental collapse in 1899, a final retreat to the inner recesses of the psyche.

Third among the major American symbolist landscape artists of the period was Albert Pinkham Ryder, more flexible but equally Romantic in his style. In addition to paintings such as *Siegfried and the Rhine Maidens* (see plate 298), on themes drawn from literature admired at the time (Wagnerian libretti, Longfellow, Poe, Chaucer, and Shakespeare), Ryder later created extremely simplified images of the night world, as in *Moonlit Cove* (plate 359). His method grounded on the dark tonalities and rich brushwork of the Barbizon masters, Ryder's paintings became visionary in the 1880s. He had spent one month in London in 1877; in 1882 he traveled more extensively through Europe and North Africa, seeing the art of Delacroix, Monticelli, El Greco, and Rembrandt, and Oriental works. He already knew about Oriental art in the late 1870s when he painted a three-panel screen on gold-leafed leather for his dealer, Cottier and Company (plate 360); the vertical, two-dimensional, curvilinear designs of the screen panels have obviously a Far Eastern source. These elements of design remain essential to his later mystical work. Ryder, even more than Blakelock, turned from representing external reality toward images formed by his inner vision, their meaning conveyed directly through rhythmic form in abstract patterns. His curvilinear rhythms, stronger than Blakelock's, bring him closer to the graphic style of Art Nouveau, although the translucent layers of his thick paint in a dark color range suggest the substance of the tangible world.

Ryder worked on his canvases over several years' time; he is said to have remarked: "I work altogether from my feeling for these things, I have no rule."[54] In *Moonlit Cove* the light from the full moon falls on the single, beached dory, which represents the end of man's voyage from the limitless sea to the enclosing earth, suggesting lonely melancholy, nature's immanence, and a reverie on the infinitely repeatable theme of life. The related movement of reversed curves—the dark earth with its boat, the sky with its moon—interlocks them in their opposition, similar to the Oriental yin-yang image. Ryder described his personal quest in a letter:

> Have you ever seen an inch worm crawl up a leaf or a twig, and then, clinging to the very end, revolve in the air, feeling for something, to reach something? That's like me. I am trying to find something out there beyond the place on which I have a footing.

By simplifying nature, Ryder expressed moods more drastically and abstractly than Inness; in 1885–87 Inness had used much the same elements in *Etretat* (plate 361), but treated them more naturalistically, with none of the explicit human connotations of Ryder's dory.

It is precisely this degree of simplification (albeit varying) and of dependence on curving line and flat plane that allies these paintings with the Art Nouveau style that flourished in the graphic arts of the 1890s, and thereby with the French Post-Impressionist group around Gauguin. Young Arthur Wesley Dow, who studied art in Paris from 1884 to 1889, spent his summers of 1885 to 1888 in Pont-Aven, and there he undoubtedly absorbed Synthetist-Symbolist concepts of composition and expression from the artists in Gauguin's circle (plate 362). Dow admired Puvis de Chavannes, and did much to obtain for him the mural commission for the Boston Public Library (see plate 329). It is well known that Dow, after working with Fenollosa in the Boston Museum of Fine Arts, became a main supporter of

359. ALBERT PINKHAM RYDER. *Moonlit Cove*. 1890–1900. 14 x 17″. The Phillips Collection, Washington, D.C.

360. ALBERT PINKHAM RYDER. *Children Pointing to a Rabbit; Children Playing with a Rabbit; Female Figure,* three panels for a screen. 1876–78. Oil on leather, each panel 38½ x 20¼″. National Collection of Fine Arts, Smithsonian Institution, Washington, D.C. (Gift of John Gellatly,1929)

361. GEORGE INNESS.
Etretat, Normandy, France.
1885–87. 30 x 45¼".
Art Institute of Chicago
(Edward B. Butler
Collection)

362. ARTHUR W. DOW.
Moonrise. 1916. 24¼ x 10".
Collection
Mrs. Harvey F. Short

Japanese art. His 1895 cover for *Modern Art* (see plate 245) shows the diagonal composition of simplified natural forms—sky and trees reflected in a river—of the American paintings discussed above. Here the combination of pictorial and graphic styles—the Symbolist poppies curving behind and thereby flattening the central space even more—exemplifies the congruence of Symbolist painting with Art Nouveau design at the end of the century.

A comparison of *Snowbound*, an American painting of 1885 by John H. Twachtman, with Henri van de Velde's cover design for Max Elskamp's *Salutations*, 1893, brings out underlying concepts that are shared by both works (plates 363, 364): flattened space, natural forms reduced to their essence of curvilinear and planar patterns, and strong rhythmical lines accentuated to convey the mood. Twachtman's expressive color, painterly strokes, and allegiance to the natural scene are not, of course, to be seen in the Belgian artist's graphic design. Will Bradley's March 1895 cover of *The Inland Printer* further simplifies landscape to a two-dimensional image (see plate 243).

Arthur Dow's continuous influence through two decades of the twentieth century came from his teaching, and from his widely used book, *Composition*. In 1914–15 at Teachers College of Columbia University, New York, he taught Georgia O'Keeffe, later his best-known pupil. From Dow's art and teaching she developed the style of abstract simplification, rhythmical lines, and light-and-dark patterns (plate 365) which she subsequently associated with Kandinsky's nonobjective experiments. Other American painters influenced by Dow were Max Weber, Marsden Hartley, and Arthur Dove.

The evidence is clear that the nonnaturalistic tendencies of certain American artists drew support after 1860 from the growing awareness of Japanese and other Oriental arts. In their search for a way beyond mere naturalism, artists found images in Oriental art which captured an essence of nature, its basic "life-movements" or forces, and used sophisticated design and craftsmanship to suggest these mystical or spiritual actualities. It was precisely this Japanese concern for nature blended with expressive, decorative (classical-linear) design and subtle color harmonies which attracted late nineteenth-century artists. The flat diagonal compositions lent the power and force of abstraction first to linear depictions of the imaginary, later to painterly images of nature—from La Farge's 1864 illustration of *Enoch Arden* to Winslow Homer's *Breaking Wave* of 1887 (plate 366; see plate 300), and including artists as seemingly diverse as Albert Ryder and Louis Tiffany (plates 360, 367). Homer's sinister *The Fox Hunt* derives its strength as late as 1893 from these visual terms (plate 368).

After 1900, young American painters became more aware of other facets of contemporary French art. Puvis de Chavannes' poetic murals of idyllic allegories in the Boston Public Library, the space shallow but less flattened than in graphic art or even in many oil paintings (see plate 329), consisted of two or more parallel planes in a vertical or horizontal format. A reflection of this manner can be seen in the works of Arthur B. Davies, in whose *Crescendo* of 1910 similar poses, movements, and forms are set against a schematic, suggestive landscape (plate 369), and in Edwin Abbey's murals for the State Capitol of Pennsylvania (plate 370). In contrast, Maurice Prendergast followed the Post-Impressionist trend of Seurat and the Nabis when he painted his *Eight Bathers* (plate 371).

Americans at the turn of the century in general avoided the decadence they saw in such artists as Toulouse-Lautrec. Fabricating instead their images of sweetness and light, wholesomeness and health, the Beaux-Arts-oriented American artists closed their eyes to the psychological and social realities in Lautrec's famous café, circus, and prostitute scenes of the 1890s (plate 372). Even the "social realist" group called The Eight avoided intense themes. No American version of Lautrec's *demi-monde* appeared until the introspective Charles Demuth[55] made his scenes of bars, among these *The Purple Pup* (plate 373). Using pencil and watercolor, he achieved abstract two-dimensional effects not dissimilar from those in Lautrec's famous *At the Moulin Rouge* of 1892 (plate 374). Demuth steeped himself in the decadence of J. K. Huysmans' novel *A rebours*, and was well acquainted with

363. (above, left) JOHN H. TWACHTMAN.
Snowbound. 1885. 25¼ x 30⅛". Art Institute of
Chicago (Friends of American Art Collection)

364. (above, right) HENRI VAN DE VELDE. Cover
of Max Elskamp's *Salutations,* Paul Lacomblez,
Brussels, 1893. 9 x 6¾". Harvard College
Library, Department of Printing and Graphic
Arts, Cambridge, Mass.

365. GEORGIA O'KEEFFE. *Spring.* 34½ x 30".
Vassar College Art Gallery, Poughkeepsie,
N.Y. (Bequest of Edna Bryner Schwab, 1967)

366. WINSLOW HOMER. *Breaking Wave*. 1887. Watercolor,
14 x 20½". Museum of Fine Arts, Boston

367. LOUIS COMFORT TIFFANY. *A Corner of
the 72nd Street Studio.* c.1896. 30¼ x 12⅛".
Yale University Art Gallery, New Haven
(Gift of Louis Tiffany Lusk)

368. WINSLOW HOMER. *The Fox Hunt.* 1893.
38 x 68". Pennsylvania Academy of the Fine
Arts, Philadelphia

369. ARTHUR B. DAVIES. *Crescendo*. 1910.
18 x 40". Whitney Museum of American
Art, New York City (Purchase)

370. EDWIN A. ABBEY. *Spirit of
Vulcan*. 1906. Lunette in rotunda,
Pennsylvania State Capitol,
Harrisburg (photograph courtesy
Pennsylvania Council on the Arts)

371. MAURICE PRENDERGAST.
Eight Bathers. Museum of Fine
Arts, Boston (Abraham Shuman
fund)

372. HENRI DE TOULOUSE-
LAUTREC. *In the Circus Fernando:
The Ring-master*. 1888. 38¾ x
63½". Art Institute of Chicago
(Joseph Winterbotham Collection,
1925)

373. CHARLES DEMUTH. *The Purple
Pup*. 1918. Pencil and watercolor.
Museum of Fine Arts, Boston
(Charles Henry Hayden Fund)

374. HENRI DE TOULOUSE-
LAUTREC. *At the Moulin Rouge*.
1892. 47½ x 55⅜". Art Institute of
Chicago (Helen Birch Bartlett
Memorial Collection)

375. CHARLES DEMUTH. *Acrobats*. 1919.
Pencil and watercolor, 13 x 7⅞". The
Museum of Modern Art, New York City
(Gift of Abby Aldrich Rockefeller)

376. CHARLES DEMUTH. *Still Life No. 3.*
1918. Watercolor, 9⅝ x 13½". Columbus
Museum of Art, Columbus, Ohio (Gift of
Ferdinand Howald)

377. JOHN LA FARGE. *Water Lily and Butterfly*.
1870s. Watercolor, 13½ x 11¼". Wadsworth
Atheneum, Hartford

Beardsley (his family owned a Beardsley ink drawing), and with artists as diverse as Cranach, El Greco, Blake, Sharaku, Rubens, and Watteau;[56] being tubercular and a dandy, Demuth may have felt more than an artistic kinship with Beardsley and Toulouse-Lautrec. His early art teacher, Henry McCarter, had known Lautrec, and when Lautrec's works were exhibited at Stieglitz' "291" in 1909, Demuth must have looked carefully at them, as he did during his trips to Paris in 1904–5, 1907–8, and 1912–13. It seems ironical that between 1915 and 1919 the same artist was creating his devastating Art Nouveau illustrations (as for Zola's *Nana*) together with Cubist landscapes and flower paintings. But Demuth's simultaneous work in two styles suggests that Art Nouveau was a help in freeing him and other artists from three-dimensional, perspective depth, that it led them to an awareness that figure and background might be interrelated and line and tonal areas loosed from forms, and that ambiguous space-form relationships could gain expression through line and color. As Demuth's biographer explained:

> In his tastes Demuth literally bridges two centuries. Because his imagination embraced the past as well as the future, he belonged intellectually and emotionally to several centuries. He felt an affinity for the elegant, dynamic Mannerism of the 16th century and El Greco; and for the civilized, refined 18th century of Wren, Watteau, and Blake. Perhaps more than anything he was *fin de siècle*, a Victorian allied in his sensitivities to the rarefied climate of the 19th century *Art Nouveau*—which served as an important agent for carrying Cubist theory to America.[57]

Demuth's *Acrobats* of 1919 is related in form, though not in theme, to the highly abstract watercolor *Still Life No. 3* of 1918 (plates 375, 376). The arrival of Cubism to American art is allied in *Still Life* with an expressive symbolism of incredible delicacy, the culmination of artistic concepts that could already be seen in the 1870s in La Farge's *Water Lily and Butterfly* (plate 377).

SCULPTURE

Sculpture during this period lagged behind the other arts in America; there were, as Bing put it, "neither the craftsmen skilled in sculpture's severe laws nor a public to do her honor."[58] Until 1880 American sculpture, like that of European countries, was dominated by Italian styles, from the Neoclassicism of Canova to the sentimental realism of Bartolini. Many Americans admired and emulated Canova, as much for his rise from poverty to world fame as for his art; meanwhile John Rogers sold them eighty thousand plaster casts of his realistic statuettes and groups through mail-order catalogues. William Rimmer stands out as unique in carving directly, the forms melded into powerful, sweeping compositions.

Between the Philadelphia Centennial in 1876 and the Chicago Exposition in 1893 a number of young American sculptors studied at the Ecole des Beaux-Arts in Paris. They were dazzled by the financial and social awards open to French sculptors, and by 1893 they had set up national organizations of their own. This movement was dominated by the powerful architects who designed and decorated the Chicago Exposition and indeed excercized much control over style in architecture and sculpture for forty years, through the successive expositions in America that began in Philadelphia and ended with Buffalo (1901), St. Louis (1904), and San Francisco (1915).

Sculpture in its three-dimensional form was, like architecture, poorly adapted to take on the flattened and curvilinear abstractions of Art Nouveau. Only a few works in relief suggest the concept at all, such as the base of Augustus Saint-Gaudens' 1881 statue of Admiral Farragut in Madison Square, New York (plate 378). In March 1878 Saint-Gaudens wrote from Rome to Stanford White that he wanted to talk to his friend and designer about the

pedestal; when White joined him in Paris they designed it as an integral part of the monument.[59] The images in the relief merge with the inscriptions praising the heroic admiral; water and dolphins were suitable symbols for a navy hero, and the allegorical females, Courage and Loyalty, their hair and drapery joining with the flowing water patterns, look like forerunners of Art Nouveau mermaids ten years later. The sophisticated assimilation of the flat surface with the shallow relief forms, especially the dolphins, gives this design a spatial ambiguity suggesting Oriental art. Perpetual life was symbolized by the subject matter and the visual means. White's contribution to this pedestal remains undefined, but the curvilinear design seems more in keeping with his interior decoration style at that time than with Saint-Gaudens' Neoclassical naturalism.

Saint-Gaudens vividly demonstrates his own ability to create rhythmic images in his *Diana* of 1892 (his only nude figure), made as a weathervane for the tower of Stanford White's Madison Square Garden (plate 379). A copy of the work stood on the very top of the Liberal Arts Building at the Chicago Exposition, and from a distance the slender figure's poised stance, with curved bow and flying drapery, suggests an Art Nouveau decorative silhouette. Daniel Chester French relies on somewhat similar curvilinear rhythms in his *Mourning Victory*, 1909, the monument to three brothers who died in the Civil War (plate 380):

> French . . . carried the image of a mourning nation, grieving over the loss of her fine men, to its highest pinnacle of expressiveness within the scope of the personifying figure and academic idealism. A monumental maiden, whose torso and arms are undraped, emerges from a prismatic block. There is an Art Nouveau element in the swirling curvilinear design of her hair, the shroudlike American flag about her head, and the draperies at her side.[60]

Perhaps French's decorative style was affected by his work for the Boston Public Library in 1902, three bronze doors bearing large reliefs of allegorical female figures whose heavy drapery falls in curving patterns (plate 381).

Diana as the goddess of the moon and of the hunt reappears in 1924 in Anna Hyatt Huntington's *The Young Diana* (plate 382), its precise and poetic naturalism accentuated by the decorative swirl of dolphins on the base where the sweeping movement starts upward. In startling contrast to Saint-Gaudens' classically idealized *Diana* and Huntington's delicate realism is the archaizing orientalism of Paul Manship's *Diana* of 1915–24 (plate 383). In his *Evening* Manship straddles the archaic classical style and the curvilinear abstractions of the modern symbolist dream world (plate 384).

Certain other American sculptors responded to the decorative rhythm and movement related to Art Nouveau. Hermon A. MacNeil's high relief *From Chaos Came Light* is a Rodin–Art Nouveau–Symbolist image (plate 385). MacNeil had studied at the Ecole des Beaux-Arts and the Académie Julian from 1888 to 1891, gradually changing his style after his return home to a more naturalistic and nationalistic one and often portraying the American Indian. Henry Linder and Alfred Lenz evolved their sculptural styles from their careers as decorative silversmith and jeweler, respectively. Linder's work evidently grew from his designs of hardware and andirons, for his relief *Architecture, Painting, and Sculpture* (plate 386) is far from his contemporaries' Beaux-Arts style. Lenz returned in 1893 from a trip to Paris and London to become a designer for a New York firm that manufactured jewelry. Most of his works are small metal figures so exquisitely cast that they earned him the title "the modern Cellini." *The Dragonfly–Pavlova* of 1916 is an outstanding example of his Art Nouveau sculpture (plate 387).

Other sculptors who maintained some relationship to the late nineteenth-century style include the emigrant Polish artist Elie Nadelman:

378. AUGUSTUS SAINT-GAUDENS
(pedestal design by STANFORD
WHITE). Admiral Farragut
Monument. 1881. Bronze, with
stone pedestal. Madison Square,
New York City

379. AUGUSTUS SAINT-GAUDENS. *Diana*. 1892.
Hammered copper. Tower, Madison Square
Garden (contemporary photograph). Installed
1932 at Philadelphia Museum of Fine Arts

380. DANIEL CHESTER FRENCH.
Mourning Victory. Marble copy of
Melvin Memorial (1909), Sleepy
Hollow Cemetery, Concord, Mass
The Metropolitan Museum of Art,
New York City (Gift of James C.
Melvin, 1912)

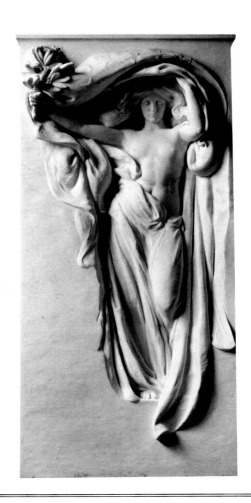

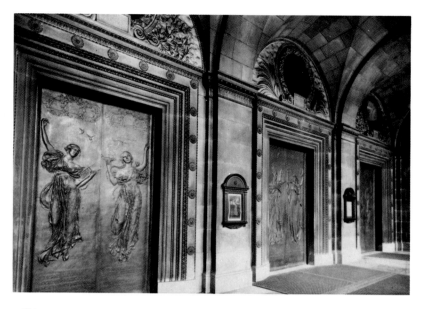

381. DANIEL CHESTER FRENCH. Bronze Doors in vestibule
of Boston Public Library. 1902

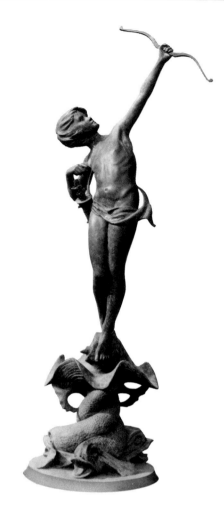

382. (right) ANNA HYATT HUNTINGTON.
The Young Diana. 1924. Bronze. Brookgreen
Gardens, Georgetown, S.C.

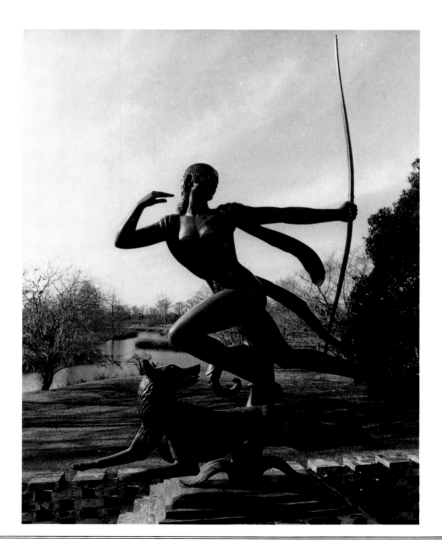

383. PAUL MANSHIP. *Diana*.
1915–24. Bronze. Brookgreen
Gardens, Georgetown, S.C.

384. PAUL MANSHIP. *Evening*. 1938. Bronze.
Brookgreen Gardens, Georgetown, S.C.

385. HERMON ATKINS MACNEIL. *From
Chaos Came Light*. 1895–99. Bronze.
Whereabouts unknown (photograph
courtesy New York Public Library)

386. HENRY LINDER. *Architecture, Painting, and Sculpture*.
Bronze. Whereabouts unknown (photograph courtesy
New York Public Library)

387. ALFRED LENZ. *The Dragonfly: Pavlova.*
1916. Bronze, height 8″. The Metropolitan
Museum of Art, New York City (Rogers
Fund, 1920)

388. ELIE NADELMAN.
Seated Woman. c.1918–19.
Cherrywood and wrought
iron, height 33″.
Portland Art Museum,
Portland, Ore.
(Evan H. Roberts Memorial
Sculpture Fund)

> The pioneers of modern American sculpture were affected by radical European art forms, but without exception gave their Continental sources a more stylized and decorative character. Elie Nadelman, for example, who came to America in 1914, had experienced at first hand the influence of the Munich Jugendstil and the School of Paris. . . . Essentially his style stems from the bloodless and artificial ornament of Art Nouveau, despite an apparent commitment to the scrupulous streamlining and drastic geometric simplifications of vital modern [Cubist] forms.[61]

Upon arriving in America Nadelman occupied himself with images of high society, not with his previous decorative cubistic work called *Research in Form and Volume: Identification of Forms*. His drawings and painted wooden figures in modern clothing, simplified into smooth, continuous curves, have something of Seurat's earlier geometry of Parisian dress—and indeed *L'Art Décoratif* of 1914 containing the first major article on Nadelman, published just before he left Europe, also has an article on Seurat's charcoal sketches.[62] The curvilinear contours of *Seated Woman* of 1917 (plate 388) and *Man in Top Hat* of 1927 suggest the poster style of Art Nouveau, yet maintain the geometric form of Seurat's art. They give an accurate, sometimes amusing image of upper middle-class American society. These sculptures were stylishly modern and also easy to like, and Nadelman became successful in America.

More abstract are the works of Robert Laurent (1890–1970), born in France and brought to America in 1902; as a young man he learned direct woodcarving in Rome. The Armory Show evidently affected such works as *Head (Abstraction)* of 1916 (plate 389), although Laurent never became a fully abstract artist. The interlocked curves in his work are organic in derivation, rather than geometric like Nadelman's. His joy in the nature of his sculptural materials and his manner of expressing their organic forces still associate such works as *The Flame* (plate 390) with the realm of Art Nouveau.

American Art Nouveau

389. ROBERT LAURENT. *Head (Abstraction)*. 1916. Wood. Collection Sue and David Workman, New York City

390. ROBERT LAURENT. *The Flame*. c.1917. Wood, height 18″. Whitney Museum of American Art, New York City (Gift of Bartlett Arkell)

CONCLUSION

Into this Universe, and why not knowing
Nor whence, like water willy-nilly flowing,
And out of it, as wind along the waste,
I know not whither, willy-nilly blowing.
—*Rubáiyat of Omar Khayyám*

*D'où Venons Nous / Que Sommes Nous / Où
Allons Nous*
—PAUL GAUGUIN

THE SEARCH FOR MEANING

Samuel Bing had originated the term "Art Nouveau" for "art as applied," but the style of design must be evaluated in relation to the major arts, particularly painting. In his opinion painting had continued to develop "in a normal and regular way," which to him included the great breakthrough in French painting in the 1880s, the synthesis of new styles achieved by Seurat, Cézanne, Van Gogh, and Gauguin. This confident burst of creativity provided the impetus for a "new departure" in the applied arts, in addition to the succession of masterworks it produced in painting.

To search for a synthesis in the realm of artistic vision belonged within the general state of mind of the nineteenth century. From Blake's poetic and visionary creations at the beginning of the century to the "symbolic" paintings of the Post-Impressionists at its end, the search for a new equilibrium, for a modern unity, concerned all major artists and a large part of their public. Nineteenth-century artists and philosophers were aware that traditional modes of thought and belief were dissolving, and they found it terrifying that life might not have an ultimate, rational meaning. The desire to find a meaning, a new purpose in living, brought many attempts to unify the growing fragmentation in private, social, and religious life, the contrary pull from opposite ends: man and nature, life and death, spirit and matter, objectivity and subjectivity, science and religion, individual and society, thought and feeling, order and anarchy, dream and reality, machine age and lost Eden. The gap seemed large between man's inner feelings and his ability to express them coherently in the technological and scientific reality of the modern world.

Throughout the century can be seen the search for oneness: in the belief of Rousseau, Blake, and Shelley in a "lost Eden"; in the pervasiveness of Swedenborg's writings on the essential oneness of the universe, all natural things having a correspondence to spiritual realities; in the overwhelming receptivity to religions, art forms, and philosophies from all periods and all parts of the world, especially those seeming to offer the unity man craved—medieval art, Oriental philosophies, ancient myths, modern primitive cultures. This religious and artistic pluralism in the nineteenth century, the belief of artists and public that every religion may have some portion of the truth and that all art forms are valid in man's search for a new vision, underlay the broad eclecticism in art, literature, and philosophy.[1] The universalizing and rationalizing tendencies of the Enlightenment had opened these sources. Artists and philosophers turned continually to the distant past; the public reveled in the occult and in Oriental philosophies based on Buddhist concepts, in works like Sir Edwin Arnold's *Light of Asia*, Schuré's *Les Grands Initiés*, Pierre Loti's *Vers Ispahan*, and Omar Khayyám's *Rubáiyat*.

In 1902 Charles Caffin described the mid-century attitudes:

> In matters of belief and feeling, it was a period of little faith and less initiative. Men moved forward with their faces turned backward—in the religious world seeking ideals in medievalism; in art, also, borrowing their motives from the past. It was a time of rediscovery, of revivals; less of new birth and growth than new assimilations . . . a Caucasian civilization became conscious of an Oriental art from farther round the globe than the Levant or even India. Japan was discovered.[2]

The search increased in intensity as the century neared its end, with the spread of urbanization and mechanization. Some sought an escape rather than a synthesis. Others rejected the rational and material world for the realm of imagination, and sought the source of the subconscious mind. Many returned to William Blake, who had seen the need to unite opposites rather than destroy the one or the other, and who created a linear vision and elaborate private symbolism where his "contraries are [both] positives," similar to the yin-yang concept. Blake was a source of continual inspiration throughout the century, but his imaginary world went beyond nature, and it was too one-sided for artists seeking to synthesize the spiritual and the material. Likewise "symbolic" subject matter, especially ancient myths which contained the secret of primordial wisdom—the Sphinx, Phaëthon, sibyls—provided a source of ideas quickly picked up and admired, although not in themselves sufficing, being remote from reality and not yet translated into modern terms.

The searchers, groping in one way then another, began to formulate answers in the 1880s. Post-Impressionist painters, struggling to unite their own formal, visual language, began to complete earlier attempts by Gros, Géricault, and Chassériau to create a new vision of the world. Understandably each of them—Gauguin, Seurat, Van Gogh, and Cézanne—found his own solution, but each one's style was filled with a tension which allowed polarities to exist and even to create unity from opposites: color and line, nature and spirit, the individual and the universal, the new visual space and the object.[3] Positive shapes and spaces interlocked with negative shapes and spaces in a dynamic interchange.

Georges Seurat was acknowledged a leader by his generation of artists. He had set out to apply to art the results of research in physics and thereby to find "something new, an art entirely my own."[4] Artists and critics reacted to the withdrawal in Seurat's art from the uncertainty, the multiplicity, of "nature" and his concomitant turn to the "certainty" of the scientific laws underlying physical reality. Paul Signac, Seurat's follower, expressed his confidence in the new art:

> Our formula is certain, demonstrable, our paintings are logical and no longer done haphazardly.[5]

Likewise, the critic Fénéon praised the new art of the Post-Impressionists:

> . . . exemplary specimens of a highly developed decorative art, which sacrifices the anecdote to the arabesque, nomenclature to synthesis, the fugitive to the permanent, and confers upon nature—weary at last of its precarious reality—an authentic reality.[6]

Most important to the development of European Art Nouveau were the works and writings of Henri van de Velde, who made of Seurat's style a primary formulation for decorative art. Van de Velde explained Seurat's accomplishments in these words:

> Seurat, as chief of a school, had inaugurated a new era of painting—a return to style.[7]

In seeking to escape the "yoke of nature," to find the "essential" or "authentic" reality rather than "apparent" reality, Seurat and Gauguin remained in touch with Paris and exhibited throughout the 1880s and early 1890s, establishing reputations and "schools"; Cézanne and Van Gogh isolated themselves in the provinces, and their effect was greater on the next generation. All four contributed to creating a "new era of painting"—a return to style and a new view of the art of the Old Masters.

These artists found the "laws" of this new visual language in their scrutiny of nature. Nature in continual and haphazard change, as seen through the Impressionist eye, had raised the fear that she offered no regularity, no absolute to rely upon. This loss and its accompanying anxiety was gradually replaced by understanding through science, from Darwin to Einstein, that the flux of life has its own laws—not as goal-directed as man might desire, but laws nevertheless. Vincent van Gogh, working with color, one of the most variable of expressive elements, wrote that "the laws of color are unspeakably wonderful, just because they are not accidental." In reducing separate objects and three-dimensional space to one plane having absolute flatness and suggesting infinite depth, the forms constantly fluctuating among freed contour lines and color patches, the Post-Impressionists' language came to express the new scientific reality: the relativity and multidimensionality of all being and nonbeing. The river constantly flows, but its movement is not "willy-nilly": in this chance-filled, natural order man still finds a place, if a tiny one.

Certainly the various scientific and social revolutions of the nineteenth century brought about a "revaluation of being in all spheres." The modern individual, meaningless by himself, found his meaning or identity as a particle within large, law-governed systems. As the small dissolving brush strokes of Impressionism became regularized, the infinite shifting movement of the forms they described now joined into structural systems, the curvilinear arabesques of Van Gogh and Gauguin and the interlocked geometric planes of Cézanne and Seurat.[8]

The expressive possibilities of the new synthesis could be expanded almost indefinitely, allowing the range of individualistic statements which have since been made. As each creative act required a new struggle, each painting and likewise each building, book, vase, or chair was to achieve its own unity. The two "rules" that Bing applied to Art Nouveau were simple: "Each article to be strictly adapted to its proper purpose; harmonies to be sought for in line and color."[9]

THE DECORATIVE

A concern for aesthetic values in all phases of life grew steadily in France and England during the second half of the nineteenth century. The Art for Art's Sake movement; Walter Pater's Aestheticism; Baudelaire's dandyism and decadence; the Arts and Crafts Society—though different, all were deliberate attempts to affirm and celebrate the uniqueness of the

aesthetic experience and to transcend the dull ugliness of commercialized and urbanized existence.

Several variations of aestheticism arose in Europe, but the new concept, so antithetical to American puritanism, arrived in the United States only with the person and statements of Oscar Wilde in 1882. While touring the country, he repeatedly called for beauty in all areas of daily life, and declared that barriers between the fine and the decorative arts must be overcome: "All the arts are fine arts and all the arts are decorative arts." A concern for decorative beauty, for heightened aesthetic pleasure, was to be cultivated in every corner of life—from the office building to the teacup.

This "decorative aesthetic" differs sharply from the subsequent "functional aesthetic" which dominated the first half of the twentieth century. The attitude that a functional aesthetic is somehow better than a decorative aesthetic is based on a misunderstanding: "function" means primarily the "acts or operations expected of a person or thing," and since expectations of such an operation will vary, and may include expectations of aesthetic pleasure, so too the form may vary. The machine aesthetic of sleek lines that characterizes much industrial design is no guarantee that the object will function better or be easier to produce, or that smooth form expresses function better than decorated form.[10] One serious charge against Art Nouveau, that decorative concerns led the artist or designer to disregard function or content in his work, raises the question of quality in decorative design.

The difference between decorative art and an isolated "work of art"—an easel painting or piece of sculpture—was fully acknowledged in the 1890s. Ernest Fenollosa wrote in *The Knight Errant*:

> That art alone . . . is properly decorative which has been designed to ornament something useful, as a wall or utensil.[11]

More recently the relationship between ornament and a work of art has been discussed by Rudolf Arnheim:

> Shall I say that the work of art proper serves to represent and interpret a content, whereas ornament does nothing of the sort but instead simply makes things look attractively opulent? There are several objections to this description. First of all, there cannot be a pattern that represents nothing. Any shape or color has expression, it carries a mood, shows the behavior of forces, and thus depicts something universal by its individual appearance. Therefore, every ornament must have a content.
>
> The content of ornament, however, is affected by its function. An ornament is almost always a part of something else. It is an attribute meant visually to interpret the character of a given object or situation or happening. It sets a mood, it helps define the rank and *raison d'être* of a tool, a piece of furniture, a room, a person, a ceremony. Being a part of something else, the ornament is limited to the particular character of its carrier. . . .
>
> The story of ornament is thus simply one aspect of artistic form. Wherever integrated form exists, it is impossible to separate the shape of an object "itself" from the ornament "added" to it. . . . What is painted on a vase is no more and no less a part of the object itself than the shape given to it by the potter. This distinction becomes possible only when a split has occurred between the function of the object and the meaning of the form applied to it.[12]

Thus ornamentation conveys through its form a content that is limited to interpreting further the character of the object it decorates; and it must be an integral part of that object's form. The originators of Art Nouveau understood and revived this concept of decoration. We will see that two major artists, although they worked in different art forms and in different countries, have strongly similar ideas when they define ornament and its purpose.

LOUIS H. SULLIVAN AND MAURICE DENIS

The achievement of Louis Sullivan, once called the "only American modernist," was described in 1904 by H. W. Desmond:

> He has evolved and elaborated a highly artistic form of . . . decorative expression in logical connections with the American steel skeleton building. . . . There is not a vestige of the past in Sullivan's work. It is as modern as the calendar itself. . . . Here is L'Art Nouveau indigenous to the United States, nurtured on American problems. . . .[13]

This early recognition of the necessarily "logical connections" between Sullivan's new architectural designs in skyscraper construction and his elaborate ornament is often denied by later twentieth-century writers, who prefer to stress Sullivan's own statement of 1892:

> Ornament is mentally a luxury, not a necessity . . . it would be greatly for our aesthetic good if we should refrain entirely from the use of ornament for a period of years, in order that our thought might concentrate acutely upon the production of buildings well formed and comely in the nude.[14]

To isolate this passage from the rest of Sullivan's article is to give only a partial idea of his statement; he went on to insist that the stage he called "organic ornament" should follow this purge. In *Kindergarten Chats* he clearly stated his belief in the purpose and necessity of decoration in architecture:

> The decoration of a structure is, in truth, when done with understanding, the more mobile, delicate and sumptuous expression of the creative impulse or identity basically expressed in the structure; it is the further utterance, the more sustained and delicate rhythmical expression thereof. For the *new architecture* a new decoration must evolve to be the worthy corollary of its harmonies, a decoration limitless in organic fluency and plasticity, and in inherent capacity for the expression of thought, feeling and sentiment. And when this power of plastic modulation, of rhythmical fluency, shall characterize your expression, throughout the entire being of a structure, you will have arrived at the heights of that art of expression I wish you to attain.[15]

Sullivan did not conceive of ornament as extraneous to the structure of his buildings, nor as "dictating their shape"; it was the completion of their structural identity, expressing more delicately and rhythmically the harmonics and inherent meaning of the buildings (plate 391). That final expression was to come from the rhythm of the ornamental elements, through the "inherent capacity" of its forms to express thought, feeling, and sentiment.

Sullivan's ideas on ornamentation can be directly compared with those of the French Post-Impressionist theorist Maurice Denis (plate 392), who wrote of the art of illustration:

> Illustration is the decoration of a book . . . without slavery to the text, without exact correspondence of the subject with the writing; but more of an embroidery of arabesques on the pages, an accompaniment of expressive lines.[16]

The similarity of the ideas of these two artists, whose work was not in the same medium, country, or tradition, establishes the consistency of the artistic ideal behind Art Nouveau at its inception and during its main development: a love of ornament, a delight in ornament, and a sense of the necessity of ornamentation to heighten the beauty and thus the expressive content of the form of an object. Ornamentation to both men was indeed related to the expressive content of the object it decorated. In the later phases of commercial-

391. LOUIS H. SULLIVAN. Portion of façade, Carson, Pirie, Scott Store, Chicago. 1903–4

392. MAURICE DENIS. Illustrated page for verse
XIX of Paul Verlaine's *Sagesse,* Paris, 1911.
Harvard College Library, Department of Printing
and Graphic Arts, Cambridge, Mass.

ization "Art Nouveau became only a display of pretentious facility, lacking in the aesthetic and moral meaning it should have had," as Denis himself expressed it.[17]

UNITY OF DESIGN

In general, quality in art relies on unity. The unity of expressive form—whether a building, painting, or book illustration—had prime importance for the Art Nouveau artist, whose ornament was meant to continue the expression of the form in a "more mobile, delicate and sumptuous" way. In contrast to the naturalism which dominated art at mid-century, "composition" was stressed at the end. In the work of artists seeking photographic illusionism, the absence of coordination of their forms into a unified, dynamic pattern or composition was becoming noticeable. Arthur Dow stressed this fact in his article on Japanese art in the 1893 *Knight Errant*, calling attention to the danger of sacrificing "composition" in the drive for realism.

Maurice Denis and other artists of the 1880s and 1890s found the way out of this "spoiling" of art by a "disdain for composition and concern only to 'make it natural,' " in the "great art, *that which is called decorative*, of the Hindus, the Assyrians, the Eygptians, the Greeks, the art of the Middle Ages and the Renaissance, and the decidedly superior works of Modern Art"[18] [italics added].

If the minor arts differ "in degree, not in kind" from the major arts, then the style of design that Samuel Bing labeled Art Nouveau was part of the new visual language created by the major painters of the times.

AMERICAN ART NOUVEAU

The Paris 1900 Exposition marked the triumph of international Art Nouveau, and the most popular American exhibit featured the dancer from Illinois, Loïe Fuller:

> Modelled in glowing embers, Loïe Fuller does not burn; she oozes brightness, she is flame itself. Standing in a fire of coals, she smiles and her smile is like a grinning mask under the red veil in which she wraps herself, the veil which she waves and causes to ripple like the smoke of a fire over her lava-like nudity.[19]

Images of Loïe Fuller's famous veil dances occur throughout Art Nouveau, European as well as American. From her first triumph in Paris in 1892 to her dominant position, with her own pavilion, at the Paris 1900 Exposition, this American dancer came to symbolize many popular aspects of the new style. Using flowing silks and gauzes and multiple lighting effects, she created dance routines in which she transformed herself into a flame, a butterfly, a lily. "La Loïe" was an experimenter and inventor as well as an "artist," and she revolutionized the art of theatrical lighting with the streaming colored lights and phosphorescent salts she threw on her diaphanous materials.[20] Her famous Serpentine Dance, rendered in graphic form by Toulouse-Lautrec and Will Bradley among others (plates 393, 394; see plate 248), was a pantomime-ballet of Salomé:

> We shall not easily forget the Serpentine Dance, undulating and luminous, full of weird grace and originality, a veritable revelation![21]

Fuller's performances impressed artists as diverse as Yeats, who wrote a poem about her, and Isadora Duncan, who described her dances:

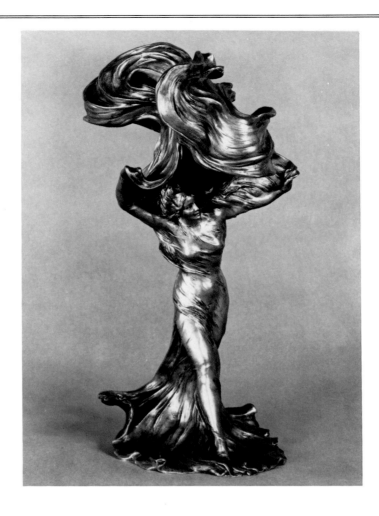

393. RAOUL LARCHE. *Loïe Fuller.*
c.1901. Gilt bronze, height 18¼".
University Art Museum,
University of California,
Berkeley, Cal.

394. HENRI DE TOULOUSE-
LAUTREC. Poster for *Loïe Fuller.*
1893. Color lithograph, 14⅜ x
10½". The Museum of Modern
Art, New York City (The Ludwig
and Erik Charell Collection)

Before our very eyes she turned to many coloured, shining orchids, to a wavering, flowing sea flower, and at length to a spiral-like lily, all magic of Merlin, the sorcery of light, color, and flowing form.[22]

Fuller's drive for originality was typical of the American form of Art Nouveau: her fusion in motion of music, drama, and visual imagery; her use of recent technological discoveries in electricity; the luxuriant, anti-Puritan sensuality of her dances; the symbolic connotations of her images, from fantastic Arabian Nights to Byzantine to floral; her accentuation of the "organic" evolution of one art form into another; her evocative use of color and arabesques—and her great financial success.

The *Exposition Universelle* of 1900, however, dominated by Art Nouveau, helped the new art to become identified in most American minds as a French style of exuberant decoration. The designs developed by the pioneering artists of the 1880s and 1890s rapidly became commercialized, which drastically cheapened and soon ruined the movement as a whole. Only two years later, at Turin, Louis Tiffany participated in his last European exhibition. Large industries, picking up superficial bits of imagery and style, turned out thousands of objects, from restaurant decor to hat pins, accurately described as having

> . . . a free-flowing or organic form, based on some floral abstraction, linear swirling, flatly patterned with a skipping or undulating rhythmic design that often obscures the entire structure or surface of the thing it decorates. Its restless, moving, agitated line takes on a nervous, expressive quality . . . dictating the shape of the object.[23]

This description suggests that ornament has overstepped its role and brought about a split between the object's function and the meaning of the ornament applied to it. Such a description is often adopted for a general definition of the Art Nouveau "style" by those considering mainly the poorest mass-produced items and world's-fair souvenirs—"parasitic vegetation," Bing called them—rather than the best innovative works of the movement.

The American form of the new style, developed in the 1880s and 1890s by three principal proponents—Bradley in graphic design, Sullivan in architecture, and Tiffany in the applied arts—has a peculiar relationship to the phase of decorative art style which was fashionable in Europe after 1900 under the title "Art Nouveau." Earlier the term "art nouveau" or "eine neue Kunstgattung" had occurred in European comments on Tiffany and Sullivan at the Chicago Exposition of 1893, and on "poster art."[24] With this in view, there seems to be some truth in A. D. F. Hamlin's assertion in 1902, that "What is in Europe a new Propaganda, with a name, organs, adherents, and apostles, has in fact and substance long existed in the United States."[25] Yet Americans by 1902 had rejected the "new art" of its three American proponents: Bradley's art periodical had ceased publication; Sullivan's work had been rejected in favor of historical revivals; Tiffany's most original objects had found their greatest market in Europe.

Americans did not become really familiar with the French term until 1900, at the Paris Exposition. The great popularity of Samuel Bing's salons there, abetted by various imitations of his ideas, established a vast international fad. Every up-to-date restaurateur, hotel manager, or homeowner now redecorated his establishment "in the new style," and the aesthetic ideals of the 1890s crumbled into full-fledged commercialized fashion.

After 1900 the "patriotic" Craftsman art promoted by Gustav Stickley—the "wholesome, honest" Mission style—dominated domestic architectural and interior design in America, while the classical revival dominated public design. Only in 1902 did Art Nouveau, as such, become a general topic of discussion in American journals like *The Architectural Record*, and the movement was considered to be European, especially French. America, which by then had crushed the minority "quest for beauty" of the 1890s and was following the morally upright path of Roosevelt's "strenuous life," was suspicious of any new foreign fad. One *Architectural Record* essayist wrote:

Particularly in this country one hears the question continually asked: "What is this Art Nouveau? Is it anything more dignified than a mere revolt against traditional architectural and decorative forms? What positive and formative influences are there behind it, and what new technical discipline and motives does it offer?" And back of these questions can always be discerned a suspicion that the "New Art" is only one more of many expressions of "*fin de siècle*" sensationalism, which tries to whip jaded sensibility into new life by violent stimulation, and which authorizes any departures from traditional motives, however bizarre, formless, and even ugly, provided only that they are piquant and impertinent.[26]

Apparently the art forms that Sullivan, Tiffany, and Bradley had created were not recognized to be Art Nouveau as it was presented at and after the 1900 Fair. Americans saw the style as a *fin-de-siècle* revolt against tradition, and although many designers of pottery, furniture, and silver produced a commercial version of Art Nouveau for American consumption between 1900 and World War I, these had little connection with the earlier visions of Sullivan, Tiffany, and Bradley. The absence of a strong artistic tradition in America, seen as the source of her freedom and strength by European critics, from Wilde in 1882 to Bing and to Hector Guimard in 1902, now seemed to a conservative American, Herbert Croly, a danger which would lead to anarchy:

> What American art needs most of all at present is the informing and refining presence of the best European models, so that it may start upon its career with a solid ground of safe, if not of brilliant achievement.[27]

The fate of the original "new style" in American architecture, as epitomized in the works of Sullivan, becomes clear in the attitude that Croly expresses. Sullivan's work in 1893 had been judged "a radical departure" from the re-created style of "stately buildings" at the Chicago Exposition, and he was not one to "adapt to business conditions and compromise the integrity of his work." Thus he remained "good, but lonely," and dotted small communities of his Midwest with banks in his original designs.[28]

Tiffany, on the other hand, with his financial backing and his willingness to adapt his art to the desires of wealthy clients, at first built a most successful business out of his eclectic "original" art in glass and ceramics. He was not, however, tied to America: from the beginning he had been in touch with European developments in the crafts, and in the 1890s it was largely Bing's promotion that brought him fame through exhibiting his works along with European Art Nouveau. Thus he was better known in Europe than in the United States, and seemed less concerned with social problems or with "raising the tastes of the masses" than with originating works of "aesthetic extravagance" for a select audience. By 1900 numerous imitations of his glass, such as the Widow Loetz variety in Austria with its glaring metallic surface, had flooded the European market:

> The very proliferation of this Tiffany glass and the disappointing effect of its exaggeration of form and sheen and its general lack of quality, were detrimental not only to the imitations, but also to the genuine article itself.[29]

Tiffany's fame died when the fashion of Art Nouveau spent itself, shortly after its proliferation at the Turin Exposition of 1902.

The situation of Will Bradley, and of the poster movement which was so much a part of Art Nouveau, was also affected by the specifically American reaction. Bradley's fame came with the exploitation of his designs through new processes of mechanical reproduction. Bradley had designed his covers and posters for the explicit purpose of selling a product, be it fish or fashion magazine, but he dreamed of being an "artist" instead of "a clown in the circus" of fashionable crazes. This led him to leave that lucrative field and establish

his one-man press to publish "artistic" works in the style of William Morris. The public, though supporting the young designer by buying thousands of his cheap, decorative posters, was not interested in supporting his "fine art" periodical. Unlike Sullivan, Bradley gave up his dream, and went to work for promoters of mass-produced culture. His house designs in the *Ladies Home Journal* combined English Art Nouveau decoration with Craftsman construction, and led the public to believe it could build their "individual," "original" versions on a "do-it-yourself" plan. Allying himself wholeheartedly with the business world, Bradley remained a "prominent American designer" throughout his long life.

By 1902 the new art of the 1890s had become rejected as "degenerate," or ignored through the putative "need for tradition," or, in the case of fine printing and interior design, vulgarized for mass consumption by businessmen like Gustav Stickley and Elbert Hubbard. The originality of the artistic and cultural movements of the 1880s and 1890s soon gave way to a "onesided and merely commercial growth."[30]

An honest American reaction to the new art of the end of the century was expressed by an enterprising young inventor, who wrote to Samuel Bing in 1902 that he had "invented a machine for making Art Nouveau"![31] Oscar Wilde's earlier indictment is recalled: "For the American, Art has no Marvel."

CHRONOLOGY

Selected events that give a framework of reference points in the United States and abroad, relating to the development of Art Nouveau concepts in American art.

1851 The London Great Exhibition; exhibits show the poor quality of industrial design.

1853 Commodore Matthew Perry arrives at Japan; trade interchange begins in 1854.

1855 Paris World's Fair; first Pre-Raphaelite exhibit outside of England, Edward Burne-Jones is admired.

1856 Owen Jones, English architect, publishes *Grammar of Ornament*.

1857 First Pre-Raphaelite exhibit in New York City.

1859 John La Farge and William Morris Hunt work together in Newport; both study art of the Pre-Raphaelites and Barbizon School, and Chevreul's color analysis.

1861 William Morris forms the Morris, Marshall, Faulkner Company for interior design, in London.
 Whistler meets Edouard Manet in Paris.

1862 First systematic display in the West of Japanese art, at the London International Exhibition. Exhibits also of Pre-Raphaelite applied arts.
 William Rimmer's *Falling Gladiator* exhibited at the Paris *Salon*.

1863 The Gorham Manufacturing Company is founded in Providence, R.I.
 Whistler exhibits *Symphony in White, No. 1: The White Girl* at the *Salon des Refusés*.
 Vedder paints *The Questioner of the Sphinx*.

1864 La Farge and Vedder make illustrations for Tennyson's *Enoch Arden*.

1865 La Farge designs decorative panels for an interior.

1866 Louis C. Tiffany works on watercolor painting with George Inness.
 Winslow Homer travels to Paris, possibly sees Japanese prints.

1867 Paris International Exhibition exhibits extensive Japanese collection, as well as Pre-Raphaelite art and design. Large retrospective exhibit of Ingres.
 Whistler paints first *Nocturnes*.

1868 Eastlake publishes *Hints on Household Taste* in London.

1869 La Farge publishes chapter of analysis of Japanese art in Raphael Pumpelly's *Across America and Asia*.

1870 James J. Jarves writes in *Art Thoughts* on Japanese art at the 1867 Paris Exhibition.

1871 The great Chicago fire.
 Richard Morris Hunt designs cast-iron storefront in New York in Islamic style.
 Burne-Jones and Fairfax-Murray work on a handmade book of the *Rubáiyat* for William Morris.

1872 La Farge travels to England; visits Rossetti at home, as well as Burne-Jones and Morris. He and Louis Tiffany study glassmaking with Boldini at Heidt and Company, New York.
 H. H. Richardson begins work on Trinity Church, Boston.

1873 Louis Sullivan leaves firm of Frank Furness in Philadelphia and joins Jenney in Chicago.
 La Farge travels to Europe; studies medieval glass and again contacts the Pre-Raphaelite designers.
 Economic panic in the United States.
 Dresser publishes *Principles of Design*; Furness changes his designs for ornament of the Pennsylvania Academy of the Fine Arts in response to Dresser's concept of abstraction.

1874 Sullivan goes to the Ecole des Beaux-Arts in Paris; travels through Europe.

Richardson works on Watts Sherman residence in Newport.

La Farge receives commission for Memorial Hall windows at Harvard.

Whistler's one-man show in London arouses great interest.

1875 Ryder begins to paint *Siegfried and the Rhine Maidens*.

Jarves publishes *A Glimpse at the Art of Japan*.

La Farge requests a copy of Pumpelly's *Studies on Japan* for use in glass designs, for the Watts Sherman residence in particular.

Richardson begins work on the New York State Capitol in Albany.

Sullivan returns to Chicago.

1876 International Centennial Exhibition in Philadelphia demonstrates height of international eclecticism of the 1870s; marks a change of taste in American decorative art toward more original, non-Western forms.

Richardson commissions La Farge to design the interior of Trinity Church, Boston.

Whistler works on the Peacock Room for F. A. Leyland in London.

Vedder travels to London, sees major Blake exhibition.

1877 Whistler-Ruskin lawsuit. Edward Godwin and Whistler cooperate in designing interiors. Publication of the influential *Art Furniture*, designed by Godwin and manufactured by William Watt, establishing the Aesthetic Anglo-Japanese style.

Fenollosa arrives in Japan; stays 10 years.

Rimmer publishes *Art Anatomy*.

Rhode Island School of Design founded in Providence, R.I.

1878 Paris Universal Exposition has large display of Japanese art and design; Whistler exhibits his Primrose Room there, created with Godwin.

William Morris lectures on "The Lesser Arts."

John White Alexander travels to Munich; meets Whistler, later, in Venice.

1879 Louis C. Tiffany and friends found interior decorating company in New York, Tiffany and Associated Artists.

Sullivan joins Adler in Chicago.

Death of William Rimmer and of William Morris Hunt in Boston.

Augustus Saint-Gaudens and Stanford White work in Paris on the pedestal design for the Farragut Monument, Madison Square, New York.

1880 La Farge is awarded a patent for colored glass windows. Tiffany and La Farge attempt to collaborate, but La Farge later sues Tiffany. Both men, together with Saint-Gaudens, Will H. Low, and others, design interiors for the New York Union League Club, designed by Peabody and Stearns of Boston and built by the builders of Richardson's Trinity Church.

Rookwood Pottery opens in Cincinnati.

L. Prang and Company, Boston, initiates art competitions for Christmas cards.

American edition published of Owen Jones' *Grammar of Ornament*.

First American exhibit of William Blake's art, in Boston.

1881 Gilbert and Sullivan's *Patience* plays to large audiences in England, makes the Aesthetic Movement well known.

Arthur Mackmurdo founds the Century Guild.

Whistler's *An Arrangement in Gray and Black, No. 1: Portrait of the Artist's Mother* is exhibited in Philadelphia.

Alexander makes illustrations for *Harper's Magazine*.

1882 Richardson travels to Europe, visits William Morris.

Vedder wins Prang's Christmas card competition, judged by La Farge, Samuel Colman, and Stanford White.

Louis Tiffany commissions Vedder for designs for stained-glass panels.

Ryder travels to Europe and North Africa.

Oscar Wilde tours America, lecturing on the English Renaissance and decorative art.

Burne-Jones designs windows for Trinity Church, Boston.

Edward Colonna comes to America, works for Louis C. Tiffany, later moves to the midwest.

1883 Mackmurdo publishes *Wren's City Churches*, which includes Art Nouveau page designs.

Vedder begins illustrations for the *Rubáiyat*.

Louis Rhead leaves England for America.

Georges Petit Galeries in Paris stage large exhibit of Japanese prints; Louis Gonse publishes *L'Art Japonais*.

Puvis de Chavannes paints *The Poor Fisherman*.

1884 In Paris: Sargent paints *Mme. X*; Manet's retrospective exhibit opens; Huysmans publishes *A rebours*; Seurat paints *Sunday Afternoon on the Island of the Grand Jatte*; *Gazette des Beaux-Arts* publishes a long article on posters and Jules Chéret.

Arthur Dow studies painting in Pont-Aven.

In England: Whistler and Godwin design a house for Oscar Wilde; Walter Crane and Lewis F. Day work for the Art Workers' Guild; Mackmurdo begins publishing the Century Guild's *Hobby Horse* periodical, containing works by Blake and the Japanese.

In Brussels: Octave Maus and others organize *Les XX* exhibits.

1885 Richardson works in Chicago; designs furniture in proto-Art Nouveau style for the Malden Public Library, Malden, Mass. Ernest Fenollosa converts to Buddhism.

Revue Wagnerienne is published in Paris, accentuating idea of *Gesamtkunstwerk*.

Samuel Bing opens a shop for Japanese goods in Paris.

1886 Sullivan and Adler begin work on the Chicago Auditorium, with Healy and Millet doing interior stencils and stained-glass windows.

Durand-Ruel's first Impressionist exhibit in America.

La Farge travels to Japan, with Henry Adams.

Whistler meets and befriends Mallarmé. *Symbolist Manifesto* appears. Whistler is included in *Les XX* exhibition.

Mackmurdo's Century Guild works receive praise for their exhibit in Liverpool.

1887 Colonna publishes his *Essay on Broom-Corn*, sends a copy to Louis Tiffany.

Sargent returns to America.

Seurat exhibits *La Grand Jatte* at Les XX; Alfred Picard writes an article on "L'Art Nouveau" in *L'Art Moderne*.

1888 La Farge, Saint-Gaudens, and Stanford White collaborate on designs for the Church of the Ascension in New York.

Bing begins to publish *Le Japon Artistique*.

1889 Paris Exposition: Vedder exhibits his painting *The Fates*; Rookwood Pottery wins a medal; Lalique and Gallé exhibit "symbolist" glass and decorative objects; Whistler, Godwin, and Burne-Jones win prizes; La Farge praised in *American Glass* for his Watson Memorial window, Buffalo.

Schuré publishes *Les Grands Initiés*.

Gauguin exhibit held at Café Volpini.

Grolier Club in New York exhibits Japanese prints; Rhead and Grasset design covers for American magazines.

1890 Grolier Club in New York exhibits French posters.

Alexander leaves to live in Paris for 11 years.

McKim contacts Sargent and Abbey to paint murals for the Boston Public Library.

Fenollosa begins 5-year curatorship of Oriental collections in Boston Museum of Fine Arts.

Sullivan designs Getty Tomb; begins work on the Transportation Building for the Chicago Exposition, to open 1893.

Will Bradley begins free-lancing in Chicago.

1891 *Les XX* puts on first exhibit that includes applied art with sculpture and painting.

Toulouse-Lautrec's poster for the Moulin Rouge establishes the popularity of posters in France.

Large exhibition of Japanese prints in Paris affects Mary Cassatt's prints.

Durand-Ruel again exhibits Impressionist art in New York.

Morris' Kelmscott Press begins publication.

Ryder's *Siegfried and the Rhine Maidens* is exhibited in New York.

Walter Crane tours and lectures in the United States.

1892 Horta designs the Tassel House in Brussels.

The Rose+Croix exhibits works by Toorop, Hodler, and Knopff at Durand-Ruel in Paris.

Tiffany exhibits his *Four Seasons* window in Paris and London.

Large Whistler exhibit held at Goupil's, London.

Samuel Bancroft's collection of Pre-Raphaelite art is exhibited in Philadelphia, together with a Blake collection.

The Knight Errant appears in Boston, along with Cram's *The Decadent.*

1893 Chicago World's Columbian Exposition marks ascendancy of the Beaux-Arts tradition in American architecture and sculpture.

Sullivan's Transportation Building at Chicago considered a "radical departure."

Wilde's *Salome*, illustrated by Aubrey Beardsley's instantly famous drawings, is published.

Penfield begins to make cover designs for *Harper's.*

Artus Van Briggle leaves Rookwood Pottery to study in Paris.

The Studio, soon to become the most influential periodical in transmitting Art Nouveau and Arts and Crafts styles, begins publication in England.

1894 Tiffany patents favrile glass.

McKim contacts Whistler for a mural for the Boston Public Library.

Sullivan and Tiffany are awarded medals by foreign decorative arts organizations for their exhibits at Chicago.

Fenollosa and Dow arrange several large exhibits of Japanese art at Boston Museum of Fine Arts.

Les XX is dissolved and replaced by *La Libre Esthétique*, with emphasis on the applied arts.

The Dreyfus Affair.

1895 Puvis de Chavannes, Sargent, and Abbey install murals in the Boston Public Library.

Fenollosa leaves Boston.

Elbert Hubbard begins publication of *The Philistine* at peak of the avant-garde periodical and poster movement in America.

Oscar Wilde is tried and imprisoned; Beardsley loses art editorship of *The Yellow Book.*

Samuel Bing opens first *Salon de l'Art Nouveau* in Paris.

Cézanne exhibits at Vollard's; Lalique's exhibit at the *Salon du Champ de Mars* is successful; La Farge has one-man show at this salon.

1896 Van Briggle returns from Paris to Rookwood; Ashbee visits the United States to encourage the development of Arts and Crafts societies.

New York's Grolier Club holds a large Japanese print exhibit.

Bradley moves to Massachusetts to start his private press.

Poster movement reaches its height in America.

1897 Bradley exhibits at the Boston Arts and Crafts Society.

Chicago Arts and Crafts Society holds an exhibit that marks beginning of what will become the Prairie School.

Grueby begins producing art pottery, influenced by French ceramics seen at the Chicago Fair.

Alexander paints *Isabella and the Pot of Basil* in a French Art Nouveau style.

Louis Tiffany opens a foundry in Corona, Long Island, producing lamps and other items.

Last Rose+Croix exhibit held in Paris at Georges Petit Galeries.

American small-periodical movement ends.

Queen Victoria's Diamond Jubilee.

1898 Arthur Dow begins teaching French "synthetist" concepts of painting at Pratt Institute, Brooklyn; his students include Max Weber.

Gustav Stickley studies Voysey's work.

Frieseke moves to Paris.

1899 Sullivan begins work on Carson, Pirie, Scott Store in Chicago; Elmslie helps with decorative work.

Dow publishes influential art manual *Composition.*

Van Briggle moves to Colorado, starts own pottery company.

Bradley designs his last Art Nouveau book, Crane's *War Is Kind.*

Whistler makes watercolor sketch for Boston Public Library mural.

1900 Paris Exposition marks height of international popular acceptance and exploitation of Art Nouveau movements.

1901 Bradley's house designs appear in *Ladies Home Journal*, one month after Frank Lloyd Wright's.

Stickley begins publication of *The Craftsman;* spread of an Arts and Crafts "Mission" style.

Charles Rolhfs' furniture designs are published in America and Germany.

Alexander returns to New York.

Theodore Roosevelt becomes President.

1902 Tiffany Studios expands, becoming a large commercial enterprise.

Stieglitz founds *Camera Work* and the Photo Secession.

Ryder is made a member of the National Academy.

Turin Exposition marks decline of Art Nouveau.

The Architectural Record publishes a series of articles denouncing Art Nouveau, supporting traditional styles in architecture and design.

1903 Whistler dies.

Van Briggle wins many medals for one-man exhibit of pottery at the Paris *Salon.*

1904 Tiffany introduces his pottery line at St. Louis Exposition. Van Briggle's exhibit sweeps the Fair; he dies in July.

Charles Demuth makes first visit to Paris.

1905 Paris: *Les Fauves* exhibit; Whistler memorial exhibition.

1906 Gauguin retrospective exhibition in Paris.

1907 Cézanne retrospective exhibition.

Sullivan designs bank in Owatonna, Minnesota, with Elmslie.

Dove, Demuth, Hopper, Carles, Maurer, and Weber travel to Paris.

1908 Drawings by Matisse and Rodin exhibited at Stieglitz' "291" gallery.

1909 Toulouse-Lautrec lithographs exhibited at Stieglitz' "291."

1910 La Farge and Homer die.

Fenollosa's *Epochs of Chinese and Japanese Art* published posthumously.

1911 Frieseke at the height of his popularity.

1912 Georgia O'Keeffe begins to study with Dow at Teachers College, Columbia University.

Demuth makes extended trip to Europe.

Manship returns from Greece; his new style in sculpture is immediately successful.

1913 The Armory Show held in New York.

Chronology

NOTES

INTRODUCTION: ART NOUVEAU:
A GENERAL DISCUSSION

[1] Samuel Bing, "L'Art Nouveau," *Architectural Record*, XII (1902), 279 ff. For further information concerning this first exhibition, see: Robert Koch, "Art Nouveau Bing," *Gazette des Beaux-Arts*, LIII (March, 1959); and Samuel Bing, *Salon de l'Art Nouveau, Catalogue Premier*, (Paris, 1895). This first exhibit included: ten stained-glass windows designed by Ranson, Bonnard, Grasset, Ibels, Roussel, Sérusier, Toulouse-Lautrec, Vallotton, and Vuillard, all produced by Louis Tiffany; paintings by Anquetin, Beardsley (although listed as paintings, most of these were probably pen drawings), Besnard, Bonnard, Brangwyn, Carrière, Denis, Ibels, Khnopff, Menzel, Pissaro, Ranson, Roussel, Sérusier, Signac, Toulouse-Lautrec, Vuillard, and Zorn; sculptures by Bourdelle, Meunier, Rodin, and Vallgren; prints by Anquetin, Carrière, Mary Cassatt, Walter Crane, Eckmann, Toulouse-Lautrec, and Whistler. Also included were twenty pieces of Tiffany blown "favrile" glass, glass by Gallé, jewelry by Lalique, furniture for a dining room and a smoking room by Van de Velde and Lemmen, tapestries, lighting fixtures, and American and English posters by Bradley, Penfield, Beardsley, Mackintosh, and the Beggarstaff Brothers.

[2] Jan Verkade, *Le Tourment de Dieu* (Paris, 1923), 94. Quoted in Peter Selz and Mildred Constantine, eds., *Art Nouveau* (New York, 1959), 55.

[3] Maurice Denis, *Theories: 1890–1910* (Paris, 1912), 1.

[4] Oscar Wilde, *The Complete Works* (New York, 1966 ed.), 261; from "The English Renaissance" lecture.

[5] For a history and details of *Les XX* see Madeleine Octave Maus, *Trente Années de Lutte pour l'Art: 1884–1914* (Brussels, 1926).

[6] Diane Chalmers Johnson, "*The Studio*, A Contribution to the Nineties," *Apollo Magazine*, XCI (April 1970), 97.

[7] Nikolaus Pevsner, *Pioneers of Modern Design: from William Morris to Walter Gropius*, 2nd ed. (New York, 1949), 55.

[8] Stephan Tschudi Madsen, *Sources of Art Nouveau* (Oslo, 1955), 30.

[9] Robert Schmutzler, "The English Origins of Art Nouveau," *Architectural Review*, CXVII (Feb. 1955), 108.

[10] Renato Poggioli, *The Theory of the Avant Garde* (Harvard University Press, Cambridge, Mass., 1968), 83.

[11] James Grady, "Nature and the Art Nouveau," *Art Bulletin*, XXXVII, 3 (Sept. 1955), 188.

[12] J. M. Richards and Nikolaus Pevsner, eds., *The Anti-Rationalists* (London, 1973), 2.

[13] Samuel Bing, *Artistic America (La culture artistique en Amérique)* (originally Paris, 1895). This work has been translated by Benita Eisler and published by Robert Koch, together with three important articles by Bing ("Louis C. Tiffany's Coloured Glass Work" from *Kunst und Kunsthandwerk*, 1898; "L'Art Nouveau" from *The Architectural Record*, 1902; and "L'Art Nouveau" from *The Craftsman*, October 1903), in *Artistic America, Tiffany Glass, and Art Nouveau* (Cambridge, Mass.–London, 1970). Quotations from these writings by Bing are taken from this book. The quotation cited appears on page 66.

[14] *Ibid.*, 250.

CHAPTER ONE: THE AMERICAN CULTURAL
RENAISSANCE, 1876–1893

[1] Lloyd Lewis and Henry Justin Smith, *Oscar Wilde Discovers America* (New York, 1936), is a basic source for information pertaining to America's reactions to Wilde's trip. The book contains reference material taken from the newspapers of nearly every city the Englishman visited.

[2] *Ibid.*, 267.

[3] Oscar Wilde, *The Complete Works* (New York, 1966 ed.), 261. This book has been used as the source for the quotations from Wilde's lectures.

[4] *Ibid.*, 281. The next three quoted words and phrases are also from "House Decoration," found consecutively on pages 282 to 290.

[5] *Ibid.*, 293–308.

[6] Arthur Meier Schlesinger, *The Rise of the City: 1878–1898*, Vol. X: History of American Life series (New York, 1933). Chapter four, in particular, deals with "The Urban World," and chapter six with "The American Woman." A contemporary appreciation of the dynamic role of the city in the cultural developments of the 1890s is given by F. J. Kingsbury, "The Tendency of Men to Live in Cities," *Journal of Social Science*, XXXIII (1895), 1–19.

[7] "Contributor's Club," *Atlantic Monthly*, XLVI (1880), 724–25.

[8] Sources for the Philadelphia Centennial: Walter Smith, *The Masterpieces of the Centennial International Exhibition*, especially Vol. II: *Industrial Art* (Philadelphia, n.d.); J. S. Ingram, *The Centennial Exposition Described and Illustrated* (Philadelphia, 1876); Thompson Westcott, *Centennial Portfolio: A Souvenir of the International Exhibition at Philadelphia* (Philadelphia, 1876); and Walter Smith, *Examples of Household Taste* (New York, 1878). In *Masterpieces* Smith discussed and illustrated Walter Crane's award-winning "Margarite" wallpaper design on page 7; on page 64 he described the embroidery from the Royal School of Art Needlework based on designs by Crane and William Morris, works especially influential on Candace Wheeler (see note 10, below).

[9] S. G. W. Benjamin discussed the rising interest in art in "American Art since the Centennial," *New Princeton Review*, IV (1887), 14–30.

[10] Candace Wheeler, *Yesterdays in a Busy Life* (New York, 1918).

[11] The recently published facsimiles of the Sears, Roebuck and Montgomery Ward catalogues (Dover Publ.) from the 1890s give clear indications of the objects most desired by this large majority of Americans.

[12] Lewis and Smith, *op. cit.*, 181.

[13] Washington Gladden, "Christianity and Aestheticism," *Andover Review*, I (Jan. 1884), 18–20.

[14] From an address quoted in Kermit Vanderbilt, *Charles Eliot Norton: Apostle of Culture in Democracy* (Cambridge, Mass., 1959).

[15] Lewis and Smith, *op. cit.*, 21.

[16] In *Ideas in America* (Cambridge, Mass., 1944) Howard Mumford Jones devoted chapter eight to "The Renaissance and American Origins," in which he presented analogies between the "robber barons" of the 1880s and the Italian Renaissance merchant princes. He also discussed the rise in Renaissance scholarship in the later decades of the nineteenth century, seen in Burckhardt's *Die Kultur der Renaissance in Italien* (1860), Pater's *Studies of the Renaissance* (1873), Symonds' *Renaissance in Italy* (1875), and, of course, Jarves' *Art Studies: The Old Masters of Italy* (1860). Jones proposed that "the special quality of the relation between wealth and culture beginning in the second half of the nineteenth century . . . is closer to Cosimo dei Medici than it is to John Calvin," page 146.

[17] One well-known American artist, John Sloan, acknowledged the influence of Crane's works in the 1870s and 1880s: "When I started to use drawings as a way of earning a living, the work of Walter Crane, which had been such a familiar part of my childhood, was very naturally the source from which I started to form my concept of design. He was a good model to have, because his feeling for classical forms was very healthy and not at all academic. His own style was not eccentric or dominating. I learned things from the study of his work about line, form, arabesque. . . . I was fortunate in having been brought up with books illustrated by Walter Crane, who had a fine sense of classical form, a very robust sense of the classical spirit." Quoted from Helen Farr Sloan, *American Art Nouveau: The Poster Period of John Sloan* (Pennsylvania, 1967), n.p.

[18] *Transactions of the Grolier Club*, I (Jan. 1884–July 1885). This exhibit opened on May 28, 1885, and was deemed "highly successful." Included were works by E. A. Abbey, Howard Pyle, Bouguereau, John La Farge, and F. Hopkinson Smith.

[19] Robert Koch, "Artistic Books, Periodicals and Posters of the 'Gay Nineties,' " *Art Quarterly*, XXV, 4 (1962), 370–83.

[20] Clay Lancaster discussed the Japanese exhibits at the Centennial, especially the architectural exhibits, in his *Japanese Influence in America* (New York, 1952). The various catalogues of the Fair, such as those mentioned in note 8, also contain discussions of specific examples of Oriental art on display.

[21] Smith, *Examples of Household Taste*, 121.

[22] Robert Koch, "Art Nouveau Bing," *Gazette des Beaux-Arts*, LIII (March 1959), 180. Although Bing himself did not come to the United States until 1893, he opened a branch of his firm during the 1880s in New York City. The firm was represented in America by John Getz (see Getz, *Auction Catalogue of Oriental Works of Art, Firm of S. Bing, New York*, November, 1888). Other distributors of Oriental goods in the late 1870s in New York City included the Japanese Manufacturers and Trade Company, and A. A. Vantine and Company—Japan, China, and India Goods. These two companies advertised in the catalogue for the Loan Exhibition in Aid of the Society of Decorative Arts, 1878, National Academy of Design, New York. In this exhibition was a section on Oriental art which included works on loan from Tiffany and Company.

Gabriel P. Weisberg has published a series of articles on the international influence of S. Bing: "Samuel Bing: Patron of Art Nouveau: Part I. The Appreciation of Japanese Art"; "Part II. Bing's Salons of

Art Nouveau"; "Part III. The House of Art Nouveau Bing," in *Connoisseur*, 172, 173 (Oct., Dec., Jan., 1970–71), respectively 119–25; 294–99; 61–68; and "Samuel Bing: International Dealer of Art Nouveau: Part I. Contacts with the Musée des Arts Décoratifs, Paris"; "Part II. Contacts with the Victoria and Albert Museum"; "Part III. Contacts with the Kaiser Wilhelm Museum, Krefeld, Germany, and the Finnish Society of Crafts and Design, Helsinki, Finland"; "Part IV. Contacts with the Museum of Decorative Art, Copenhagen," in *Connoisseur*, 176 (March, April, May, July, 1971), respectively 200–205, 275–83, 49–55, 211–19.

[23] Samuel Bing, *Artistic America* (Koch edition), 156.

[24] *Ibid.*, 121.

[25] *Transactions of the Grolier Club*, II (July 1885–Feb. 1894), Ch. VI, 56–58. The Japanese print show opened on April 4, 1889, and was said to have "attracted wide attention." According to the *Transactions*, the exhibition "brought together works of the chief artists of Japan from the beginning of wood engraving in that country to the present time." The exhibit was "accompanied by a very full catalogue prepared by Mr. Horomich Shugio," *Grolier Club Catalogue No. 7*. The poster exhibition opened on November 27, 1889. The Club expressed "surprise that such a collection could be got together in New York, and that there was such a variety, vivacity, and artistic excellence in the works themselves," particularly rich in Jules Chéret's works.

[26] Crane writes at some length about his American visit in *The Decorative Arts: Sir Edward Burne-Jones, William Morris, and Walter Crane* (London, 1900). The description of Crane's murals is taken from Donald Hoffmann, *The Architecture of John Wellborn Root* (Baltimore–London, 1973), 194.

[27] Helene Barbara Weinberg, "John La Farge and the Decoration of Trinity Church, Boston," *Journal of the Society of Architectural Historians*, XXX (Dec. 1974), 328.

[28] James F. O'Gorman, *Selected Drawings: H. H. Richardson and His Office* (Boston, 1974), 203.

[29] Helene Barbara Weinberg treated the subject of "The Decorative Work of John La Farge" in her dissertation for Columbia University, Department of Art History and Archaeology, 1972, from which she has published numerous articles (see Bibliography).

[30] E. R. and J. Pennell, *The Whistler Journal* (1921), 192; quoted in Denys Sutton's *Nocturne: The Art of James McNeill Whistler* (London, 1963), 80. On page 86 Sutton quotes the lengthy description of Whistler's Primrose Room (shown in Paris in 1878), taken from *American Architect and Building News* (July 27, 1878).

[31] Regina Soria, *Elihu Vedder: American Visionary Artist in Rome* (Cranbury, N. J., 1970).

[32] Lloyd Goodrich, "Ryder Rediscovered," *Art in America*, 56 (Nov. 1868), 32–45.

[33] Vincent J. Scully, Jr., *The Shingle Style and the Stick Style: Architectural Theory and Design from Richardson to the Origins of Wright* (New Haven–London, 1971), 16.

[34] Charles Eliot Norton, "A Portion of an Address Given in 1888," *The Knight Errant*, I, 1 (April 1892), 4–6.

[35] Bertram Grosvenor Goodhue, "A Criticism of the Methods which Obtain in Journalistic Reviewing of the Period," *The Knight Errant*, I, 1 (April 1892), 7–9.

[36] For a thorough study of Fenollosa, see Lawrence W. Chisolm, *Fenollosa: The Far East and American Culture* (New Haven, 1963).

[37] Ernest Francisco Fenollosa, "The Significance of Oriental Art," *The Knight Errant*, I, 3 (Oct. 1892), 65–70.

[38] Arthur Dow, "A Note on Japanese Art and What the American Artist May Learn Therefrom," *The Knight Errant*, I, 4 (Jan. 1893), 114–17.

[39] Madeleine A. Fidell, "Letter to the Editor," *College Art Journal*, XXIX (Dec. 5, 1969), 102; and Frederick C. Moffatt, *Arthur Wesley Dow* (Washington, D.C., 1977).

[40] Bertram Grosvenor Goodhue, "Concerning Recent Books and Bookbinding," *The Knight Errant*, I, 4 (Jan. 1893), 123–28.

[41] Although the dates on the covers of *The Knight Errant* are given as April, July, and October 1892, and January 1893, for unexplained reasons the magazine actually appeared over a two-year period, instead of the expected one year. This fact is contained in the Epilogue of number four and explains the mentioning of *The Yellow Book* and *The Chap-Book*, both of which appeared in Spring 1894.

[42] Henry Van Brunt, "The Columbian Exposition and American Civilization," *Atlantic Monthly*, LXXI (1893), 588.

[43] William Walton, *The World's Columbian Exposition: Art and Architecture* (Philadelphia, 1893), n.p. Other sources for material on the Exposition are listed in the Bibliography.

[44] Francis D. Millet, "The Decoration of the Exposition," *Scribner's Magazine*, XII (July–Dec. 1893), 692.

[45] Montgomery Schuyler, "Last Words about the World's Fair," *Architectural Record* (1894), 291.

[46] Daniel Burnham, quotation taken from "a Chicago newspaper" and given in Schuyler, *op. cit.*, 292.

[47] Louis H. Sullivan, *Autobiography of an Idea* (New York, 1924), 317–25.

[48] Walton, *op. cit.*, n.p.

[49] Robert Koch, *Louis C. Tiffany: Rebel in Glass* (New York, 1964), 75–76.

[50] *Ibid.*, 75.

[51] See Herwin Schaeffer, "Tiffany's Fame in Europe," *Art Bulletin*, XLIV (Dec. 1962), 302–28.

CHAPTER TWO: LOUIS COMFORT TIFFANY AND ART NOUVEAU APPLIED ARTS IN AMERICA

[1] Benjamin C. Truman, *History of the World's Fair: Being a Complete and Authentic Description of the Columbian Exposition from its Conception* (New York, 1976; reprint of 1893 Philadelphia publication), 218.

[2] *Ibid.*, 219.

[3] Samuel Bing, *Artistic America, Tiffany Glass, and Art Nouveau* (Cambridge, Mass.–London, 1970), 121.

[4] André Bouilhet, "L'Exposition de Chicago: Notes de Voyage d'un Orfèvre," *Revue des Arts Décoratifs*, XIV (1893–94), 74.

[5] Bing, *op. cit.*, 147.

[6] *Ibid.*, 150.

[7] *Ibid.*, 185.

[8] *Ibid.*, 161.

[9] *Ibid.*, 164.

[10] *Ibid.*, 191.

[11] Bouilhet, *op. cit.*, 72.

[12] Robert Koch, *Louis C. Tiffany: Rebel in Glass* (New York, 1964), 76–77.

[13] Bouilhet, *op. cit.*, 73.

[14] Bing, *op. cit.*, 120.

[15] Detailed information and illustrations on the Centennial are to be found in Professor Walter Smith's *The Masterpieces of the Centennial International Exhibition*, Vol. II: *Industrial Art* (Philadelphia, n.d.; c. 1876).

[16] *Ibid.*, 4.

[17] A copy of a page of the Howell and James catalogue, reproduced from the *Art Journal* catalogue of the Paris International Exhibition of 1878, is illustrated as No. 40 in Gillian Naylor, *The Arts and Crafts Movement: a Study of Its Sources, Ideals and Influence on Design Theory* (Cambridge, Mass., 1971).

[18] This quotation and the following are taken from Truman, *op. cit.*, 177.

[19] James F. O'Gorman, *Selected Drawings: H. H. Richardson and His Office* (Cambridge, Mass., 1974), 203.

[20] For a discussion of the "Renaissance Complex," see Oliver Larkin, *Art and Life in America* (New York, 1949), introduction to Ch. III.

[21] Henry Hobson Richardson, *Description of Trinity Church* (Boston, 1877), 10.

[22] "Trinity Church, Boston—Decoration," *American Architect and Building News*, I (1876), 345.

[23] James F. O'Gorman, *The Architecture of Frank Furness* (Philadelphia, 1973).

[24] George Sheldon, *Artistic Houses* (New York, 1883), Vol. I, Part 1, 7.

[25] *Ibid.*, 7–8.

[26] *Ibid.*, 1–6.

[27] *Ibid.*, 1.

[28] *Ibid.*, 2.

[29] Bing, *op. cit.*, 130.

[30] Sheldon, *op. cit.*, Vol. I, Part 2, 71–74.

[31] *Ibid.*, Vol. I, Part 1, 53–56.

[32] *Ibid.*, 67–71.

[33] Bing, *op. cit.*, 189.

[34] Sheldon, *op. cit.*, Vol. I, Part 1, 24–33.

[35] "Some of the Union League Decorations," *Century Magazine*, XXIII (1882), 745.

[36] *Ibid.*, 747.

[37] Bing, *op. cit.*, 148.

[38] Koch, *Rebel*, 59.

[39] *Ibid.*, 61.

[40] Sheldon, *op. cit.*, Vol. II, Part 2, 125–26.

[41] David Gebhard, "C. F. A. Voysey: To and From America," *Journal of the Society of Architectural Historians*, XXX (Dec. 1971), 304–12.

[42] For a thorough study of the European reactions to both Richardson and Sullivan, see Leonard K. Eaton, *American Architecture Comes of Age: European Reaction to H. H. Richardson and Louis Sullivan* (Cambridge, Mass.–London, 1972).

[43] For Edward *vs.* Eugène Colonna, see Martin Eidelberg, "E. Colonna: An American in Paris," *Connoisseur*, 166 (1967), 261.

[44] See Richard H. Randall, Jr., *The Furniture of H. H. Richardson* (exhibition catalogue), Museum of Fine Arts, Boston, 1962. Randall suggests an Art Nouveau "prototype" in the Malden chair.

[45] Charlotte Moffitt, "The Rohlfs' Furniture," *House Beautiful*, VIII (Jan. 1900), 82.

[46] Charles Rohlfs, "The Grain of the Wood," *House Beautiful*, IX (Feb. 1901), 147–48.

[47] O'Gorman, *Furness*, 43.

[48] Helene Barbara Weinberg, "John La Farge and the Invention of American Opalescent Windows," *Stained Glass*, LXVII (Autumn 1972), 4–11. Weinberg has published major works on La Farge, based on her unpublished Ph.D. dissertation, "The Decorative Work of John La Farge," Department of Art History and Archaeology, Columbia University, 1972. See Bibliography for further listing of her work.

[49] Caryl Coleman, "Second Spring," *Architectural Record*, II (1893), 485.

[50] Bing, *op. cit.*, 134.

[51] *Ibid.*, 138.

[52] *Ibid.*, 140–41.

[53] Quoted from *Harper's Magazine*, 1878; Koch, Rebel, 57.

[54] E. Didron, "Le Vitrail depuis cent ans et à l'exposition de 1889," *Revue des Arts Décoratifs*, X (1889–90), 146.

[55] Herwin Schaeffer, "Tiffany's Fame in Europe," *Art Bulletin*, XLIV (Dec. 1962), 302–28.

[56] Didron, *op. cit.*, 146.

[57] Coleman, *op. cit.*, 485.

[58] "Some of the Union League Decorations," *Century Magazine*, XXIII (1882), 748.

[59] Bouilhet, *op. cit.*, 74.

[60] *Ibid.*, 76.

[61] *Ibid.*, 77.

[62] *Ibid.*, 77.

[63] *Ibid.*, 78.

[64] *Ibid.*, 79.

[65] See Entry No. 230 in *Nineteenth-Century America: Furniture and Other Decorative Arts* (exhibition catalogue), Metropolitan Museum of Art, New York, 1970.

[66] Bing, *op. cit.*, 156.

[67] Charles H. Carpenter, Jr., "Nineteenth-century Silver in the New York Yacht Club," *Antiques Magazine* (Sept. 1977), 496–505, illustrates and discusses many of these early silver trophies.

[68] See Martin Eidelberg, "Edward Colonna's *Essay on Broom-Corn*: A Forgotten Book of Early Art Nouveau," *Connoisseur*, 176 (Feb. 1971), 123–30.

[69] George F. Heydt, *Charles L. Tiffany and Company* (New York, 1893), 26. The historical information given in the following paragraph on Tiffany and Company is taken from Heydt.

[70] *Ibid.*, 28.

[71] Quoted in Heydt, 33.

[72] Bouilhet, *op. cit.*, 75.

[73] Charlotte Moffitt, "New Designs on Silver," *House Beautiful*, VII (Dec. 1899), 55–58.

[74] Smith, *op. cit.*, Vol. II, *Industrial Art*.

[75] "Louis C. Tiffany and His Work in Artistic Jewelry," *International Studio*, XXX (1906), 33–42. The works described in this paragraph are illustrated here.

[76] Bing, *op. cit.*, 206.

[77] See Schaeffer, *op. cit.*

[78] Mario Amaya, "The Taste for Tiffany," *Apollo*, n.s. 81 (Feb. 1965), 106.

[79] Bing, *op. cit.*, 208–9.

[80] *Ibid.*, 211.

[81] *Ibid.*, 212.

[82] *Ibid.*, 202.

[83] See Robert Koch, *Louis C. Tiffany's Glass—Bronzes—Lamps: A Complete Collector's Guide* (New York, 1971).

[84] Martin Eidelberg, "Tiffany Favrile Pottery: a new study of a few known facts," *Connoisseur*, 169 (Sept. 1968), 57–61.

[85] See Dorothy McGraw Bogue, *The Van Briggle Story* (Colorado Springs, Colo., 1968).

[86] "Biloxi Pottery from an Artistic Standpoint," *China, Glass and Pottery Review*, IV (June 1899), 20.

[87] For further information on many of the artists discussed here, see Robert Judson Clark, ed., *The Arts and Crafts Movement in America, 1876–1916* (exhibition catalogue), Princeton Art Museum (Princeton, N.J., 1972).

[88] Martin Eidelberg, "The Ceramic Art of William H. Grueby," *Connoisseur*, 184 (Sept. 1973), 50.

[89] See the articles on Samuel Bing by Gabriel Weisberg listed in the Bibliography.

[90] For an overall look at American pottery in the Art Nouveau vein, see Marion John Nelson, "Art Nouveau in American Ceramics," *Art Quarterly*, XXVI, 4 (1963), 441–59.

[91] Koch, *Rebel*, 150.

CHAPTER THREE: LOUIS H. SULLIVAN AND AMERICAN ART NOUVEAU ARCHITECTURE

[1] The quotations by Samuel Bing used throughout this book are from *Artistic America, Tiffany Glass, and Art Nouveau* (Cambridge, Mass.–London, 1970), a collection of translations of Bing's major writings, introduced and illustrated by Robert Koch. This first quotation is on page 57.

[2] *Ibid.*, 66.

[3] *Ibid.*, 79.

[4] John Forbes Robertson, *Great Industries of Great Britain*, II (1886), 21.

[5] This and the following quotations in this paragraph are from *Photographs of the World's Fair* (Charleston, S.C., 1894).

[6] Rand, McNally & Company, *Handbook of the World's Columbian Exposition* (Chicago, 1893), 30–34. For a thorough discussion of the Transportation Building, see David H. Crook, "Louis Sullivan and the Golden Doorway," *Journal of the Society of Architectural Historians*, XXVI (Dec. 1967), 250–58; and Dimitri Tselos, "The Chicago Fair and the Myth of the 'Lost Cause,' " *Journal of the Society of Architectural Historians*, XXVI (Dec. 1967), 259–68.

[7] Letter: W. C. Purcell to John Szarkowski, February 21, 1956, P & E Archive as rewritten Nov. 1961 in "Letter to a photographer," 1–4. This quotation and its reference are from R. R. Warn, "Bennett and Sullivan: Client and Creator," *Prairie School Review*, X, 3 (1973), 8.

[8] Montgomery Schuyler, "Last Words about the World's Fair," *Architectural Record* (1894), 294 ff.

[9] André Bouilhet, "L' Exposition de Chicago: Notes de Voyage d'un Orfèvre," *Revue des Arts Décoratifs*, XIV (1893–94), 68.

[10] *Ibid.*, 69.

[11] Hugh Morrison, *Louis Sullivan: Prophet of Modern Architecture* (New York, 1962), 189.

[12] Leonard K. Eaton, *American Architecture Comes of Age: European Reaction to H. H. Richardson and Louis Sullivan* (Cambridge, Mass.–London, 1972), 208.

[13] Morrison, *op. cit.*, 135–36; Albert Bush-Brown, *Louis Sullivan* (New York, 1960), 22; and probably the original source of the phrase, Schuyler, *op. cit.*, 295.

[14] Letter from Daniel H. Burnham to Frederick Law Olmsted, February 10, 1891; *Copybook*, I, 358. The letter is quoted in Crook, *op. cit.*, 256.

[15] Bing, *op. cit.*, 69.

[16] See Donald Hoffmann, *The Architecture of John Wellborn Root* (Baltimore–London, 1973), 65–83.

[17] *Ibid.*, 67.

[18] See Tselos, *op. cit.*, for a discussion of Islamic influence in Sullivan's Golden Gateway. For a discussion of Islamic influences in American architecture, see Gerald Steven Bernstein, "In Pursuit of the Exotic: Islamic Forms in Nineteenth-century American Architecture," unpublished Ph.D. dissertation, University of Pennsylvania, 1968, which served as the major source for the discussion of Islamic influence in this chapter.

[19] Bernstein, *op. cit.*, 2

[20] *Ibid.*, 151. Bernstein quotes A. D. F. Hamlin's "The Battle of Styles," *Architectural Record*, I (1892), 409–10.

[21] O'Gorman, *Furness*, 32.

[22] *Ibid.*, 41.

[23] "La première au Théâtre de la Bourse," *L'Etoile Belge* (Dec. 31, 1885).

[24] Bernstein, *op. cit.*, 5.

[25] For a study of the symbolism underlying Islamic architecture and ornament, see Nader Ardalan and Laleh Bakhtiar, *The Sense of Unity: The Sufi Tradition in Persian Architecture* (Chicago–London, 1973).

[26] Louis Sullivan, "Style," *Inland Architect*, XI (May 1888), 60.

[27] *Idem, Kindergarten Chats* (Lawrence, Kans., 1934), 194.

[28] Louis Sullivan's address to the 1894 meeting in New York of the American Institute of Architects is quoted in Maurice English, *The Testament of Stone* (Evanston, Ill., 1963), 21–22.

[29] Louis H. Sullivan, *A System of Architectural Ornament* (New York, 1924), n.p.

[30] *Ibid.*

[31] These quotations and the indented quotation above are taken from *Kindergarten Chats*. Sullivan's symbolic intent is fully discussed in Sherman Paul, *Louis Sullivan: An Architect in American Thought* (Englewood Cliffs, N.J., 1962).

[32] Paul, *op. cit.*, 40.

[33] Bouilhet, *op. cit.*, 70–72. Bouilhet was well aware that the flat stenciling and details were done by the Chicago firm of Healy and Millet, which was also responsible for the stained-glass windows. Consequently, he reproduced the three-dimensional areas of decoration in his article.

[34] Originally published in *Lippincott's*, LVII (March 1896), 403–9.

[35] William H. Jordy, *American Buildings and Their Architects: Progressive and Academic Ideals at the Turn of the 20th Century* (New York, 1972), 135.

[36] Christopher Dresser, *Principles of Decorative Design* (New York, 1873), 24. A close comparison exists between Furness's interior and exterior decorations of the Pennsylvania Academy of the Fine Arts and illustrations 41, 59, 61, and 170 in Dresser.

[37] Yvonne Brunhammer et al., *Art Nouveau: Belgium–France* (Houston, 1976), 325.

[38] C. Matlack Price, "Secessionist Architecture in America," *Arts and Decoration*, III (Dec. 1912), 52.

[39] Brunhammer, *op. cit.*, 347. The quote is from Horta, *Memoirs*.

[40] Peter Selz and Mildred Constantine, eds., *Art Nouveau* (New York, 1959), 105.

[41] *Ibid.*, 123.

[42] Maurice Rheims, *The Flowering of Art Nouveau* (New York, 1965), 37.

[43] Robert Schmutzler, *Art Nouveau* (New York, 1964), 227.

[44] *Ibid.*, 228.

[45] Rheims, *op. cit.*, 11, 12

[46] Herbert Croly, "The New World and the New Art," *Architectural Record*, XII (1902), 137.

[47] H. W. Desmond, "Another View—What Mr. Louis Sullivan Stands For," *Architectural Record*, XVI (July 1904), 61–67.

CHAPTER FOUR: WILL H. BRADLEY AND THE POSTER AND PERIODICAL MOVEMENTS, 1893–1897

[1] The major source for information pertaining to Bradley's life is his autobiography: *Will Bradley: His Chap-Book* (New York, 1955), published by the Typophiles, and giving a colorful description of Bradley's life (with Introduction by Walter D. Teague); written in the second person, this first-hand account was assembled from separate papers written by Bradley after 1949. These sources are: a booklet entitled *Memories: 1875–1895*, printed for the Typophiles

and other friends by Grant Dahlstrom in Pasadena, Cal., 1949; another booklet, *Picture of a Period, or Memories of the Gay Nineties*, printed by Dahlstrom for the Rounce and Coffin Club of Los Angeles, 1950; the Huntington Library hand list, *Will Bradley: His Work*, Pasadena, Cal., 1951. The fourth source is "Will Bradley's Magazine Memories," from *Journal of the American Institute of Graphic Arts*, III, 1 (1950). Information concerning Bradley's biography can be found in the following: an article based on an interview which Robert Koch had with Bradley shortly before the artist's death in 1962: "Will Bradley," *Art in America*, L, 3 (Autumn 1962), 78–83; and an article by Fred T. Singleton, Bradley's foreman at the Wayside Press: "Will Bradley," *American Printer and Lithographer* (Aug. 1936), 13–17.

2 "The Field of Art," *Scribner's Magazine*, XX (1896), 649–52. This article discusses the founding of museums, art associations, and schools of art, "becoming so numerous throughout the Western States."

3 H. B. Fuller, "The Upward Movement in Chicago," *Atlantic Monthly*, XXXX (1897), 544–47.

4 Francis F. Browne, "American Publishing and Publishers," *Dial*, XXVIII (1900), 340–43. *The Dial: A semi-monthly Journal of Literary Criticism, Discussion, and Information* was founded by Browne in Chicago in 1880; on May 1, 1900, the magazine celebrated its twentieth anniversary with an entire issue devoted to "studies and facts on transatlantic literature, American bookselling and booksellers, American libraries, American periodicals, and American editors."

5 W. Irving Way, "Aubrey Beardsley," *The Inland Printer*, XIII, 1 (April 1894), 27–28.

6 According to Bradley in his autobiography, p. 38, this poster was a "twenty-eight sheet stand" and "probably the first signed theatrical poster produced" in America.

7 Edgar Breitenbach, *The American Poster* (New York, 1967), 8–10.

8 "The Streets as Art Galleries," *Magazine of Art* (1881), 299.

9 *Ibid.*, 298–99.

10 Catherine Morrison McClinton, *The Chromolithographs of Louis Prang* (New York, 1973), 77–78.

11 *Ibid.*, 80.

12 Brander Matthews, "The Pictorial Poster," *Century*, XXII (Sept. 1892), 749.

13 Octave Uzanne, "Eugène Grasset and Decorative Art in France," *Studio*, IV (1894), 34–47. For further information on Grasset and on other artists mentioned in this chapter, the following sources are available: from the American point of view, Charles Knowles Bolton, *The Reign of the Poster* (Boston, 1895); an English source, Charles Hiatt, *Picture Posters* (London, 1895); from Germany is Jean Louis Sponsel, *Das Moderne Plakat* (Dresden, 1897); internationally authored is M. Bauwens *et al.*, *Les Affiches Etrangères Illustrées* (Paris, 1897); more recently, Robert Goldwater, "L'Affiche Moderne: A Revival of Poster Art After 1880," *Gazette des Beaux-Arts*, L (Nov. 1957), 285–96. For biographical facts and bibliographies of the major graphic artists of the 1890s, see Hans H. Hofstätter, *Jugendstil Druckkunst* (Baden-Baden, 1968), and *Das frühe Plakat in Europa und den USA, ein Bestandskatalog* (Berlin, 1973).

14 *Transactions of the Grolier Club*, I (Jan. 1884–July 1885).

15 *Catalogue of an Exhibition of Illustrated Bill-Posters*, Grolier Club catalogue no. 10, Nov. 1890.

16 Matthews, *op. cit.*, 754.

17 Louis Rhead, "The Moral Aspect of the Artistic Poster," *The Bookman*, I (1895), 312 ff.

18 *Ibid.*, 314.

19 Herbert Stone, "Mr. Penfield's Posters," *The Chap-Book*, I, 10 (Oct. 1894), 247–50.

20 Algernon Tassin, *The Magazine in America* (New York, 1916), 340.

21 *Ibid.*, 342.

22 Helen Farr Sloan, *American Art Nouveau: The Poster Period of John Sloan* (Pennsylvania, 1967; collected writings of John Sloan), n.p.

23 Joseph Pennell, "Aubrey Beardsley: A New Illustrator," *The Studio*, I (April 1893), 16–18.

24 Percival Pollard, "In Eighteen Ninety-five," *The Echo*, I, 8 (Aug. 15, 1895), 172.

25 W. Irving Way, "Books, Authors, and Kindred Subjects," *The Inland Printer*, XIII, 3 (June 1894), 230.

26 Pollard, *op. cit.*, 172.

27 Sidney Kramer, *A History of Stone and Kimball and Herbert S. Stone and Company, with a bibliography of their publications: 1893–1905* (Chicago, 1940), provides extensive information on *The Chap-Book*.

28 Pollard, *op. cit.*, 172.

29 Edgar Breitenbach, "The Poster Craze," *American Heritage*, XIII, 2 (Feb. 1962), 31.

30 Frederick Winthrop Faxon, *Ephemeral Bibelots: A Bibliography of the Modern Chap-Books and Their Imitators* (Boston, 1903). Faxon writes a 6-page introduction, then identifies over 200 periodicals, giving for each the title, place of publication, date of publication, size, and a brief statement of purpose.

31 Charles Hiatt, *Picture Posters* (London, 1895), 367.

32 Claude Fayette Bragdon, "On Posters," *The Poster Lore*, I, 1 (Jan. 1896), 24.

33 Bradley's interview was in *Paper World*, XXXI, 5 (Nov. 1895), 165–68.

34 Robert Koch, "Artistic Books, Periodicals, and Posters of the 'Gay Nineties,' " *Art Quarterly*, XXV, 4 (Winter 1962), 373.

35 Bradley designed a set of twelve covers for *The Inland Printer* during 1894. The original commission was for a single, permanent cover, but Bradley made a "tempting offer" to Mr. McQuilken, and a series of monthly changing covers was begun in April (see Bradley's autobiography, p. 36). However, the stylistic differences in these twelve designs indicate that Bradley drew them at various times throughout the year. Although the *Black Parasol* cover was used in August, its style suggests it was designed early that spring, before *The Twins* poster.

36 This fact was stated by William M. Clemens in *The Poster*, I, 1, 1896.

37 Charles Hiatt, "On Some Recent Designs by Bradley," *The Studio*, IV (1894), 166.

38 These designs by Grasset had been reproduced in the same volume of *The Studio* in which Hiatt's article on Bradley appeared.

39 For this and the following quotation see Bradley's autobiography, 39.

40 In his autobiography, pp. 58–62, Bradley gives a delightful account of how he obtained this contribution from the generous Davis. Bradley had previously designed publications for both Harriet Monroe and Nixon Waterman.

41 These comments were reprinted from various sources by Bradley in *Bradley: His Book*, I, 3, 110–13.

42 This suggestion is substantiated by the mention of a February number in Faxon, *op. cit.*: "A volume II, number four, was bound up in a few complete sets offered for sale, but was not complete, and had never been intended for issue thus by Will Bradley. It was published without his consent or approval, and was never received by regular subscribers."

43 Bradley's autobiography, 53.

44 *Ibid.*, 62.

45 Bradley made several mentions of Ricketts' work in *Bradley: His Book*, and reproduced Ricketts' design for *Milton: Early Poems* there in Vol. II, no. 1 (Nov. 1896).

46 Will H. Bradley, *Memories: 1875–1895* (Pasadena, Cal., 1949). Bradley speaks of his trip to see the Barton collection of books "printed in New England in Colonial times." He studied the Caslon type and "made sketches of the woodcut head and tail pieces and the crude woodcut decorations depicting a bunch or basket of flowers."

47 Singleton, *op. cit.*, 17.

48 Gleeson White, "Some Glasgow Designers and Their Work," *The Studio*, IX (July 1897), 86f., 227f.; M. H. Baillie Scott, "A Country House," *The Studio*, XIX (Feb. 1900), 30–38.

49 Robert Koch, "Will Bradley," 80.

50 Walter Dorwin Teague, "An Introduction," in *Will Bradley: His Chap-Book* (New York, 1955), v–vi.

51 Aubrey Beardsley, "The Art of Hoarding," *New Review* (July 1894), 53–55.

52 Bradley, interviewed by *Paper World*, *loc. cit.*

53 Max Nordau, *Degeneration* (New York, 1895), translated from the second edition of the German publication.

54 Harry Thurston Peck, *The Personal Equation* (New York, 1898), 157.

55 Grace McGowan Cooke, "Posters," *Chattanooga Sunday Times*; quoted by P. N. Boeringer, "The Advertiser and the Poster," *Overland Monthly*, XXVIII (July 1896), 47.

56 Kramer, *op. cit.*, 50–51.

57 Quoted from Karl Beckson, *Aesthetes and Decadents of the 1890's* (New York, 1966), xvii.

58 Sloan, *op. cit.*, n.p.

*American
Art Nouveau*

59 W. J. Randall, "Aubrey Beardsley, Artist of Decadence," *Metropolitan Magazine* (August 1896), 49.

60 *Ibid.*, 50.

61 Roger Fry, "Aubrey Beardsley's Drawing," *Athenaeum* (1904). Reprinted in *idem*, *Vision and Design* (New York, 1956; original ed. 1920), 232–36.

62 Oscar Wilde, *The Complete Works* (New York, 1966), 267.

63 Maurice Talmeyer, "The Age of the Poster," *The Chautauquan*, XXIV (Jan. 1897), 12–19.

64 Faxon, *op. cit.*

65 "Mr. Roosevelt's Address" (report of his speech on civil service reform), *Harvard Crimson*, XXVI, 41 (Nov. 10, 1894), 1.

66 Ralph Adams Cram, *The Decadent* (Boston, 1893).

67 Richard Hofstadter, *Anti-intellectualism in American Life* (New York, 1963), 196.

68 Kramer, *op. cit.*, 40.

69 *Ibid.*, 41.

70 Stickley's book, *Craftsman Homes* (New York, 1909), contains a history and discussion of this style, including many illustrations. See also John Crosby Freeman, *The Forgotten Rebel: Gustav Stickley and His Craftsman Mission Furniture* (New York, 1966).

71 Roosevelt, *loc. cit.*

CHAPTER FIVE: DECORATIVE PAINTING AND SCULPTURE IN AMERICA

1 Samuel Bing, *Artistic America, Tiffany Glass, and Art Nouveau* (Cambridge, Mass.–London, 1970), 48.

2 Royal Cortissoz, *American Artists* (New York and London, 1923), preface.

3 Quoted by Regina Soria, *Elihu Vedder: American Visionary Artist in Rome* (Cranbury, N.J., 1970), 220.

4 Jan Verkade, *Le Tourment de Dieu* (Paris, 1923), 94.

5 Kenyon Cox and Russell Sturgis, "The Lesson of the Photograph," *Scribner's Magazine*, XXIII (May 1898), 637–40, as reprinted in H. Wayne Morgan's collection of essays, *Victorian Culture in America, 1865–1914* (Itasca, Ill., 1967), 34.

6 *Ibid.*, 33.

7 Frank Fowler, "The Outlook for Decorative Art in America," *The Forum*, XVIII (Feb. 1895), 686–93, as reprinted in Morgan, *op. cit.*, 47.

8 Walter M. Cabot, "Some Aspects of Japanese Painting," *Atlantic Monthly*, XCV (June 1905), 804–13, as reprinted in Morgan, *op. cit.*, 12.

9 *Ibid.*, 14.

10 Quoted in Royal Cortissoz, *John La Farge, a Memoir and a Study* (New York, 1911), 122.

11 Quoted in Melvin Lyon's *Symbol and Idea in Henry Adams* (Lincoln, Nebr., 1970), 5–6.

12 As Charles Baudelaire stated in 1856: "Il y a bien longtemps que je dis que le poète est souverainement intelligent, qu'il est l'intelligence par excellence—et que l'imagination est la plus scientifique des facultés, parce que seule elle comprend l'analogie universelle, ou ce qu'une religion mystique appelle la correspondance." Taken from Baudelaire's *Correspondance générale* (Paris, 1947), I, 367.

13 Quoted from the La Farge Family Papers, Yale University Library, by Helene Barbara Weinberg in "John La Farge: The Relation of his Illustrations to his Ideal Art," *The American Art Journal*, 5 (May 1973), 61.

14 *Ibid.*, 65

15 A. J. Arberry, *British Orientalists* (London, 1943), 9. See also *idem*, *The Romance of the Rubaiyat* (London, 1959).

16 Editorial on "Vedder's Drawings for Omar Khayyam's *Rubaiyat*," *Atlantic Monthly*, LV, 327 (Jan. 1885), 111. Other contemporary reviews of note are: William Stillman, "The *Rubaiyat*," *The Nation*, XXXIX, 1011 (Nov. 13, 1884), 423; and H. E. Scudder, "Vedder's Accompaniment to the Song of Omar Khayyam," *Century Magazine*, XXIX, 1 (Nov. 1884).

17 Soria, *op. cit.*, 94.

18 Elihu Vedder, *The Digressions of V* (Boston, 1910), 410.

19 Author of the *Atlantic Monthly* article cited in note 16 above, 111.

20 Cortissoz, *American Artists*, 96.

21 See Truman H. Bartlett, *The Art Life of William Rimmer: Sculptor, Painter, and Physician* (Boston–New York, 1890).

22 *Ibid.*, 27–28.

23 *Ibid.*, 81.

24 Pauline King, *American Mural Painting: A Study of the Important Decorations by Distinguished Artists in the United States* (Boston, 1902), 50.

25 Charles H. Caffin, *American Masters of Painting* (New York, 1902), 25.

26 Cortissoz, *American Artists*, 91.

27 Soria, *op. cit.*, 220–21.

28 King, *op. cit.*, 152.

29 See Walter M. Whitehill, "The Making of an Architectural Masterpiece—The Boston Public Library," *The American Art Journal*, II, 2 (Autumn 1970), 13–32.

30 *Ibid.*, 24.

31 Quoted by Whitehill from the journal of Thomas Russell Sullivan, entry dated April 25, 1895.

32 Ernest F. Fenollosa, *Mural Painting in the Boston Public Library* (Boston, 1896), 9.

33 King, *op. cit.*, 124.

34 Quoted from a letter in the collection of the Curtis family, this statement is found in Richard Ormond, *John Singer Sargent: Paintings, Drawings, Watercolors* (New York, 1970), 89.

35 William Howe Downes, *John Singer Sargent: His Life and Work* (Boston, 1925), 35.

36 *Ibid.*, 134–35.

37 Downes (*ibid.*, 134) quotes from M. L. de Fourcaud in *Gazette des Beaux-Arts* (June, 1884).

38 "John Singer Sargent's Judaism and Christianity: A Sequence of Mural Decoration Executed between 1895 and 1916," published by the Boston Public Library.

39 See Denys Sutton, *Nocturne: The Art of James McNeill Whistler* (London, 1963), 37–40, for a discussion of the symbolic interpretations of this painting.

40 *Ibid.*, 21.

41 Margaret Steele Anderson, *The Study of Modern Painting* (New York, 1914), 231.

42 Christian Brinton, "Robert Reid: Decorative Impressionist," *Arts and Decoration*, II (1911), 34.

43 Pierre Baudin, "Les Salons de 1904," *Gazette des Beaux-Arts*, 3me pér. (1904), 472. Cited by Allen S. Weller, "Frederick Carl Frieseke: The Opinions of an American Impressionist," *Art Journal*, XXVIII, 2 (Winter 1968–69), 160.

44 For Inness' own statements on art, see George Inness, Jr., *Life, Art, and Letters of George Inness* (New York, 1917).

45 Nicolai Cikovsky, *George Inness* (New York, 1971), 38.

46 Peter Bermingham, *American Art in the Barbizon Mood* (Washington, D.C., 1975), 70, quotes Inness here.

47 See Inness, Jr., *op. cit.*, 210–19.

48 *Ibid.*, 168–76, for the letter discussing George Inness' attitudes toward what he regarded as Impressionism.

49 Robert Rosenblum, *Modern Painting and the Northern Romantic Tradition: Friedrich to Rothko* (New York, 1975), 14.

50 Soria, *op. cit.*, 354.

51 *Ibid.*, 94.

52 Elliott Daingerfield, *Ralph A. Blakelock* (New York, 1914), 16.

53 *Ibid.*, 35.

54 Quoted in Lloyd Goodrich, "Ryder Rediscovered," *Art in America*, LVI (Nov. 1968), 45.

55 See Emily Farnham, *Charles Demuth: Behind a Laughing Mask* (Norman, Okla., 1971).

56 *Ibid.*, 19, 24.

57 *Ibid.*, 29.

58 Bing, *op. cit.*, 49.

59 Quoted from Saint-Gaudens' *Reminiscences*, I, 256, in Wayne Craven, *Sculpture in America* (New York, 1968), 380.

60 Craven, *op. cit.*, 402.

61 Sam Hunter and John Jacobus, *American Art of the 20th Century: Painting, Sculpture, Architecture* (New York, 1973), 264–65.

62 See Lincoln Kirstein, *Five American Sculptors* (New York, 1969), 29.

CONCLUSION

[1] Brooks Wright, *Interpreter of Buddhism to the West: Sir Edwin Arnold* (New York, 1957), 69.

[2] Charles H. Caffin, *American Masters of Painting* (New York, 1902), 37.

[3] See Sven Loevgren, *The Genesis of Modernism: Seurat, Gauguin, Van Gogh, and French Symbolism in the 1880's* (Bloomington, Ind.–London, 1971).

[4] John Rewald, *Post-Impressionism: From van Gogh to Gauguin* (New York, 1962), 79. Rewald quotes Seurat but gives no reference.

[5] *Ibid.*, 112; Signac to Pissarro, May 1887 (unpublished document).

[6] *Ibid.*, 136; Félix Fénéon, "Paul Signac," *Les Hommes d'Aujourd'hui*, VII, 1890, 373.

[7] *Ibid.*, 421; Henri van de Velde in a letter to Rewald, January 1950.

[8] See Klaus Berger, "Stilstrukturen des 19. Jahrhunderts," *Sonderdruck aus Jahrbuch für Aesthetik und Allgemeine Kunstwissenschaft*, XII, 2, 192–203.

[9] Samuel Bing, *Artistic America, Tiffany Glass, and Art Nouveau* (Cambridge, Mass.–London, 1970), 219.

[10] See Philip Johnson, "Decorative Art a Generation Ago," *Creative Art*, XII, 4 (April 1933), 297–99, for an early awareness of the "values" seen in decorative *vs.* functional aesthetics.

[11] Ernest F. Fenollosa, "The Significance of Oriental Art," *The Knight Errant*, I, 3 (Oct. 1892), 65–70.

[12] Rudolf Arnheim, *Art and Visual Perception* (Berkeley, Cal., 1954), 135, 137–39.

[13] Desmond's statement is taken from "Another View—What Mr. Louis Sullivan Stands For," *Architectural Record*, XVI (July 1904); quoted in Edgar Kaufmann, Jr., ed., *Louis Sullivan, Catalogue* (Chicago, 1956), 32.

[14] Louis Sullivan, "Ornament in Architecture," *Engineering Magazine*, III, 5 (Aug. 1892), 633–44.

[15] *Idem, Kindergarten Chats and Other Writings* (New York, 1947), as quoted in Hugh Morrison, *Louis Sullivan, Prophet of Modern Architecture* (New York, 1962), 255.

[16] This statement by Denis is quoted by Eleanor Garvey in "Art Nouveau and the French Book of the 1890's," *Harvard Library Bulletin*, XII, 3 (Autumn 1958), 379.

[17] Maurice Denis, *Theories, 1890–1910* (Paris, 1913), 3rd ed., 149.

[18] *Ibid.*, as quoted in Elizabeth Gilmore Holt, *From the Classicists to the Impressionists* (New York, 1966), 513, 516.

[19] Jean Lorrain, as quoted in Philippe Jullian's *The Triumph of Art Nouveau: Paris Exposition 1900* (New York, 1974), 89.

[20] Walter Terry, *The Dance in America* (New York, 1971), 46.

[21] Gaston Vuillier, *A History of Dancing from the Earliest Ages to our own Times* (Boston, 1898), 378.

[22] Lincoln Kirstein, *Dance* (Westport, Conn., 1970), 268–69.

[23] Mario Amaya, *Art Nouveau* (London, 1966), 6.

[24] André Bouilhet, "L'Exposition de Chicago: Notes de Voyage d'un Orfèvre," *Revue des Arts Décoratifs*, XIV (1893–94), 73, when writing about the Tiffany chapel at Chicago, described what he called "du sentiment de l'art très nouveau et très personnel des Américains." Similarly, Wilhelm Bode, in "Moderne Kunst in den Vereinigten Staaten von Amerika, Eindrücke von einem Besuch der Weltausstellung zu Chicago. II. Die Architektur und das Kunstgewerbe," *Kunstgewerbeblatt*, N.F., V (1894), 142–43, wrote of Tiffany's glass: "Was wir hier vor uns sehen, ist in seiner Art eine ganz neue Kunstgattung, der unser Jahrhundert in stilvoller Behandlung und Pracht der Farbe wohl keine zweite an die Seite stellen kann." Then, in October of 1895 Octave Uzanne wrote of the new poster art in "Les Affiches Etrangères," *La Plume*, No. 155 (October 1895), 412 and 425: ". . . car la France n'est plus seule à posséder des maîtres en l'art des chromolithos souveraines par l'éclat décoratif et la facture impétueuse; les Anglais, puis les Américains, les Belges, les Allemands, se sont manifestés et déjà nous familiarisons avec un art nouveau qui nous vient d'outre-manche ou d'outre océan, art d'une recherche de décoration rare et exquise ou d'une simplesse de moyens qui nous déconcerte par l'intensité de l'effet obtenu. . . .

". . . Les affiches illustrées nous semblent devoir être les bannières esthétiques des nouvelles écoles qui s'approchent lumineusement douées pour la rénovation de notre goût et de nos sensations. Sur nos vieilles murailles: place aux jeunes apôtres de l'art nouveau."

[25] A. D. F. Hamlin, "L'Art Nouveau, Its Origin and Development," *The Craftsman*, III (Dec. 1902), 129.

[26] Herbert Croly, "The New World and the New Art," *Architectural Record*, XII (1902), 137.

[27] *Ibid.*, 135 ff.

[28] *Ibid.*, 137 ff.

[29] Herwin Schaeffer, "Tiffany's Fame in Europe," *Art Bulletin*, XLIV (Dec. 1962), 327.

[30] These phrases are taken from Croly, *op. cit.*

[31] Bing, *op. cit.*, 215.

BIBLIOGRAPHY

James Grady, who compiled one of the first major bibliographies on Art Nouveau (see Section 1, below), has stated that any bibliography on the subject will necessarily be complex even though the movement lasted so short a time. It must contain source material for the various aspects of the style, publications from the period, and studies on the topic which have been appearing in ever-increasing numbers during the last thirty years. This bibliography on American Art Nouveau is not comprehensive, but it presents specific works that the reader will find useful to the subject.

The bibliography is divided into six sections: 1) general material on Art Nouveau, as well as specific studies on topics important here; 2) general source material for Art Nouveau; 3) materials dealing specifically with American art as related to Art Nouveau; 4) source material for Art Nouveau in America; 5) works on the three major artists discussed in this book—Will H. Bradley, Louis Comfort Tiffany, and Louis H. Sullivan; 6) a brief list of periodicals relating to the movement in the United States. The periodicals movement was especially productive in this country. Frederic Faxon's 1903 bibliography of what he calls "Ephemeral Bibelots" lists over two hundred publications between 1892 and 1902, and only those particularly relevant to the text are included here.

1. GENERAL MATERIAL ON ART NOUVEAU AND RELATED TOPICS

Amaya, Mario. *Art Nouveau*. London, 1966.

Arberry, H. J. *The Romance of the Rubaiyat*. London, 1959.

Arnheim, Rudolf. "From Function to Expression." *Journal of Aesthetics*, XXIII, No. 1 (Autumn, 1964), pp. 29–41.

Aslin, Elizabeth. *The Aesthetic Movement: Prelude to Art Nouveau*. London, 1969.

Barnard, Julian. *The Decorative Tradition*. London, 1973.

Barnicoat, John. *A Concise History of Posters*. New York, 1972.

Berger, Klaus. "Stilstrukturen des 19. Jahrhunderts." *Sonderdruck aus Jahrbuch für Aesthetik und Allgemeine Kunstwissenschaft*, XII, No. 2, pp. 192–203.

Bloch-Dermant, Janine. *L'Art du Verre en France*. Lausanne, 1974.

Brunhammer, Yvonne, *et al. Art Nouveau: Belgium–France* (exhibition catalogue). Institute for the Arts, Rice University, Houston, 1976.

Garvey, Eleanor. "Art Nouveau and the French Book of the 1890's." *Harvard Library Bulletin*, XII, No. 3 (1955), pp. 379–91.

Goldwater, Robert. "L'Affiche Moderne: A Revival of Poster Art after 1880." *Gazette des Beaux-Arts*, XXIII (December, 1942), pp. 173–82.

Grady, James. "Hector Guimard: An Overlooked Master of Art Nouveau." *Apollo*, n.s. 89 (April, 1969), pp. 284–95.

———. "Bibliography of Art Nouveau." *Journal of the Society of Architectural Historians*, XIV (May, 1955), pp. 18–27.

Grover, Ray and Lee. *Art Nouveau Glass*. Rutland, Vermont, 1967.

Guerrand, Roger Henri. *L'Art Nouveau en Europe*. Paris, 1965.

Harrison, Martin, and Bill Waters. *Burne-Jones*. New York, 1973.

Hillier, Bevis. *Posters*. London, 1969.

Hilton, Timothy. *The Pre-Raphaelites*. New York, 1970.

Hofstätter, Hans H. *Geschichte der europäischen Jugendstilmalerei*. Cologne, 1963.

———. *Jugendstil Druckkunst*. Baden-Baden, 1968.

Ives, Colta Feller. *The Great Wave: The Influence of Japanese Woodcuts on French Prints* (exhibition catalogue). Metropolitan Museum of Art, New York, 1974.

Janson, Dora Jane. *From Slave to Siren: The Victorian Woman and her Jewelry from Neoclassic to Art Nouveau* (exhibition catalogue). Duke University Museum of Art, Durham, N.C., 1971.

Johnson, Philip. "Decorative Art a Generation Ago." *Creative Art*, XII, No. 4 (April, 1933), pp. 297–99.

Jullian, Philippe. *The Triumph of Art Nouveau: Paris Exposition 1900*. New York, 1974.

Lee, Sherman E. *Japanese Decorative Style*. New York and London, 1962.

Letheve, Jacques. "Aubrey Beardsley et la France." *Gazette des Beaux-Arts*, LXVIII (December, 1966), pp. 343–50.

Loevgren, Sven. *The Genesis of Modernism: Seurat, Gauguin, Van Gogh, and French Symbolism in the 1880's*. Bloomington, Ind., and London, 1971.

Maus, Madeleine Octave. *Trente Années de Lutte pour l'Art: 1884–1914*. Brussels, 1926.

May, J. Lewis. *John Lane and the Nineties*. London, 1936.

Mebane, John. *The Complete Book of Collecting Art Nouveau*. New York, 1970.

Metzl, Ervine. *The Poster: Its History and Its Art*. New York, 1963.

Morgan, H. Wayne. *Victorian Culture in America, 1865–1914*. Itasca, Ill., 1967. Contains a collection of essays of that period.

Mumford, Lewis. "The Wavy Line Versus the Cube." *Architecture* (December, 1930). Reprinted in *Architectural Record*, CXXXV (January, 1964), pp. 111–16.

Naylor, Gillian. *The Arts and Crafts Movement: A Study of Its Sources, Ideals and Influence on Design Theory*. Cambridge, Mass., 1971.

Pevsner, Nikolaus. *Pioneers of Modern Design: From William Morris to Walter Gropius*. 2nd ed. New York, 1949.

———. "Beautiful and if need be, Useful." *Architectural Review*, CXXII (November, 1957), pp. 297–99.

Poggioli, Renato. *The Theory of the Avant Garde*. Cambridge, Mass., 1968 (original Italian edition, 1962).

Reade, Brian, and Frank Dickinson. *Aubrey Beardsley* (exhibition catalogue). Victoria and Albert Museum, London, 1966.

Reade, Brian. *Aubrey Beardsley*. New York, 1967.

Rheims, Maurice. *L'Objet 1900*. Paris, 1964.

———. *The Flowering of Art Nouveau*. New York, 1965.

Rookmaaker, Hendrick R. *Synthetist Art Theories*. Amsterdam, 1959.

———. *Gauguin and 19th-Century Art Theory*. Amsterdam, 1972.

Rosenblum, Robert. *Modern Painting and the Northern Romantic Tradition: Friedrich to Rothko*. New York, 1975.

Schindler, Herbert. *Monografie des Plakats*. Munich, 1972.

Schmutzler, Robert. "The English Origins of Art Nouveau." *Architectural Review*, CXVIII (February, 1955), pp. 108–16.

———. "Blake and Art Nouveau." *Architectural Review*, CXVIII (August, 1955), pp. 90–95.

———. *Art Nouveau*. New York, 1964.

Seling, Helmut. *Jugendstil: Der Weg ins 20. Jahrhundert*. Heidelberg, 1959.

Selz, Peter, and Mildred Constantine, eds. *Art Nouveau*. New York, 1959.

Sewter, A. Charles. *The Stained Glass of William Morris and His Circle*. New Haven and London, 1974.

Spencer, Robin. *The Aesthetic Movement*. New York and London, 1972.

Tschudi Madsen, Stephan. *Sources of Art Nouveau*. Oslo, 1955.

———. *Art Nouveau*. New York, 1967.

The Turn of a Century: 1885–1910: Art Nouveau–Jugendstil Books (exhibition catalogue). Department of Printing and Graphic Arts, Harvard University Library, Cambridge, Mass., 1970.

Um 1900: Art Nouveau und Jugendstil (exhibition catalogue). Kunstgewerbemuseum, Zurich, 1952.

Watkinson, Raymond. *Pre-Raphaelite Art and Design*. Greenwich, Conn., 1970.

Weisberg, Gabriel P. "Samuel Bing: International Dealer of Art Nouveau. Part I. Contacts with the Musée des Arts Décoratifs, Paris"; "Part II. Contacts with the Victoria and Albert Museum"; "Part III. Contacts with the Kaiser Wilhelm Museum, Krefeld, Germany, and the Finnish Society of Crafts and Design, Helsinki, Finland"; "Part IV. Contacts with the Museum of Decorative Art, Copenhagen." *Connoisseur*: 176 (March, April, May, July, 1971), pp. 200–205; 275–83; 49–55; 211–19.

———. "Samuel Bing: Patron of Art Nouveau: Part I. The Appreciation of Japanese Art"; "Part II. Bing's Salons of Art Nouveau"; "Part III. The House of Art Nouveau Bing." *Connoisseur*: 172, 173 (October, December 1969; January 1970), pp. 119–25; 294–99; 61–68.

Wember, Paul. *Die Jugend der Plakate: 1887–1917*. Krefeld, 1961.

Wilde, Oscar. *Complete Works*. New York, 1966 (new edition).

Wright, Brooks. *Interpreter of Buddhism to the West: Sir Edwin Arnold*. New York, 1957.

2. SOURCES FOR ART NOUVEAU IN GENERAL

Alexandre, Arsène, *et al*. *The Modern Poster*. New York, 1895.

Art Furniture Designed by Edward W. Godwin F.S.A. and Manufactured by William Watt. London, 1877.

"Aubrey Beardsley's Strange Art." *The Critic*, XXXIV (1899), p. 439.

Bate, Percy H. *The English Pre-Raphaelite Painters, Their Associates, and Successors*. London, 1899.

Bauwens, Maurice, ed. *Les Affiches Etrangères Illustrées*. Paris, 1897.

Beardsley, Aubrey. "The Art of Hoarding." *The New Review*, XI (July, 1894), pp. 53–55.

Bell, Malcolm. *Edward Burne-Jones: A Record and a Review*. New York and London, 1892.

Bella, Edward, ed. *A Collection of Posters*. Catalogue of the First Exhibit at the Royal Aquarium. London, 1895.

———. *Histoire de L'Affiche Illustrée*. Paris, 1895.

Bing, Samuel. *Salon de l'Art Nouveau, Catalogue Premier*. Paris, 1895.

———. "L'Art Nouveau." *Architectural Record*, XII (1902), pp. 280–85.

Bolton, Charles Knowles. *The Reign of the Poster*. Boston, 1895.

Casford, Ethel Lenors. *The Magazines of the 1890's: A Chapter in the History of English Periodicals*. Eugene, Ore., 1929.

Crane, Walter. *The Claims of Decorative Art*. Boston, 1892.

———. *Of the Decorative Illustration of Books Old and New*. 2nd ed. London and New York, 1909 (original edition 1896).

Day, Lewis F. *Everyday Arts: Short Essays on the Arts Not-Fine*. London, 1882.

The Decorative Arts: Sir Edward Burne-Jones, William Morris, and Walter Crane. London, 1900.

Denis, Maurice. *Théories, 1890–1910*. 3rd ed. Paris, 1913.

Guimard, Hector. "An Architect's Opinion of Art Nouveau." *Architectural Record*, XII, pp. 130–33.

Hamilton, Walter. *The Aesthetic Movement in England*. London, 1882.

Hamlin, A. D. F. "L'Art Nouveau: Its Origins and Development." *The Craftsman*, III (December, 1902), pp. 129–43.

Hiatt, Charles. *Picture Posters*. London, 1895.

Jones, Owen. *The Grammar of Ornament*. New York and London, 1972 (reprint of original 1856 edition).

Maindron, Ernst. *Les Affiches Illustrées: 1881–1895*. Paris, 1896.

Marx, Roger. *Les Maîtres de l'Affiche*. 5 vols. Paris, 1896–1900.

———. "On the Role of the Influence of the Arts of the Far East and of Japan." *Artistic Japan*, VI, No. 36 (1891), pp. 459–66.

Meier-Graefe, Julius. "Aubrey Beardsley and his Circle," in *Modern Art*. London and New York, 1898.

Mourey, Gabriel. "An Interview on Art Nouveau with Alexandre Charpentier." *Architectural Record*, XII, No. 2 (June, 1902), pp. 281–85.

Nordau, Max. *Degeneration*. 7th ed.; translated from the 2nd German ed. New York, 1895.

Pennell, Joseph. "A New Illustrator: Aubrey Beardsley." *The Studio*, I (April, 1893), pp. 16–19.

Picard, Alfred. *Rapport Général: Exposition Universelle de 1889 à Paris*. Paris, 1889 (work by Tiffany and Company is discussed in Vol. I, p. 266; Vol. V, pp. 137–138).

Sagot, Edouard. *Catalogue d'Affiches Illustrées Anciennes et Modernes*. Paris, 1891.

Sponsel, Jean Louis. *Das Moderne Plakat*. Dresden, 1897.

Uzanne, Octave. "Les Affiches Etrangères." *La Plume*, CLV (October 1, 1895). pp. 409–25.

Vallance, Aymer. *The Decorative Art of Sir Edward Burne-Jones*. London, 1900.

Zur Western, Walter von. *Reklamekunst*. Beelefeld and Leipzig, 1903.

3. MATERIALS ON ART NOUVEAU AND RELATED TOPICS

American Victorian Architecture: A Survey of the 70's and 80's in Contemporary Photographs. Introduction by Arnold Lewis; notes by Keith Morgan. New York, 1975.

Arnest, Barbara M., ed. *Van Briggle Pottery: The Early Years* (exhibition catalogue). Colorado Springs, 1975.

The Artist and the Book: 1860–1960 in Western Europe and the United States (exhibition catalogue). Museum of Fine Arts, Boston, 1961.

Arts and Crafts in Detroit 1906–1976: The Movement, The Society, The School (exhibition catalogue). Detroit Institute of Arts, 1976.

Beer, Thomas. *The Mauve Decade: American Life at the End of the Nineteenth Century.* New York, 1926.

Berkelman, Robert. "John La Farge, Leading American Decorator." *South Atlantic Quarterly,* 56 (January, 1957), pp. 27–41.

Bermingham, Peter. *American Art in the Barbizon Mood* (exhibition catalogue). National Collection of Fine Arts, Washington, D.C., 1975.

Bernstein, Gerald Steven. "In Pursuit of the Exotic: Islamic Forms in Nineteenth-century American Architecture." Unpublished Ph.D. dissertation. University of Pennsylvania, 1968.

Bogue, Dorothy McGraw. *The Van Briggle Story.* Colorado Springs, 1968.

Bolton, Theodore. *American Book Illustrators.* New York, 1938.

Breeskin, Adelyn D. *The Graphic Art of Mary Cassatt* (exhibition catalogue). Museum of Graphic Art, New York, 1967.

Breitenbach, Edgar. *The American Poster.* New York, 1967.

Brown, Milton W. *The Story of the Armory Show.* New York, 1963.

Brown, Theodore M. "Greenough, Paine, Emerson, and the Organic Esthetic." *Journal of Aesthetics and Art Criticism,* XIV (1956), pp. 304–17.

Carpenter, Charles H., Jr. "Nineteenth-century Silver in the New York Yacht Club." *Antiques Magazine* (September, 1977), pp. 496–505.

Chisolm, Lawrence W. *Fenollosa: The Far East and American Culture.* New Haven, Conn., 1963.

Christ, Arthur. *The Orient in American Transcendentalism.* New York, 1972.

Cikovsky, Nicolai. *George Inness.* New York, 1971.

Clark, Robert Judson, ed. *The Arts and Crafts Movement in America, 1876–1916* (exhibition catalogue). Art Museum, Princeton University, Princeton, N.J., 1972.

Craven, Wayne. *Sculpture in America.* New York, 1968.

Dickason, David H. *The Daring Young Men: The Story of the American Pre-Raphaelites.* Bloomington, Ind., 1953.

Dillenberger, Jane, and Joshua C. Taylor. *The Hand and the Spirit: Religious Art in America 1700–1900* (exhibition catalogue). University Art Museum, Berkeley, Cal., 1972.

Dorra, Henry. "Ryder and Romantic Painting." *Art in America,* XLVIII, No. 4 (Winter, 1960), pp. 22–23.

Eidelberg, Martin. "Edward Colonna's *Essay on Broom-Corn:* A Forgotten Book of Early Art Nouveau." *Connoisseur,* 176, No. 708 (February, 1971), pp. 123–30.

———. "The Ceramic Art of William H. Grueby." *Connoisseur,* 184 (September, 1973), pp. 47–54.

Farnham, Emily. *Charles Demuth: Behind a Laughing Mask.* Norman, Okla., 1971.

Feidelson, Charles, Jr. *Symbolism and American Literature.* Chicago, 1953.

Ferriday, Peter. "The Peacock Room." *Architectural Review,* LXXV, No. 749 (June, 1959), pp. 407–14.

Freeman, John Crosby. *The Forgotten Rebel: Gustav Stickley and His Craftsman Mission Furniture.* Watkins Glen, N.Y., 1966.

The Freer Gallery of Art. *The Whistler Peacock Room.* Washington, D.C., 1972.

Das frühe Plakat in Europa und den USA: Ein Bestandskatalog. Kunstbibliothek Staatliche Museen Preussischer Kulturbesitz, Berlin, 1973.

Gardner, Albert TenEyck. *American Sculpture: A Catalogue of the Collection of the Metropolitan Museum of Art.* New York, 1965.

Gebhard, David. "C. F. A. Voysey: To and From America." *Journal of the Society of Architectural Historians,* XXX (December, 1971), pp. 304–12.

Gerdts, William, and Russell Burke. *American Still Life Painting.* New York, 1971.

Gere, Charlotte. *American and European Jewelry, 1830–1914.* New York, 1975.

Goodrich, Lloyd. *Albert P. Ryder.* New York, 1959.

———. "Ryder Rediscovered." *Art in America,* LVI (November, 1968), pp. 32–45.

———, and John Barr. *American Art of Our Century.* New York, 1961.

———, and Doris Bry. *Georgia O'Keeffe.* New York, 1970.

Hills, Patricia. *Turn-of-the-Century America: Paintings, Graphics, Photographs, 1890–1910* (exhibition catalogue). Whitney Museum of American Art, New York, 1977.

Hitchcock, Henry-Russell. *The Architecture of H. H. Richardson and His Time.* New York, 1936.

Hoffmann, Donald. *The Architecture of John Wellborn Root.* Baltimore and London, 1973.

Hofstadter, Richard. *Anti-intellectualism in American Life.* New York, 1963.

Homer, William I. "Ryder in Washington." *Burlington Magazine,* CIII (June, 1961), pp. 280–83.

Hood, Graham. *American Silver.* New York, 1971.

Hunter, Sam. *Modern American Painting and Sculpture.* New York, 1973.

Kirstein, Lincoln. *Elie Nadelman Drawings.* New York, 1970.

Koch, Robert. "American Influence Abroad, 1886 and Later." *Journal of the Society of Architectural Historians,* XVIII (May, 1959), pp. 66–69.

———, ed. *Artistic America, Tiffany Glass, and Art Nouveau.* Cambridge, Mass., and London, 1970.

Kovel, Ralph and Terry. *The Kovels' Collector's Guide to American Art Pottery.* New York, 1974.

Kramer, Sidney. *A History of Stone and Kimball and Herbert S. Stone and Company, with a Bibliography of their Publications: 1893–1905.* Chicago, 1940.

Lancaster, Clay. *The Japanese Influence in America.* New York, 1963.

———. "Synthesis: The Artistic Theory of Fenollosa and Dow." *Art Journal,* XXVIII, No. 3 (Spring, 1969), pp. 286–87.

Larkin, Oliver W. *Art and Life in America.* New York, 1949.

Lewis, Lloyd, and Henry Justin Smith. *Oscar Wilde Discovers America.* New York, 1936.

Margolin, Victor. *American Poster Renaissance.* New York, 1975.

McClinton, Katherine Morrison. *The Chromolithographs of Louis Prang.* New York, 1973.

———. *Collecting American Nineteenth-century Silver.* New York, 1968.

McLanathan, Richard. *The American Tradition in the Arts.* New York, 1968.

———. *Art in America: A Brief History.* New York, 1973.

Miller, Perry, ed. *American Thought: Civil War to World War I.* New York, 1954.

Moffatt, Frederick C. *Arthur Wesley Dow* (exhibition catalogue). National Collection of Fine Arts, Washington, D.C., 1977.

Morse, Peter. *John Sloan's Prints: A Catalogue Raisonné of the Etchings, Lithographs, and Posters.* New Haven, Conn., and London, 1969.

Museum of Fine Arts, Boston. *Decorations of the Main Stairway and Library: John Singer Sargent.* Boston, 1926.

Museum of Modern Art, New York. *Five American Sculptors.* New York (reprint), 1969.

Nelson, Marion John. "Art Nouveau in American Ceramics." *Detroit Institute of Arts: Art Quarterly,* XXVI, No. 4 (1963), pp. 441–59.

Nineteenth-Century America: Furniture and Other Decorative Arts (catalogue). Metropolitan Museum of Art, New York, 1970.

Noble, David W. *The Progressive Mind, 1890–1917.* Chicago, 1970.

Noffsinger, James Philip. *The Influence of the Ecole des Beaux-Arts on the Architects of the United States.* Washington D.C., 1955.

O'Gorman, James F. *The Architecture of Frank Furness.* Philadelphia, 1973.

———. *Selected Drawings: H. H. Richardson and His Office* (exhibition catalogue). Fogg Art Museum, Cambridge, Mass., 1974.

Ormond, Richard. *John Singer Sargent: Paintings: Drawings: Watercolors.* New York, 1970.

Page, A. A. "Four Watercolor Studies for Mural Decorations in the Baltimore Courthouse." *Detroit Institute of Arts Bulletin,* XXIX, No. 1 (1949), pp. 18–20.

Randall, Richard H., Jr. *The Furniture of H. H. Richardson* (exhibition catalogue). Museum of Fine Arts, Boston, 1962.

Revi, Albert Christian. *American Art Nouveau Glass.* New Jersey, 1968.

Schau, Michael. *J. C. Leyendecker.* New York, 1974.

Scheyer, Ernest. *The Circle of Henry Adams: Art and Artists.* Detroit, 1970.

Schlesinger, Arthur M. *The Rise of the City: 1878–1898* (History of American Life Series, Vol. X). New York, 1933.

Schuyler, Montgomery. *American Architecture.* Two vols. William H. Jordy and Ralph Coe, eds. Cambridge, Mass., 1961.

Scott, David W., and John E. Bullard. *John Sloan: 1871–1951. His*

Life and Paintings: His Graphics (exhibition catalogue). Boston and Washington, D.C., 1971.

Scully, Vincent J., Jr. *The Shingle Style and the Stick Style: Architectural Theory and Design from Richardson to the Origins of Wright.* Revised edition. New Haven and London, 1971.

Sloan, John. *American Art Nouveau: The Poster Period of John Sloan.* Collected by Helen Farr Sloan. Pennsylvania, 1967.

Soby, James Thrall, and Dorothy C. Miller. *Romantic Painting in America.* Reprint edition. New York, 1969.

Soria, Regina. *Elihu Vedder: American Visionary Artist in Rome.* Cranbury N.J., 1970.

———. "Elihu Vedder's Mythical Creatures." *Art Quarterly,* XXVI, No. 2 (Summer, 1963), pp. 180–93.

Spain, May R. *The Society of Arts and Crafts—Boston and New York, 1897–1924.* New York, 1924.

Stebbins, Theodore E., Jr. "Richardson and Trinity Church: The Evolution of a Building." *Journal of the Society of Architectural Historians,* XXVII (December, 1968), pp. 281–98.

Stein, Roger B. *John Ruskin and Aesthetic Thought in America, 1840–1900.* Cambridge, Mass., 1967.

Sutton, Denys. *Nocturne: The Art of James McNeill Whistler.* London, 1963.

Terry, Walter. *The Dance in America.* New York, 1971.

Tutag, Nola Mary Huse. "A Reconstruction of the Career of Elihu Vedder Based upon the Unpublished Letters and Documents of the Artist, His Family, and Correspondents Held by the Archives of American Art." Unpublished Ph.D. dissertation. Wayne State University, 1969.

Weinberg, Helene Barbara. "John La Farge and the Decoration of Trinity Church, Boston." *Journal of the Society of Architectural Historians,* XXX (December, 1974), pp. 323–53.

———. "The Early Stained Glass Work of John La Farge (1835–1910)." *Stained Glass,* LXVII (Summer, 1972), pp. 4–16.

———. "John La Farge and the Invention of American Opalescent Windows." *Stained Glass,* LXVII (Autumn, 1972), pp. 4–11.

———. "The Decorative Work of John La Farge." Unpublished Ph.D. dissertation. Department of Art History and Archaeology, Columbia University, 1972.

———. "A Note on the Chronology of John La Farge's Early Windows." *Stained Glass,* LXVII (Winter, 1972–73), pp. 12–15.

———. "John La Farge: The Relation of his Illustrations to his Ideal Art." *The American Art Journal,* V (May, 1973), pp. 54–73.

Weller, A. S. "Frederick Carl Frieseke: The Opinions of an American Impressionist." *Art Journal,* XXVIII, No. 2 (Winter, 1968–69), pp. 160–65.

Whitehill, Walter M. "The Making of an Architectural Masterpiece—The Boston Public Library." *American Art Journal,* II, No. 2 (Fall, 1970), pp. 13–32.

Wilmerding, John. *A History of American Marine Painting.* Boston, 1968.

Young, Mahonri Sharp. *Early American Moderns: Painters of the Stieglitz Group.* New York, 1974.

Young, Vernon. "Out of Deepening Shadows: The Art of Blakelock." *Arts Magazine,* XXXII (October, 1957), pp. 24–29.

4. SOURCES FOR AMERICAN ART NOUVEAU

L'Architecture Américaine. Paris, 1886. An original photographic essay.

"Ein Amerikanischer Möbelkünstler: Charles Rohlfs–Buffalo." *Dekorative Kunst,* Band VII (1901), pp. 74–9.

Anderson, Margaret Steele. *The Study of Modern Painting.* New York, 1914.

"Art Magazines of America." *The Studio,* I, No. 4 (July, 1893), pp. 143–49.

Bartlett, Truman H. *The Art Life of William Rimmer: Sculptor, Painter, and Physician.* New York, 1970 (reprint of 1890 edition, Boston and New York).

Benjamin, S. G. W. "American Art since the Centennial." *New Princeton Review,* IV (1887), pp. 14–30.

Bing, Samuel. *La Culture Artistique en Amérique.* Paris, 1896.

Blashfield, Edwin H. *Mural Painting in America.* New York, 1913.

Bode, Wilhelm. "Moderne Kunst in den Vereinigten Staaten von Amerika, Eindrücke von einem Besuch der Weltausstellung zu Chicago." *Kunstgewerbeblatt,* N.F.V (1894), pp. 137–43.

Bouilhet, André. "L'Exposition de Chicago: Notes de Voyage d'un Orfèvre." *Revue des Arts Décoratifs,* XIV (1893–94), pp. 65–79.

Brinton, Christian. "Robert Reid: Decorative Impressionist." *Arts and Decoration,* II (1911), pp. 13–15.

Bunner, Henry C. "The Making of the White City." *Scribner's Magazine,* XII (July–December, 1892), pp. 399 f.

Caffin, Charles H. *American Masters of Painting.* New York, 1902.

Calkins, Ernest Elmo. "The Chap Book." *The Colophon* (April, 1932), Part X, n.p.

Coleman, Caryl. "Second Spring." *Architectural Record,* II (1893), pp. 473–92.

———. "A Comparative Study of European and American Church Glass." *House Beautiful,* III (April, 1898), pp. 143–48.

Cortissoz, Royal. *American Artists.* New York and London, 1923.

———. *John La Farge, a Memoir and a Study.* New York, 1911.

Cram, Ralph Adams. *The Decadent.* Boston, 1893.

Croly, Herbert. "The New World and the New Art." *Architectural Record,* XII (1902), pp. 136–53.

Daingerfield, Elliott. *Ralph A. Blakelock.* New York, 1914.

Dow, Arthur W. *Composition.* 5th ed. New York, 1903.

Downes, William Howe. *John Singer Sargent: His Life and Work.* Boston, 1925.

Faxon, Frederick Winthrop. *Ephemeral Bibelots: A Bibliography of the Modern Chap-Books and Their Imitators.* Boston, 1903.

Fenollosa, Ernest F. *The Masters of Ukiyoye: A Complete Historical Description of Japanese Paintings and Color Prints of the Genre School* (exhibition catalogue). Fine Arts Building, New York, January, 1896.

Fraser, W. L. "Decorative Painting at the World's Fair." *Century Magazine,* XLIV, n.s. XXII (May–October, 1892), pp. 41 ff.

Fuller, H. B. "The Upward Movement in Chicago." *Atlantic Monthly,* XXXX (1897), pp. 544–47.

Galloway, George D. "The Van Briggle Pottery." *Brush and Pencil,* IX (October, 1901), pp. 1–11.

Garnett, K. Porter. "The Poster: A New Province Claimed by Art." *Overland Monthly,* XXVIII (March, 1896), pp. 296–300.

Hartmann, Sadakichi. *A History of American Art.* Boston, 1902.

———. *Modern American Sculpture.* New York, n.d.

Hitchcock, R. *Art of the World: Painting, Sculpture, and Architecture at the World's Fair.* 2 vols., illustrated. 1896.

Hopkinson-Smith, F. *American Illustrators.* New York, 1892.

Ingram, J. S. *The Centennial Exposition Described and Illustrated.* Philadelphia, 1876.

Inness, George, Jr. *Life, Art, and Letters of George Inness.* New York, 1969 (reprint of 1917 ed.).

Isham, Samuel. *History of American Painting.* New York, 1927.

King, Pauline. *American Mural Painting: A Study of the Important Decorations by Distinguished Artists in the United States.* Boston, 1902.

Kurtz, Charles M., ed. *Illustrations from the Art Gallery of the World's Columbian Exposition.* Philadelphia, 1893.

Madeley, Rev. Edward. *The Science of Correspondences Elucidated.* 17th American ed. Philadelphia, 1883.

McCabe, James D. *The Illustrated History of the Centennial Exhibition.* Philadelphia, 1876.

McSpadden, J. Walker. *Famous Painters of America.* New York, 1907.

Millet, Frank D. "The Decoration of the Exposition." *Scribner's Magazine,* XII (July–December, 1893), pp. 692 ff.

Moffitt, Charlotte. "The Rohlfs Furniture." *House Beautiful,* VIII (January, 1900), pp. 81–85.

———. "New Designs on Silver." *House Beautiful,* VII (December, 1899), pp. 55–58.

Peck, Henry Thurston. *The Personal Equation.* New York, 1898.

Photographs of the World's Fair. Charleston, S.C., 1894.

Pollard, Percival. "In Eighteen Ninety-Five." *The Echo,* I, No. 8 (August 15, 1895), pp. 172–73.

Rhead, Louis. "The Moral Aspect of the Artistic Poster." *The Bookman,* I (1895), pp. 312 ff.

Rohlfs, Charles. "The Grain of Wood." *House Beautiful,* IX (February, 1901), pp. 147–48.

Scudder, Horace E. "Vedder's Accompaniment to the Song of Omar Khayyam." *Century Magazine,* XXIX (November, 1884), pp. 2–9.

Schuyler, Montgomery. "Last Words about the World's Fair." *Architectural Record* (1894), pp. 292 f.

Sheldon, George. *Artistic Houses.* 4 vols. in 1. New York, 1883. Reprint 1971.

Smith, Walter. *The Masterpieces of the Centennial International Exhibition.* Philadelphia, 1876 (esp. Vol. II, *Industrial Art*).

———. *Examples of Household Taste.* New York, n.d. (c. 1880).

Stickley, Gustav. *Craftsman Homes.* New York, 1909.

Stillman, William J. "The Rubaiyat." *The Nation,* XXXIX, No. 1011 (November 13, 1884), p. 423.

Tassin, Algernon. *The Magazine in America.* New York, 1916.

Townsend, P. "American and French Applied Arts at the Grafton Galleries." *International Studio,* VIII (1899), pp. 39–46.

Triggs, Oscar Lovell. *Chapters in the History of the Arts and Crafts Movement.* Chicago, 1902.

Truman, Benjamin C. *History of the World's Fair: Being a Complete and Authentic Description of the Columbian Exposition from Its Conception.* New York, 1976 (reprint of 1893 Philadelphia ed.).

Van Brunt, Henry. "Architecture at the Columbian Exposition." *Century Magazine,* XLIV, n.s. XXII (May–October, 1892).

Van Rensselaer, Mrs. Schuyler. *Henry Hobson Richardson and his Works.* Park Forest, Ill., 1967 (reprint of 1888 Boston edition).

Vedder, Elihu. *The Digressions of V.* Boston, 1910.

Walton, William. *World's Columbian Exposition—Art and Architecture.* Philadelphia, 1893.

Weitenkampf, Frank. *American Graphic Art.* New York, 1912.

Westcott, Thompson. *Centennial Portfolio: A Souvenir of the International Exhibition at Philadelphia.* Philadelphia, 1876.

Wheeler, Candace. *Yesterdays in a Busy Life.* New York, 1918.

5. INDIVIDUAL BIBLIOGRAPHIES FOR BRADLEY, SULLIVAN, AND TIFFANY

WILL H. BRADLEY

Bennett, Paul A. "Will Bradley, A Selection of his Works." *Penrose Annual,* XLIX (1955), pp. 31–33.

Bradley, Will H. *Catalogue of Works Exhibited at Springfield, Massachusetts, January, 1896.*

———. *Picture of a Period, or Memories of the Gay Nineties.* Los Angeles: Rounce and Coffin Club, 1950.

———. "Will Bradley's Magazine Memories." *Journal of the American Institute of Graphic Arts,* III, No. 1 (1950).

———. *Will Bradley: His Chap-Book. An account in the words of the Dean of American typographers, of his graphic arts adventures: as boy printer in Ishpeming; art student in Chicago; designer, printer and publisher at the Wayside Press; the years as art director in periodical publishing; and the interludes of stage, cinema, and authorship.* The Typophiles, New York, 1955.

———. *Memories: 1875–1895.* The Typophiles, Pasadena, 1949.

"A Bradley House." *Ladies Home Journal* (February, 1901).

Ettinger, Paul. "Will H. Bradley." *Zeitschrift für Bücherfreunde.* I, Part 2, pp. 223–33 (reprinted in *Das Plakat,* 4 [July, 1913], pp. 149–56).

Hiatt, Charles. "On Some Recent Designs by Will H. Bradley of Chicago." *The Studio,* IV (Fall, 1894), pp. 166–68.

Hornung, Clarence P., ed. *Will Bradley: His Graphic Art.* New York, 1974.

Koch, Robert. "Will Bradley." *Art in America,* L, No. 3 (1962), pp. 78–82.

"Pictures and Posters: The Passing Fancy in its Relation to True Art: The Interesting Personality of Springfield's Popular Young Artist, Will H. Bradley." *The Paper World,* XXXI, No. 5 (November, 1895), pp. 165–68.

Rowland, Stanley. "Masters of the Poster (7): Edward Penfield and Will H. Bradley." *Design for Industry,* XVI (January, 1934), pp. 34–35.

Scotson-Clark, G. F. "The Black Spot in America." *The Poster,* V (November, 1900), pp. 84–87.

Singleton, F. T. "Concerning the Poster Tendency and Mr. Will H. Bradley." *Poster Lore,* I, No. 1 (January, 1896), pp. 10–11.

Stone, Herbert. "Will Bradley." *The Chap-Book,* II (December, 1894), pp. 55–62.

Will Bradley: His Work: An Exhibition (catalogue). Henry E. Huntington Library and Art Gallery, San Marino, Cal., 1951.

Wong, Roberta Waddell. *Will H. Bradley: American Artist and Craftsman (1868–1962)* (exhibition catalogue). Prints and Drawings Galleries, Metropolitan Museum of Art, New York, 1972.

LOUIS COMFORT TIFFANY

Amaya, Mario. "The Taste for Tiffany." *Apollo,* n.s. 8 (February, 1965), pp. 102–9.

The Arts of Louis Comfort Tiffany and His Times (exhibition catalogue). John and Mable Ringling Museum of Art, Sarasota, Fla., 1975.

Bing, Samuel (introduction and editing by Robert Koch). *Artistic America, Tiffany Glass, and Art Nouveau.* Cambridge, Mass., and London, 1970.

De Kay Charles. *The Art Work of Louis Comfort Tiffany.* Garden City, N.Y., 1914.

Eidelberg, Martin. "Tiffany Favrile Pottery: a new study of a few known facts." *Connoisseur,* 169 (September, 1968), pp. 57–61.

Fred, A. W. "Interieurs van L. C. Tiffany." *Dekorative Kunst,* IX (1901), pp. 110–16.

Heydt, George F. *Charles L. Tiffany and Company.* New York, 1893.

Koch, Robert. *Louis C. Tiffany: Rebel in Glass.* 2nd edition. New York, 1966.

———. *Louis C. Tiffany's Glass—Bronzes—Lamps: A Complete Collector's Guide.* New York, 1971.

———. *The Stained Glass Decades: A Study of Louis C. Tiffany and Art Nouveau in America.* Ph. D. dissertation, Yale University, 1957.

"Louis C. Tiffany and His Work in Artistic Jewelry." *International Studio,* 30 (1906), pp. 33–42.

Neustadt, Egon. *The Lamps of Tiffany.* New York, 1970.

"On the Exhibit of Stained Glass at the Fair." *American Architecture and Building News* (November 11, 1893), pp. 74–75.

Schaeffer, Herwin. "Tiffany's Fame in Europe." *Art Bulletin,* XLIV (December, 1962), pp. 302–28.

"Some of the Union League Decorations." *Century Magazine,* XXIII (1882), pp. 745–52.

Speenburgh, Gertrude. *The Arts of the Tiffanys.* Chicago, 1956.

Tiffany Studios: Ecclesiastical Department. *Memorials in Glass and Stone.* New York, 1913.

Waern, C. "The Industrial Arts of America: The Tiffany Glass and Decorating Company." *International Studio,* II (1897), pp. 156–65; V (1898), pp. 16–21.

LOUIS H. SULLIVAN

Bush-Brown, Albert. *Louis H. Sullivan.* New York, 1960.

Connely, Willard. *Louis Sullivan: The Shaping of American Architecture.* New York, 1960.

Crook, David. "Louis Sullivan and the Golden Doorway." *Journal of the Society of Architectural Historians,* XXVI (December, 1967), pp. 250–58.

Desmond, H. W. "Another View—What Mr. Sullivan Stands For." *Architectural Record,* XVI (July, 1904), pp. 61–67.

Eaton, Leonard K. *American Architecture Comes of Age: European Reaction to H. H. Richardson and Louis Sullivan.* Cambridge, Mass., and London, 1972.

English, Maurice, ed. *The Testament of Stone.* Chicago, 1963.

Garcznski, Edward R. *Auditorium.* Chicago, 1890.

Gebhard, David. "Louis Sullivan and George Grant Elmslie." *Journal of the Society of Architectural Historians,* XIX (May, 1960), pp. 62–68.

Hasbrouck, Wilbert R. "Chicago's Auditorium Theater." *The Prairie School Review,* Third Quarter (1967), pp. 7–19.

Hope, Henry. "Louis Sullivan's Architectural Ornament." *Architectural Review,* CII (October, 1947). pp. 111–14.

Kaufmann, Edgar, Jr., ed. *Louis Sullivan* (exhibition catalogue). Art Institute of Chicago, 1956.

Morrison, Hugh. *Louis H. Sullivan, Prophet of Modern Architecture.* New York, 1935 (reprint, New York, 1962).

Paul, Sherman. *Louis Sullivan: An Architect in American Thought.* Englewood Cliffs, N.J., 1962.

Price, C. Matlack. "Secessionist Architecture in America." *Arts and Decoration,* III (December, 1912), pp. 51–53.

Scully, Vincent J., Jr. "Louis Sullivan's Architectural Ornament." *Perspecta*, No. 5 (1959), pp. 173–80.

Sprague, Paul E. *The Architectural Ornament of Louis Sullivan and His Chief Draftsmen.* Ph.D. dissertation, Princeton University, 1969.

Sullivan, Louis H. "Ornament in Architecture." *Engineering Magazine*, III (August, 1892); reprinted in *Kindergarten Chats and Other Writings*, New York, 1947, pp. 187–90.

———. "The Tall Office Building Artistically Considered." *Inland Architect*, XXVII (May, 1896), pp. 32–34 (reprinted in *Kindergarten Chats and Other Writings*, pp. 202–13).

———. *A System of Architectural Ornament: According with a Philosophy of Man's Powers.* New York, 1966 (originally published by the American Institute of Architects, 1924).

Szarkowski, John. *The Idea of Louis Sullivan.* Minneapolis, 1956.

Tselos, Dimitri. "The Chicago Fair and the Myth of the 'Lost Cause.'" *Journal of the Society of Architectural Historians*, XXVI (December, 1967), pp. 259–68.

Turak, Theodore. "French and English Sources of Sullivan's Ornament and Doctrine." *The Prairie School Review*, XI, No. 4, Fourth Quarter (1974), pp. 5–28.

6. SELECTED PERIODICALS RELATED TO AMERICAN ART NOUVEAU

Artistic Japan. London, 1889–91 (originally *Le Japon Artistique*, Paris, 1888).

Bradley: His Book. Springfield, Mass., 1896–97, seven issues.

The Chap-Book. Chicago, May 15, 1894–98.

The Craftsman. Eastwood, N.Y. 1901–.

The Echo. Chicago, 1895–98.

The Hobby Horse. London, 1884, No. 1; 1886–92; n.s. 1893.

The Inland Printer. Chicago, 1887–.

The Knight Errant. Boston, 1892–93.

The Lark. San Francisco, May 1895–April 1896.

The Lotos. Kansas City, Mo., 1896.

Modern Art. Boston, May 1895–.

The Philistine. Aurora, N.Y. 1895–.

La Plume. Paris, 1899–1913.

The Poster. New York, 1897–.

Poster Lore. Kansas City, Mo., 1896, Vols. 1, 2.

The Studio. London, April 1893–.

The Yellow Book. London, 1894–97.

INDEX

Index

307

Post-Impressionists, 279–80
Prairie School, 162
Prang, Louis, 168; Christmas card competition (1881), 27, 168
Prendergast, Maurice, 261, *plate 371*
Pre-Raphaelites, 14, 17, 22, 28, 165, 209, 214
Price, C. Matlack, 152
"Primer of Design" (Bradley), 194
Primrose Room (Whistler), 14, 27
Prints, Japanese, 216–20
Prophets (Sargent), 241
Prudential Building, Buffalo. *See* Guaranty Building
Punch bowl (Tiffany and Company), 98, *plates 99, 136*
Punch Set Martelé (Gorham Manufacturing Company), *plate 114*
Purcell, William, 127
Purple Pup, The (Demuth), 261, *plate 373*
Puvis de Chavannes, 217, 236, 238, 241, 242, 258, 261, *plate 329*

Queen Guenever (Beardsley), 184, *plate 258*
Questioner of the Sphinx, The (Vedder), 216, *plate 296*
"Quest of Beauty, The" (Tiffany), 112
Quezal Art Glass and Decorating Company, vases, *plates 138–39*
Quiet Hour, A (Alexander), 242, *plate 342*

Randall, W. J., 210
Redon, Odilon, *plate 311*
Reed, Ethel, 192, *plate 269*
Reflections of a River Bank (W. M. Hunt), *plate 293*
Reid, Robert, 232, 241, 242, 248, *plates 333, 343, 345*
Republic (French), 34
Research in Form and Volume (Nadelman), 276
Rêverie du Soir (Mucha), 248, *plate 346*
Revue des Arts Décoratifs (periodical), 36, 39
Rhead, Louis, 170–72, 179, 192, *plates 230, 239, 266*
Rheingold, Das (Beardsley illus.), 192
Richardson, Henry H., 25–26, 44–46, 54–55, 60, 73, 82, 230; andirons (drawing), *plate 69;* chairs, *plates 22, 47;* John Hay residence, *plate 42;* New York State Capitol, *plates 39, 41;* Marshall Field Wholesale Store, *plate 166;* Watts Sherman residence, *plate 88;* Trinity Church, *plates 11, 23, 92*
Ricketts, Charles, 28, 30, 179, 192, 194, *plates 274, 281*
Riemerschmid, Richard, 64, *plate 61*
Rimmer, William, 16, 227, 228–29, 270, *plates 314, 315, 316*
Rip Van Winkle (Irving), Bradley poster for, 201
Riverside Magazine for Young People (periodical), La Farge illus., 224, *plates 302–3*
Rivière, Henri, 191
Rodeph Shalom Synagogue, Philadelphia (Furness), 131, *plates 174–75*
Rogers, John, 270
Rogers, Randolph, 47
Rohlfs, Charles, 64; chair, *plate 55;* chest of drawers, *plate 56;* lamp, *plate 57;* lectern, *plate 59;* table, *plate 58*
Rome (Vedder), 236, *plate 323*
Rookery, The, Chicago (Burnham and Root), 128, 130, 152, *plates 169–70, 192*
Rookwood Pottery, 24, 38, 108, 112; pottery, *plates 94, 151–53*
Root, John Wellborn, 25, 128, 130, 148, 163; Houghteling Houses, *plate 208;* ornament, Rookery, *plate 192;* stairs, Mills Building, *plate 72. See* Burnham and Root
Rossetti, Dante Gabriel, *plate 331*
Royal School of Art Needlework, 20, 42; fire screen, *plate 21*
Roycroft Press, 213
Rubáiyat of Omar Khayyám (Vedder), 27, 184, 216, 224, 227–28, *plates 250, 305–8*
Ruskin, John, 17, 148
Ryder, Albert Pinkham, 16, 27, 221, 251, 258, *plates 298, 359, 360*

Saarinen, Eliel, 128
Sagesse (Denis), *plate 392*
Saint-Gaudens, Augustus, 44, 82, 236, 270–71, *plates 378–79*
Saint-Gaudens, Louis, 236
St. Louis World's Fair (1904). *See* Louisiana Purchase Exposition
St. Nicholas magazine, 172
Salome (Wilde), 31–32, 165; Beardsley illus., *plates 221, 255*

Salon de l'Art Nouveau (Paris), 13, 14, 37, 82, 208, 217
Salon des Cent, 179, 191
Salon des Refusés, 242
Salutations (Van de Velde cover), 261, *plate 364*
Sand Larking (Sloan), *plate 234*
Sargent, John Singer, 236, 238, 241, 242, 248, *plates 326–28, 332*
Scarab Mirror (Tiffany), *plate 105*
Schaeffer, Herwin, 78
Schmidt, Charles (vase), *plate 151*
Schmutzler, Robert, 15, 159
Schuyler, Montgomery, 32, 34, 127
Science of Correspondences Elucidated, The (Madeley), 220
Science Revealing the Treasures of the Earth (Abbey), 261
Screen (Mackmurdo), *plate 68*
Scribner's magazine, 217–18; Rhead poster for, *plate 239*
Sea with Sunrise (Friedrich), *plate 354*
Seahorse Vase (Gallé), *plate 158*
Seal of Silence, The (La Farge), 228, *plate 312*
Seated Woman (Nadelman), 276, *plate 388*
Selz, Peter, 159
Sense of Touch, The (Reid), *plate 345*
Serpentine Dance, The (Bradley), *plate 248*
"Service à Roses" (Tiffany and Company), 90
Seurat, Georges, 279, 280
Severn, Edmund, 192
Sheldon, George, 47–48, 50, 51, 52, 54, 148
Sherman, Watts, residence, Newport (Richardson), 82; interior, *plate 88;* La Farge window, *plate 89*
Sicard, Jacques (vase), 112, *plate 165*
"Sicardoware," 112, *plate 165*
Siegfried and the Rhine Maidens (Ryder), 221, 258, *plate 298*
Siegfried's Song (Leyendecker), *plate 336*
Signac, Paul, 279
Silence, Le (Khnopff), *plate 313*
"Silver Brook, The" (Bradley wallpaper), 73, *plate 75*
Silver Morning, A (Inness), 256, *plate 357*
Sirens Three, The (Crane), *plates 4, 5*
Skirt Dance, The (Bradley), *plate 237*
Sloan, John, 172, 175, 210, 248, *plates 234, 291, 348*
Smith, Walter, 22
Snake Charmer Puzzle (Sloan), *plate 291*
Snowbound (Twachtman), 261, *plate 363*
Society of American Artists, 27
Society of Decorative Arts, New York. *See* New York Society of Decorative Arts
"Some Aspects of Japanese Painting" (Cabot), 218–20
Soul's Answer, The (Vedder), *plate 307*
Sphinx (Moreau), 221
Sphinx of the Gods, The (Gardier), *plate 310*
Spirit of Vulcan (Abbey), *plate 370*
Spring (O'Keeffe), *plate 365*
Stained glass windows, *plates 87* (Bonnard and Tiffany); *95* (Elmslie); *81–83* (Healy and Millet); *84* (Horta); *85, 89, 91–92* (La Farge); *78–80, 86, 87, 93* (Tiffany); *94* (Tiffany Studios); *96* (Wright)
Sterling Company, 95, 98, *plate 108*
Steuben Glass Company, Frederick Carder vases for, *plate 140*
Stevenson, E. I., 194, *plates 282, 283*
Stewart, A. T., 47; *entrance hall, plate 25*
Stickley, Gustav, 201, 213, 286, 288
Still Life No. 3 (Demuth), 270, *plate 376*
Stone, Herbert, 172; and Ingalls Kimball, 176, 178, 179, 201, 213
Storer, Maria Longworth Nichols, 24, 112; vase, *plate 159*
Stream Kadisha, The (Bradley), 184, *plate 256*
Strobridge Company, 168
Studio, The (periodical), 14, 60, 165, 172, 192; Chéret sketch for poster, *plate 229*
Study of Modern Painting, The, 248
Sugar bowl and creamer (Tiffany and Company), *plate 98*
Sullivan, A. W., residence, Chicago (Sullivan), *plate 210*
Sullivan, Louis H., 16, 32, 47, 54–55, 90, 125–32, 134–51, 152, 159–62, 220, 282–84, 286, 287, 288; A. W. Sullivan residence, *plate 210;* Auditorium Theater, 138–40; Carson, Pirie, Scott Store, *plates 197, 391;* comb, drawing for, *plate 214;* Getty

Index

PHOTOGRAPHIC CREDITS